Art in the Elementary School

Drawing, Painting, and Creating for the Classroom

Art
in the
Elementary
School

Drawing, Painting, and Creating for the Classroom

Third Edition

Marlene Linderman
Arizona State University/Extension Division

ꞷcb
Wm. C. Brown Publishers
Dubuque, Iowa

Cover: Stuart Davis—*Composition with Boats*.
 Oil on canvas. 20″ × 22″.
 Courtesy of The Fine Arts Gallery of San Diego

Library of Congress Catalog Card Number: 83–72171

ISBN 0–697–03317–1

Printed in the United States of America
10 9 8 7 6 5

*This book is dedicated to
ART and ART students.*

Contents

Preface ... ix

Acknowledgments ... xi

Part 1. The Art Curriculum Structure 1

1. The Importance of Art 3
 Art as a Universal Language 5
 Art as Culture ... 6
 Art in the School .. 8
 Art and the Brain 10
 Art and Perception 11
 Creative Thinking and Imagination in Art 18
 Summary ... 21

2. Planning Objectives and Instruction for Art .. 23
 The Art Curriculum Sequence: Structure and Flow ... 23
 General Art Objectives 24
 Identifying Art Growth in Preschool through Sixth Grade ... 28
 Craft Media .. 43
 Summary ... 47
 A Guide for Planning Art Instruction 48
 Instruction Example 50
 Assessment of Student Art 51

3. Questions Teachers Ask Regarding Elementary Art .. 57
 How Is the Classroom Environment Important? ... 57
 What Are Teacher Strategies? 59
 Is Enthusiasm Important? 59
 How Can We Use Body Language When We Teach? ... 60
 How Should We Encourage Art Thinking? 60
 Which Is More Important—The Process or Product? ... 60
 How Do We Boundary-Push? 60
 Do Most Elementary Schools Have Art Teachers? ... 61
 Where Do You Get Good Teaching Examples? 61
 Do You Provide Time for Verbal Communication—Talking About Art? ... 61

viii Contents

Why Study Artists? 62
Do We Always Need Exciting and Unusual
 Subject Matter for Art? 62
Should Students Have Time to Experiment? 63
What Is Talent? Who Are the Talented? 63
When and How Do We Decide What is Good
 Art? .. 64
How Do You Know When the Drawing Is
 Finished? .. 64
Should the Teacher Ever Repeat an Art Project? .. 64
How Often Should We Have Art? 64
Should the Student Complete the Assigned
 Project? .. 64
How Important Is Exhibiting the Finished
 Artwork? .. 65
What About the Student Who Is Hesitant to
 Draw? .. 65
What About the Student Who Copies From Other
 Students? .. 66
Why Do Students Seem to Lose Their Talent as
 They Get Older? 66
Should the Teacher Give Students Patterns,
 Workbooks, or Mimeographed Sheets? 66
When Is the Best Time to Pass Out Art
 Materials? .. 66
What Does the Teacher Need to Start an Art
 Program? .. 66

4. Integrated Art Learning 71
Integration of the Arts 72
Teaching Examples .. 72
Relating Language and Art 74
Science and Art .. 78
Mathematics and Art 79
History and Art .. 79
The Gifted Program 81
Art Therapy .. 81

5. The Artist and Me: Art Appreciation 85
Yesterday's Artists .. 85
Art Movements .. 87
The Artist Model .. 89
The Importance of the Museum 97
Looking at Art .. 100
Examples: Teaching about Artists 103

Part 2. Art: The Visual Structure 109

6. Design Principles 111
Balance .. 112
Dominance/Emphasis 113
Rhythm/Movement .. 113
Contrast .. 114
Summary .. 114

7. The Art Elements: Line 117
Line as Expression 117
Line as a Tool .. 118
Contour Drawing .. 119
Gesture Drawing .. 121

Other Lines .. 123
How Students Understand Line 124
Line Motivations .. 127
Artists to Study .. 138

**8. The Art Elements: Shape, Value, and
Shadow** .. 141
Shape .. 141
Drawing with Flat Values 142
Shadows .. 143
Modeled Drawing .. 148
How Students Understand Shapes, Value, and
 Shading .. 149
Motivations: Shapes, Values, Shadows, and
 Shading .. 149
Artists to Study .. 156

9. The Art Elements: Space 163
Visual Illusions .. 163
Imaginative Space .. 165
Realistic Space .. 167
How Students Understand Space 171
Space Motivations .. 173
Artists to Study .. 174

**10. The Art Elements: Color, Pattern,
Texture** .. 177
Color Vocabulary .. 179
Color Psychology .. 180
Color Movement .. 182
Making a Movie .. 182
The Light Show as Motivation 183
How Students Express Color 185
Color Motivations .. 187
Pattern—Rhythm .. 188
Texture—A Surface 188
Texture Motivations 189

Part 3. Art Practice 193

11. Drawing Is Seeing 195
How Do Artists Get Started? 195
Drawing Approaches 198
Portraits .. 198
Figure Drawing .. 208
Drawing Drapery .. 222
Landscapes .. 222
The Still Life .. 224

**12. Drawing and Painting Materials and
Motivations** .. 233
Drawing Materials .. 234
Drawing Motivations 237
Painting Materials .. 239
Painting Techniques 241
Painting Motivations 243

Glossary of Art Terms 253
Bibliography .. 259
Index .. 263

Preface

We are moving into the global, universal arena of electronic imagery, satellites, and computers, bombarded with multiple options of thinking, feeling, and experiencing. The vapor trail of our lifestyle seldom encourages us to contemplate, investigate, and discover the fullness of experience that is all around us. We need to establish focusing stations where our mind's eye can perceive the aesthetics crucial to our existence.

Art in the Elementary School is concerned with drawing, painting, and creating at the elementary level. It is intended to fill the art needs of classroom teachers, art teachers, principals, members of school boards, parents, and those students who strive to achieve in art. By perceiving more intensely, we feel more deeply and express this in and through art. As teachers, we can encourage others, as well as ourselves, to build upon our individual uniqueness and talents.

There are many important goals of this text. They are, first, to illustrate how teachers and parents can plan and motivate students for art experiences that will stress individual directions in art. As a young student once said, "Art is the only learning where I can be me. In math, the right answer is in the book; in spelling the same is true. Even music has the right musical notes and melody to follow. In art, I am me and my own ideas." This book provides students with opportunities for inquiry into all areas of art with creativity, freedom, exploration, and even artistic "mistakes."

Other goals of this book are to enrich intellectual, artistic, and perceptual awareness; to provide procedures to develop the fundamental skills needed to produce art; and to study the function of art in our rich cultural heritage. We live in communities richer in the fine arts than ever before in history—in architecture, books, television, photography, film, graphic design, interior spaces, computer imagery, clothing, and product design as well as in visual arts. From all these sources, we form critical opinions and judgments. These judgment skills are important for the student to arrive at personal aesthetic choices during a lifetime.

This third edition includes three major sections. The information has been updated in art philosophy, photography, drawings, illustrations, artists' reproductions, and artistic statements, and has been organized for greater clarity. The text is a direct, practical approach explaining how to teach art to students. The author has had experience in teaching elementary age students as well as practicing teachers (all levels and learning areas). The concepts and instructional procedures were researched and practiced with all levels of students. The art instructional methods and the photographic examples are the culmination of teaching, visiting classrooms, museums, and galleries (all over the world), as well as gathering student art examples. The author is an exhibiting artist and has been a courtroom trial news artist for CBS-TV in Phoenix, Arizona.

The first section, "The Art Curriculum Structure," focuses on the importance of, and the planning for, art in the classroom. This includes learning about art within the society, culture, and school; perceiving with our sensitizers; and discussing what creativity and imagination are in art (with specific ideas for motivations).

The second chapter of this section presents specific art objectives and developmental stages for each grade level; artistic skills, media skills, art appreciation skills, motivations (specific experiences), materials (specific media) to use, and various craft media to explore at these levels. The framework of the chapter is a discussion of ways to plan art lessons and includes a sample lesson. Criteria to use to determine the student's progress in art as well as to assess student art and questions for discussion are next. Integrating art with other subject areas has proven to be valuable for teachers. Also helpful is knowing answers to the most frequently asked questions by teachers in my

classes about the day-to-day task of teaching art. A section on the gifted child is included also. The person reading this book may wish to do further investigation in some or all of these areas and for that reason an extensive bibliography is included. "The Artist and Me" is an important chapter about artists—how and where to look at art and specific examples of how to teach about artists.

The second major section of the book is the study of the design tools involved in art production. They are the means to teach specific art skills in design, and the concepts of line, shape, value, space, color, texture and pattern. Each concept includes performance levels to expect, concept charts to act as check lists, related art motivations and recommended artists for continued study. There are numerous photographic examples of student art works, artists drawings, and paintings illustrating our historical and contemporary heritage.

The third section, "Art Practice," teaches how to produce art with instruction in drawing portraits and figures, landscapes and still lifes. The last chapter is concerned with drawing and painting materials, painting preparation, ordering supplies, drawing and painting techniques, and an extensive list of ideas and motivations for drawing and painting.

There are many ways to grow through art. You, the teacher or parent, can determine the best avenue suited to achieve your individual goals. Your students will be eager to learn new information; to seek ways to experiment and practice art; and to learn about artists, movements, concepts, processes, and techniques. The vocabulary, or glossary of art terms, is valuable in discussing art and art appreciation. The new edition emphasizes the artist, art appreciation, ways to study art, the student's growth in art, art ideas, and techniques and motivations in producing art. It also includes extensive illustrations.

Each one of you contains unique creativity and artistic talent. The instruction, motivations, art topics and art techniques within these pages help tap this expressive spirit.

Acknowledgments

The author wishes to thank the following individuals and organizations for supplying statements and excellent photographs relating to the teaching of art: Earl Linderman, Mrs. Milton Avery, Arizona State University Art Collection, The Art Institute of Chicago, California Palace of the Legion of Honor, M. H. De Young Memorial Museum, The Fine Arts Gallery of San Diego, Adele Bednarz Galleries, Richard Feigen Gallery, Sidney Janis Gallery, Marlborough Gallery, Inc., Gallerie Ann, Houston, Texas, Dr. Jacob Lenzner, Anne Lenzner, the Phoenix Art Museum, Dr. Richard K. Hillis, Lyn Matthew, Katherine Coe, KTSP-TV Phoenix CBS affiliate, Marilyn Butler, Fine Arts, Fritz Scholder, Barbara Herberholz, Dr. Anne Taylor, Dr. Muriel Magenta, Linda Baumgartner, Tucson Parks and Recreation, Scott Harris, Miriam Chynoweth, Hazel Scott, The American Crayon Company, The John Dixon Crucible Company, Roland Peterson, Kenneth Kerslake, Leo Castelli Gallery, Houghton Mifflin Company, Pamela Hudson Krewson, Betsy Benjamin-Murray, Andrea Bartlett, Dr. Edna Gilbert, Mesa Public Schools, Dr. William E. Arnold, Leigh Hann, John Armstrong, Katherine Middleton, Scottsdale Center for the Arts, Robert Frankel, The Hand and the Spirit Craft Gallery, Scottsdale, Art Jacobson, and Andre Duetsch Limited, London, for the quotations from *The Natural Way to Draw* by Kimon Nicolaides.

My deepest gratitude to Cheryl Linderman and to the many outstanding students, teachers, and artists who helped make this book a reality.

All photographs not credited were taken by the author.

Part 1
The Art Curriculum Structure

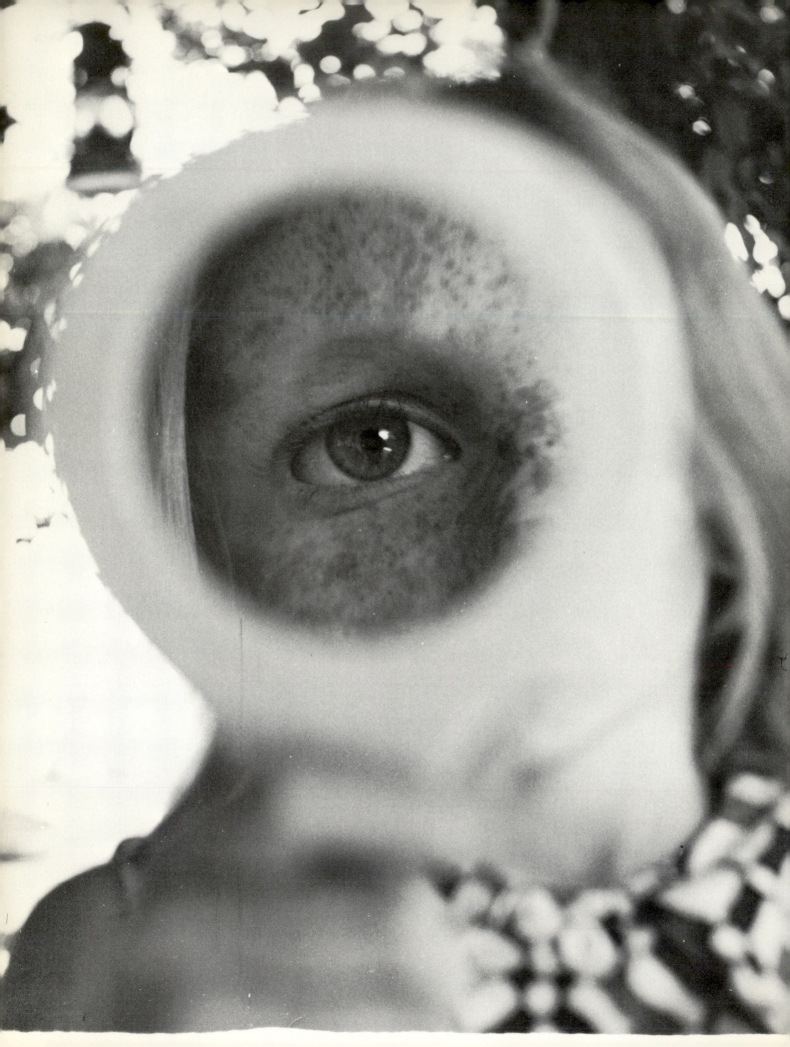

1

The Importance of Art

If we look at it from the psychological side, however, art is a term with a very much more extended meaning. It signifies, essentially, any adequate mode of self-expression, any outward act or attitude which conveys with a certain degree of purity and completeness and transparency, the mental state, the ideas and emotions that lie back of it—John Dewey, *Democracy and Education,* New York: Macmillan Company, 1916.

From the root the sap flows to the artist, flows through him, flows to his eye. . . . Thus he stands as the trunk of the tree. . . . And yet, standing at his appointed place, the trunk of the tree, he does nothing other than gather and pass on what comes to him from the depths. He neither serves nor rules . . . he transmits—Paul Klee, lecture to the Jena Kunstverein, *Paul Klee: On Art,* London: Faber and Faber; 1948.

My aim is always to get hold of the magic of reality and to transfer this reality into painting . . . to make the invisible visible through reality. . . . It may sound paradoxical, but it is, in fact, reality which forms the mystery of our existence— Max Beckman, *On My Painting,* New York: Curt Valentin, 1941.

No longer can we consider what the artist does to be a self-contained activity, mysteriously inspired from above, unrelated and unrelatable to other human activities. . . . Instead we recognize the exalted kind of seeing that leads to the creation of great art as an outgrowth of the humbler and more common activity of the eyes in everyday life . . . there was a wholesome lesson in the discovery that vision is not a mechanical recording of elements but rather the apprehension of significant structural patterns . . . the mind functions as a whole, all perceiving is also thinking, all reasoning is also intuition, all observation is also invention[1].

1. R. Arnheim, *Art and Visual Perception: A Psychology of the Creative Eye,* Berkeley: University of California Press, 1974.

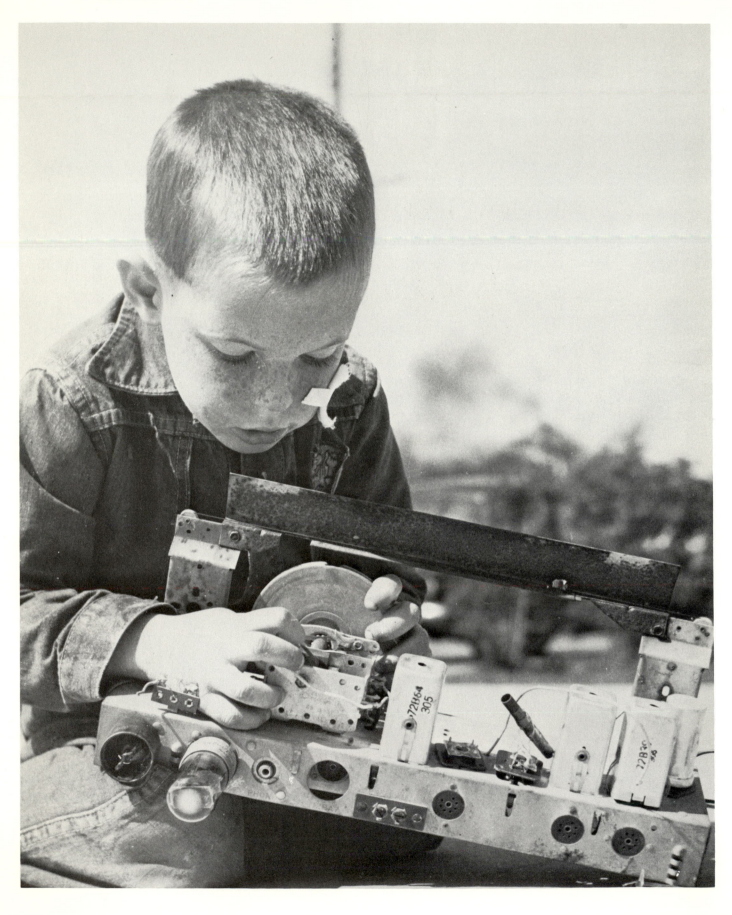

Albert Einstein's great inspiration was to capture a beam of light and believe that imagination was more important than knowledge. As adults we sometimes forget how to dream. It is the artist who reminds us how. Art speaks to the creative spirit within you. In art you can be the creator or the appreciator. Aesthetics touch the lives of everyone and make our lives more beautiful. Art is a creation and creation is an extension of the creator. Art helps to identify who we are and what our potential can be. In an age of number systems, the importance of each person can be expressed through his or her creation.

The quest for new boundaries of inquiry into the arts is exciting. We are becoming more involved with personal forms of expression in the arts—music, visual arts, performing arts, literature, dance, drama, and architecture. We find ourselves searching into the sensory, intuitive aspects of our experiences, toward self-examination that stresses the importance of each individual's own natural resources. Rather than responding to situations in predictable patterns of behavior, we look inwardly and outwardly to see how we can explore our responses to thinking, perceiving, and being. Students question the meaning of existing social institutions, including the relevance and meaning of the entire school structure. How we live, how society is structured, how we help others achieve their greatest potential within a group society—these are all subjects of inquiry. We, as teachers of art, can make students aware that art can provide many opportunities for individuals to seek their personal identity within our society through self expression in the arts.

ART AS A UNIVERSAL LANGUAGE

Art is a universal visual language. It is the culmination of the creative and aesthetic merging of the eye (perception), the hand (skill), and the mind (imagination). Art forms overlap each other in our world and many combinations occur. We paint on pottery and fibers and we print on cloth as well as books. For the purposes of clarification of what art is, the following categories are defined:

- Visual and Tactile Arts: Painting, drawing, sculpture, collage, assemblage, printing
- Handcrafted Arts: Ceramics, fibers, textiles, jewelry, wood, small metal, paper, puppetry
- Technological Art: Photography, film-making, computer art, holography, television
- Environmental Arts: Architecture, community structuring, environmental design, product design
- Concept Art: Nonpermanent art that invites the viewer to actively participate; intended to be disposable, and often involves movement or performance

- Consumer Arts: Advertisements, magazine and television commercials, product packaging, clothing design, illustrations, covers for books, magazines, records, comic books, and cartoons

Art is a practiced skill. In many past and present cultures, art was and is a part of everyday living. It seems peculiar that today, in our technological society, art is separated from life and placed in museums or exhibition halls. Art then becomes something extraordinary, special subjects for special people. We have placed art into special categories which in turn take on a magical quality for the wonderously talented few. But, as the multitude and variety of the above arts indicate, art experiences and art objects influence our life in every way. It is the *quality of aesthetic excellence* of an art object or art experience that lifts it into the artistic realm. In order to achieve excellence, we must practice the four major components of art: (1) *art perception,* (2) *art production,* (3) *aesthetic judgment-making and valuing* of art, and (4) the *study of cultural heritage.*

Photo courtesy of Dr. Howard Conant

We must also foster *creative art attitudes,* stress value, and cherish the *unique and personal imagery of each individual's expression,* learn to *aesthetically interact with our environment, expand our art skills and abilities,* and pursue how *art functions in our lives today.*

ART AS CULTURE

Art is a form of universal communication with other cultures as well as in history. Art has been a record of mankind's achievements and, as such is a reflection of a society—the values, beliefs, and attitudes that are cherished. We can better understand other cultures through studying such reflected attitudes. In studying the painting, sculpture, architecture, utensils, and tools of a culture, we can gather information about the people, their aims, and what they felt significant enough to communicate to others. We can try to understand the way they did or to see the world.

Every culture has influenced the artist. Our contemporary American culture is a blending of many avenues of thoughts and beliefs. Our goal should be to cherish these individual differences and to encourage them to be able to gain insight into and share the traditions of others. Every person is a reflection of his or her environment. Our environments are exchanges depending on our physical and social needs: how spaces are to be used, the scale of our living, and our design concepts. Art provides us with ways to analyze and study the function of structures and cities, to design them, and to reorganize them into new wholes.

Our cities and countries, our communication networks, and our electronic media are meshing and leveling our individual differences in environments as well as cultures so that "McDonald's" or the "Golden Arches" have reached around the world. As a result, art has become international in scope. The architecture of the cities has become the architecture of the world. As we accept this meshing of culture, environment, and design, we eliminate the inherent qualities that make our differences and create our uniqueness. Our environments are similar in content. Does this indicate our leveling as individuals? Our spaces reflect what we are and where we are going. Which came first—the environment, the culture, or the people? These beliefs only intensify the need for us to cherish our differences, our inherent artistic gifts, and the need for us to respect our individual artistic uniqueness.

From the artist's point of view, art is a total life commitment—a way of life. It is a way one perceives, is aware, and interprets experiences. It is how one uses knowledge and imagery, how one develops and expands one's imagination. It dictates to us our flexibility to situations and ideas, how one goes about searching to be unique in ideas, and how one is sensitive to the needs of others. The artist strives to improve the aesthetic environment.

Art influences what and where we go to study and to practice art, such as art films, concerts, museums, schools, and studios and how we organize our thoughts and ideas and who we share these ideas with. By practicing, improving, and expanding in the arts, one develops discrimination and aesthetic criteria in making choices.

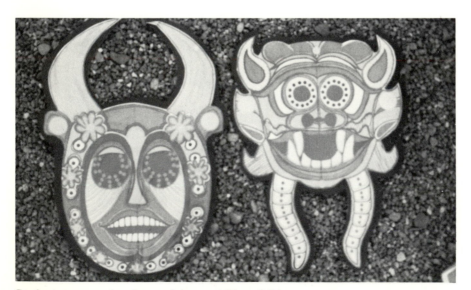

Student paper masks after studying an African folklore.

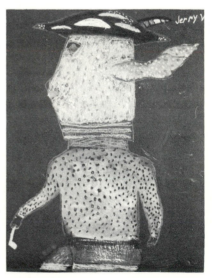

Fifth-grade student interprets an American Indian story in a painting.

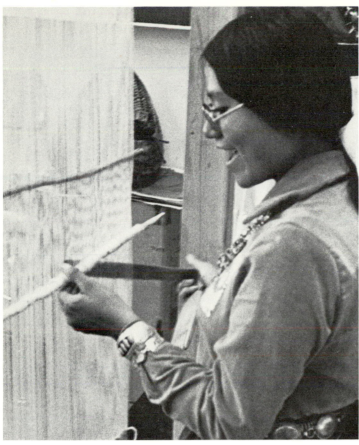

Navajo students treasure traditional weaving techniques handed down for centuries and still practiced today.

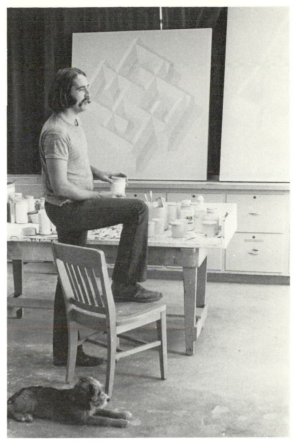

Artist Dennis Gillingwater in his studio.

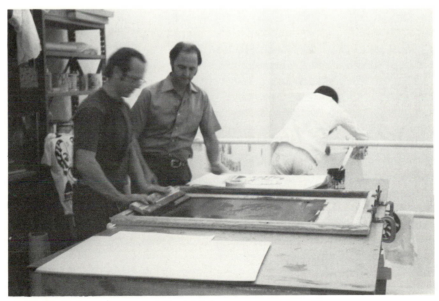

Artists John Armstrong and Earl Linderman prepare a silk-screen print.

Art development and art skills aid us in understanding such related arts as music, dance, theater, literature, and architecture. We are all *art practicers;* students of any age, whatever level of ability, we can strive to increase and broaden our art scope.

You, the teacher, contribute the most to the society of tomorrow. You provide the creative energy for students to make qualitative judgments and intelligent decisions. You aid them in dealing with contemporary issues with ingenuity, inventiveness, flexibility, and originality.

ART IN THE SCHOOL

Art is a value we share all of our lives; it is a universal subject area where we can learn together, discuss together, and express our ideas and opinions. The art teacher is the artist in your school. His/her talents and abilities should be expressed throughout the school; his/her expert ideas should be obvious in a variety of ways when one enters a school.

Our art objectives in the school should include such words as search, discover, inquire, inspire, invent, self-direct, organize, structure, think, involve, question, try new ways, analyze, synthesize, explore, experiment, reevaluate, reexamine, assess, reveal new possibilities, expand and strike out beyond.

We bring with us to the art experience our inherent abilities and past experiences. Past experiences help to build knowledge of a subject. To write you must first know how to read and write; you must have some understanding of the language and comprehension of the structure. You must understand the underlying skeleton of the process and how to make the process work for you as an individual. In drawing you must have information concerning skills and materials; you must interpret an idea or subject in a personal way. To communicate an idea effectively, whether with words or visual literacy, you must explore many ways of expressing ideas and study how other people have expressed ideas and skills with words or vision. You may try many combinations with your own ideas, being selective in what you want to express in order for it to be meaningful. Then you can organize, reorganize, select, and evaluate ideas. Through self-understanding, constant analysis, search, study, and continual practice in looking and expressing, you grow in your confidence and freedom to artistically express yourself in a significant and effective way. The more you are involved with an art study area, the more you learn and the greater is your success in artistic expression.

When classroom practice is narrow and limited in learning, young students are deprived of their individuality, art potential, and unique modes of expression. In research at Stanford University, the time between a teacher's question and the student's answer averages less than two to three seconds. It appears the questions asked did not require any review or contemplation, any reasoning or thinking, but were questions calling on the left brain responses of skill proficiencies. All true/false and multiple-choice questions call for convergent knowledge. In art, we probe with questions for responses such as, "I don't know yet," "Let's wait and see what happens," "Try many ways of doing it," and "Maybe we need to explore some more." This approach offers the student time to reflect, imagine, invent, discover, and consider more than one way of solving a problem.

Our educational curriculums emphasize the highly technological aspects of our society. Our culture reflects the analytical, structured information that we pass on to our children in our schools. This is evident in our great technological achievements during the past 100 years. Mankind has never achieved such advances in such a short period of history—partly due to our emphasis in the schools on rational and analytical thinking. We have done a good job in feeding facts to our students and we can measure these facts by standard measuring tests. By the time a child is an adolescent, we have channeled him to thinking in terms of being a scientist, a mathematician, or a highly skilled technologist. Public education stresses the importance of earning a living rather than making a life. Our schools reward the analytical and information tasks; therefore, these are dominant in our curriculums. Grades, which can be measured objectively, tend to be the greatest reward factor.

The child enters school as a painter, a musician, a composer, a dancer, an actor, a poet. It's as natural for him as breathing. We are born unique individuals, but we learn to be copiers and imitators. The child enters school with an acutely developed "sense" awareness; he is highly sensitive to learning by looking, feeling, smelling, tasting, and listening. The child is intuitive, responsive, and likes to fantasize, dream, invent, and create. We need to provide opportunities for our students to have time to fantasize, to practice intuition and rely on feelings, to make independent decisions, to practice the art of creating, and to rely on their senses in perceiving the world.

We must reassure and cultivate the entire child and his potential. We must treasure the painter, the sculptor, the musician, the dreamer as well as the scientist, the mathematician, the fantasizer, the inventor.

Innovative "arts involvement" programs being established across the country include community programs that receive aid from the parent-teacher's associations, National Endowment for the Arts, local school districts, and community resources such as banks, and state funds—all designed to integrate professional and visiting artists

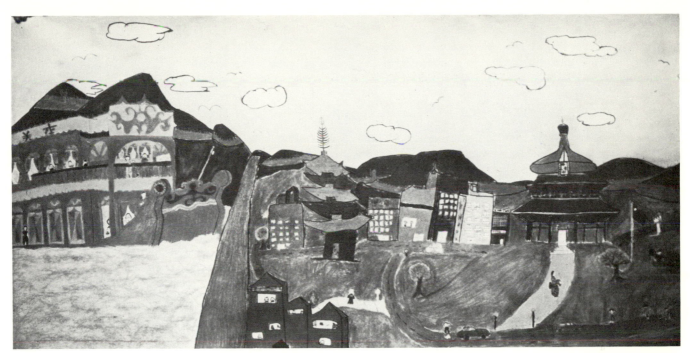

A painted mural by sixth graders increases their knowledge of the traditions, architecture, and customs of another culture.

into the educational program. The objectives of such programs are to involve and expose arts-related activities to students and teachers. The school involvement includes artists in the fields of visual arts, writing, music, acting, crafts, consumer arts, and filmmaking; they work alongside teachers in the classroom. Other programs include museum docents and volunteer parents. Such artists offer demonstrations of their art form and encourage students to work on their own. They offer first-hand technical assistance and oversee student projects and products. Often slide-lectures are presented on art fundamentals and techniques. With student involvement, interests expand to request further knowledge of the subject area, such as in the related art forms of writing, English, and history. The professional artist focuses on art learning and appreciation through student participation.

Students gain from visiting art programs outside of the school, such as museums, galleries, artist studios, art classes from museums and artists, university classes, and television studios. Paintings and art work can be borrowed from artists. Attend dance studios, rehearsals, mime programs, and libraries, and watch films and television programs about artists and art history. Encouragement at home comes about by actively involving the parent in the arts programs. Parental involvement comes through attending artist demonstrations; donating surplus materials; acting as aides; helping with visits; encouraging PTAs

Holiday celebrations offer motivations for murals.

to purchase art objects, artifacts, or art supplies; requesting parents to demonstrate their art expertise; and helping to organize students' art exhibits. At times parents will ask the teacher how they can encourage their child individually to engage in the arts. The teacher will suggest the above lists and that the student have his or her own materials of high quality at home. If possible, the student might have a place to draw and paint or perform craft works. Many of the concepts discussed in this book are helpful aids to the parent who wishes to know more about children's art and ways to support their art interests.

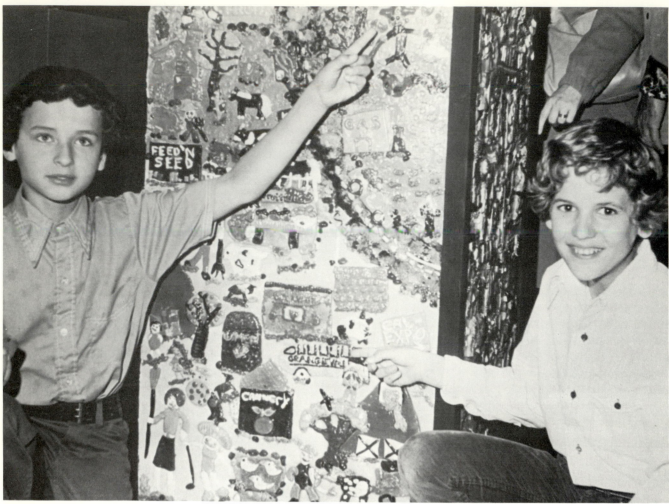

A baker's clay mural by fifth graders is exhibited in a municipal building that describes the landmarks of Sacramento, California. Courtesy of Barbara Herberholz.

ART AND THE BRAIN

In recent years, research and scientific testing have provided us with evidence that there are two working parts to the brain, which interlock in a series of networks to perform different functions. Scientists reveal that the left hemisphere dominates in tasks dealing with language, speech, and rational and analytical thinking. The right hemisphere of the brain deals more with spacial, synthetic (bringing ideas together), intuition, forms, and skills that relate more to drawing and painting, dance, music, acting, and creating with one's hands; more with the spiritual literacy of our lives.

The right hemisphere is responsive for information processing related to art thinking.

". . . our educational system and modern society generally (with its very heavy emphasis on communication and on early training in the three Rs) discriminates against one whole half of the brain. I refer, of course, to the nonverbal, nonmathematical minor hemisphere, which we find, has its own perceptual, mechanical and spatial mode of apprehension and reasoning. In our present school system, the attention given to the minor hemisphere of the brain is minimal compared with the training lavished on the left, or major, hemisphere."[2]

Dr. Robert Ornstein has said, "Parents can encourage right brain development in their children by letting them know their fantasies, hunches and intuition are valuable."

As associate professor of medical psychology at the Langley Porter Neuropsychiatric Institute at the University of California, he has scientifically researched and given symposiums on the human brain explaining the function of the right and left hemispheres. According to research,

2. Roger W. Sperry, "Left-Brain, Right-Brain," *Saturday Review,* 9 August 1975.

it is established that the human brain has two hemispheres and that psychologically they each have their own method of thought. According to Dr. Ornstein, in normal, righthanded people the left brain operates rationally and the right brain intuitively. The right brain appears to have control over creative behavior. Both right and left hemispheres control our motor behavior, but the left exceeds the right. Each side learns independently and has memory. One side can work on one task while the other works on another and both have communication with each other.

> We found that the left hemisphere controls the functions of language, rational cognition, and a sense of time. . . . In the right hemisphere of the same subjects, such simultaneous activities occur as intuitive thinking, the establishing of spatial relationships, the direction of certain body activities. Painting, sculpting, dancing are examples of right brain activities. . . . And perhaps most of all, we know that there are many paths to learning that do not require words . . . the psyche is the individual's center of thought, feeling and behavior. Often the psyche is referred to as the mind. Then what is consciousness?

Dr. Ornstein describes it "as the awareness of one's existence and environment with the capabilities to make complex responses to them."[3]

To investigate this further, the left hemisphere analyzes, differentiates, is deductive, influences language and logic, and deals with information. In contrast, the right brain hemisphere dominates integration (relating parts of an experience to a large whole), imagination, intuition, free association, wisdom, and spatial realizations and is responsible for emotional responses.[4]

Our schools and students are victims of half-brain education. We emphasize the scientific, realistic, and verbal modes of thinking in school and neglect the opportunities for free organization, such as fantasy, dreaming, and discussion of open-ended ideas. Instead of continually processing information, which is easily measured in standardized tests, acquiring specific skills and knowledge makes the student perform in specific ways.

We now have scientific data that confirms our belief that our educational curriculums *must* provide the creative arts for the student. The arts, and specifically the visual arts, give impetus to such learning that deals with attitudes, values, and truth. These attitudes and values concern themselves with the entire person. Martha Graham once said that she dances the truth.

3. Robert Ornstein, *The Psychology of Consciousness.* (San Francisco: W. H. Freeman and Co., 1972), pp. 50–53.

4. For further reading on the effect on emotional responses, see Howard Gardner, *The Shattered Mind: The Person After Brain Damage* (New York: Knopf, 1975), pp. 371–72.

ART AND PERCEPTION

Children are wonderful to watch as they experience new situations. How long has it been since you watched a two-year-old? Everything in the world is new to him. He is deeply sensitive to the new. He laughs with delight at new experiences. He looks for and welcomes new challenges, new unveilings. He runs *toward* new happenings, not away from them. Give a child a new toy. He *looks* at it—all around it. He feels it, he tastes it, he squeezes it, he hits it, pinches it, smells it, throws it, sits on it, explores it, discovers it, jumps on it, moves it back and forth, up and down, in and out—tries it in as many ways as he can think of to see if and how it does anything. He explores it like a discoverer, experimenting and having fun! When he's done "playing with it," doing with it as many possible things as he can think of, and taken from it all the information he can gain, then he's finished and throws it down—and is on to something new, all over again. Next time, when you can, watch a small child eat. He has "fun" with his food. He experiences everything he can about it, as well as eats it. He "plays" with his food. He is *open* to it!

Now begin! Learn to see by opening your senses, your eyes, and your mind. Walk down the street and look down the street and look down at your feet! For all these years your feet have been walking along in a world of their own! Soft green grass . . . rough, gray cement . . . hot sand that burns . . . rain and water . . . ice and snow . . . patterns and patches of color and stones creating their own designs around them. Little animals, ants, spiders, bugs of all kinds, moving and creating their designs of living. Put your brain in your toe. Is it enclosed and stifled by leather? Did you ever really *see* this world before? Look again, closer. Make a discovery about the world at your feeet. Green or red grass? How many weeds do you see, . . . different plants and leaves? Can you name them? . . . smell them? . . . feel, taste, rub them over your arms? What do you know about them now? How do they grow? Any browns, blues, yellows, reds, whites? Lie down on the ground. What can you discover about them now? Look up at the sky, look down at the dirt and insects. Stay there and experience for half an hour. You will find many new discoveries.

To discover is to enter openly with the senses into situations and environments. Discovery learning occurs when the student is guided to "discover" information; when he can manipulate objects, has boundless freedom to experiment, can ask relevant questions, is encouraged to act on his intuitive and spontaneous responses, has time to contemplate, discriminate, and form conclusions and judgments. These discovery behaviors are needed in situations and environments that invite inquiry; require imaginative solutions; offer challenge and success; display

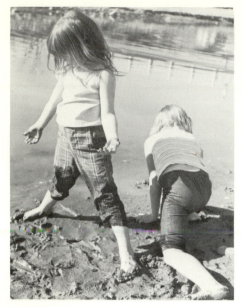

LOOK!

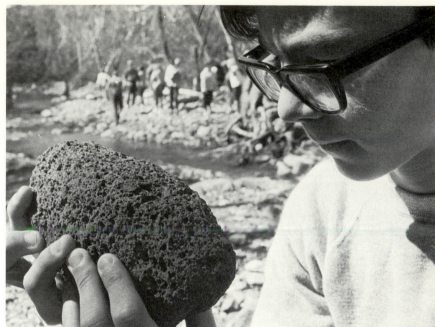

Photograph courtesy of Mesa Public Schools

cause and effect; develop initiative; require exploration; deepen sensory involvement; require one to analyze as well as to synthesize; offer numerous solutions that do not require approval; provide for mistakes; provide for positive feelings; and provide for confidence, enthusiasm, and feelings of self-satisfaction and achievement.

We perceive with the brain—the mind—the senses are the instruments that gather the information. Art perception deals with multisensory awareness—learning to take in information and learn through the senses. In our world, it is through our senses of sight, touch, hearing, taste, and smell that we participate in a myriad of experiences. We sometimes compartmentalize these senses from other behaviors. It is through the senses that we interact with our environment, and as a result, the intellect grasps this information to synthesize, form certain conclusions, make choices, reevaluate situations, consider aesthetic judgments, and respond in behaviors. This is a complex relationship in which a succession of isolated events take place for all of us. But no experience is isolated in itself. Our pasts relate to our present and influence our future. We perceive these situations and events as total wholes, not separated parts. John Dewey stated that aesthetic perception is of wholes, not parts. We are constantly aware of the relations of parts to the larger context. "Where there is form, there is a sense of qualitative unity; each color, line, plane, etc. is related to its neighbors in such a way that a sequential whole is built up in the act of perception."[5]

Multisensory learning offers situations with many ways to take in information. It is through sensory development that the infant first learns about the world around him. In a television documentary, "Nova: Benjamin" produced by Time-Life, film studies in slow motion the first six months of a baby's life. It shows several interesting relationships dealing with the senses. Twenty minutes after birth the baby is responding to a voice and opens his eyes for the first time. At two weeks the infant is able to follow a moving shape with his eyes. At times his hand points to an object. Bubbles and other mouth movements are imitations of adult speech movements and the beginnings of language development. Babies have conversations very early with their parents through sounds and body movement. When parents stop talking, babies respond and fill in gaps with sounds and movements. During a conversation between two adults, the babies moved to the rhythm of the human speech in terms of the syllable sound and the high and low pitches. Before language develops, the human being relies totally on perceptual contact.

5. John Dewey, *Art as Experience*. (New York: Putnam, 1958).

Photograph courtesy of Clayton Peterson

The student sorts out from various sensory experiences the information and knowledge that have meaning to him or her and stores this knowledge in the brain. Physicist Robert Jastrow notes that the brain houses between 10 billion and 100 billion items of information; if it were to be built as an electronic computer to match the brain's capacity, it would be almost as large as the Empire State Building, but only a clumsy imitation.

The student forms together associative pieces of information, synthesizes it, and builds understanding, meaning, and concepts (or theories) about the world in which he lives. What information, values, and beliefs we transmit during the teaching process, what books students read, and what television they watch helps make people WHO THEY ARE.

A highly important avenue in personal identity relates to the senses. Mankind is rediscovering a personal need for sensory experiences. Our senses emphasize the human factor in contrast to the man-made mechanical society with its dehumanizing effects, the impersonal mass manufacturing of quantities of goods, the nonindividual housing spaces we have built.

Gather your own exciting materials and construct unique environments for the classroom. Call it an "adventure environment." Go out and explore, as fully as you can, a situation such as the beach, the desert, the river, a skyscraper, a taxidermist, a mountaintop, a TV station.

Record your impressions with tape recorders, on note pads for writing and sketching, by photographing and filming, etc. Invent sounds, poems, movements "on the spot." Improvise, communicative, interact, respond. In the classroom, interpret your impressions and perceptions into total environmental sensory experiences.

The "props" will be lights and materials that add suspense, excitement, and imaginative involvement: elastic bandage (pretend "spider web") strips that students can push, pull, stretch, move, create tensions; "tents" from sheets of plastic or an old parachute that moves and changes with air currents and suspended ropes, holes for walking through; structures that students build (or stack) that are painted or reflect lights that are cast on them. Large boxes can be different on the inside as well as on the outside, can be worn or hidden behind, can divide spaces; sheets and other reflective surfaces can be worn, and slides projected on the forms will create exciting images. Bring in tree trunks, stuffed birds, forms from nature. Collect your own.

The "stage" is the classroom and can become anything your imagination can invent. Improvise and change the spaces within the room as the ideas develop and progress. How the students move and dance can determine the division of spaces.

The "dancers" are the students. They will invent and create body movements that relate to the environment and move within these imaginary spaces.

The "sounds" can be improvised inventions of musical instruments—"playing the room" by rhythmically hitting walls, chairs, tables, running water, squeaking chairs, rustling paper or plastic, etc.; chanting and singing; making up poems and word expressions of ideas, feelings and thoughts.

Follow up your environmental creations by responding and recording sensory impressions through interpretations with words, drawing and painting, structured body movements, and invented music and sounds.

Environments that invite participation are student oriented in terms of his/her abilities and growth. Environments today are often designed for the student learner to actively learn by doing. Student-centered learning environments should reflect, reinforce, provide stimuli for, and motivate the student toward interests and art concepts. We can offer stimuli that generates discovery learning and art concepts. The following tools and stimuli will help develop greater sensitivity and awareness in perception.

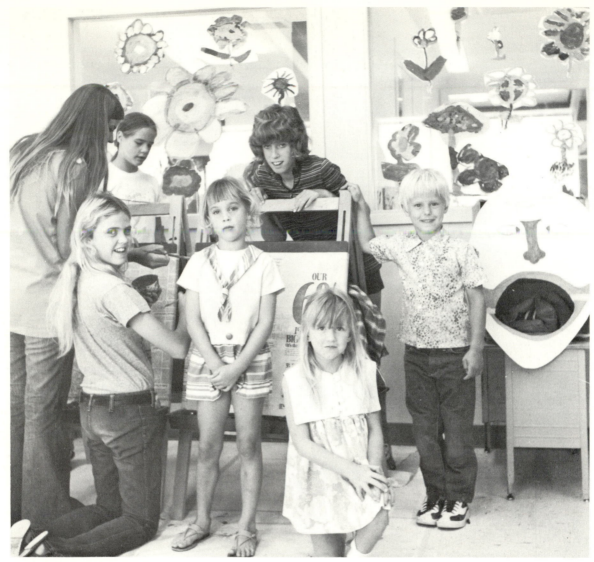

Floors, tables, easels, walls, and windows are good work surfaces for art. Note the *feeling* face in the photo. Older students are good art helpers.

VISUAL SENSITIZERS

Telescopes, microscopes, magnifying devices, kaleidoscopes, spectroscopes, prisms, a reflection device, mirrors, funny mirrors, drawing on mirrors, dropping items in thick liquids (oils in water), photographs (shapes, shadows, and positive and negative forms), looking at distortion through a glass of water, plastic, fish tanks, into rivers, oceans, lakes, or swimming pools.

Look through a one-inch, cut-out square for a selective view; look through a camera, make a pinhole camera; look through lace, chiffon, fog, rain, street lights at night, reflections off cars, windows, eyeglasses, metal; look at geometric shapes (squares, triangles) in nature and manmade objects—ice cubes, clouds, clay, cups, heads, wood grains, all edges of surfaces; construct differently colored eyeglasses, look through these optical viewers; make slides, project multiple slide images; films, slow motion, project

films with slides; black lights; irridescent colors on posters; project slides and colored lights on moving figures; develop negatives, photograms, draw on old negative for use in making slides; draw on acetate paper with permanent felt pens; create optical illusions or stories on acetate rolls, or use several in overlays to project on overhead projectors; blinking lights, strobe lights, mirror balls; interesting signs, skylines of buildings, and landscapes; laminate two pieces of waxed paper containing scraps of cellophane, grasses, lace, ferns, scrap crayons, thread, inks, place on windows; rocks, fossils, and various kinds of manmade or natural textures, exhibit, sort, and classify; television sets, change the color and create effects with knob adjustments; flashlights—experiment, move, invent hand shadows; use opaque and overhead projectors, slide projectors in inventive ways; many artifacts and art objects; look at objects from different viewpoints (perspectives),

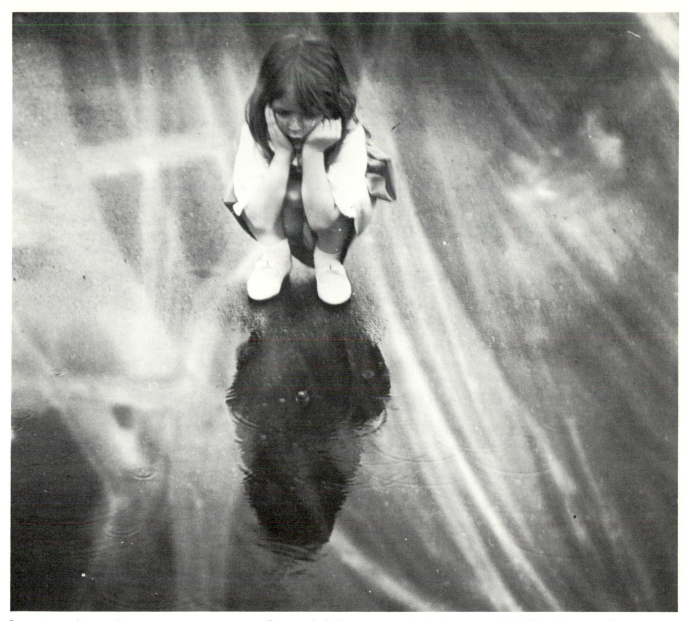

Learn to see by opening your senses, your eyes, and your mind. Have you ever looked into a puddle? What do you see?

top like a bird, from the bottom like an ant; consider how illusions create space, depth, and distance; discuss color theories and concepts, how they look in atmospheres and make us feel.

TACTILE SENSITIZERS

Plan "things to feel" trips; establish concepts like *soft* things, *rough* things; plant a garden; take care of classroom plants; scraps of assorted woods for building, carving, playing; build with blocks; gather tools for work benches; collect various textures that make us feel "good" or "bad"; exhibit, sort, and classify textures; make feeling boxes that enclose different textures to feel, not see, but guess—sometimes they are cloth feeling bags with drawstring tops; sandboxes, dirt boxes, sculpting in sand, making plaster castings in sand; going on an architectural dig; feel stones, flowers, leaves, grasses; visit parks, create your own imaginary landscape; feel bricks, bark, seeds, houses, bugs, ants, butterflies; feel ice cubes, snow, water, oil, cement; feel wax, candles, crayons, paint, cars, jewelry, mechanical objects, clocks, motors, projectors, wind on your body, rain, dust in your mouth, other people, hair, nails, skin; climb a tree; cook with foods, such as dough; sculpt with clay, plastic, plaster; feel animals, birds, visit a taxidermist, a zoo; feel objects in your personal spaces at home, in school, and in communities; visit the school cafeteria kitchen, feel knives, forks, spoons, dishes; all kinds of fabrics, textiles, and clothes, and foods—meats, vegetables. Visit a supermarket for exciting textures; feel various spaces, scales, and levels in your environments.

SOUND AND LISTENING SENSITIZERS

Use the tape recorder to record sounds and conversations; listen to your breathing, swallowing, sneezing, blowing your nose, hiccuping, coughing, your pulse, your heart; listen with a stethoscope; compare various moods of music—powerful, delicate, joyful, weary; various instruments in music—try to identify high-low, soft-loud, long-short sounds; name orchestra instruments and compare them with orchestral instruments; invent songs, sounds, poems to sounds; listen to radios, clocks, motors, electrical equipment, television sets without looking; invent musical toys with cans, sticks, drums, bells, straw horns, kazoos, spoons, glasses, pots, and pans, listen to street noises, animals, footsteps.

Cars, trains, planes, birds, sounds of nature, dogs barking.

Invent music to city sounds.

Differences in people's voices (low and high); compare voices to industrial sounds.

Sound effects on radio and TV.

Background mood music in movies and TV.

Creaking of chairs, doors.

Records and tapes at unreal speeds; motors.

Chewing your food; singing; multiple voices.

Typewriter; fountains, water in pool, splashing, running water.

How sounds affect your movement; experiment and move to sounds.

Write a sound poem to music; write a "noisy" poem.

Write down all the words that describe various sounds; write a poem with these "sound" words.

Compare city sounds and country sounds; invent music to express these sounds.

Go high on a mountaintop—what sounds are there? What sounds are there underground? among pine trees? atop a skyscraper?

Listen to the empty spaces between sounds. Can you paint silence? Noise?

Listen to operas, concerts; interpret your feelings visually.

Compare classical music to rock music, to country music; invent folk melodies.

Go somewhere all alone and listen to the silence.

Listen to your "insides" through a stethoscope. Draw your "insides."

Compare natural sounds to machinery.

Move to a typewriter.

Find new sounds that repeat themselves; find new sounds; invent new sounds.

List sounds of nature (hailstones, hail); listen to man-made sounds (airplanes, trucks).

Compare two soft sounds with two hard sounds. Compare two dogs' barks—two birds' songs.

Echoes. Place your ear on the ground, a building, a car—and listen.

Listen to sounds as they move closer and then farther away.

Sounds that you like. Sounds that you don't like.

Sew bells on clothing, socks; attach bells to bracelets.

Talk through tubes, telephones, microphones.

Invent instruments such as tambourines, drums, bells, rattles.

Invent melodies to words such as "boom-crash-screech-scream-singsong-whisper." Draw them.

Study historical artists, contemporary musical figures, dancers.

Can you think of some more? What do they sound like? Can you draw them?

SPACE AND MOVEMENT SENSITIZERS

List and compare how we move through spaces at home, in school, in communities. Be aware and compare various sizes, scales, levels, and ways to move through space. Consider how rooms and spaces are designed to determine how we move.

List space differences in the indoor and outdoor environments; consider your playground and design your own to meet your specifications.

How do you use "centers" of interest and what do they accomplish?

Go on "moving" walks. Walk, hop, skip, run in rhythms; alternate rhythms. Move, looking only at the sky; dance like a cloud; float like a balloon. Move to sounds that you hear, to your friend's voice. Dance in slow motion; walk and dance in double time. Move as if you're swimming, playing tennis or baseball. Dance as if you're on ice, in a rainstorm, ice-skating, skiing, tobogganing. Move like a car, a bicycle, a horse, a bird, a bee. Move like an ant, a butterfly, a spider, a grasshopper, popcorn, growing seed, a wave, machines. Dance to words like *leaning, sliding, pulling, twisting, rolling, falling, leaping, jumping;* select one word and invent a dance to it. Dance at different levels: high, low, medium; creep, freeeze, pierce, explode. Select one word and invent a dance around it. Dance to words of feeling and emotion—*love, fear, anger, joy.* Pretend to move through space with a blindfold on. Move through the smallest space you can find, like a barrel or a hallway. Walk as if you're a tall building; run as if you are a bicycle. Move like an old man, a baby, a clown, a giraffe, a pelican, a monster. Move to an object near you, like a car. Walk in keeping with the mood you feel today. Walk like a football, a basketball. Invent forms to geometric shapes—a circle, triangle, square. Dance as if you are trapped inside a box—feel the inside of the box, crawl out. Record your impressions—how you moved, how you felt, while moving—in a drawing.

Analyze materials as to their use as space dividers and for construction projects, such as railroad ties, plastic sheeting, telephone poles, cement culverts, oil drums, tree stumps, tires, telephone cable spools, ropes, and walkways.

Discovery movements during a workshop of Arts Exploration at the Scottsdale Center for the Arts. Courtesy of Katherine Dee.

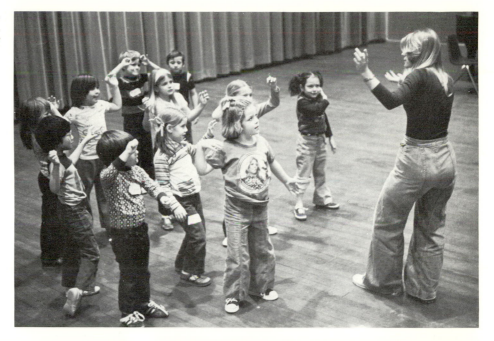

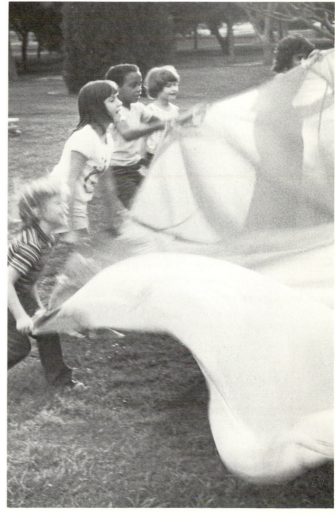

Outside space invites large free movements. Students use plastic sheeting and a parachute as motivation. Courtesy of Linda Baumgarter, Tuscon Parks and Recreation.

Visit various buildings, such as churches, airports, a mechanic's garage, a roof, a printing shop, a farm, department stores, supermarkets, photography darkrooms, television studios, factories, walls, fences, museums, art galleries, artist's studios, planetariums, taxidermists, a bridge, a greenhouse, and many others, and consider their space organization.

Do school spaces meet the students' needs—physical as to size, scale, and levels; does the curriculum determine space needs, is space flexible; does it reflect the students' interests and skills?

Go on moving, walking, walk, hop, skip, run in rhythms, alternate rhythms.

TASTING AND SMELL SENSITIZERS

Discover flavors (with eyes covered) how food is used as ornamentation; use food coloring in cooking; invent new recipes; experiment with cooking devices and recipes; decorate cakes and cookies; visit the cafeteria kitchen and examine the utensils and stove; examine how objects react in an oven, such as plastic, metal, clay, glass, butter, candle; discuss how heat is a reflector and is absorbed, some surfaces and colors absorb heat, others reflect; expose various objects to the sun (candles, photographic papers); discuss heat in the winter, cooling in the summer, the importance of a thermometer.

Experiment with foods from other cultures, such as hot chilies; nutrition and why we eat what we do; methods of food processing (freezing, canning), eating foods hot or cold, where things grow in parts of the country; the recycling of wastes, the growing aspects and chain of foods, the storage of foods, the supermarket and its resources, the mass, weight of foods; differences and similarities of foods, foods associated with cultures, holidays, seasons; discussion of how foods change, such as milk to ice cream, yeast, baking powder, flours, eggs; how artists have used foods as subjects in paintings, sculpture, assemblage.

One of the first ways the infant relates to others is through the sense of smell. We learn to identify certain kinds of foods and cooking through their smells. Flowers are identified partly through their smell. My grandfather died when I was about four years old, but I remember a cigarette smell that I associate with him. Smells can intensify our senses; there's a bread factory that I pass on the way to work, and I look forward to passing by for the wonderful smell of bread baking.

Smells and taste share identification qualities, such as sweet, sour, salty, and bitter.

The painter's studio may be filled with the pungent smell of oil paint, linseed, oil, and turpentine.

Create a "smell" game by creating smells in jars and guessing what they are. Use herbs, candles, grasses, flower petals, dried fruit, etc.

CREATIVE THINKING AND IMAGINATION IN ART

The imagination spirit exists in each of us and should be a top priority in our lives, as in art. The imagination functions in all of life and is part of all our behavior. It is "brain energy," which singles out our creative activity and art of the person.

According to researchers, creative behavior is not a one-time reaction to a situation, but a continual ongoing response that involves relationships and grows as a pattern. We can motivate the imagination as part of learning.

Let us consider how the imagination functions. In art, we often stress imaginary concepts—ideas that deal with originality, uniqueness of response, inventive independent solutions—all the ingredients attributed to creativity. We can motivate with subject areas that require imaginative interpretations, such as "a visit to Saturn." Such a theme demands an inventive solution because no one knows what Saturn is like. Therefore, the *first* step in imagination is the *idea* or the selection of an INVENTIVE THEME.

The artist "gets his ideas" from either a commissioned work, or a self-stimuli, one which he decides for himself. He may invent an idea, that can be a fantasy or a dream, such as in the work of Joan Miro (p. 196). The forms can be fantasy, purely developed from the imagination, or they can be inspiration from something—an object, a person, or a place. The creator takes the form and plays with it—interprets it in a unique way.

From the inspiration, the subconscious mind deliberates and explores the idea. The mind plays with the idea, as in a daydream. That is why time for contemplating ideas and playing with inventions is important in our curriculum.

The production of an idea occurs when the action takes form, such as in an art product. The concrete form of the product permits the person to advance with it, to take it steps farther into the dream or the idea. Then the person steps back from the idea and considers it more objectively and with a more critical eye in order to make conscious adjustments.

The imaginative person searches for unique ways to communicate an idea. This person uses relationships in a new way in an art work. Ideas may deal with reality, in the external world, or with the unreality, the abstract in the mind's inventive world.

In imaginative experiences, there may be emphasis on the discovery of solutions, how many divergent ways can we approach a situation. The emphasis could be on the *spontaneous* form of behavior, what outpourings will come from the mind?

In the *imaginative* approach to drawing and painting, forms and ideas are invented, ideas materialize and develop from the imagination. Sometimes real objects,

models, or photos stimulate ideas. Often the forms are not taken from real-life objects, but are fantasies or "make-ups." An imagination is to be desired and encouraged in all art objectives. Imagination is a dominant force in art, transferring an experience into an expressive work of art.

Are people born more creative? Psychologists have analyzed creative behavior and studies have investigated such questions as the ratio of creativity to intellectual ability, the part of humor in creative people, the relationship between environment and aesthetic response, and the importance of classroom environment on productive thinking. By identifying creative characteristics, we can aim our teaching goals toward such characteristics. We realize that today we have creative "thinkers," persons who demonstrate creativity in science, in mathematics, in communication arts, and in the arts. We can discuss the individual's nonverbal capabilities, not measured by I.Q. tests, that identify creative characteristics.

J. P. Guilford characterized creative people by the following traits. *Flexible*—in creativity tests, such persons respond with unusual uses for bricks and other common objects. These persons are able to adapt, redefine, reinterpret, and are able to find new ways to reach goals. *Fluency* is measured in tests by the ability to produce a large number of ideas within a given time period. The ideas are generated with ease. *Elaboration*—the complexity of detail and the richness shown in the verbal or visual tasks. *Originality*—the ability to come up with unusual ideas.

According to Donald W. MacKinnon, highly creative persons are discerning, curious, receptive, reflective, and eager to experience. Abraham H. Maslow states that creative students are secure, spontaneous, natural, and uninhibited. They do not rely on the familiar, and they respond to the mysterious and puzzling.

Carl R. Rogers believes that creative persons respond openly to experience. They are open to many possibilities and do not distort experience, but relate it with predetermined concepts. Lawrence Kubie concludes that creative people are able to use free association in the subconscious as an initial start for ideas that come forth "artistically or not of a stereotype."

Calvin Taylor has resolved that creative people do not seek quick solutions but resist early closure and yet have a strong desire for ultimate closure. Paul Torrence states that creative persons are attracted to the mysterious, the more difficult, and remain independent in ideas and judgment. They question, are open to new ideas, constructive in criticism, willing to take risks, energetic, persistent, intuitive, sensitive to the outside world, preoccupied with a problem, and willing to regress.

The opposite of creative is rigid. Such persons want to be shown how to do everything, want to be supplied with solutions, want correct answers, and feel threatened if their thinking or behavior is challenged. The flexible

person adapts to new situations easily, is able to remain open to a problem until all the information relevant to the problem is gathered. Such students can find reason and value in a situation that has been unsuccessful. Such students are fluent in solving art problems. The creative person is willing to try many solutions and can change one small item to make a whole art piece work successfully. The creative person can look at art problems, analyze them, select the details, synthesize them, and put them together in new relationships.

The teacher can encourage creative behavior by experimenting with tools and media, looking at objects in the environment from many viewpoints and attitudes, be able to analyze objects in detail, bring together new ideas, remain independent with ideas, and think out and be inventive with many solutions for a single art idea.

Researchers question whether creativity tests can be applied in the classroom. This is due to the familiarity with school tools and because much of the creative criteria of students is difficult to measure. As teachers, we can emphasize creative behaviors in the classroom, such as fluency (coming up with many ideas), inventiveness, looking for differences and similarities, flexibility, originality, curiosity, imagination, more elaborate and complex thinking, and risk taking. Encouraging these attitudes in a classroom environment based on far-out, questioning, speculative, anything-goes, fun approach and open inquiry methods without judgment will foster creative attitudes.

The teacher can devise games, relate unusual words to pictures, compose animals from various animal parts, create space imaginations, look at the world through the eyes of an elephant, an ant, a bird. Fantasy subjects, such as a trip to the bottom of the sea, a ride on a windstorm, tracing the adventure of a raindrop, or the travels of a butterfly are some endless possibilities that engage the imagination in new ways of seeing the world.

Art and creativity have always been closely associated. The art program should include the creative attitudes and behaviors we have discussed. We need to be more concerned about the creative processes so that all areas of learning can be based on such creative attitudes. Not all artists are necessarily creative. Art experiences can be the important motivators in creative thinking for all creative endeavors, as in the arts, the sciences, in mathematics, and so on. Art experiences can be the educational tools to foster creative thinking for all learning areas.

The teacher should have a creativity space in the room—a table or corner where the students can go to invent, explore, manipulate, create, and paint. Plan a theme ahead—something for the day. The children can select these topics: "Can you invent a math game that we can play in teams?" "Can you build some furniture out of paper that we can use for our playhouse?" This is not considered "art" time. This creative time does not interfere with art experiences.

You will find that when you encourage (reward) children to work independently, to be resourceful and to solve their own problems (instead of letting adults solve problems for them), when you eliminate stereotyped solutions in art, the students will begin to work independently in other areas of study as well.

Invent a painting problem for the day: "What do you think Jennifer will find when she visits the Hopi reservation?" The students are encouraged to go to the creativity center and paint or write a poem or story.

Also have unusual, exciting, stimulating materials available.

Why not post a "mystery painting"? Guess the subject, artist, technique.

CREATIVITY SPARKERS

The following imagination sparkers are subject areas for the teacher to explore with students. Such ideas can also be themes and subject matter for art works.

Real or imaginary flowers; real or imaginary animals; finding objects at the beach; living things in water (real or imaginary); such buildings as schools, homes, farms, shopping malls, cities; transportation, such as railroads, planes, busses; on the water with boats, surfing, sailing, water skiing; sports such as baseball, football, basketball, tennis, golf; historical themes, such as governments, wars, plantations; circuses, rodeos; real or imaginary birds or insects; kinds of plants and trees; ideas related to real or imaginary space concepts; sky forms such as imaginary clouds; foods, fruits, and vegetables (inside and outside); magnification, precision instruments; clocks, radios, television sets; psychedelic forms; irridescent lights and color and how they work; optical illusions; geometric shapes; holidays; plays, stories, myths, fables, improvisation; other cultures, lands, and peoples; inventing poems and stories to draw; inventing new melodies and word pictures; social themes, such as pollution, nutrition, family relationships, poverty, crime, war, drugs; seeing flat and rounded forms; landscape looking; viewing distances; light creations with overhead, opaque, and slide projectors, colored lights, blinking lights; skeletal frameworks of fish, people, animals, bridges, architecture, bones.

Pretend to be someone else, an object or a place; invent masks, mustaches, noses, super glasses; paint on make-up; measuring devices, scales, yardsticks, cups; games that interact, such as spelling bees, playing ball, Simon says; build with blocks, boxes, wood scraps; assemble and invent with scraps of all kinds, such as yarns, leather, string, cloth; invent toys with objects such as spoons, strainers, corks, plastic bottles, packing materials for sculpturing and building, popsicle sticks and toothpicks for structures; design and sew doll clothes, cut up old clothes and reassemble for costumes; discover cuisiniere rods, magnets, cookie cutters, ovens, bottle caps, buttons, iron filings, electric resistors, internal combustion engines; collections of all kinds; magazine and book images; invent word games, such as names, becoming characters; build doll houses and furniture; motors, electrical equipment that can be taken apart and put back together to find out how they work; puppets, stages, and scenery; cameras, both still and movie; clean, play, swim in water; typewriters, computers, adding machines to investigate and draw; invent machines, pulleys, shafts, joints; rubbings and printing devices; visits to taxidermists, airports, supermarkets, restaurants, movies, television studios, fashion stores, malls, factories, photography studios, city and government buildings. All serve as imagination stimuli.

SUMMARY

Art awakens the eye of the artist within you; it is as basic an expression for you and me as breathing. Learning to "Look and See" deeply is one of the secrets of learning to draw.

Art is a nonverbal universal language. It is the creative and aesthetic merging of the eye, hand and mind. Art can increase your perception through the senses, which in turn helps us to relate to all artistic forms. Art is expressive of your ideas and feelings to yourself and others. Art is one way to focus in on ideas and to represent an idea symbolically. Art skills aid us in creating aesthetically pleasing and functional art forms. Art gives us a record of man's achievement as well as our own achievement. Art informs us about other people, both past and present—their ideas, feelings, values, social concerns, and their personal expressions. Art knowledge helps increase our aesthetic sensitivity in art choices, whether in manufactured or natural form. Art is one way to respond to our environment.

Art learning and environments can be designed to encourage verbal or nonverbal forms of communication for optimal learning. Art offers the student opportunities for expressions other than with words, often times expressing ideas that the student is unable to verbalize. Art reflects the emotional, physiological, and intellectual development of the student. It is a reflection of his ideas and serves as an arena for problem solving. Art offers a solution to a problem where no authority will say the idea is the "right" way. Art offers ways for students to relate to one another through involvement, abilities, and feelings.

Longitudinal study:
These drawings (dated) are by Cheryl Linderman, soon after her fourth birthday (December). The top drawing indicates use of various media. Legs grow from head; many fingers with fingernails. Drawing above right shows legs from head again (the last drawing and a regression), as well as interest in learning letters (to suggest a talking figure). Lower right drawing shows birds and kites in the air, and the forms float on the page. The drawing above indicates a body from which legs grow. A significant development is the establishment of the tree on the right and the ground lines under the figure, placing the figure within an environment and on a base line.

<div style="text-align: right;">

2

Planning Objectives
and Instruction for Art

</div>

Purpose: The art program has four aspects: seeing and feeling visual relationships, the making of art, the study of works of art, and the critical evaluation of art. At the elementary level, the major emphasis should be on making works of art with a variety of materials and processes. At the same time, the learning situation should include opportunities for the child, within the limits of his intellectual, social, and aesthetic maturity, to gain knowledge about art objects in his culture, and develop the ability to judge art products critically.—"The Essentials of a Quality School Art Program," *Art Education* 26, no. 4 (April 1973):23. A position statement by the National Art Education Association, Journal of the National Art Education Association.

THE ART CURRICULUM SEQUENCE: STRUCTURE AND FLOW

This section represents an overall picture of the student from before he enters school until he is ready to enter seventh grade. The identifying level characteristics inform the practicing teacher, as well as the teacher-to-be, about the concepts and media to use, what the student will learn, what the student will produce in art, and aspects that represent what the child is like at a certain level of development in order for the teacher to develop an art curriculum. These are to be generally interpreted, as one child is intellectually and behaviorally different from another child. Art growth is a continuous development and many stated objectives overlap each other. Even one child may indicate varying level characteristics at one time. No particular child is typical of any defined skill level. There are many variations and fluctuations within the general outline. The characteristics imply and identify certain growth; the objectives aid the teacher in knowing what goals to aim for. In the following section, Planning Art Lessons, use the characteristics and objectives in planning your art curriculum.

We all see and act differently from each other. We grow at various speeds and levels. We "see" with our senses, our thoughts, and our minds. We respond differently, some of us spontaneously, quickly, and intuitively. Some of us reflect on previous experiences and ideas, others with emotion. Some of us see objects in an analytical way, observing the many details that give us information. At times we do not consider the details, but we see the overall pattern of things with a more global perception. Sometimes we organize and plan and order things; at times we are unfocused. At times we are filled with a multiple flow of images and ideas, other times we focus on one aspect or item. In considering art growth characteristics and art curriculum objectives, we must plan for all students to learn in all ways. Please read the entire section to comprehend the art growth for all students; then go back and focus and study the various areas and levels of art learning.

In using this guide, plan for both the *structure* and the *flow* in your art curriculum. The *structure* deals with the concepts, the objectives to be reached; it is the foundation, the skeleton, the building blocks, what information is offered to the student. The *flow* is what *you do* with the concepts and objectives; the flow is the process, the experience, it is what the student does with the information and how he uses what he has learned.

The art curriculum should have as its aims to enrich self-concepts, to use art as a natural form of expression, to challenge and strengthen sensory experiencing, to develop increased aesthetic awareness, to improve in artistic skills, to communicate effectively through an art vocabulary, to learn about art in history and cultures, and to form art judgments through critical skills. These skills all relate directly to the student's humanistic life goals, which have application not only in art but in all of living. Art is a humanistic value, it is a positive lifelong attitude and search.

Where else in our educational curriculum do we find such opportunities to express our uniqueness, and personal ideas, and identity? Where else are we invited to think freely and to form individualized opinions and judgments for ourselves? In most other learning areas, the answers are provided.

Our curriculums today are geared towards teaching concrete facts and there is little time for independent questioning. Memory and verbal and mathematical performances are significant ways to measure and score students. Such skills are often considered the measure of the student's abilities and greatly influence the student's attitudes of self-success.

People develop expectations of how bright or stupid they are based on I.Q. tests and scoring, and they are often a self-fulfilling prophecies. If a student thinks he is a failure, he is likely to become a failure. The student learns to adapt within such a school structure. We start testing students on verbal and mathematical skills early in the school career. We place great emphasis on the five or six brain functions that are measurable in such testing. We evaluate and assess our curriculums on how well students perform on such tests and structure our curriculums based on such scoring. But, research and brain studies have identified at least 150 various brain skills and functions.

Art is a unique and indispensable learning area of the curriculum. Our art expressions are part of our intellectual, emotional selves. Art learning develops attitudes of success that include the need to *express creative and personal ideas, flexibility of ideas, many possible solutions to a problem, lack of required teacher approval, provision for mistakes, self-competitiveness* and *rewards, self-direction,* a *challenge, required reasoning and thinking, development* of *intiative,* can be *nonverbal,* and *strives for feelings of achievement.*

We who teach art are the first to realize that there are no perfect solutions to art, no prescribed scientific formulas, and no sure methods or guarantees for producing art! That is part of the excitement, the surprise, the unknown possibilities that are an inherent part of the experience in forming art experiences and art products.

Who establishes the so-called art standards, the "right" or "wrong" ways of going about art? Is the "real" way the best way? In art, we have the freedom to make artistic mistakes, in art all ways are right or wrong, as long as they are *our* ways.

GENERAL ART OBJECTIVES

Art is a separate learning area, containing *content, instruction,* and *skills.*

Secondly, art is a curriculum support related to the other literary and performing arts as well as to interdisciplinary studies.

Encourage individual art direction, personal imagery, the exploration and expression of each student.

Show how art is an important, integral part of life, the nature and value of art.

Encourage art openness, the taking in, involvement, new ideas, creative and imaginative approaches, inventing, unusual and unexpected responses, spontaneous responses, enthusiasm, independence, flexibility, originality, decision and choice making, differences and similarities, interaction of ideas, self-evaluation, discovery, experimentation, trial and error, active feedback through discussions, and imagination-sparking.

Study the function of art in today's society and in other cultures.

Encourage students to appreciate the art needs and feelings of others, to work independently as well as cooperatively in groups, and to be aware of each student's unique art contributions to the group's efforts.

Drawings by Cheryl at later age. Figures express smiles and outreached arms as in earlier drawings. Interest now is in costumes, hairstyles, action, friends and pets.

Doll making is an ancient craft. These cloth stuffed dolls reflect the face and figure concepts of young students, and could be used for social development, emotional development, new skills and tools, and the study of the folk craft.

Develop a fluent art vocabulary that includes discussion of artists and art objects, purposes of art, the forms of art, which provides opportunities to analyze and make meaningful art judgments.

Develop artistic literacy into the nature and character of art. Be able to recognize, describe, and produce specific processes and techniques in art.

Provide opportunities for exhibiting art works in classrooms, school, museums for sharing and communicating ideas verbally and nonverbally.

Encourage art expression and appreciation of cultural differences.

We can then establish and define a sequential curriculum structure for art. The objectives and behaviors within such a structure can be outlined and provide guidelines for the teacher as to what the student will learn and what the student will produce.

High schools that receive feed-ins from elementary and middle schools need to work with elementary schools in defining an individualized art curriculum sequence and structure. Each individual school curriculum should remain unique to the needs of the students. We can define broad objectives and developmental characteristics of each grade level in art within the total sequential art structure. Each classroom should still function with an independent flexible format, but meet established goals within a framework.

In defining an art content framework, we can outline to administrators, parents, and students our objectives and goals in art. We can define concepts to be learned and discuss media skills that amplify such concepts appropriate to the student's level of development. We can discuss ways of motivating students (through art perception and art study) and offer instructional content, skills, and heritage information. From these objectives, we can develop evaluative and assessment procedures that relate to artistic skills, perceptual skills, media skills, and art appreciation skills.

GENERAL ARTISTIC SKILLS

Produce artists and art appreciators. Produce attitudes of appreciation and joy in the creation of art works in the art works of other students and artists.

Stress visual imagery that is personal and individually expressive. Develop the ability to communicate personal ideas and feelings through an art vocabulary and artistic expression. Develop each individual's unique potential through creative behavior, skill performance, and aesthetic response to his own art work and work of others.

Encourage the student to reach beyond with his senses, imagination, intellect, and feelings.

Promote art as an experience of the spirit and therefore a humanizing endeavor. Apply art knowledge directly to personal living.

Consider the relevance of the visual arts in relation to the literary and performing arts.

Provide art stimulus from objects, scenes, situations, imagination, invention, materials, tools, museums, artists' studios, electronic media, and all the related arts.

Focus on art relationships—the similarities and differences.

Exhibit growth in art content and skills, including the formal elements of art; the practice of line, color, shape, pattern, and space texture; and how each interacts and depends on the whole art form.

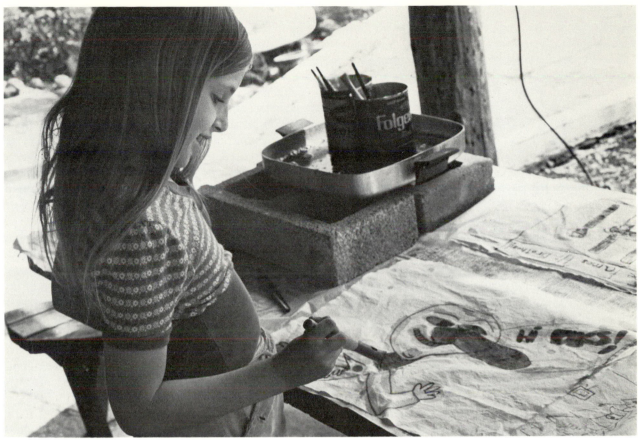

Art is often humorous. The above student creates a "batik" with exciting art media, a janting tool, wax, and colored dyes.

Experience success in one's own work. Practice organizing, composing, analyzing, and evaluating work in progress.

Enable students to increase an art vocabulary that permits discussion of artists, art forms, and purposes of art, and permits thoughts, ideas, and judgment to be expressed meaningfully.

Discuss and evaluate various types of art solutions, such as space, perspective, figure/ground relationships, foreground, middle ground, and background relationships.

Discuss the value of art in one's environment through design and planning, from space at home to school and community space. Consider awareness and critical judgment of environmental issues.

GENERAL PERCEPTUAL SKILLS

Intensively observe, examine, study, select, and evaluate art experiences.

Encourage the continued discovery of perceptual experiences, such as visual, tactile, sound, taste, smell, space, movement, walks, games, and observation techniques.

GENERAL MEDIA SKILLS

Engage in exciting art media, tools, and various processes and techniques. Provide in-depth opportunities to experiment, explore, and discover uses of various media and their possibilities.

Learn appropriate use and care of art tools and materials.

ART HERITAGE AND JUDGMENT

Study art in history as part of our heritage, including the study of the lives of artists and their art works. Discuss the role of the artist within a society—the influence on the other. Learn about where they worked and what kind of people they were.

Study art as a reflection of man throughout history.

Study contemporary artists.

Study art movements and the development of art forms.

Appreciate cultural differences.

Encourage study and discussion relating to analysis of art elements and art principles, the meaning of art works, and an awareness of the diversity of art solutions to art problems.

Develop an aesthetic criterion as it relates to nature, art works, architecture, industrial and commercial products, and handcrafted artworks.

Use the art forms in the making of informed aesthetic choices and be able to justify art judgments.

IDENTIFYING ART GROWTH IN PRESCHOOL THROUGH SIXTH GRADE

Two- to Five-Year-old Art Objectives

According to Benjamin S. Bloom, of the University of Chicago, there are characteristic growth curves. For instance, half of a child's future height is reached by age two and a half. Half of a child's general intelligence is formed by approximately age four. By the time a child enters school at approximately age six, he will have developed up to two-thirds of his mature intelligence. In terms of pure academic achievement, one-third of his development at age eighteen is reached before the child even enters first grade.[1]

Therefore, according to Bloom, the environment will have greatest impact on a specific trait during that trait's period of greatest growth. In other words, if we ignore this period of rapid growth of the intellect during these early preschool years, we may never be able to make up for this loss of growth.

For the preschooler, this means we must provide the most stimulating, exciting, challenging, meaningful, and perceptive experiences that we possibly can during this accelerated growth period.

Because the preschooler is just "learning all about life," everything in his environment is "new" to him. Nothing is structured. He is open to all experiences. He welcomes, runs toward, enjoys, takes in, even laughs at new kinds of experiences. All of life is an adventure! He is "turned on" to discovery and living.

His greatest learning happens through his senses—where he sees, feels, smells, hears, tastes, and how he moves through space. Listen to his conversation. Very much of what he says relates to the way he perceives his environment.

Art growth two to three

Scribbling is the first step in growing. Scribbling is an important kinetic, developmental, expressive form. Do not ask questions, make suggestions, or interfere while the young child is scribbling. Provide materials that encourage large, free movements and big motions, such as lots of paper and crayons or other marking tools.

1. *Disorderly scribbling.* Haphazard lines going in many directions. The child uses large movements of the arm, big kinetic motions.

1. Maya Pines, *Revolution in Learning* (New York: Harper & Row, Publishers, 1967).

2. *Controlled scribbling.* Development of motor coordination in the discovery of the relation of arm movements to marks on the paper. Circular, longitudinal, horizontal, and diagonal lines.

3. *Naming of scribbling.* The child's scribbles become objects or "things" to him. They do not *look like* the object or "thing." The drawing is still a scribble. This is an important development because the child begins to think in terms of images. He connects himself to the world around him. He thinks in imaginative terms. He may begin to include some geometric forms which suggest people or objects. For example, the concept for "Daddy" might be a circle with extended lines for legs growing directly from the circle.

Do not introduce stereotypes, such as coloring books, which offer adult concepts and adult solutions. These are crutches and do not encourage independent solutions and thinking. Encourage painting and exploration of colors. Do not present representational objects to be painted or drawn. Encourage varied, deeply involving experiences that emphasize perceptual development in looking, smelling, hearing, touching, tasting, and moving. Color and proportions have no realistic meaning for the child during this period.

Art growth three to five

The child is ego-centered and thinks of himself as the center of his world. He is concerned with concepts that relate mainly to the bodily parts of the self and the self in relation to other things in the environment. Challenge the child with action stories, films, field trips, discussions, dramatics, action, and perceptual activities.

Encourage—sensory experiences; exploration of many ways of seeing—as through a microscope, magnifying glass, prisms, water, colored glass, cameras, slides, octoscopes, etc.

increase art vocabulary—such as naming colors;

learning about art and artists;

discussions on art and its place in history and in our lives today;

visits to artists' studios, art galleries and museums, and have discussion of paintings;

selectivity in toys provided for the child;

discovery, exploration, involvement;

investigation of old and new art tools and materials;

independent, original, and inventive ideas in all experiences.

In the first representational drawings, the child is in the center of his world and drawings. There are no correct proportions. Objects and people do not appear realistically (as we as adults think of realism) but express what the child knows and how he feels. The first drawings use shapes that are more geometric, such as circles for the head, eyes, and mouth, and lines for feet, hands, and legs.

Drawings are one type of communication of ideas and feelings, and they express what the child knows.

Drawing does not depend on what the child actually sees but, rather, on the child's active knowledge about the subject. The drawing includes parts and images that are important to the child and what is meaningful to him. Parts that are not important are left out. Part of the self that have special meaning are often exaggerated. There is little or no relationship between the color selected and the objects represented. Grass could be orange or purple. Selection of color becomes more emotional. The child puts many objects on a base line along the bottom of the paper. The sky is drawn at the top.

Media skills

Felt-tip pens offer uninterrupted movement—direct expression of movement of ideas. Crayons offer the same direct expression, although the colors are not as intense, and they do not permit as free a flow. However, crayons also permit expression of small detail. Felt pens encourage smaller muscular movements, while paint and chalks encourage larger muscular movements. Motor skills increase in coordination.

Provide good quality crayons (both large and small) with a great variety of colors. Crayons should be used where the learning objective is for more detail than can be achieved with paint and offers more variety of color. There is not as much mixing of color with crayon, nor does it have the flexibility of paint. Providing charcoal, drawing pencils, and other artists' tools encourages experimentation and sensitivity to various types of created lines, darks and lights.

Provide many painting experiences with an easel and with both tempera paint and boxed watercolor paints. Have the child explore individual colors and learn the name of each. Encourage him to experiment in mixing colors together, both on the paper and before putting them on paper. Talk with him about color and how it makes him feel. Large brushes encourage free bodily movements. Smaller brushes provide opportunities for expressing greater detail. Paint is not as direct an expression as crayon or felt-tip pen. Encourage the child to express verbally the intent and idea in his art work: "Tell me about your painting." Sometimes the painting is just a design or the free manipulation of paint.

Clay and clay substitutes offer direct manipulation of form and develop the additive concept of building as well as the substractive concept of taking away. Construction media include scrap woods (nailing and hammering), plastic packing materials, papers, telephone wire, boxes, and other media. Printing techniques, such as vegetable and simple stamp, aid in the concept of repetition and du-

plication. Puppets and other fiber processes, such as papers and foils, add emphasis to tactile experiences. Oil pastels and charcoal are other drawing media to explore. Cameras and camera techniques, such as sun prints and slide making, texture collage, paper weaving, rubbings, and weaving on cardboard, are unique art procedures.

KINDERGARTEN OBJECTIVES

Artistic and perceptual skills

A drop of color on a surface is an exciting experience. Five-year-olds enjoy bright, vivid colors and active, dramatic experiences. Adding and combining colors adds to the excitement. The child is free, spontaneous, and direct in his expression with the media he uses. He does not reflect much on his past experiences; his expression is intuitive. Because of this open, free attitude, the tools and media selected for his use should encourage an open, free, spontaneous behavior—large brushes, vivid colors, large-size papers that permit the child to describe his concepts of space, paints that respond directly. Often-repeated experiences with tools and media encourage the student to experiment and "boundary-push" his previous awareness. Once-in-a-while art is not enough to provide adequate development in individual expression. Frequent opportunities encourage discovery, and exploration reveals new possibilities. The five-year-old is an adventurer eager to make new discoveries. Painting experiences reveal that mixing of two colors produces a third color. He explores the dancing of a brush, how it can move across the surface of a paper—straight, dancing, hopping, and turning. Color innovations form designs and instant compositions.

The five-year-old is a natural designer. His color selections show a keen awareness of one color relationship to the next. Although color is emotional, selection of color does not relate to the object; lips could be green, and grass could be red. Include physical activity as part of the experience and consider the duration of the lesson; shorter time spans are most effective. Include opportunities for individual experiences as well as group-type experiences.

Because of the intense perceptual development of the child at this time, many kinds of perceptual experiences should be encouraged. Invent new ways to have meaningful sensory experiences—singing walks, tape-recorded stories, smelling walks, feeling games, listening walks, and others.

PROPORTIONS *He does not use correct proportions* nor draw what we as adults might think of as correct proportions. Proportions relate to their significance, importance, and meaning to the child.

He does not include parts that are not important to him. He does include important parts.

How he draws the object does not depend on what the child sees visually, but more on what the child knows about the person or object he is drawing.

FIRST REPRESENTATIONAL ATTEMPTS INCLUDING THE FIGURE The child's first attempts at drawing a figure should not be considered for *correct or realistic proportions!* Usually, geometric shapes are used—circles for head, eyes, mouth, feet, hands; lines for arms and legs. These first-time-around concepts are important avenues of communication for the child.

He includes parts that are important and meaningful to him, sometimes exaggerated.

He omits unimportant parts.

There is little relationship between color selected and the objects represented.

Selection of color has to do with emotional appeal.

SPACE The student should focus his attention on one object, experience, or tool at a time. He visually sees one object at a time; he does not see objects as they overlap. He sees length and knows about distance but cannot yet draw or express three-dimensional space.

His spatial relationships have more emotional meaning relating to the base-line concept of space. All things take place along a base line, but forms can be haphazardly placed, perhaps upside down and unrelated. Sometimes fold-overs or X-ray concepts are expressed where both inside and outside are drawn in the same picture.

The five-year-old can identify such art qualities as the following:

Straight, curved, or diagonal lines
Lines and shapes that are long, short, thick, thin, light, dark, fine, or rough
Large-small, many-few, and warm-cool
Variety of shapes, such as square, rectangle, circle, oval, triangle, diamond, and irregular (some of these shapes may be difficult for the child to draw)
Spaces filled with varying marks, dots, and lines, which create designs and patterns

The five-year-old can identify a number of colors, shapes.

He can discriminate between colors that are bright, dull, dark, light.

He knows that colors can be mixed and changed. He experiments with mixing colors; he knows what colors to add.

He recognizes differences and similarities in texture, color, size, and pattern.

He has discovered textural qualities, such as hard, soft, rough, or smooth.

He recognizes geometric forms and shapes which combine to become symbols for representing objects and people.

He has learned to perceive details within the figure and body parts, noticing how they go together.

Media skills

Explore with the student various art tools for their expressive and manipulative properties—painting, cutting, gluing, tearing, pasting, sewing, weaving, printing, sawing—using such tools as brushes, paints, crayons, felt pens, clay, hammers and nails, wood for building, scissors, sandpaper.

Work with the student to develop his ability to name and describe various art tools and their function. Language is very important to him and helps him analyze art processes, thereby aiding in his concept formation.

Conduct discussions, both individually and in groups, emphasizing how tools work. Learn what the students like; what they don't like.

Discuss art tools and their manufacture—where they come from (such as various pens, brushes, and pencils) and what they are made of.

Discuss tools and materials used in painting and sculpture, pointing out differences and similarities; for example, the kinds of tools or materials utilized in a work of art such as one in which watercolor paint or opaque paint was used.

Felt-tip pens, direct, fast, and of intense color, may be used for direct expression.

Painting is very often a manipulative experience at this age. The exploration of color and color-mixing becomes a discovery experience; how the colors run and blend is purely accidental. The five-year-old enjoys many colors, and most children of this age can name them, especially children with preschool experiences. Finger painting is a favorite manipulative experience for children.

Crayons should be of good quality with a great variety of color. Large crayons are good for encouraging large, free movement, but sometimes they are difficult for small children to hold; have these children use regular size. Crayons should be used where the objective is for more detailed work than can be achieved with paint. Crayon does not allow for easy mixing of color, nor does it have the flexibility or intensity of paint, but it is direct and provides for immediate expression of ideas. Crayons do not cover the space as quickly or as freely as paint.

Art heritage and judgment

Looking at and talking about paintings and reproductions of famous paintings and sculptures that relate to the student's interest will help his appreciative growth. Study might include identification of items or colors, storytelling factors, shape and color interrelationship. Five-year-olds like subjects such as food, the circus, work and play, self-image, body parts, other children, home and family activities, make-believe, television heroes, fantasy and inventing imaginative forms.

Exhibit and discuss the children's own paintings and art works, as well as other school displays.

Encourage presentation of paintings and drawings before the class, with verbal explanations by the student.

Have students help in arranging space in class display arrangements or interest centers.

FIRST AND SECOND-GRADE OBJECTIVES

Artistic and perceptual skills

At this age, the students are excited about everything. They are bright, colorful, simple, uncomplicated motivations and experiences. They are instinctive designers and creators. They enjoy fantasy and make-believe; they like to play and pretend and use their imaginations. It is best to present one idea, subject, theme, or tool at a time.

MOTIVATION Include motivations that activate the student's awareness about himself. Motivations should deal with what he does, what he looks like, how he feels, and how he relates to others within his expanding environment. He likes ideas that have emotional appeal, that are imaginary and inventive, such as, "If I were ice cream, what I would see on the way to my stomach?" "How I felt when I fell off my bike." Include, also, motivations that involve him with other people and what is happening around him. At this age, he is more socially aware and sees himself as part of the social structure. Use art experiences as a way to explore the environment and the world in which we live. Have him investigate by observing, touching, listening, smelling, and tasting. He will want to explore and discover everything possible. You can provide meaningful exploratory experiences that will encourage the use of his intellectual and perceptual capacities.

COLOR In the second grade, the child begins to use color in a more realistic way. He realizes that the grass is green, and he uses color symbolically to represent objects. He does not see variations within a color unless he has a meaningful experience that extends his concept. The teacher can help students in learning to look, name, organize, describe, and define; to see similarities and differences in shapes, colors, textures, linear forms.

SPACE At this level, figures and objects change from geometric symbolic forms to more specific characterizations and will include greater detail. In terms of space, many students will include a base line or ground line in the picture. Children are ego-centered at this age and see themselves as the center from which all things extend. Space, therefore, is emotional in concept. Objects are exaggerated in size in relation to their importance during the act of drawing or painting. The child may indicate many views of the same object in one drawing, as his view of space is conceptual, not visual. Because he does not rely on observing the object he is drawing, the object becomes simplified in his drawing and reveals only what he remembers and is essential. Important parts are exaggerated, parts not thought of are left out, or parts are reduced in importance. Some commonly used ways of handling space include base lines, fold-overs, and overlapping. Cooperation in groups can be encouraged by exchanging ideas and properties and by sharing. Murals offer opportunities for sharing and cooperation.

In the second grade, the student begins to group objects and realistic events, including families, animals, and friends. School appears in his art work. His previous single base line may change to two or more, indicating that some objects are closer. Sky may come down to meet the ground.

Paintings become one more way to draw with a brush and then fill in the outlines with color. Students start with simple forms, essential characteristics isolated from each other and done in flat, two-dimensional outline. They add or subtract parts that are emotionally significant to them. Proportions are not adult-conceived. In teaching, I have found that constant exaggeration of one particular body part may have special significance to the child. For example, if the eyes are constantly crossed in the drawing of figures, the child may have an eye problem.

Media skills

Provide time for exploratory manipulation, student improves in coordination.

Repeated experiences provide the student with the opportunity to gain confidence and discovery through exploration. New experiences should be frequent enough for the child to grow through the manipulative stages to more controlled skill after successive lessons with media. Media or materials should be repeated frequently so the student does not forget. Always provide sufficient time for experiencing with new tools and materials. Encourage verbalizing about them and about art experiences. (Children like to dramatize art experiences.)

above: First-grade student exaggerates the important features, his eyes and ears. He omits fingers, and there is little detail of body and feet. The figure faces front, no action.

This young student is aware of bending knees and a side profile. The smaller figure suggests depth of near and far.

below: Second-grader indicates roundness by showing top and bottom views of a pencil and can.

The student's view of space at this age is conceptual. He draws what he knows.

Provide numerous painting experiences. Often these experiences are purely manipulative—exploration of paint and what paint will do. Provide more colors to explore; also, running and blending, blow, spatter, sponge paint, string paint.

Large crayons sometimes are difficult for the young student to manipulate. Smaller crayons are better suited for smaller hands and offer a great quantity of color (offer both large and small). Primary colors are adequate and well-liked, but children also like colors such as turquoise, gold, silver, crimson, ocher, Prussian blue (crayons have color names printed on them). This also builds a working vocabulary with colors.

Explore with the students many tools and materials. Discover and mix paint with them in an intuitive way, and analytically. Have the students discover many new colors themselves.

Art heritage and judgment

Continue building an active art vocabulary, adding names of tools, more shapes, colors, lines, textures, design, body parts, tints, shades, brightness and dullness of color. Discuss how tools are made.

Subjects of paintings studied should be at the interest level of the students. Include paintings about people in professions (clowns, policemen, teachers).

Encourage the students to classify art media such as crayon, charcoal, chalks, pen and inks, oil pastel, felt pens, watercolor, and oil paint.

Second-grade student is concerned with the social space conquest of man on the moon.

Analyze, describe, and interpret items, colors, and storytelling ideas of paintings studied. Include discussions of each other's art works. Encourage active verbal description.

Art appreciation will have greater meaning for the students if it is related to an experience they have had. Provide reproductions or original paintings and sculpture (and other art works) that are appropriate to student understanding and interest.

Students at this level can begin grouping paintings as to artists, styles, and techniques. Have them start making decisions and judgments about how they interpret what they like and do not like and why they prefer what they do. Find and discuss similarities and differences in artists, styles, and painting techniques.

Students can classify various sculpture into wood, metal, stone, etc. Discuss the part that art and artists played in the past and their part in contemporary cultures.

When discussing paintings, talk about—

a real or imaginary place, a wild place, happy or sad people, or a funny happening;

colors and how they make us feel: sad, quiet, loud, beautiful;

textures: rough, smooth, soft, hard, cold, or hot;

lines: straight, curved, diagonal, crooked, graceful;

human figure: the detail, age, costume, activity (what he is doing);

how the paintings relate to the students' interest and understanding;

tools, their names and how they work; identify and name colors, materials, styles;

classifying various art works—whether they are drawings (pencil, crayon, pastel, ink), paintings (watercolor, oil, acrylic), sculptures (clay, steel, wood), etc.;

preferences among art works and likes and dislikes;

artists and their works that express childlike qualities, such as those of fantasy artists Paul Klee and Marc Chagall; and

storytelling ideas, the meaning behind a painting.

Select one artist, such as Chagall, and study the artist, his ideas, what he painted, why he painted that way, what meaning the work had to the artist, and what meaning the work has to other people. Study his life, the elements he used, such as the colors he liked. Refer to displayed reproductions on exhibit. If possible, take field trips to museums and galleries for further study of the artist.

Discuss art in the environment. Subjects could deal with parks, building structures, bridges, airports, schools, houses, mechanical tools, motorcycles, bikes, cars, airplanes, architectural adornments, murals, design of daily articles such as food containers, utensils, dishes, clothing, furniture.

Discuss how art is used in television and the meaning it has for society.

Art motivation

Emphasis should be placed on perceptual and intellectual experiences—analyzing, describing, identifying, classifying details; investigation of many of the looking, listening, feeling, smelling, and tasting experiences (prisms, microscopes, telescopes, binoculars, comparative sounds of whistles, birds, machinery, animals).

At first, the human figure is represented by geometric shapes—circles for the important head, with the arms and legs growing from the head. Discover differences and similarities of the human form. Faces and figures will then be drawn with greater awareness of detail. Include motivations of the joints of the body—bending at the waist, neck, knees. Richer concepts will develop with motivations related to the body and its parts. Proportions are emotional, not visual; therefore, do not correct the children for "proper" proportions. Instruct them to look into full-length mirrors and have them draw their images on the mirrors with felt pens. Motivate with personal experiences that involve the sensory concepts, body parts, family relationships, friends, animals, plants, food, transportation, and other places and events. Use topics that call attention to size relationships.

Provide opportunities to practice remembering and conduct recall games with visual materials. The child approaches drawing intuitively; he does not stop to analyze.

Develop an effective vocabulary concerning the self-image and the student's environment, words about his family, school, body parts, etc. Describe objects and details that are discovered. Students enjoy sharing ideas and expressing feelings with the other children. Encourage them to use the vocabulary list you have developed.

Review shapes. Find basic shapes and forms in flowers, plants, animals, insects, birds, figures, and in a bird's tail, wing, or bill. Match and sort shapes and forms. Encourage discovery of varieties of shapes in the environment and classroom. Students start paintings with the simplest forms, isolated from each other, and do them one at a time in flat, two-dimensional outlines. Paint fills in the outlines. Objects are usually separated from each other. Students often use symbols to represent objects and people. Drawings and paintings deal with "real" objects that are important "now" and are not abstractions. They like topics that are imaginative. Colors and space may or may not be realistic to them.

The student recognizes differences and similarities in—

shapes-sizes	bright-dull
near-far	left-right
in-out	up-down
natural-man-made	over-under
oval-irregular	open-closed

Art materials

Drawing and painting with all materials: felt markers, charcoal, oil pastels, chalk pastels, crayons, watercolor techniques (beginning), tempera painting, crayon resist; cutting, tearing, gluing, stapling paper, both two- and three-dimensionally, with various kinds of papers, textures, and patterns for collage concepts; also cloth collage, stitchery, weaving, batik, tie-dye, simple macrame procedures; printing with vegetables, stamps, styrofoam, stencils; puppets, clay, wood building, papier mache, box construction, found object construction, and assemblage; initial jewelry procedures; and camera techniques are many art media to explore.

THIRD- AND FOURTH-GRADE OBJECTIVES

Students are growing out of the egocentric stage into the sociocentric stage. They are enthusiastic, able to work more independently with a greater attention span, flexible, interested in each other, helpful, interested in and like what others are doing, anxious to cooperate, full of ideas, willing to listen to opposing viewpoints, and are interested in the events around them. They like to practice skills, excel in something, need their share of approval and attention, like to share in the planning, and need to know the importance of finishing an assignment. They are strongly social, with the need for belonging and to be like their friends. Their drawings include many group situations—several objects, people, and places.

Artistic and perceptual skills

The student likes to paint from his own ideas and stories: "Close your eyes and imagine," "Is this an imaginary animal? Is it giant, plump, slim? Does it have dots, stripes, pointed head?" Invent other images.

The third-grader is aware of the three-dimensional space we exist in but does not yet represent this fact in perspective. Objects do appear in an order, and he likes to design and arrange them. He understands nearness, en-

above: Jill, third-grade student, shows round forms with lines only.
top left: Third-grade Navajo Indian student indicates spatial depth in showing overlapping, shading of clouds and ground, three-quarter view of the figure, and receding horizon line. The drawing is on scratchboard.
bottom left: This painting was done by Bill, a third-grade student, after he had studied Impressionism and Impressionistic painters. Space is indicated by overlapping hills.

closure, and continuity. The fourth-grader indicates the greatest change in his understanding of space in terms of viewpoints, overlapping, changes in value, and ability to indicate distance. He is able to use the single-viewpoint approach; he can distinguish differences and similarities and discuss relationships. He can draw more solid geometric forms with greater accuracy, such as cylinders, cubes, and pyramids. He begins to draw the figure with three-dimensional qualities, using variations in color, forms, and shading. He prefers drawing from models, nature landscapes, and still life to aid his vision, as well as ideas from the imagination.

LINE Lines have infinite variety according to the medium and tool used and the hand of the artist. Look for specific details in the environment, including lines in the classroom, and see how they repeat and form patterns. Point out the way a line continues, changes form, and recedes in space. Name and describe various types of lines, how they could make us feel. With the students, experiment with various tools and produce different lines. Have them practice contour lines and draw from mirrors (their own images). Suggest that they look at contours of skylines and horizons. Create lines with thread, yarn, and string. Emphasize that lines create shapes, patterns, and textures.

SHAPE The student knows and can describe similarities and differences in various shapes, such as cubes, cones, spheres, and volumes. Practice finding shapes in buildings and natural forms in the environment. Discuss how shape and form can influence feelings and attitudes. Discuss similarities and differences between organic and man-made shapes.

SPACE A space concept is a significant development for the third- and fourth-grader. He knows that more than one object occupies space and that these objects form some sort of organization within surrounding spaces. He realizes that objects can be viewed from more than one position: sides, top, bottom, and front. Plan experiences that involve moving into and through spaces. Call his attention to various viewpoints, such as bird's-eye view and ant's-eye view. Discuss ways of indicating receding spaces; how objects may appear in foreground, middle ground, and background. Objects appear in a successive order, and students enjoy trying various combinations and possibilities in terms of designing. Discuss receding spaces; how objects appear to recede through overlapping, planes, color changes, size differences, and lights and darks. These are the beginnings of perspective. Plan arranging spaces with furniture; organize using three-dimensional materials, collage materials; practice rearranging and composing; discuss arrangements of physical spaces in rooms, buildings, and communities. Plan living and playing spaces.

Study how artists interpret space. Study reproductions dealing with Cubistic space, Surrealistic space, and Abstract space.

COLOR Color is magic. Color surrounds us everywhere. In his art work, the student now tends to use color more realistically. Direct the student to look for variations within a color; talk about changes in color and atmosphere. Examine the fascinating blending, mixing, and swirling of color. Talk about the way color can make us feel. How does one color affect the colors around it? Invite students to experiment and discover color surprises by adding one color to another. Use color transparently in thin washes; then try thick opaque colors. Practice making color choices; discuss and study tints, shadows, intensities, values. Examine color as it is reflected on surfaces. Examine the many subtle relations found in nature's use of color. Create moods and atmosphere with color. Use contrasts of color, such as light-dark, bright-dull, rough-smooth, warm-cool.

TEXTURE *Looking* and *feeling* are the bywords in meaningful texture experiences for students. The students' natural curiosity to explore invite activities such as texture walks and touch pictures. Further their sensitivity to textural qualities of materials, brick walls, clays and earth, furs, and sandpaper. Talk about the differences and similarities. Discover how to create textures with various tools. Explore undiscovered areas of touch. Practice touching, pounding, squeezing, grasping. Plan new and exciting sensory experiences involving touch as well as smell, listening, and looking.

PATTERNS Have students study how nature uses pattern in organic objects, especially in plants and flowers. Practice adapting patterns from natural forms. Experiment with various tools to create pleasing patterns. Discuss how pattern can be useful in designing a more pleasant home and school surrounding. Conduct studies of patterns and designs in fabrics, as well as how other cultures use decorative patterns, such as Navajo Indian rugs. Plan an art activity in tie-dye, with the emphasis on arranging patterns.

COMPOSITION Students study and discuss composition in nature, in art objects, in buildings, in man-made objects, in their environments. Talk about how these forms are put together into the best possible arrangements. Practice composing with flexible materials that can be moved, changed, and reorganized. Compose and design everything from fabric design and community planning to murals and model construction. Practice using the total area of all working spaces. Create three-dimensional compositions. Discuss visual movements within a composition, such as directional lines.

"The Bicentennial Girls," by Cheryl, age 8. Figure interest in hair styles, costumes, action, figure placement within the group.

Drawing skills are necessary for copper repouse. (Copper is mounted on wood.)

Horses are favorite drawing subjects at any grade level.

PORTRAITS AND FIGURES The student's increasing involvement with the functions and appearance of his own body offers many opportunities for further study and observation in art activities. He is concerned with figure placement within the group, as well as with change of costumes and uniforms. He shows more detail and awareness in body parts such as lips, fingernails, hairstyles, boy/girl interests, joints, and movements.

Students should practice contour drawing; look for details; look for organization of the body—how parts go together; look for similarities and differences in people. Practice the figure in action, such as playing sports, gesture drawing to capture action. Look for inventive costumes, uniforms, differences in professions (such as teachers, mayors, doctors, waitresses). In drawings, represent figures in group social situations such as families, groups at the circus, state fair, political campaigns. Show the figure in relation to other objects in the environment. Draw the figure as the student feels about his own body. Express emotions through the use of the figure—happiness, sorrow, exaggeration, distortion; include important parts and omit unimportant parts. One art lesson might be of a figure showing sorrow and all the details that make up sorrow. Another art lesson might be the expression of a theme or idea, using just certain parts of the figure. The fourth-grader begins to draw three-dimensional qualities of the figure, three-quarter views; he begins to shade and show color differences, rounded forms, realistic proportions.

LANDSCAPE In the third and fourth grades, the student begins to indicate depth, realizing all objects occupy space. Space is the distance between objects. In landscape drawing, the student begins to use foreground, middle ground, background. Review composition objectives with him. Select and focus on certain shapes, lines, colors, textures, patterns. Find basic geometric shapes within natural and architectural forms. Combine and compose these forms into an exciting arrangement. Look for size and space differences. Have them do many practice sketches. Sketch with charcoal, graphite, chalks, pens, etc.

STILL LIFE Students practice selection and exciting arrangements of objects, considering variety, similarities and differences in shape, balance, depth, textures, flat and round forms, color relationships. Have them describe and discuss shapes and their shadows. Discuss positive and negative shapes, color that are harmonious, colors that are disharmonious. Consider proportions, pleasing and not pleasing. Shapes depend on viewpoint, where the viewer is. Shapes can be flat or three-dimensional.

Media skills

For third- and fourth-graders, manipulative experiences are important for greater refinement and control in handling tools and materials. They now control tools and media consciously with growth of small muscles.

Have students create designs for wallpaper, clothes, wrapping paper, fabrics, tissue-papper collage. Practice print-making, pen and ink, various painting techniques.

Composite group activities are important—activities such as murals, puppet shows, dramatic plays and costumes, stage design, group sculptures, mobiles, film-making, light shows.

Art-heritage and judgment

Have students discuss the art elements and how artists use these elements: color, line, texture, pattern, shape, form, shading, etc. How do these elements relate to each other? Discuss similarities and differences in art works.

How are the art elements put together—composed?

Encourage the student to continue making judgments about his and other art works. Verbalize about "what he likes—what he doesn't like." Discuss why.

Continue building a greater vocabulary. Keep a dictionary of art terms as they are discovered.

In the classroom, continue visual study of artists and their art works. Learn all about an artist, his ideas, his place in history, and his purpose in producing art.

Keep an art scrapbook of events about artists in the community, lectures, exhibits, art reproductions found in magazines, etc.

Study reproductions and original works of art.

Analyze the art elements in paintings in simple ways, naming and describing colors, how the artists used color, such as watercolor washes or building of color in oil painting, the various textures of the paint, pencil, or charcoal, the materials used in sculpture, and techniques such as pencil, pen and inks, lines, shading.

Analyze space (positive and negative). Study landscape scenes and nature for ground-sky relationships; foreground, middle ground, background. Study how other artists have used space.

Study art examples that relate to the community, school, and civic structures.

Consider how artists interpreted their subject matter from people, nature, events in history, imaginary fantasies.

Discuss emotional response to color, how students feel about certain combinations of color, about the way artists have used color to express an idea.

Practice expressing personal feelings about works of art. Mysterious? Wondrous? Exciting? Do we like it? Why?

Study the role of artists in society, yesterday and today—car designers, photographers, architects, city planners, furniture and clothes designers, art teachers, TV artists, film-makers, layout artists.

Keep a rotating art corner, displaying art works of all kinds; sculpture, crafts, folk art, paintings, art from other countries and cultures.

Art motivation

Motivations might include themes such as sports, summer and winter activities, social events, school, where they live and play, family doings, and "we" and "action" words. They find they are able to represent objects more realistically and are pleased with this new ability. They are also more critically aware of how objects "really" look in their environment and the way they previously drew these objects with visual symbols and schemata. Their drawings become less expressive, more rigid, and tighter because they perceive more detail with greater accuracy. They improve in eye-hand coordination and with small muscle development. Discuss with them differences and similarities in shapes of eyes, noses, mouths, hands, forms, color variations, landscape forms, and still-life composition. This will help them analyze their world visually and aid them in their drawing. Encourage the use of details. Encourage memory drawing and have them practice contour drawing. Suggest including several objects in a drawing to approach a conscious combining of images into an arrangement.

Naming and classifying are important to the student. He likes to collect objects and categorize them to show differences and similarities (such as color variations, shades, intensities, forms, sizes, function) in collection such as rocks, tree barks, flowers, and foods and their manufacture.

Emphasize the individuality of the student and his unique contribution to the group. Offer challenges that emphasize fluent solutions to problems. The first answer is not the only answer; many solutions are possible. Encourage the student to "boundary-push," not to be satisfied with the simplest or first solutions: encourage him to study, investigate, take in, focus, organize, reevaluate, and make changes before deciding the solution is finalized.

Art materials

Continue exploring and developing skills in various media. Drawing and painting techniques with markers, charcoal, pencils, oil pastels, chalk pastels, crayons, watercolors, tempera, acrylic paints, crayon resist; paper sculpture, papier mache, paper cutting and folding processes, paper collage; cloth collage, cloth applique, stitchery, batik, weaving, tie-dye; wood construction, carving, found object assemblage, more complex printing techniques; jewelry construction; sculpture techniques with plaster, clay, wash; printing procedures, applied design found in motif-repetition-pattern-variations for manufactured objects; produce experimental slides, films, filmstrips, animated films; clay and clay substitute construction with slab and coil methods.

FIFTH- AND SIXTH- GRADE OBJECTIVES

During these grades, there is an important maturing and understanding of art. If students have had adequate perceptual experiences, artistic, manipulative, appreciative behaviors, and creative art production, then certain goals may have occurred. A developed art vocabulary, an art heritage understanding, aappreciation for their own and other art works, tools and materials, skill development—all should culminate in more mature art preferennces and opinions. The student can now use this knowledge as a tool to complete more sophisticated concepts. Art, "what art is," a comprehension of the structure of art—these art qualities remain with us throughout our adult life. They add excitement, appreciation, and enrichment to our daily living.

The following art skills describe student characteristics at fifth- and sixth-grade levels, with art objectives appropriate to this level.

Artistic and perceptual skills

Continue observation of detail, recall, and memory drawing.

Practice the interrelation of the arts: art, music, dance, drama, theatre, writing.

Practice perceptual activities involving scents, sounds, touch, movement, and observing.

LINE Students observe line qualities in nature and man-made objects.

Experiment with inventing as many types of lines as possible.

Use a repetition of lines to develop texture, pattern, composition.

Draw a variety of lines with different tools and materials.

SHAPE Review basic shapes.

Students should look for new shapes in all things.

Use simple shapes for simplified forms in a composition.

Use basic geometric shapes to create objects in nature, landscape, still life.

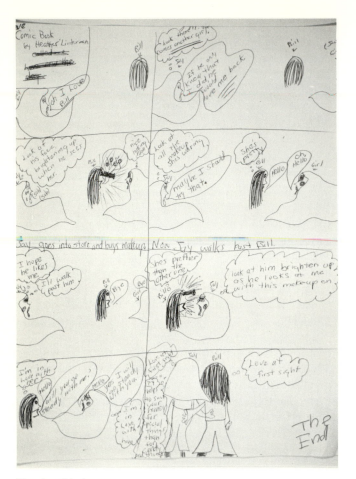

Heather Linderman

Mark Linderman

Sixth-grade drawings reflect beginning aware-
ness of social interests.

Bird emphasizes most important parts.

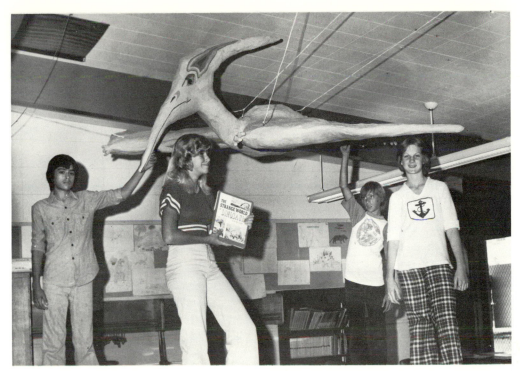

A three-dimensional papier-mache group science project by fifth and sixth graders.

Fifth- and sixth-grade drawing examples illustrate interest in social themes and mechanical subjects.

Use shapes which are harmonious to each other, and others which are not.

Search for similarities and differences.

Create shapes with textures, colors, lines, and shadows.

SHADOWS Observe shadows as being soft or sharp.

Use only shadows in a compositional design.

Use shadows to show the form of muscles, bones, folds in drapery.

Use shadows to suggest the third dimension in a composition.

Use shadows that suggest light sources from more than one direction.

SPACE Observe space in nature and discuss the definition of perspective.

Show three-dimensional depth through overlapping, color changes, size changes, and changes in light to dark.

Understand and use terms such as horizon line, vanishing point, center of vision.

Work with a vanishing point using lines and forms.

Work with more than one vanishing point in a single drawing.

Employ different viewpoints such as bird's-eye, worm's-eye, and overhead.

Recognize that lights and darks give perspective results and try them.

Use size relationships to indicate distance.

COLOR AND LIGHT Observe color in the environment and work to develop a color consciousness.

Experiment freely with mixing pigments and painting materials.

Recognize primary, secondary, and intermediate color hues.

Develop the concepts of hue, value, and intensity.

Observe how color is influenced by its relation to adjacent colors.

Study the spectrum by using a prism to understand the various colors.

Identify various colors with regard to emotional effect, including warm and cool colors.

Use white and black to alter a color for a given purpose or value study. Explore tints and shades.

Use various colors to note changes in shading.

Experiment with light shows, projections, cameras.

PATTERNS Observe patterns in nature—flowers, trees, hills, mountains.

Observe man-made patterns, fabrics, buildings, furniture.

Make a collection of patterns.

Create new patterns from your imagination.

Use patterns to create compositional effects.

TEXTURE Discover as many textures as possible.

Collect and display as many textures as possible.

Use various textures to form a composition.

Use textures in drawing shadows.

Use textures in harmonious ways.

Use various types of lines to indicate texture.

Use various media to indicate texture.

Use opaque and thin washes to show texture.

COMPOSITION Recognize that composition involves the whole paper or project.

A study balance, unity, repetition, rhythm, and harmony, contrast, variety.

Apply principles of design including selection, dominance, placement, space, movement, similarities, differences.

PORTRAITS Observe detailed features of the human head. Greater realistic proportions.

Feel your own head and sketch it without looking.

Observe yourself through use of a mirror and sketch your image.

Study the proportions of the human head.

Study muscles and bones of the head.

Use shadowing (shading) to accentuate highlights, bones, muscles.

Use various types of lines and other materials and tools to make portraits.

Study gesture, contour, modeled, and memory drawing.

Try an imaginative approach in drawing a portrait.

HUMAN FIGURE Great physical and emotional changes in body awareness. Observe people in daily life.

Make quick gesture sketches of the human body and of its parts.

Use television as a sketching source.

Study the proportions of the human figure.

Use a variety of media in creating a figurative composition.

Combine more than one figure in a composition.

Practice gesture, contour, modeled, memory, and imaginative drawing techniques.

Shows interest in the human figure and the sex characteristics, clothing, and dress differences.

STILL LIFE AND LANDSCAPE Plan a composition and make several variations of it.

Decide textures and colors which will be harmonious.

Choose objects which are related in a harmonious way, then a disharmonious way.

Find and utilize contrast and variety in the drawing.

Media skills

Enjoys more complex exploration and experimentation with materials and tools.

Greater practice and knowledge of techniques and search for improvement in skills.

Develop more advanced skills in handling paints, pencils, pastels, tools, and materials.

Encourage students to invent and discover new personal ways in using tools and materials.

Continue to emphasize group activities.

Heritage and judgment

Review previous art skills.

Identify and name various art tools and materials such as papers, charcoal, paint, pencils.

Hold open discussions on art works, making decisions and judgments of art works based on past knowledge and experiences. Provide the opportunity for students to express and discuss their feelings and decisions about art works.

Keep an art center where art works can be displayed.

Take trips to artists' studios and to museums.

Invite artists to the classroom.

Develop an effective art vocabulary.

Discuss the meaning of art in our lives today.

Discuss the difference between commercially made objects and artistically made works.

Continue the exploration of art in the man-made environment.

Continue investigating art in nature.

Investigate art of the past, such as impressionism, expressionism, surrealism.

Research art in science, history, literary subjects, music, dance, theater, TV, photography, film, architecture, industrial design, and commercial design.

Strengthen an awareness and appreciation of our cultural as well as artistic heritage.

Art motivation

Some students are now more analytical about their visual world, while others think in more imaginative terms. The students' motor skills and dexterity with tools are developing into artistic expressions and techniques. There is greater interest in longer working times and in pursuing independent directions. Each student should be encouraged to investigate resources for inspiration and information, establish his own interest areas, interpret and use related ideas with art, be flexible and inventive, value originality, and express moods and feelings within his own art creations.

He should continue to explore new ideas and tools and expand his personal horizon. There should be opportunities for greater in-depth experiences in learning and working with materials, rather than a smattering of experiences. There should be improved skills with drawing and painting tools, media such as felt pens, paints, oil pastels, various pencils, charcoal, etc.

The student now has a special interest in social awareness, human interests such as how bodies function, drugs, war, smoking, community and world responsibilites, personal grooming, family interrelationships, environment pollution, social structures, diseases, and working toward the future. He wants to learn more about life, how art relates to life, nature, science, and history. He wants to express these ideas in his art products. Practice remembering and recalling experiences, go on field trips, relate art forms to forms in writing, dance, music, and so forth. He is sensitive to his own inadequacies, loyal to his peers, and to the group.

He is familiar with some artists, their ideas as well as their place and function in society, past and present. He should be able to compare and describe works of art in relation to their sensory qualities, style, materials, and processes used to create them. He should make personal, informed judgments about art and the design quality that affects our living in utilitarian products and community environments.

Continue to stress the uniqueness and important contribution of each student's ideas and art and their relation to the success of the group as a whole. The student respects differences of opinion and enjoys learning about different points of view. He openly discusses likes and dislikes. He likes space-time relationships; enjoys research, scientific and historical data; understands past-present, simple-complex, near-far concepts; is interested in planning, following through, workmanship, and the finished product, and enjoys practical projects.

Art materials

Drawing and painting techniques with all tools available; design awareness and applied design with multiple media (found in all utensils, furniture, clothing, environments); clay and plastic sculpting, building, casting construction; creative stitchery, applique, more complex weaving procedures, batik, tie-dye, cloth designs, sculpting and jewelry with metals, cloth, papers, woods, clays, found objects. Develop printing procedures in relief, intaglio, stencil, rubbing processes; study and construct architectual models; lettering and calligraphy methods. Photography concepts with and without a camera for capturing images such as sun prints, photograms and pinhole cameras; produce experimental slides, films, animated films, filmstrips.

CRAFT MEDIA

The following craft materials are fun to use; all art curriculums are enhanced with the addition of three-dimensional expressive media.

Most craft materials and procedures require initial designs and drawings. Sketching ideas first helps to visualize the design elements and principles.

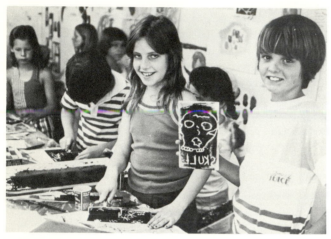

Printmaking with styrofoam. "Skull" is carved in reverse to print correctly. Fourth-grade students from Linderman Workshop.

Simple stitchery by first grader.

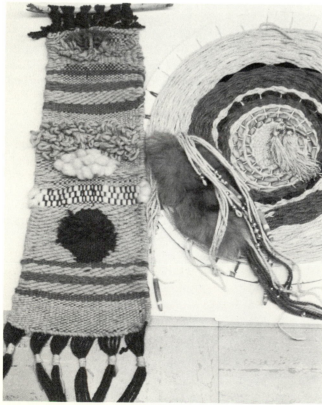

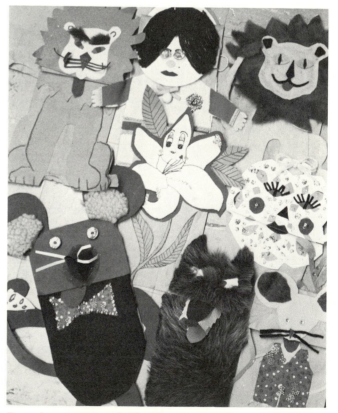

Weaving examples are from fifth- and sixth-grade students. Linderman Workshop.

Paper bag puppets, mixed ages.

Clay masks and pottery by the students in the "Children's Art Workshop," Arizona State University, Dr. Jon Sharer, director.

Batik

Teach the necessary procedures for each material, with the basic attitude that the child uses the skill and materials to expressively state individual ideas. In craft media, the knowledge and practice of *design* is important, as most craft processes deal with ways to use tools and work with materials, rather than dealing with subject areas. Design can be inherent in the form of the object produced, as well as the design *applied* to the object. One improves in working with tools and materials and therefore develops skills. Craft media skills are important when they are used in personally expressive and creative ways.

Most craft processes require designing and planning drawings. In this way, many of the concepts of design elements and principles are used. Sketching out ideas permits the student to make changes and improvements in the design rather than in the material. Such planning aids in batik, mask making, printmaking, and photography and filmmaking procedures. Weaving can be created spontaneously, as can work with clay and other sculpture materials, tie-dye, collage, and puppets.

Craft advantage is that there doesn't necessarily have to be an image. The media often dictates what happens in the design. The older student, who is now more critically aware of his own work, does not necessarily have to have an image that is representational. This permits greater freedom with ideas.

As in drawing and painting, the model for crafts is the craft artist. Such persons excel in producing craft forms and are excellent examples for the student who is learning. Visits to studios, galleries, and museums help in understanding the past and present artist. Crafts are an

excellent avenue into the study of other cultures. Most societies expressed their religious beliefs, social customs, festivals, and celebrations through the crafts they produced. What a wonderful way to learn about neighboring countries and other cultures.

When using the following chart, refer to Earl W. Linderman and Marlene Linderman, *Arts and Crafts for the Classroom* (second edition) (New York: Macmillan Co., 1984).

CONSTRUCTION AND SCULPTURE

Ages 3–12 Build paper into three dimensions by bending, curling, folding cutting. Build with slots, gluing, and other ways of joining. Make masks from paper plates. Do clay experimentation. Roll, pinch and pull, press, squeeze, add-to forms. Use boxes of all sizes and materials for construction from the simple to more complex such as architectural concepts. Build mobile kinetic sculptures from papers, string, cardboard, reed, wire, and cellophane. Construct with found materials such as egg cartons, stuffed paper bags, stuffed cloth (for soft sculptures and dolls). Hammer, glue, and join soft woods and sticks.

Ages 5–12 Make masks from cardboard, large paper bags. Use clay to build small animals and figures; pinch pots. Papier mache over simple forms. Use baker's clay and salt ceramic for clay substitutes to create storybook characters, animals, dioramas, murals, and simple jewelry.

Ages 7–12 More complex paper folding and cutting, such as origami. Use a variety of papers, foils, wrapping, wallpapers, colored construction, tissues, doilies; use hole punchers, pinking shears. Make masks with papier mache. Relate to American Indian, Chinese, and African cultures. Use clay for coil buiding forms, pots, and slab building; experiment with decorative glazing, textures, and applied designs. Use paper pulp for modeling, build papier mache over more complex armatures.

Ages 9–12 Use clay for larger and more complex forms. Sculpt heads, figures, and animals. Repousé with copper tooling. Try copper enameling and jewelry processes.

TEXTILES

Ages 3–12 Weave with paper, plastics, screening, and large yarns. Tie-dye with paint on cloth and T-shirts. Learn knots for tying.

Ages 5–12 Design yarn and fabric shapes with glue on cardboard. Weave on cardboard looms. Make crayon resist on paper and cloth.

Ages 7–12 Make simple stitching with yarn on openweave cloth. Create original designs with stitches and applique cloth shapes to make banners, flags, soft sculptures, cloths. Weave on fingers, cardboard, wooden and free-form looms. Try rug hooking and basketry. Wax and glue batik on cloth of dip and dye paper. Learn macrame knots. Add beads and more complex forms.

9–12 Weave on back strap looms and larger tapestry looms. Plan designs and patterns. Batik cloth for wall hangings, pillows, lampshades, scarves, clothing.

PRINTMAKING

Ages 3–12 Monoprints—place inks or paint on plastic or glass surfaces, draw designs and images into paints, removing some of the paint. Place papers on top of paints, rub gently, and remove paper from top of surface to reveal monoprint. There is a current art revival using this process by such artists as Fritz Scholder. Rubbings—place papers, such as typing, tissue, or newsprint over surfaces with raised textures or designs (such as coin, wall, signs, of plants). Rub with crayons or pencils. Found-object printing—stamp print with found objects such as kitchen utensils, old toys, screens, etc., by placing object into paint and stamping it onto surfaces. Vegetable printing—carve vegetables, such as potatoes, into designs and stamp print. Print on various papers and textiles. Print cards, newspapers, simple books, posters, book jackets, class books.

Ages 9–12 Young students should use popsickle sticks to carve vegetables for printing. Older students (9–12) can use linoleum tools. Experiment with linoleum, stencil, and silk screen printing.

PUPPETS

Ages 3–12 Vegetable heads on a stick
Ages 5–12 Paper bags
Ages 7–12 Sock and cloth
Ages 9–12 Marionettes

PHOTOGRAPHY—FILMMAKING

Ages 3–12 Learn about communication media—film, videotape techniques, television production, super graphics, and murals.

Ages 5–12 Draw and develop stories in sequence. Draw flip books. Draw on overhead projector mylar paper and develop color overlays. Make sun pictures.

Ages 7–12 Bleach 16-mm film and draw with permanent felt pens on the film. Learn parts of the camera. Photograph and develop pictures; enlarge large photographs. Create your own slides.

Ages 9–12 Develop black-and-white film. Develop story lines for film. Create jointed figures for film animation, such as in cartoons. Produce animated films. Produce light shows.

SUMMARY

ARTISTIC AND PERCEPTUAL SKILLS

Selects color emotionally in first grade to symbolic color in third; uses personal symbols; applies greater detail; uses imagination and inquisitiveness. In third grade uses more realistic proportions, colors, greater representation; works for predetermined effects; awareness of differences in people.

Introduction and recognition of the elements of design—*line, shape, color, space, texture, pattern*—and their uses as principles of art—*balance, selection, rhythm, interest, similarities, differences.* Experience these forms in nature and manufactured objects. Look for design in awareness exercises. Explore during walks, discussions, and viewing art works. Find similarities in form, difference in art forms. Explore the figure concept from geometric lines in first grade to group figures in action in the environment in third grade. Develop the art concept of "art and the child" in first grade to "art and the world," in third grade. Encourage all students to value artistic skills as essential for expression; that all persons are creative and productive. Practice art vocabulary with such words as hue, value, and emphasis.

Recognize and practice differences in art expressions, such as realistic art and imaginative art. Discuss how art is created through careful organization. Student relates to self-centered interests. The student is curious and eager to learn. Short to longer attention span. Awareness of self, people, and objects in the environment. Enjoys group projects in third grade. Likes to classify objects. Impatient with self; likes the real and make-believe.

Interest in fourth grade is in "boy-girl" relationships; fifth graders show interest in the real and details; sixth graders like group activities, are loyal to peers, like to analyze the world, and have the longest attention span. Continue sensory experiences and awareness exercises. Continue observation and practice of design skills—line shape, color, space, and texture pattern—and the way they are organized with balance, repetition, emphasis, and perspective differences. Practice drawing, painting, and creating with imaginative, original, and expressive responses. Discuss space concepts, what we know, feel, and see in space, and use of spacial perspective. Practice size relationships and proportions. Practice mood expression, the qualities of line, form, and color. Discuss and practice how art is a means of communication of ideas and feelings, from political cartooning and public art to commercial illustration. Art is telling others of our thoughts, dreams, and feelings. What is the impact of the artist in our world? Artists have enriched our world. Art objects contain direct values of their cultures. Art experiences and values help each person to see the world through aesthetic statements, opinions, choices, and the place art has in the culture. Study where the artists get their inspiration—from nature, objects, events, and imaginations. Study art in our environment from design to architecture to city structure. Who are the artists? What is their function? Do you want to be an artist? Discuss art careers, including advertising art, graphic artist, printer, craftsperson, and architect. Visit art exhibits, museums, artists-in-schools programs, "arts" festivals, attend art classes, demonstrations. Interpret the related arts and the arts in other cultures as well as in the American culture. Observe how other artists have interpreted the figure, portrait, landscape, seascape, and still life in realistic and imaginative ways. Continue art practice by sketching, keeping sketchbooks, idea books, and journals. Emphasize the importance of art in communication media—film, graphics, super graphics, and video.

Observe and identify the art elements in nature and man-made objects: line, shape, color, space, texture, and pattern.

Observe and identify the art principles in nature and man-made objects: balance, movement, rhythm, placement, emphasis, similarities, and differences.

Practice art elements and organization in art works with originality and creative ideas.

Verbalize about art, the importance of light and light sources (shadows and shading), realistic and imaginative interpretations.

Demonstrate and explore color concepts: mixing, color moods, light, and color.

Demonstrate and explore space concepts: perspective, foreground, middle ground, background, overlapping, and imaginative space.

Draw and paint the human figure in visual as well as emotional interpretations.

Translate visual information into art forms by using models, objects, landscapes, and seascapes.

Use a variety of resources for creating art.

MEDIA SKILLS

Practice skills in drawing and painting with a variety of media: charcoal, felt pens, crayons, chalks, oil pastels, pencils, wet brush on dry paper, wet brush on wet paper, watercolor techniques, and tempera paint techniques on white or colored construction paper. Explore color mixing, from simple to complex, and design practice with geometric shapes of sut-colored paper. Construct three-dimensional forms with papers, wood, clay, and fibers (weaving, soft sculptures, batik, yarn designs, puppets). Print with cut cardboard, styrofoam, rubbings, monoprint, simple stencils. Produce crayon on textiles, papier mache procedures from puppets to masks, paper masks, dioramas, yarn baskets, banners, simple stitching, applique, and doll making from applehead to clothespin. Develop skills that require more complex procedures, working with tools for large muscles to tools for smaller

muscle control. Discuss how art can be the unique expression of the individual, relating to personal imagery and ideas. Likes to explore and achieve mastery of skills. Develops small muscles, improves in eye-hand coordination.

Intermediate grades enjoy experimenting with new and varied tools and materials; more complex procedures. More developed motor skills and control. Continue expressive skills in drawing, painting, printmaking, three-dimensional design, mixed media, and crafts. Create original works that demonstrate organization and composition. Discuss how media influences for form and idea including both the possibilities as well as the limitations. The choice of media and tools will influence the art form. Design affects function of manufactured products and structures in our environment. Media can influence the art structure.

The upper grades continue to explore various media, such as pens, crayons, pastels, charcoal, and chalks. Use various paints and brushes. Build and sculpt with art material, such as clay and fibers. Experiment with printing materials. Use communication media, such as cameras, video, graphics, and murals.

ART HERITAGE AND JUDGMENT

Practice thoughtful viewing and discussion of the art objects of past cultures as well as present; consider similarities and differences. View art works depicting the visual world as well as the imaginary world. Discuss how art is and has been used in societies—religious, celebration, festivals, ornament, and communication. Understand the value of art in cultures regarding its purposes, forms, the artist creators, and artistic contributions. Art as imagery records the feelings, ideas, and events of peoples. There are artists in the communities that one can hear and visit. Identify various expressions in art, works that relate as portraits, figurative, landscapes, seascapes, and still life. There are other art forms, such as in architecture, film, community sculptures, murals, and ceramics. Learn about American artists as well as artists in present and past cultures and art movements. Investigate the importance of other artists' productions, such as illustrators, industrial designers, fabric designers, and television producers. Discuss how art is a universal, cross-cultural language. Pursue art concepts in the related arts—music, dance, theater, and literature. Relate how art is integral to the total learning experience as self-expression. Recognize differences and similarities in colors, lines, shapes, texture, and patterns. Make independent choices in ideas. Develop greater interest in the finished product.

In the middle grades discuss how environments are reflections of art works. Aesthetic choices can improve environments. Practice aesthetic and critical skills in looking at art works and one's own art products. Making judgments helps develop evaluation abilities of one's own

work and that of others. Make aesthetic judgments concerning the qualities of the environment. Develop the student's appreciation of various ethnic art contributions in our culture. Compare similarities and differences in art styles; select a favorite artist and discuss the selection; discuss how various ethnic groups have contributed to our heritage.

Study art, artists, architecture, art forms in the past/present/future. Understand art in cultures as records, celebrations, decoration, and religious beliefs. Recognize similarities and differences in art styles. Identify art careers. Expand the art vocabulary. Study the related arts in other cultures. Study art as science, history, music, and engineering. Discuss the value of art as a way of life. Art is communication. Discuss how art has changed the world.

Shows greater understanding of space concepts, moods, and atmosphere of color, three-dimensional concepts; works independently; greater realistic proportions; is able to plan the art form, select materials, tools, and design for purpose; is interested in the finished product; likes to use products; likes subjects dealing with space and time; enjoys three-dimensional construction; enjoys human interest subjects, such as community and world interests. Discuss the different purposes of art today.

In the upper levels, the student learns to recognize and describe various media, including watercolor, tempera, oil paint, acrylic paint, clay, fibers, and prints.

Describe and differentiate among art forms: drawing, painting, sculpture, constructions, architecture, ceramics, textile design, environmental design, collage, printmaking, illustration, cartooning, advertising art, industrial design, photography, film making, and television art.

Recognize and describe folk art and art of various cultures: American Indian, Mexican, Oriental, African, Western and Eastern Europe, Middle Eastern, and South and Central American.

Study art from the past and recognize significant artists of various periods.

Describe the differences in art styles and art movements.

Describe various subject contents of artists.

Learn about artists, their lives, and art products.

Discuss the function of artists in society and art in our lives today. Describe how the quality of design affects function of products and environments. Develop critical skills when viewing other art works and one's own art works. Form aesthetic judgments in personal choices.

A GUIDE FOR PLANNING ART INSTRUCTION

As we consider the art growth of students, we should state that the areas of growth have been defined according to age objectives and characteristics. We need to point out

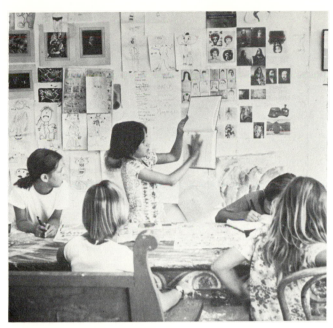

Sketchbooks keep ideas and drawings together. Note: pages from this text are tacked up on wall for study.

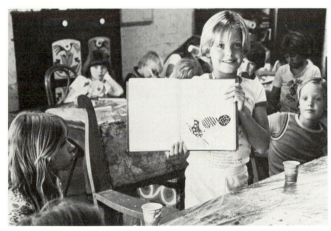

Time for sharing ideas and sketchbooks, drawn both in and outside of class, will serve as inspiration for all kinds of art impact in your class. Linderman workshop.

that there is no straight progression of art; the levels do vary as students get older, and it is difficult to determine where one starts and another stops. The child must be able to grasp the cognitive and intellectual significance of such growth; he must be able to organize his thoughts and represent his environment in ways that give us clues as to the development of his thinking. These growth levels in art are indicative of the child's whole growth pattern; the art product is an aid in understanding the total growth of the child. Some students may advance quickly through a growth level; others need greater amounts of time to follow the sequence of art development. Art learning will take place in the context of what is already known. Students

can understand new information when it is understood in relation to information already learned. The process of learning about art takes place in the child's thinking. The common element that flows through all developmental levels is the need for the child to draw and express himself, a natural need to draw and paint, and a need to explore and experiment and find relationships in learning. Our role as teachers is to use the characteristics and objectives as reference data so we can provide enriched, exciting circumstances, provide appropriate motivations, and organize materials so that meaningful art experiences will take place. Collect art examples of the various growth levels and keep these as representative. In this way, one can observe the many forms of expression and symbols. Keep these in chronological order and observe the differences and similarities of art products and children's growth and development.

1. *State the objectives*—what the student is to achieve in the lesson. State what the performance objectives are, how the student will behave after the instruction. In some instances emphasis will not be on a specific objective but rather on search and experimentation, thus permitting ambiguity and encouraging unique and unpredictable responses. The goals listed can be stated individually, or several goals can be combined.

Artistic: the specific content area the student will investigate. When the terminal behavior is compared with the stated objective, evaluation of the learning situation can take place. Artistic goals may be—

art practice—development of color, line, shape, space, texture, pattern, composition; and

improved performance in drawing—the human figure, portraits, still lifes, designs, landscape, imaginative compositions—and in drawing and painting techniques.

Perceptual: types of experiences the student will have. Verbs stressing perception are *see, touch, feel, hear, taste, move, create, invent,* and *organize*—all related to exploring the senses. Developing the awareness of one's self within one's environment. Record discovery data.

Manipulative: growth and improvement in skill in handling, experimenting with, caring for, and controlling tools and materials.

Art-appreciation: study of art and its meaning in history and cultures. Practice and improvement in making art judgments and decisions. A greater awareness of details of situations and objects; a keener aesthetic awareness of the art elements and principles, and of one's environment; learning about artists and art works; classifying art works into styles and periods of art; developing art values and attitudes; learning art terms and art language; choosing likes and dislikes; evaluating works of art,

using terms such as *naming, classifying, organizing, constructing, analyzing, synthesizing, describing, explaining,* and *interpreting.*

Intellectual: enriching concepts, dealing with the cognitive—ideas and thinking. Individual, self-directed ideas and projects or group projects. Ideas might deal with social problems such as drugs, pollution, war, food, health, growth, living spaces, community spaces, transportation, and imaginative ideas. Concepts might deal with greater observation and understanding of the human body—its function and how it moves—trees and nature or specific details such as in the workings of machinery, clocks, landscape, still lifes, etc.

Expressive: the way in which the student discovers and communicates his ideas, feelings, emotions: what he is saying and the way he communicates it—spontaneous, intuitive, subconscious, automatic, discovery, inquiry, reflective (calls upon previous experiences).

Creative: emphasis on unique, inventive, independent, fluent, personal solutions.

2. *Motivations for art*—state how to reach established objectives. What the manner of presentation will be. How you will interact with the students. Any unusual experiences as part of the motivation? What action words and movements will you have? How will you involve the students, arouse their feelings, imaginations, interpretation? Encourage interaction of ideas (verbal and nonverbal), questions, feedback, discussion.

Skill (process) motivation: use of materials and tools and instruction in technical processes.

Subject motivation: stories, storytelling. Acting out, making up mythology.

Recall—recalling situations from students' past experiences.

Working from visual models—objects, figures, landscapes, stiff lifes, photos.

Field trips. Films, visual media stimuli (light shows, slides).

Imaginary images. Inventing ideas. Fantasies.

Sharpening perception. Educating the senses.

Galleries, museums, artists, art objects. Related arts.

3. *Materials needed*—list all tools and materials to be used. Prepare before the class begins.

4. *Resource aids*—list all teaching aids to be used, such as teaching examples, projectors, films, slides, reproductions, etc.

5. *Process or strategy*—what the teacher is going to present in class. How the student will proceed with the project. If an instructional process, list step by step.

a. *Working time*—approximate time provided for motivation, visual aids, process, time needed for interaction of ideas, for solutions and evaluations.

b. *Provide opportunity for experimentation*—note experiments that take place, new ideas. Keep select data.

c. *Changes and evaluation*—keep select data.

6. *Final resolution*—student decides when product is complete.

7. *Evaluation of aims, motivation, process, other objectives*—how can these objectives be improved? How can the student gain more success in the problem? Did the student react meaningfully? Did he grow in his art skills?

8. *Conclusions*—arrived at through the experience.

9. *Expanding opportunities*—establish objectives, ideas, and aids for further lessons.

10. *Presentation and evaluation of art products*—provide a time for sharing and communicating art or art products and ideas. Can be presented orally before students, in group discussions, or exhibited in displays. Does the art product indicate if the objective has been reached—what the student has learned?

As an example, David Manje, an art teacher, outlines an art presentation for third grade.

INSTRUCTION EXAMPLE

OBJECTIVES

As a result of the art program, each pupil should demonstrate, on his personal level, his capacity to (1) perceive and understand artistic visual relationships in the environment; (2) think, feel, and act creatively with visual art materials, and (3) increase manipulative skills.

MOTIVATION

The following units are based on historical research: relics from Teotihuacan and African trade beads. They were developed with the above objectives in mind to affect students in improving their self-concept through cultural awareness. The units are a combination of culture, social studies, and art activity.

A few miles from Mexico City are the ruins of the city of Teotihuacan. The name Teotihuacan literally means "place of the gods." The city covers over six square miles and has two gigantic pyramids known since the time of the Aztecs as "of the sun" and "of the moon." When built, the city was composed of plazas, palaces, temples, and broad avenues. The structures were covered with white and red stucco. Within these structures were found clay

figurines. Figurines were used to represent many things. They were used to describe customs, ceremonies, and scenes of daily life.

1. Teotihuacan is the city of ruins.
2. In the city were built two pyramids known as "of the sun" and "of the moon."
3. Within these structures were found clay figurines representing customs, ceremonies, and scenes of daily life.

Students will be shown a number of figurines that represent those found in Teotihuacan. Briefly discuss the history of Teotihuacan, meaning "the city of gods."

MATERIALS

1. Red low-fire clay
2. Appropriate modeling tools: pin tool, cutting wire, wooden texture tools, or any other found objects that can be utilized
3. Water containers
4. Paper towels and sponges
5. Wedging boards
6. Nonlead, low-fire, cone .06 glazes and brushes

PROCEDURES

1. Each child should have a water container, sponge, towels, a modeling tool, and a slice of clay.
2. Cut a one-inch slice of clay from a bag of clay using cutting wire and give to each child.
3. Cut slice into two or three separate pieces and work until they are not so stiff. Roll into balls.
4. Work one ball into the shape of a torso, and with the additional clay shape arms, legs, headdress, and other body decoration.
5. Note: In attaching one piece of clay to another, be sure to score (scratch) both adjoining surfaces, moisten, and attach. A crack at that point will more than likely develop if this process is not followed.
6. The finished figurine is now ready to dry. Do not allow to dry too quickly or cracks are also likely to develop. Cover with plastic for two days; then let dry uncovered at its own rate. Figures are now ready to be bisque fired and glazed.

ASSESSMENT OF STUDENT ART

In art, as in all learning experiences, we want to develop the feelings of self-worth, confidence, initiative, and responsibility.

When assessing the student in terms of art, we can identify the student's knowledge and progress over a period of time. The methods of assessment should be geared to this.

The student comes to school affected by his cultural environment, learning, past experiences, perception, his world, inherited abilities, and his developed skills. He then organizes information he receives and expresses these, as well as his feelings, in an artistic response.

In forming guidelines for evaluative procedures, refer to the identifying characteristics and objectives listed for each age group. These will serve as performance objectives to work toward. Then the teacher can determine if the student has reached certain individual, as well as group, objectives. Refer also to the ends of the chapters on the design elements that state "How Students Understand Line" for establishing concrete comparisons. In the section on "Planning Art Instruction" refer to how the individual student has progressed in terms of the goals established, emphasizing the type of goals. For instance, how did the student's work progress in the art appreciation area? In the intellectual area? In the creative area? By determining the effectiveness of your goals and comparing the initial art works with the finished art works, you can assess what the student has learned.

Working independently in art offers the student opportunities for individualized instruction. The student can research a specific area of learning that he or she is most interested in. The area might be of specific artists, to learn about a particular art movement (such as abstract expressionism), or be an assignment to complete a certain number of paintings. The research might be to study the development of jewelry in the Navajo Indian culture. Another might be to experiment creatively with various types of water paints. In order to clarify the study area, the student can state what the specific topic will be; list definite objectives to work toward; list the materials to be used; list the resources to be used such as books, film, galleries to visit, libraries, self-instructional kits; outline the plan of operation to complete the project; determine how he will assess his project or research; and keep a notebook or journal containing sketches, illustrations, notes, new information, concepts, resources, etc., and indicate work progress.

When working in groups, the interchange and feedback of ideas helps establish support for creative freedom, for sharing of cultural values, for verbalization of art concepts, and for sensibility of artistic discovery.

The group can establish goals to be reached together as well as the type of assessment techniques to be used. A time limit can be set. Assignments can be reached within a definite one or two lessons, or they can be extended over a period of time, such as a month.

Provide class time for imagination storming so the group can expand their imageries together. Encourage acceptance of unusual ideas and thoughtful and aware responses. Explore a range of ideas and experiences, for these

will serve as motivations for all kinds of art impact. Keep in mind that some students prefer visual imagery, while other students prefer emotional ideas.

Individual conferences are a necessary aid in identifying change. Keeping portfolios, sketchbooks, journals, and progress file cards all aid in identifying the students' progress over a period of time.

Further checkpoints in measuring change might deal with such skills as the following:

- Is self-motivating and enthusiastic; explores in his individual direction.
- Is willing to search out and explore new ideas.
- Pursues individual research, thoughtful reading.
- Uses imaginative solutions in expressing ideas and experiences.
- Researches information concerning artists and art products.
- Participates in group efforts; discusses relevant issues.
- Increases working time, expands interest.
- Practices making decisions; forms opinions and independent judgments.
- Investigates various solutions to art problems.
- Assesses the art problem; self-evaluates; boundary-pushes.
- Identifies similarities and differences in the art elements. Includes rich detail. Invents new shapes and textures. Learns by experimenting with colors and develops a personal color consciousness.
- Exhibits improvement in design and composition. Develops a more sensitive awareness of art concepts, such as line, value, shape, color, texture, pattern, design, space, composition, portraits, figure, landscape, and still life.
- Uses a working art vocabulary.
- Is able to relate art learning to other learning areas. Shows readiness to extend previously learned information into future art solutions.
- Increases skill with art tools and materials. Creatively explores and experiments with tools and materials.
- Reaches established objectives.

Part of the assessment procedure can be the student's own identification of progress—his self-evaluation. Such positive responsibility by the student considers individual attitude, interest, effort, and product. The self-analysis can include such questions as "How does my art work compare with my past art performance?" "Can I now improve on the art piece?" "Am I working up to my creative and artistic potential?" "How does my work relate to the rest of the class?" These can be used by the student to determine his own "grade."

Puppets provide students ways to share ideas, values, and for verbalization of art concepts. Such imagination storming that takes place expands both visual and conceptual imageries.

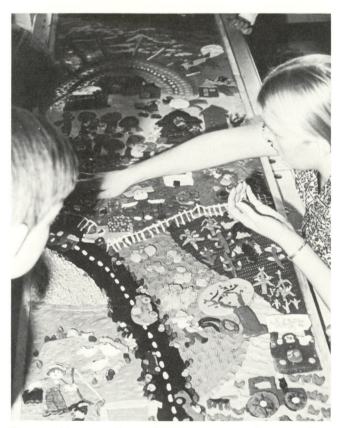

Opportunities to work together on a group project, as well as express ideas individually, should be planned for in every art curriculum. Baker's clay mural courtesy of Barbara Herberholz.

Group discussions are especially meaningful as a learning technique. In such discussions, each student presents one or two art pieces. If desired, the student can describe the project and the method of solving it. At other

Environments are art works in themselves. Interior of San Xavier del Bac, Arizona.

times, students each contribute an art piece without revealing identity, and students comment on "anonymous" works. Through such group interaction and feedback, insights that couldn't happen any other way are possible. Positive questions should start discussions, such as "What do you like about this work?" This is a question that offers acceptance and positive reinforcement. After the first few discussion periods, students will be open-ended with comments. In our class discussions, we exhibit the art piece immediately upon completion and it then becomes part of the learning process. Some class time is planned for "looking and thinking about our work." Exhibition and discussion is a natural part of the class experience.

The teacher should keep index cards on all students, a handy file that can be referred to easily and that states each student's activities, accomplishments, and presentations. Keep portfolios of art works (date art works) to compare self-growth and improvement. Cards and portfolios are meaningful to teacher and student when having individual discussion periods and in establishing long- and short-term goals. Hold these discussions as often as needed.

Encourage a positive success approach by calling attention to specific areas that require the student's attention. *Encouragement builds—criticism destroys.* Point out where specific goals and objectives have been reached (or not reached); these can offer challenge, informatioin, and guidance for the student.

Every student's solution is meaningful and significant. Unlike a math solution, there are limitless solutions to an art problem. The finished art product is the way one individual follows through with one experience at one specific time. Very often, the same individual would not solve the same problem the same way ever again. For example, a group of high-school students participated in a film class. One student presented his film, which was one particular choice or solution that he found satisfactory. In a discussion following the film, other class members offered ways they would solve the film problem, change the scenes, remove or add ideas. One person found one scene very distracting, another preferred a certain time of day to emphasize shadows and color, and so forth. Every film, painting, or drawing is an experience in time and a result of one person's unique efforts at that particular moment

in time. It could never be repeated again in the exact way, even if the person tried to duplicate it. When we (as teachers) offer our own ideas and other solutions, we make a judgment. We often offer ideas that the students may not like or even comprehend, such as "Don't you think there should be some warm color in this area?" We make decisions and judgments for the students and often expect them to understand our point of view. Because of significant and numerous experiences in art, the teacher establishes himself as the ultimate judge. However, we need to listen very carefully to what students say in order to best point directions that have relevance for the student.

Questions for Individual or Group Art Discussions

What did you find most exciting in your art work? Why did you use certain materials: Does your design suggest a definite mood—such as joy or sadness? What part of your art work establishes your mood? What are the basic colors of your painting? How are these varied? How did you treat the background spaces? The foreground? Did you include all necessary parts to make your painting function? Are you successful in presenting a story idea? How did you unify your composition? Explain why some areas are light in value, others dark in value, and others textured. Discuss what details you included from the subject matter you were drawing and what you omitted and why. Discuss the small sketches you did first and why you selected from those for your large finished drawing. How did you unify or tie the foreground to the background areas? What colors are exciting? Disturbing? Friendly? How did you use certain colors to achieve certain effects in your painting? What textures have you used? How do they make you feel? How do they feel to your hand? To your eye? How did you create movement in your design? Motion? Is your design flat, or have you created a feeling of space? How? How true to the idea did the actual drawing develop? Does the drawing have meaning for you? What? Does the drawing show competence in the handling of tools used? Does the painting have meaning for other students? How would you change the drawing to improve it?

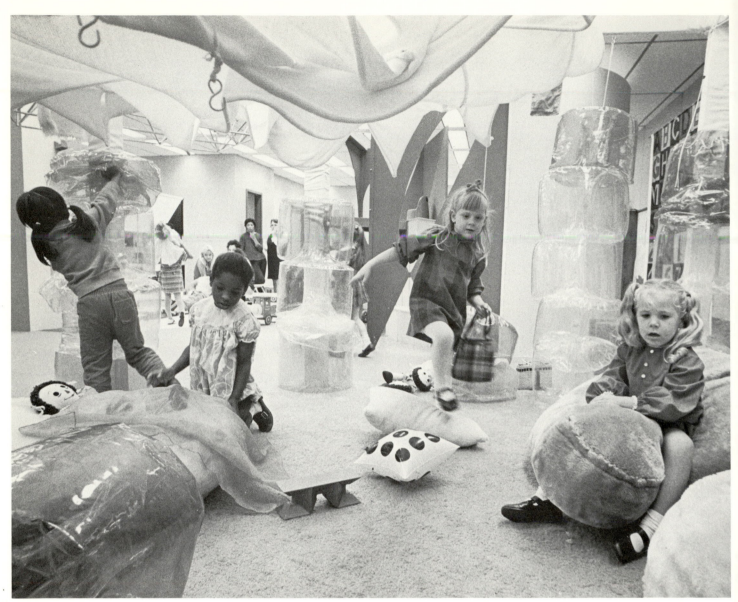

Courtesy of Dr. Anne P. Taylor. Photo by Charles R. Conley.

Educators, artists, and architects have experimented with certain selected stimuli and total environmental changes in classrooms to encourage concept formation with art concepts such as color, line, form, space, and texture. It was found that when the classroom environment had objects which exemplified concepts being taught, children's concept formation increased rapidly, and the overall aesthetic quality of the art work as well as the scores of the Goodenough Draw-a-Man Test increased during a short period of time.

Furniture (soft, round, pastel-colored pillows) afforded the child experiences with soft texture and color. A mirrored environment showed him just the opposite of soft—hard, shiny, austere, a place where he could experience infinite space, and to draw his image on the mirror with magic markers to be more cognizant of his physical self.

His imaginary self was explored, too, through role-playing and dress-up, and theatrical makeup was used to become someone else.—Dr. Anne P. Taylor, *The Effects of Selected Stimuli on the Art Products, Concept Formation,* and *Aesthetic Judgmental Decision of Four- and Five-Year-Old Children,* Tempe, Ariz.: Arizona State University, 1971.

3

Questions Teachers Ask
Regarding Elementary Art

Environments are not passive wrappings, but are, rather, active processes which are invisible.—Marshall McLuhan, Quentin Fiore, *The Medium Is the Message,* Bantam Books, 1967.

HOW IS THE CLASSROOM ENVIRONMENT IMPORTANT?

Because we all see and respond differently, we may not all agree as to what is beautiful. More than ever, we are concerned with the function as well as the aesthetics of our environment. We find air, water, noise, visual pollution, and exhaustible resources. Our environment sometimes screams with clutter, crowding, and chaotic, confusing surroundings. In your classroom, the situation should reflect yourself and the needs, interests, attitudes, beliefs, and values of your students in the most unique, creative way possible.

Is your room dynamic, vivid, electric, vital, exciting, and happy? Environments can release imagery, visions, dramatic roles, moods, privacy, and creative thinking. Are the spaces cluttered-uncluttered, busy-simple? Is your room too simple with stereotype displays; uninspiring? What is the color of your room—does it stimulate problem-solving?

Is the furniture and exhibit space to scale with the student? Are your walls, ceiling, and floor inviting, exciting, and interesting? Do you provide areas for display as well as for messes? Is the seating arrangement flexible to different needs? Do students help select what you display and how much you exhibit? Do you and the students design the display area together?

Students like to arrange spaces, control it, adjust it, and make use of it. Is there adequate and flexible storage space? Is there space for producing art? For arts-related activities? Is there quiet space for private thinking?

Do you have an art center? Are the spaces and exhibits child-centered or teacher-dominated? (Who does the most talking?) Do you change spaces with space changers, such as with panels, cloth, ropes, sculptures, or plastic sheeting? Is your classroom an exciting arrangement of spaces? Could you think of it as a sculpture? Like a large environmental sculpture? Like a moving sculpture with moveable (people) parts? Your room space is a working environment for

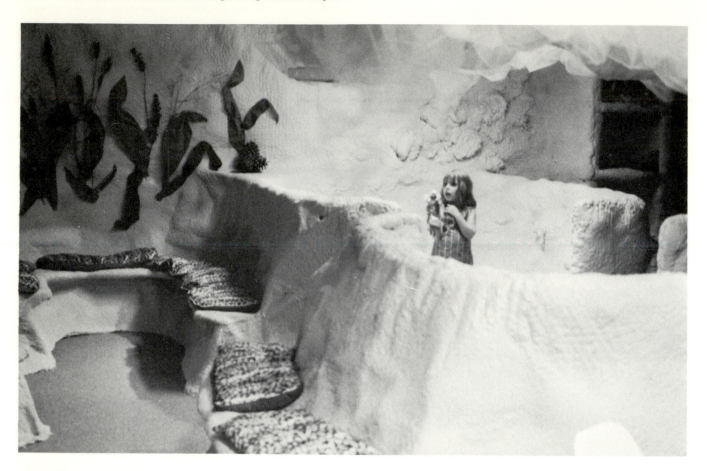

Dr. Carol Steer, Arizona State University.

Unique spaces were created in a learning experiment at Arizona State University. One purpose is to see if new environments can influence behaviors. Small space units were built, and walls, ceiling, and units were coated with polyurethane. Colored lights, mirrored surfaces, display areas, dropped ceilings and other separating devices encourage children to interrelate in play, games, and learning behaviors.

the learning activities of the student. It shouldn't overwhelm or dominate the student, yet it should be stimulating and involved with student participation. When someone enters your room, he will immediately receive an overall impression of your curriculum.

WHAT ARE TEACHER STRATEGIES?

You, the teacher, are an interested, warm, understanding person. The relationship to students is on a one-to-one basis. The teacher's role is one of a catalyst, one who carefully plans and organizes the curriculum objectives and learning packages for both individuals and groups, one who determines if the learners have reached the established objectives. The teachers is an idea generator and aids students when needed. The teacher doesn't force ideas on students and considers their feelings, attitudes, and needs. Students have opportunities for self-discipline within general but enforced requirements established by teachers and students together. The teacher provides opportunities for the student to make his own decisions. There is two-way communication where the teacher encourages discussion and expression of needs as well as disagreements. The teacher delegates opportunities within the group, but many responsibilities are assumed by the students individually and as a group, including suggestions and ideas on how to proceed and what subject material to include in the curriculum.

There are certain leadership qualities you as the teacher must possess:

The teacher must have technical knowledge of the subject being taught! This does not mean the teacher has to be "the best artist," but he must have adequate knowledge of the subject to be an effective teacher.

The teacher must show leadership competence: he must be able to *plan, organize, control effectively, and direct!*

The teacher must be able to interrelate humanly with the students. He must be able to communicate effectively; he must be able to interact. He must be able to feel for the student, to consider his feelings and attitudes. He must be warm, personal, and interested in students.

The teacher must provide opportunities for these important motivators:

Self-esteem. Self-worth. A chance to become educated and therefore *worthwhile*. A feeling of *who he is!* The teacher must help the student find *successful pathways to a success identity!* The student should be made to realize *he* is responsible for behaving so that he does achieve a successful identity. This is achieved through hard work and personal discipline which involves thinking and knowledge!

Responsibility is learned only by evaluating a situation and choosing a path that the person thinks will be more helpful to himself and to others. If the student feels responsibility to himself and to others, there is *little* need for rules or punishment.

Provide opportunity for self-expression. Opportunities that call for thinking, problem solving, self-expression, judgment, and decision making produce a sense of emotional satisfaction—also a sense of accomplishment.

Opposite of teaching a directed lesson (one where patterns are used) is the situation where the teacher distributes materials and lets the child "create" by himself. The child can work on his own if the following needs are considered.

The teacher must do the following:

Provide a rich environment for growth
Provide stimulating motivations (idea generators)
Present the necessary procedures
Encourage the child's own ideas, personal statements
Let the child work independently
Respect individual differences as to range of achievement—encourage the uncommon and unusual
Encourage opportunities to express or display products of achievement
Encourage discussion of what has been achieved by the experience
Relate art experiences to other classroom experiences and consideration of extended experiences
Relate and discuss how artists in the past and artists of the present have solved similar experiences

IS ENTHUSIASM IMPORTANT?

You, the teacher, must be the spark plug! You will generate the excitement and enthusiasm about art! The more you know about it, the better your motivation will be. How can you teach drawing if you have never drawn? Can you teach math without knowing the fundamentals? Study the area you are teaching, and this will provide knowledge and self-confidence. If you are excited about art and appear to know what you are talking about, the students will feel your enthusiasm—it's contagious! Share with another teacher; team teach. You need at least two teaching examples. Whether these are a drawing you have done, a student's art work, photos, slides, movies, filmstrips, art journals, 8 mm films, or artist examples, the better your example, the better will be the resulting student product. It is better to have more than one illustration; then the student won't tend to imitate the example. Any art book is a wealth of reproductions when used with an opaque projector.

HOW CAN WE USE BODY LANGUAGE WHEN WE TEACH?

If you can remember from your past a teacher whom you liked very much, can you remember why?

One of the reasons might have been that the teacher knew how to capture your imagination. A good teacher is one who is demonstrative, expresses emotion with gestures of his body, knows how to be *dramatic,* with both his voice and his body. Try to practice similar treatments of voice and body when talking to children about painting—such as contrast of tone, loud-soft, quick-slow, up-down, happy-sad, busy-quiet, sharp-smooth, storytelling information, colorful words, selectively descriptive adjectives, relevant information. Some people unconsciously adopt body-language gestures of a characater and live in the character—such as cowhands, young people when they wear costumes of characters, long beards, long hair, and capes. They change their image to play a part.

According to Julius Fast in his book *Body Languages,*[1] the teacher who sits behind a desk is placing an obstacle, the desk, between himself and his pupils. In body language he's saying, "I am your superior, I am here to teach you. You must obey me." Others perch on the edge of the desk and have nothing between them and their students. Still others feel that this is an elevated position, putting the teacher above the student and creating resistance to the teacher. Others prefer a position in the center of the room, surrounded by the students. "This," a teacher once explained, "puts me in the center of things. I never sit too low. I'd be no better than a student, and a teacher has to be better or why be a teacher? I sit on a student's desk in the center of the room. I'm one of them and yet I am still a teacher. You'd be amazed at how well they respond. 'I'm one of you. I'm on your side even though I'm your teacher.' " Dr. Glasser prefers a *U*-shape arrangement of chairs when participating in group discussions. The teacher, in a regular chair, sits with the students. Which approach you use is up to you—whichever is most effective for you.

HOW SHOULD WE ENCOURAGE ART THINKING?

Increase the relevance of the information studied by the student. How does he need art in his life?

Teach by inquiry. Questions are just as important as answers.

Students should be encouraged to respond openly, not to be criticized for their opinions and choices.

Factual knowledge is only important when relevant to thinking and the study of ideas. It is needed to make judgments and help in decisions. Objective tests are most helpful as self-evaluation techniques—not as comparisons with peers.

Students should be encouraged to explore ideas they don't understand. Students should develop the confidence through success to be able to make decisions and be able to follow through on independent judgments.

Decisions, important in making art choices, require—

formation of the problem;
development of possible alternatives;
selection of the best alternative; and
openness to reevaluation.

Tell the student: "We value what you are able to contribute." His contribution is important to the group and to himself. Admire him; laugh with him.

Hold classroom discussions that are relevant to thinking about art, that are helpful in sharing information related to problem solving and interacting of ideas. Art is an important part of their daily lives. The teacher does not inject personal value judgments; everyone succeeds in a classroom meeting! Discuss purposes of the painting as well as formal qualities. Accept each student's thinking. The student shares his ideas and thinking with the group, which helps build confidence, helps clarify ideas of the individual and the group, and encourages question and inquiry.

WHICH IS MORE IMPORTANT— THE PROCESS OR PRODUCT?

When the student is young, the process is more important than the product. The five- or six-year-old will keep repeating forms or symbols to gain confidence and sureness of achievement. The young student's attention span is short, motor skills are limited, and ideas are rapid and changing. The emphasis should be on the process of creating. As the student grows older, the product gains more importance. You as adults know that a satisfactory product is necessary in creative work.

HOW DO WE BOUNDARY-PUSH?

All teachers are aware of the "creative," alert actions of young children. They are clever scientists and original investigators. They solve problems and discover individual solutions for many situations that appear simple to us because we have learned a certain behavior. But to the young student, these are monumental thought discoveries. The process of walking and the magic development of language are but two illustrations. How the child recognizes the power of words and is able to relate the

1. Julius Fast, *Body Language* (New York: M. Evans and Company, Inc., 1970).

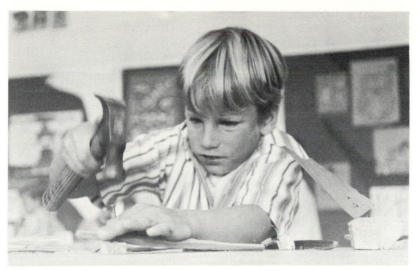

Scraps from the lumber yard are an all-time favorite for imagination sparkers.

word with a measure of meaning is a miracle. When our daughter first learned to talk, she would bring us a book and say, "Talk the book." She liked to spend hours looking at picture books and magazines, not understanding meanings necessarily, but simply enjoying the recognition of familiar objects, making personal relationships, and having fun naming (during a thunder and lightning storm she exclaimed, "Look, the sun is taking pictures"). Her favorite books were the delightful fantasies and imaginings of other children's drawings. Somehow, these symbolic drawings had secret captivations for her; she could identify and respond to them.

To boundary-push, the adult can offer stimulating situations to—

challenge the imagination, provide resources;
share with the student his natural curiosity and excitement in discovery;
share his joy in producing art;
exhibit and be exuberant about his art product;
praise him before others for his efforts and success;
inspire him and offer sincere encouragement;
provide new and exciting possibilities and ideas; and
be a confident person, and make him feel confident and creative as well.

Art should become more meaningful and an important part of the child's life. We must nurture art growth in the home as well as in the school. Art is something we live with, for it offers endless enrichment and contains unique qualities that we are able to share with other people. Invite parents to participate and boundary-push through art. Discuss together what our goals should be for children. Discuss how parents can enjoy and appreciate their children's art works at home by talking about art with them. Have a home center for display of art works and art collections. Provide working spaces at home, and plan interesting visits to galleries and other art-related functions.

DO MOST ELEMENTARY SCHOOLS HAVE ART TEACHERS?

In the American schools today, ninety percent of elementary art is taught by the elementary-school teacher. Between fifteen and twenty percent receive help from the art specialist. Of the remaining ten percent who do have art specialists as teachers, students meet with the art teacher anywhere from twice a week to once a month.

WHERE DO YOU GET GOOD TEACHING EXAMPLES?

The greatest inspirational examples you can use are from the students themselves. Keep a special file for reference; the students will be delighted when you ask to keep their art for your file. Students can identify and grow through examining and discussing other students' art work. Very often I visit classrooms and take photographs. Every child wants me to take a photo of him and his art work. This is a special form of reward and acceptance. (Even teachers like it!)

DO YOU PROVIDE TIME FOR VERBAL COMMUNICATION—TALKING ABOUT ART?

When the students and teacher are "talking" and "listening" to each other, the teacher, as part of the group, is saying, "What you have to say is important enough for

me to listen to." The need to feel worthwhile and important is a very basic, important need, vital to everyone, teachers included. Not only do they share ideas and inform each other of their feelings and thoughts, but they communicate the important need of saying something and of being heard or listened to. Whatever the child is saying that is meaningful to him is worth listening to!

This concept holds true for exhibiting works of student art. What each student has to say in his art work is important enough to be viewed. Art is worthwhile—whether talking, interacting, talking about art, or exhibiting art work. When we exhibit the art work of a child, we are saying, "This art work and this child are significant to us, and we recognize this."

When we talk and communicate an idea, we often formalize and structure our thoughts; we classify the content. In turn, our "listeners" comprehend our ideas and, many times, embellish the thought. It is through communication that we can see the development and growth of multiple ideas.

WHY STUDY ARTISTS?

Artists are people! One teacher I know has an "Artist of the Week." Reproductions are brought in, his personal life is researched, and there are stories on how the children feel about the artist (not only painters, but musicians, dancers and writers as well). This is a simple and effective way to study art history.

DO WE ALWAYS NEED EXCITING AND UNUSUAL SUBJECT MATTER FOR ART?

The subject should always be exciting to the child—you will make it so. New ideas (exciting experiences and subject matter) can be strong motivators. Yes, the idea could be unusual. Sometimes you can get many divergent ideas resulting from an unusual stimulus. New materials such as fluorescent chalks are stimulating.

But this isn't always the case. Very often, simple subject matter can be explored in many unusual ways, with various interpretations possible. A visual consciousness will develop, with new relationships and objects in the environment viewed in new and different ways. Critical and repeated viewing of a scene will help the child see relationships.

Using the same subject in many possible situations can very often develop more intense in-depth understanding of the subject as well as multiple possibilities for solutions (divergent thinking), for instance, birds. This subject could be used, perhaps, as a drawing or observation problem; as a relationship of shapes again as a design problem; as a relationship of shapes and form problem; as an intense emotional, personal experience. "How do you feel about birds?" Did you ever see a dead bird? How did you feel?" "Did you ever watch birds build a nest and then wait for babies to hatch?" "Can you recognize different bird songs and repeat some of the melodies?" Study the underlying structure of the bird and other animals. Look for differences in drawing birds with various media.

Teachers working with papier-mache.

Scottsdale Public Schools, Arizona.

I believe that if a child, no matter what his background, can succeed in school, he has an excellent chance for success in life. If he fails at any stage of his education career—elementary school, junior high, high school, or college—his chances for success in life are greatly diminished.—Dr. William Glasser, *Schools Without Failure,* New York: Harper & Row, Publishers, 1969.

Is drawing them with ink the same as drawing them with watercolor? Study bird habitats, their food likes and dislikes. One subject alone can spark many hours of various interpretations. Select the best subject areas and the most suitable art media for expression.

SHOULD STUDENTS HAVE TIME TO EXPERIMENT?

Investigation has shown that students who are given specific materials or tools and told exactly how to work tend to look for a prescribed routine and want prescribed rules explained to them. They want the authority (teacher) to show them how to use the material or how the result should be obtained.

When the student has the opportunity to be *selective* in his materials from a variety of possibilities, he will show greater initiative in being self-reliant? The teacher should provide a choice of materials and encourage the students to experiment and explore freely. Competence, skill, and improvement will automatically develop with increased manipulation and exploration of the materials. When any material is presented to the student, provide time for exploration and experimentation. Much learning occurs during such a period.

Encourage each student to invent as many ways as possible to hold, use, and manipulate the tools and media. The student should be told that he may discover a way to use a pencil that no one else in the world has thought of! Why not paint with the stick end of a brush? Or a stick off a tree?

In selection of a project of study, it is important for the student to have the opportunity to say *yes* as well as to say *no*. When the student is allowed to be selective, he must decide what he wishes to explore. Not everyone has ability or is interested in the same area of art. Just as we all have certain abilities in academic subjects, we can't all expect to be experts in every area we pursue. For instance, many people enjoy working with clay and find the experience invigorating. In the area of crafts, I enjoy making jewelry very much, and jewelry becomes much more like living sculptures of adornment rather than merely ornamentation.

WHAT IS TALENT? WHO ARE THE TALENTED?

What is beautiful to me may not be beautiful to you. When we see a group of drawings exhibited on a wall, we clearly select a few that we feel are outstandingly successful, unusually "good." Somehow, we seem to agree on the exceptional. Even though we don't have a list of checkable measurements, we can find the "best" without written tests, essays, or term papers. When we judge, we feel a subconscious knowledge we call previous experience; our educational degrees back up our decisions. Here are some standards that determine judgment making in art.

Is the drawing most accurate in visual representation? Some of us feel the most realistic, photographically accurate is the best.

Is the drawing most "decorative"? Does the drawing excite us visually in its use of color? Are the patterns drawn in an inventive, imaginative way? Some students seem to have a natural "talent" for using patterns and interesting details.

Is the drawing outstanding in the interpretation of the theme? Did this student express the idea in an unusual, unique way?

Is the drawing creative? Does this student use many personal and individual forms and ideas in his art work?

Do we like only *what we expect to see,* or do we only like what we look for?

We should always remember that perception differs with each individual. Each person will perceive an item differently, especially students. Some of us exaggerate a color, perhaps texture, perhaps size relationships, perhaps smell, perhaps touch, perhaps sound—a quality relating to something we recall in our past experience. There may be a melody that reminds us of our past. Some of us will include many details of the experience. Some of us will fantasize and relate imaginatively to the experience. How we exist in this space and time, in relationship to our environment, will be very different for each one of us. Is it any wonder that each of us will draw the same thing in his own individual way? We are all talented. Some students, more than others, may approach our way of acceptance in their art. You may like and accept one drawing because it approaches the way you might have drawn the subject or object.

"Talent" is very often plain, hard work. The person with great drive and many hours of practice achieves a level of skill. Sometimes we call this high degree of motivation *talent*. We all would agree that whoever has it should develop it. Encourage all students to strengthen their talent.

The teacher should always begin at the level of understanding of the student and with subjects and objects that are meaningful and important to the student's life!

Boys of twelve might be much more interested in drawing motor cars, electronic devices, or basketball players than a bowl of fruit!

Girls of twelve might be much more interested in drawing horses, dresses, or other girls.

The same is true in the study of art pictures. The students identify with paintings or artifacts which are of interest to them because of personal reasons which they can identify with or emphasize with, perhaps because of some past experience or emotional response, perhaps because of some past achievement or interest.

One time my husband, our two boys (then five and three), and I were vacationing in Boston, and we visited the Boston Museum of Fine Arts. We had visited several art rooms in the museum and had viewed many exciting historical and contemporary paintings. When we were ready to leave, we headed for the elevator. In a small hallway next to the elevator was a display of children's tempera paintings. The two boys, who had been restless and had ignored the previous works of art, did a complete turnabout. They became very interested and excited about these paintings and began verbalizing about them, recognizing all sorts of colors, objects, and meanings in them. They identified with them immediately. Some items were clearly concocted in their imaginations.

The boys were able to enjoy, identify with, empathize with, and relate to these paintings done by other children.

WHEN AND HOW DO WE DECIDE WHAT IS GOOD ART?

It appears there are certain people who set the standards for us, and we compare what is *good* and our work with these standards. For example, in the 1950s it was popular to paint abstract expressionism—lots of slashing paint, color, and lines. In the 1960s it was popular to paint "pop art." Now, artists are returning to a more figurative approach to art. There appear to be "fashions" and people who set the pace. These are the museums, galleries, patrons, and critics. New styles of art appear constantly; past styles seem to remain as well.

The same is true of students. You may feel that one student does a better drawing than another, but remember that *you* are setting the standard in your classroom. Better in what way? Realism? Color arrangement? Design? These are *your* feelings and decisions. Each student is different. One student may be sensitive to line and may take all of one hour to draw some simple lines.

A blank piece of paper or canvas becomes alive and active the minute you put down your first stroke. From then on it becomes a challenge, a puzzle that you or the student has to resolve. My feelings in regard to when a drawing is completed or resolved will be different from yours. Your judgment and previous experience decide all the corners you turn; and with different personalities and temperaments, the turn you take will be your very own.

HOW DO YOU KNOW WHEN THE DRAWING IS FINISHED?

Creative people stop when their criteria are met. Because the artist is creative, the criteria are personal and aesthetic. Arouse the student's imagination, and as he gains mastery in working with the media, he will not be satisfied with the easiest, first, or fastest solution.

SHOULD THE TEACHER EVER REPEAT AN ART PROJECT?

Many times it is helpful to repeat an art experience, especially if you find new ways of improving the experience. You may want to change the tools or materials. Many artists never consider the first solution as the finished product. Artists feel they have to explore before a satisfactory solution is found. Encourage the students to *extend* and *go beyond* their thinking. Suggest that they explore the details; they might include stronger contrasts, consider values, try new combinations, concentrate on spatial concepts. What will happen if they accentuate the color? The teacher can suggest possibilities to consider. In other learning areas, such as math, the teacher doesn't hesitate to repeat problems until a satisfactory solution is obtained.

HOW OFTEN SHOULD WE HAVE ART?

We should have art as often as possible. History can be taught through art. Literature, drama, art appreciation, and music can be taught through art.

It is up to you the teacher. How many ways can you discover to have art experiences? Primary-grade children should have art experiences daily. One week you might spend six hours on a project, such as a social studies mural or the drawing of insects to study science. The next week you might spend three hours. Art can be related to other areas of study but should also be studied as an independnet area in itself. Hours and scheduling should be flexible and should vary at grade levels. The heroes of yesterday were often artists and are remembered for their art. Art is one subject area to appreciate all through life.

SHOULD THE STUDENT COMPLETE THE ASSIGNED PROJECT?

The teacher should try to encourage all the students to complete the drawing or problem involved. When the motivation is meaningful and the student is involved, he will want to express his feelings about it. If you run into a problem where the student refuses to express himself, give him some individual attention. He apparently needs this extra encouragement or personal approval. Repeat the ideas you have discussed with the group; perhaps he didn't

understand them. Recall the ideas presented and question how he feels about them. Let him do some questioning and answering, as we often answer the problems for the student. Ask him to try again, just for you; and when he does, be sure you reward him with praise and encouragement, even if you feel he hasn't done the job satisfactorily. Some children need more attention and encouragement—they feel insecure in expressing themselves. Somewhere in their previous experiences they have met with conflicts of ideas. Either an adult has done the solving for the child by drawing for him or he is dependent upon stereotypes such as coloring books. Parents unknowingly hinder individual growth by rigidly controlling or criticizing what their child does, such as "Well, Jim, that doesn't *look* like a dog." Jim was probably drawing what he knew about the dog, how he saw and felt about the dog, but the adult didn't see the dog the same way. If this happens several times, the child will lose confidence in his own independent thinking and will feel threatened whenever he is asked to draw. He wants to feel accepted. So, be sure to encourage him, praise his own ideas, do not criticize negatively. "See how Donna has filled her whole page." "Do you like the way Hank has carefully drawn all the parts of the bee?" Hold up all the drawings for the children to see. They realize these are the things you consider important.

HOW IMPORTANT IS EXHIBITING THE FINISHED ARTWORK?

Each student's art work is "talking" about him.
Everyone is worthwhile.
All art work is important enough to be looked at.

Exhibiting finished artwork is very important because it provides the following:

Sharing of ideas and thoughts with others

Feelings of confidence and encouragement of individual solutions

Importance of *each* child's art expression

Opportunities for children to create and design large space areas

Recognition of and respect for individual completion of an idea

Broader insight into the subject presented by children seeing solutions of one idea

Importance of acceptance within the group

Aesthetics

Opportunities for other teachers or parents or interested individuals to observe some topics being studied in the classroom

Opportunity to discover if the individual child has reached his standards of achievement in the problem

A sense of achievement for every child (At one time or another throughout the year, every child should have his work displayed, not only the "gifted" child.)

Encouragement to an individual who has shown progress and "hard work"

Evidence of growth from previous performances

Examples of what the teacher feels are the best solutions in terms of the aims and objectives of the art experience

Consideration of solutions in terms of what the teacher may be considering in future art experiences

The teacher's aid in helping to suggest mountings and possible combinations

Opportunities for continually changing displays (two to three weeks)

Encouragement to the student (By displaying his work you are saying, "Your art work is significant and important, and you and I recognize this importance.")

The art product is a reflection of his concerns, of how he views the world, and of how he feels about himself, the world, and his experiences in the world. It is self-revealing, fulfilling, and genuine.

WHAT ABOUT THE STUDENT WHO IS HESITANT TO DRAW?

Most children who have opportunities to practice their art have an endless flow of imaginative creations. They are enormously eager and excited and are bursting with new drawing and painting ideas. Try following these suggestions:

1. Be success-oriented. Remove all threats of failure. This means to make sure the student realizes he has nothing to fear. When standards are set, be certain that they are reachable. Do not be overly critical. Make the child feel that art is an exciting accomplishment and that there are unlimited ways to say ideas through art.

2. Every art expression is worthwhile. What each person has to say is significant and meaningful both to himself and to the group. Be sure to have changing exhibits in your room and in the school. Exchanging work from other classes can be very interesting.

3. Begin with the child's frame of reference. Always have something to say that the child will understand at his developmental level. Discover what is important to his life.

4. Be an inspiring, warm human being who is fun to talk with. Just your personal warmth and positive attitude will show your interest in the child as a person.

5. Reevaluate your art goals. Make sure each student can achieve them.

6. Remember—art is fun! Art is creating! Art is meaningful! Art is self-motivating! Art is success! Art is awareness of beauty and life. Art is seeing and discovery!

WHAT ABOUT THE STUDENT WHO COPIES FROM OTHER STUDENTS?

Be sure to involve each student in the art motivation. If you are aware of a child who is unsure of himself and find that he is copying others, be sure to offer him encouragement and reward him for his independent solutions, whenever they occur. Review your aims and objectives with him. If he continues to copy his art work, find out if this is indicative of his other learning behaviors as well. Be patient and compliment and reward him with praise before the class when he displays inventive, independent, and resourceful attitudes or ideas. Make him feel confident and accepted, sometimes with special favors such as being a special "helper." Find other learning areas where he is success-oriented and indicates some individual promise. I like to appoint "experts" in various areas; then I can call on my "experts" for help when necessary.

WHY DO STUDENTS SEEM TO LOSE THEIR TALENT AS THEY GET OLDER?

Remove the threat of failure.

Who sets the standards of what is good, what is not good? Why do students become less creative with age until finally they feel they "can't draw a straight line"? We seem to encourage the children in primary grades to express themselves openly. Much emphasis is placed on self-expression through music, language, and art.

When they begin to learn to read and write, the emphasis changes to improvement in technical skill, to learn rules and regulations. Greater rewards are given the student who can imitate correctly. The child who can form the letters of the alphabet with the greatest degree of skill in imitating the standard form is given the greatest reward with the highest grade. If he stays within the ruled lines, that's great! Both teacher and parent compliment this student. He follows directions. If the student tries to solve the problem in a unique, unusual way, we correct him until he conforms to "our" direction of thinking. My second-grader prints very well, but I feel I would rather have her learn ways to communicate ideas, encourage individual expression of thoughts and ideas instead of being concerned with the correct way to spell "shouldn't." If we were to teach students to write by using the typewriter or tapes instead of pencils and pens, the emphasis would automatically turn to the thought and ideas of what is communicated instead of the technical skill of printing.

SHOULD THE TEACHER GIVE STUDENTS PATTERNS, WORKBOOKS, OR MIMEOGRAPHED SHEETS?

No! No! No! The child should be able to select and decide his ideas for himself. Some learning activities are decidedly directed. Not *art*. Art should permit the child to arrive at concepts which are his own solutions. His drawings are as a child draws them, not as an adult would draw them. That means that each student's art product will be different, his very own—not thirty Easter bunnies that look like Bugs Bunny. Each student presents his own idea, his own independent choice and solution of a problem.

At times we find teachers using hectographs or directed lessons. These are crutches and a substitute for planning for art learning. All the work is done for the teacher. We must emphasize the need to eliminate all such stereotyped adult-oriented, mimeographed, and workbook patterns. Our responsibility as teachers is to tear up all such forms of patterned art responses. The whole thrust of this book emphasizes the individual's unique art expression and potential.

WHEN IS THE BEST TIME TO PASS OUT ART MATERIALS?

Usually it will help to pass out materials before the motivation begins so there will be no waiting in order to capture the peak of excitement.

WHAT DOES THE TEACHER NEED TO START AN ART PROGRAM?

It is very helpful for the teacher to have teacher aides or parent volunteers. Teachers are sometimes able to work together, share ideas, or team-teach. Older students frequently help with younger students for a more effective program. Parents are often eager to donate scraps and materials to the art program, if they are invited to.

Materials are necessary and will differ with different age levels. Most schools provide basic art tools such as crayons, boxed paints, watercolors, tempera paints, brushes, clay. Many materials can be supplied by the community for very little, if any, cost. Many stores or industries are happy to donate discards or sell them at cost. Following are some sources from which you might collect materials:

- Old newspaper roll ends from the local newspaper office. This is newsprint paper and is ideal for large drawings with pencil, crayon, or paint.
- Plastic companies or sign companies usually have discard boxes, or you can buy plastic pieces by the pound. These are good for sculpture.
- Leather factories.
- Lumber companies have discard piles. The discards may be used for building or painting wood.
- Local Goodwill organizations for rags and cloth for collages; buttons, old dolls, or toys to use for still lifes; feathers, lace, old jewelry, magazines.
- Dowell rods at lumber companies—sharpen in pencil sharpener and use with ink; Popsicle sticks.

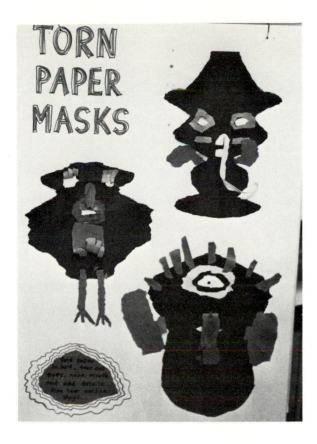

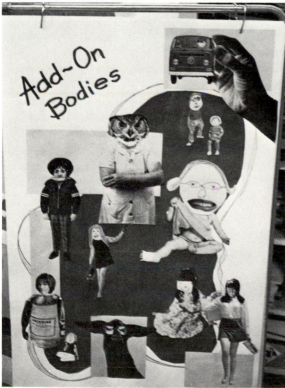

The portable flip-card arrangement for easy presentation of art examples.

- Butcher paper comes in colors and is great for drawing or painting. Teacher or student can cut to size, but can get a variety of unusual shapes and sizes that way—not limited to 12" × 18".
- Foam rubber from an upholsterer's scrap heap—for printing or sculpture.
- Yarn—unravel old sweaters, etc., from thrift stores.
- Styrofoam packing for construction and printing.
- Plastic bags from home. Cut strips for weaving or to suspend from the ceiling for environments or to divide spaces. Suspend in windows for light and color study.

A note to families might begin, "Dear Parents and Friends of Kiva School, We have planned an exciting art curriculum for your child this year. The list below has some of the materials we need to help us with our art skills in our creative art classes. These "recycled" items can be fun searching activities (even cleanup hunts) that will aid our creative arts program. Thank you for helping make our art program the success it is.

> boxes of all sizes (large/small), jewelry, seeds, button made of cardboard, styrofoam, wood, cloth; unwanted jewelry and beads; wrapping paper and wallpaper; broken and unwanted toys; 2 x 2 slides, slide mounts, unwanted cameras; sewing remnants, rick-rack, yarns; unwanted clocks, watches, electrical objects, gears, meters, bolts, springs, screws, knobs, wheels, locks, keys; seasonal cards, posters, maps, books, magazines, newspapers, foreign newspapers; old window shades; unwanted feathers, hats, uniforms, costumes; coffee cans, scrap wax crayons, old candle pieces; unusuable musical instruments, old typewriters and parts, old radios; store window dummies, wig-head stands, old bones or skulls; cornhusks, bags of apples (for applehead dolls), gourds, large juice cans, baby and juice jars; papers from a local printer and anything your imagination can come up with."

Drawings express many ideas. Sketchbooks keep ideas together. "Knitting" by Robin Swanson, pen and ink.

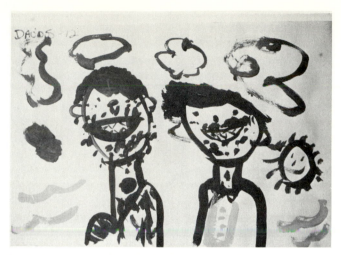

Brain-damaged student David draws himself (age 12) and his sister as they had the chicken pox.

The Very Special Arts Festival, Tucson, Arizona. Courtesy of the National Committee Arts for the Handicapped; the Arizona Committee, Arts for the Handicapped.

4

Integrated Art Learning

The arts can permeate the entire curriculum. Art thinking can be the common denominator for many learning areas. Common goals shared by all learning are self-actualization; problem-solving skills; expressing and learning about personal and cultural values; awareness of our environmental, cultural, and ethnic heritage; the study of the decorative, ceremonial, religious, symbolic, philosophic, and recreative in society; and the communication of peoples and their needs.

Our aim is to change the consciousness of a person that is expressed through his behavior; in this way we recognize that learning is a natural development of the activities of human life. In the arts, we can probe our senses, through experiencing, in order to shape our mental imagery. Learning occurs when we are able to respond and communicate; we have formed meaningful relationships.

One way to expand learning interest in the arts is to incorporate visiting artists from community resources into the educational programs. Students can learn about the visual artist, the choreographer, the actor, the writer, the poet, the composer, the filmmaker, and the urban designer. Along with the artist, resources and support instruction, such as books, magazines, television printed matter, films, filmstrips, tapes, games, and puzzles, implement the arts learning.

Curriculums are being developed that involve arts-related skills. Research has clearly shown that the integrated arts have value in general education; reading music helps in reading and computing math; drawing skills aid in reading skills.[1]

Concepts relating to the arts include lines forming a visual sequence and shapes and visual graduation increasing or decreasing in size and volume. Rhythm is progressive and can be regular or irregular. Definitions of figure and ground deal with separation of shapes. Abstraction means to separate out the main parts from a complex field. Closure is the process of completing fragmentary sections into whole forms. Art learning teaches one to search for the sections of details of the whole. The concept of color is in words, music, and dance, as well as the visual world. Patterns and textures exist in all the arts. How these forms are unified into a total unit determines the complexity or simplicity of the art forms.

1. P. Gregg, "Art and Reading: is there a relationship?" *Reading World,* May 1978, pp. 345–351.

In *Education through Art,* Herbert Read writes, "In the end I do not distinguish between science and art, except as methods. Art is the representation, science the explanation—of the same reality."

According to Robert Masters and Jean Houston, "If the current thinking is correct that the arts come out of the right, or visual, side, you are obviously damaging the brain if you don't cultivate that side as well as the analytic side." (The current thinking is that the left hemisphere dominates the analysis and sequential learning, including verbal and mathematical skills, and the right the visual-spatial abilities.)

According to Jean Houston, director of the Foundation for Mind Research in Pomona, New York, "A person needs to think in terms of images as well as words. He needs whole-body thinking to evoke more of his entire mind-body system. Verbal-linear-analytical intelligence is a small part of the intelligence spectrum. There is also visual-aesthetic-plastic (working with the hands) intelligence, but that is not acknowledged in the schools.

The child without access to a stimulating arts program is systematically cut off from most of the ways in which he can perceive the world. His brain is being systematically deprived. In many ways he is being deeducated."

Eugene, Oregon, is one of the five IMPACT cities (Interdisciplinary Model Program in the Arts for Children and Teachers) where five scattered schools in 1970 began a federally financed project, which grew into an ongoing "alternative" Magnet Arts School (K–6), where the arts are used as disciplines in themselves and also as vehicles to teach other disciplines. Students write and perform their own plays, illustrate their written books, and learn math through the medium of dance. Science instruction uses similarities between scientific and music principles. Each teacher must have a specialty in the arts as well as being the classroom teacher. In 1976, Magnet Arts school's sixth grade tied for first place in reading and fifth place in math with the other 29 district schools. In the arts-centered program at Eastgate Elementary school in Columbus, Ohio, the sixth graders reading at or above grade level increased sixfold during the school year of 1973–74. Three math categories improved from 14 percent at grade level to 39 percent, 14 to 70, and 10 to 73. The Magic Mountain school in Berkely also has an arts-centered curriculum. At Mead School, in Byram, Connecticut, a strong emphasis is placed on the arts. Students may spend as much as half their time in art classes, as well as a good deal of the other half using art to learn mathematics. The reason art is so important there is that art makes available a wide variety of materials that a student can work with immediately. Not only does he work

creatively with them, but he can use his mind with his hands and eyes. "No other subject, or medium, can offer this."[2]

INTEGRATION OF THE ARTS

While the visual arts of painting and film differ from the performing arts of theatre and dance, one cannot overlook their interrelationships. Obviously it is easier to look at the arts as separate and unique and ignore their community. What makes them related or integrated?

The most common element of visual and performing arts is the process of creating. Each artist in his or her own media attempts to solve a problem using the tools of that media. While the end product, i.e., a dance, a painting, or a dramatic production, is different, the creative process is the same.

A second element which the visual and performing arts have in common is the use of space, movement, images, and form. The theatre director must work with these elements on stage just as the artist must work with them on canvas. Perhaps the best illustration of the similarities of the visual and performing arts can be seen by looking at the film director and the theatre director. Both require the same elements but use different media.

The interrelationship of the arts must be integrated to the total curriculum. Not only are the arts important to each other, they are essential to all curriculums. The arts are as essential to general education as science, mathematics, and English.

William E. Arnold, Chairman
Department of Speech and Theater
Arizona State University

TEACHING EXAMPLES

While listening to various records (from classical to electronic sounds), the students were asked to express the music or the feeling it gave them in a painting. The students realized the variety of moods music can create, remembered the pieces better, and were motivated to further appreciation and listening on their own. In rhythm exercises, we listened to 4/4 time being a different picture from, say, 3/4. Students were given two bars and eight dots of assorted sizes and colors and asked to express the rhythms played. Sections on the paper were quartered and suggested the various patterns. A number of students selected a large dark circle for the strong down beat. Yellow and orange tended to "jump out" and these colors were used often to represent staccato. Students also were invited to "lead the band" to feel the rhythm. Part of the

2. Roger M. Williams, "Why Children Should Draw," *Saturday Review,* 3 September 1977, pp. 11–16.

musical experience is designing costumes for musical productions. Students also enjoy mask making representing the various characters portrayed in musical reviews and learning to read music with colors as well as to draw musical instruments; various instruments create various sounds. Other forms that relate to music and art are rhythms by the regular repetition or growth progression; the form grows in size by progressive repetition of its own shape. Emphasis and contrast in size, texture, color, length of line.

<div align="right">Jeanne Shimizu, art teacher</div>

These first graders recognize the music from *Carnival of the Animals* and respond to the animal characters through pantomime. We visited the Phoenix Zoo for further motivation. We (the class) sit on the floor in a circle and pretend we are at the zoo or circus—I am the ringmaster and you are the audience. O.K. folks, the show is about to begin. The music plays, the children pantomime the characters such as the lion, rooster, mule, kangaroo, elephant, turtle, birds, fish, swan. We then construct the animal figures in clay.

<div align="right">Bonnie Williams, art teacher</div>

ARTS RESOURCE TEACHERS FOR THE ELEMENTARY SCHOOLS

In the Mesa School District in Arizona, the Creative Arts Department, under the direction of Dr. Edna Gilbert, is developing a model for training teachers to act as resource people in their particular schools. Selected teachers, one from each school, will serve a 12-week (60-day) internship with replacement teachers available to release them from their teaching responsibilities. The intern teacher will not be an expert in any of the arts areas; the goal is to make the teacher a catalyst in her or his school for the integration of the arts in the curriculum. Ms. Heller states that the structure is designed with maximum emphasis on flexibility in order for the intern to develop skills and knowledge of materials, school, and community resources in the arts and to experience and participate in the arts on a personal level. Therefore, the intern will work with resident specialists in music, the visual arts, creative drama, creative writing, and dance. Actual classroom experiences will enable the intern to act as an apprentice or assistant to the specialist, whether singly or in combination, and work on projects in the classroom. Parents will be involved and the objectives of the program and the benefits of the learning experiences for the students will be explained.

Regular evaluative sessions will be held about once a week based upon observation by the interns, specialists, and resource center staff in Mesa in order to redesign areas of the program and to meet specific needs of the classroom experiences.

The classroom teacher will then develop a program to take back to the school and create a network and become a catalyst and information funnel for the other teachers within that school.

<div align="right">Gloria Heller</div>

SCOTTSDALE SCHOOL ARTS IN EDUCATION COUNCIL

The Scottsdale Schools Arts in Education Council was formed in the spring of 1974 by parents who felt that district students were culturally deprived. Inflation and diminishing student growth (the district had built seventeen schools in ten years shortly before) were making constrictive demands on the curriculum.

The idea of an arts council was welcomed by the new district superintendent. From that strength, the group grew to a cohesive unit of support for the arts in the schools.

The council's concern is with visual arts, dance, drama, humanities, and music in individual schools and in various district programs. The intent is that in each district a student's kindergarten through twelfth-grade education has the arts as an integral part of the classroom work and of everyday life.

In the past three years, there have been many changes in arts education in Scottsdale. Some changes have been the result of direct action and discussion by the council. But perhaps more importantly, the long-range programs and improvements have been the result of the district knowing that parents supported the arts.

The district has hired a part-time music coordinator and mandated string instruction in the elementary schools. It has moved seventh- and eighth-grade general music from an elective to a required subject and has extended art and music education by specialists to include kindergarten through eighth grade. The district has an elementary fine arts festival each year that includes a student art exhibit and an honors chorus and band.

The Arts in Education Council has sponsored a work/study session with the school board on the need for arts in education and the scope of the resources available to the district. Council members attend school board meetings and give their opinions, not only on the range of the arts, but as the arts affect the total program.

The council coordinates a series of performances for district students by the Scottsdale Theater for Children and by the Phoenix Symphony Guild Symphonette, an orchestra of elementary-age musicians.

The council's most extensive undertaking has been the development of the Masterpieces of Art program, which uses parent volunteers to bring art history and perception into the elementary classrooms on a regular basis. The project has involved over one hundred parents in the arts education by the beginning of the Masterpieces' third year.

Council members work hard to draw up plans to bring art programs into the schools, both for assemblies and classroom visits, working closely with art teachers. They offer suggestions for arts related field trips and topics by speakers. When plans call for funding for a school's program, the council representative asks for it from that school's parent group.

The Scottsdale council is nonfunded and nonfundraising—an important reason for its acceptance. Communication is by district mail, printing machines, and by telephone.

The council is composed of at least one parent representative from each of the twenty elementary schools and five high schools. Council representatives also belong to their own PTA or independent parent group.

The organizational concept is that of a forum to provide communication, support, and volunteers. There are no constitution or bylaws and as few officers as possible—but many chairmen. The Council has monthly meetings, which sometimes take the form of a tour or include community resource speakers.

The Art Council's work has meant endless talking, meeting, and writing on the part of those concerned. But in this process there has been a tremendous education of all concerned, particularly of the parents concerned, which is where it all begins.

Pamela Hudson Krewson

RELATING LANGUAGE AND ART

Combine language with art activities such as inventing poems, stories, and pictures. Discuss artists and their art forms as well as art interpretations.

Create murals twenty feet long resulting from trips or learning topics; "talking murals," murals that include language such as balloons in comic strips—the characters say what they are talking or thinking. Leave in students' spelling errors to encourage free flow of ideas.

Provide "magic" boxes containing "magic" materials which suggest exciting, mysterious topics to write or draw about.

List titles that teachers of students invent. Children are good at inventing their own lists for subject areas.

Conduct games that offer different types of language usage, such as gesture games, using action words to portray various moods; dramatic situations creating identities—looking angry, laughing, giggling, etc.

Invent puppets. Puppets offer opportunities for interpretations and expressions of ideas, thoughts, and feelings. Characters or subjects can be make-believe or representative. Very often, hidden feelings come forward through puppetry. Students who have stuttering handicaps often forget their problem when hidden behind the safety of another character, such as a puppet.

Books, movies, titles, songs, and thoughts are motivations for art.

Design letters and signs. Students design space displays.

Invent stories and poems. These provide strong motivations that allow for students' expression of feelings. Strong emotional feelings are often expressed toward the teacher and parent. The teacher should select titles that are highly descriptive and allow for strong reactions in the students' imaginations. She should provide opportunities for the students to write, talk about, and draw these feelings.

Draw a book report.

Make a play from a favorite book, a favorite painting. Older children read to younger children.

Students keep personal journals, much like a diary, consisting of daily activities, as well as expressions of feelings and experiences. Illustrate the journals.

Design book jackets, letters. Offer a dramatic interpretation. Write letters, making drawings of appreciation, to the book author.

Dramatize a book in dance, costume, music, art.

Share bulletin boards—personal items, photos, poems, current interests.

Call out "loud" words, "soft" words, other emotional words.

Write and illustrate poems invented by the students. Eliminate rhyming or spelling; encourage interpretations of feelings and ideas. A poem is spontaneous word music. Select a theme, such as "I wish"; have each line contain the words "I wish." Other themes would be a color, a favorite place, "What I like to eat best," "My house is . . .," "When you and I . . .," "I dream't I . . .," "If I could paint a . . .," Have fun inventing your own themes: "I want to . . .," "When we help . . .," "A color is . . ."

Creative Dramatics—improvise situations dealing with real life, family or school, take-offs on commercials, nursery rhymes, books, favorite television shows, historical events, fantasy inventions.

READING AND ART

Read plays, newspapers, art magazines, art journals, and important thoughts and issues of the day. Assign works of Lewis Carroll and A. A. Milne as necessary early reading.

Read comic books, Westerns, items on community affairs, plays of interest; pursue ideas that are relative to the interest of the child (if he is interested in spiders, research all the information available on spiders). He can research an area of particular interest for him, no matter what grade level.

Design word books—a notebook of the child's own that he fills with words he likes to use; make up different notebooks on different subjects such as an art notebook, words used in art, just a fun word book. Drawings and paintings illustrate the words.

ENGLISH AS A SECOND LANGUAGE PROGRAM

The English as a second language program in Scottsdale, Arizona, provides English language development for children of many nationalities, including Vietnamese, Korean, Thai, Mexican-American, Arab, and others. Activities based on the arts are an integral part of the English program, both as an instructional tool and as a means of sharing cultures.

When language barriers make words an insufficient means of communication, art serves as the universal language. If, as a teacher, you're having difficulty explaining a concept, draw a picture. If a child is unable to explain something to you, ask him to draw a picture. Among children of varied nationalities, art can always be depended upon to carry the message.

As teachers of new arrivals to the United States, we should take advantage of the varied backgrounds and customs of the nationalities represented in our classrooms. Encourage the children to draw pictures of their native homes, local customs, and holidays. These pictures will lead to many conversational activities and teach the students (and teacher) about many countries.

The teaching of English as a Second Language is usually discussed in terms of our main components: listening, speaking, reading, and writing. Most students of a second language will agree that conversing in the new tongue is the most difficult of the four tasks. A majority of exercises stressing listening, reading, and writing may be developed into speaking activities and probably should be.

Many of the following activities were developed for use with a small group. They may be adapted as whole-class or individual exercises.

Listening

I. Illustrate a story (grades K–12)
Tell a small group of children a story at their level of language development. Have the children illustrate the story as you read or, if more concentration is needed, after you have finished.
Example: Once, there was a black bear cub who liked honey very much. Every day, he'd walk into the woods, looking for a tree that was filled with honey. . . .

II. Cartoons (grades 2–12)
Tell the children a humorous story or poem. Have them draw a cartoon with appropriate captions.

III. Depict moods (grades 4–12)
Introduce mood words, such as angry or frustrated. Gestures and/or pictures could be used for clarification. Read the children a story with several strong emotional states included in it. Tell them to draw a line or picture to denote the feelings of a particular

character. The result should depict the changes in the character's moods throughout the story. Use of color as well as line should be discussed.

Writing

I. Illustrated glossary (grades 3–12)
Each child keeps a glossary of new words. With this booklet always nearby, he adds any unfamiliar term to the list. His own illustrations serve as reminders of word meanings. Words not easily illustrated may be written in his first language. Illustrations should be used instead of a translation whenever possible, and they speed the transfer from thinking in the native language to thinking in English.

II. Teacher-made dictionaries (grades 1–12)
Draw pictures of basic vocabulary words in alphabetical order and make ditto copies for each child. Have the children write the corresponding word for each illustration and keep these sheets in a notebook.

III. Write a cartoon (grades 3–12)
Either draw your own cartoon or cut the captions from a cartoon in the newspaper. Have the children write a story that corresponds with the cartoon.

IV. Describing pictures (grades 4–12)
Give the children a picture you have drawn or cut from a magazine. Ask them to list the objects they see. Encourage them to write sentences or paragraphs about the picture. Or have each child draw a picture and switch with another child.

Reading

I. Language experience (grades 1–3)
Language experience provides an excellent vehicle for incorporating reading in English and art. The children dictate a story, which the teacher writes on large paper on a bulletin board. Children may make copies of the story and add illustrations.

Read plays, newspapers, art magazines, art journals, and important thoughts and issues of the day. Assign works of Lewis Carroll and A. A. Milne as necessary early reading.

Read comic books, Westerns, items on community affairs, plays of interest; pursue ideas that are relative to the interest of the child (if he is interested in spiders, research all the information available on spiders). He can research an area of particular interest for him, no matter what grade level.

Design word books—a notebook of the child's own that he fills with words he likes to use; make up different notebooks on different subjects such as an art notebook, words used in art, just a fun word book. Drawings and paintings illustrate the words.

Speaking

I. Prints (grades K–12)
Bring in prints of works of art. Have the children discuss them as well as their own reactions. Discussion of the background of the artist and the work encourage additional practice in speaking English as well as an appreciation of art.

II. Puppets (grades K–12)
Make puppets from socks, papier mache, or even a clothespin. The children may use these characters to tell a story. Stories may be made up by students or read by the teacher. Many newcomers to the U.S. do not know our children's stories. I have found that even high school students are interested in hearing the stories and nursery rhymes that American children learn.

For older children, an art unit concerning the various periods or techniques is a cornucopia of vocabulary and speaking opportunities.

Field trips to local museums provide an even more meaningful experience than classroom activities.

Andrea Bartlett, Coordinator
Scottsdale School District

TEACHING EXAMPLES

1. Using either imaginary tales or factual pieces, we discussed the various animal stories the three reading groups had read, each group telling the other children. We noticed similarities and differences between animals, including scientific items like animal foods, water, oxygen, means of protection, and abilities to move and to reproduce. We divided animals into vertebrates and invertebrates (one boy brought in a cow vertebra to show). We also divided animals into categories, such as mammals, birds, reptiles, amphibians, and fish and talked about their kind and what makes them unique. They discovered that an elephant and a mouse were in the same category. We particularly discussed items they could include in their puppets, such as types of skin covering and the number and position of the limbs.

We talked about the distinctive features and how they could show three dimensions. I then showed the two puppets I had made and suggested they try a different animal. The children did come up with their own ideas, and were more aware of the anatomical characteristics of the animals. After exhibiting the puppets in class, the children presented improvisational plays based on the stories they read. Many of the children couldn't wait and were acting out their puppets as soon as they were finished.

Judy Wallace, second grade

2. The children selected their favorite story and made puppets and scenery to go along with the stories from *A Trip through Wonderland,* from the Open Court Language series.

Susan Hoen, first grade

3. We started by watching a film on the making of different kinds of puppets. The puppets could be make-believe or realistic. We made scenery, background, and props, including tables, chairs, a part of a house, and trees. We worked with the librarian and she explained how to write a script for a play and how a character communicates his ideas and emotions to an audience. We had all kinds of materials and add-ons, and the students created their puppets, scenery, and scripts. They practiced in the library and used a desk as a stage. Some titles were "Steve Hurts His Leg," "Tigger and His Bouncing," "The Skill Trip," and "The Surprise Birthday Party." Then the plays were presented to the first and second grades. We learned what goes into the making of a puppet show. The children learned to work with various materials; most of all they learned to work together in a group situation and how to work with group ideas. Even when they disagreed, they came to a workable solution after a discussion.

Barbara Wentz, fourth grade

4. The class was divided into groups with a different theme. Some listened to poems, others to music with and without words. One poem was "Poem" by Langston Hughes, about a friend going away. They were asked what they thought of when they listened to the poem. Some thought of friends who had moved away; others thought of times their mothers or fathers were away from them. We then read the poem again and painted a picture about it. About the poem, "The Little Turtle," we talked about who the turtle caught and what it might feel like to be a turtle. The music we heard was "Clowns," "Five Little Kites," and "Dance of the Little Bells" by Rebikoff. The children were not told the titles. They talked about what they thought of as we listened to the music. We sang to it and we played the music as they painted— "Polka" by Strauss and "Frightening" by Schumann.

Lorrie Miller, first grade

5. First we discussed science concepts related to animals and living things, the various kinds, animal characteristics, and animal homes. We viewed animal films and filmstrips, listened to and illustrated animal stories and poems, read animal stories, used study prints to study animal characteristics and habits. Brought in and observed small animals in class—land crab, hamster, kittens, puppies, rooster, hen, fish, tadpoles, and lamb. We constructed animal homes from wood scraps, drew with marking pens, painted with tempera and watercolor, cut and pasted bird mobiles. We wrote and illustrated animal "tales," molded salt dough animals, made science research folders, planned and made a zoo trip, dramatized a play about a lost kitten, and culminated the activities with a motivation to the poem "Brown Bear, Brown Bear,

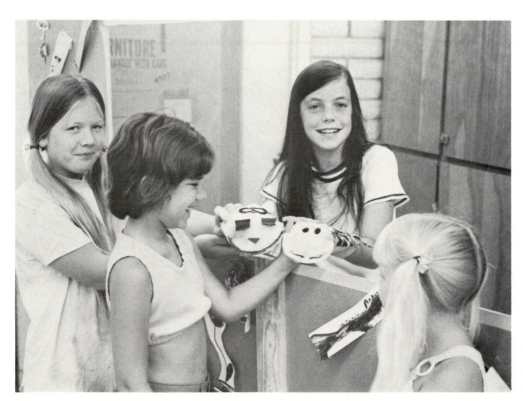

Ingrid, Pam, and Marge create spontaneous plays with their "happy" character puppets. Note the simple stage made from a large furniture box.

What Do You See?" by Bill Martin. The children interjected different animals, chanted to the poem, and the excitement rose to a high pitch at which time they were told to put the animal they "saw" on a quilt block. The drawings were in crayon directly on a 9-inch by 11-inch fabric block.

Claudia Spackman

We printed about 30 famous quotations and distributed them to the 27 fifth graders during language. We had discussed idioms and the quotations gave us an excellent chance to "think" and analyze these quotes and say sayings over a wide range of subject matter. After a class discussion of what each quote could mean, I asked the students to visually picture how each quote could look to them. We called them "visual or mind pictures." We studied vowels and the long and short vowel sounds. Then they picked a vowel and drew a picture of one. We wrote a creative story about the vowel. We made vowels from twisted tissue paper, bread dough, macaroni, colored sand.

Terri Jones, first grade

6. We read the story, "Caps for Sale," by Esphyr Slobodkina, (1976 Sehol Pap.). Then we papier mached hats over stocking caps, with papier mache mixture, wallpaper, white and colored papers, paint, trims, rick-rack, feathers, artificial flowers, etc. We used our mural of "Our Community Helpers" that we had made after field trips. Some made fireman hats, police hats, imaginary hats, and hats from true life. Then we shared our art products and talked about their ideas and reasons for selections. We made up stories about who they were when wearing the hats, how they felt, what things they would do. We wrote stories. We play-acted experiences.

Marianne Di Matteo, first grade

SCIENCE AND ART

Each of the items listed next can best be learned through careful observation and by drawing or painting the details of each examination. Learning occurs through visualization—drawing and visual study.

- Conduct a detailed study of the structure—anatomy—and the workings of natural forms, such as the figure, flowers, animals, trees.
- Group, select, classify, name, and describe rocks, leaves, plants, insects.
- Study and draw the workings of man-made objects such as clocks, motors, radios, batteries, transformers, projectors, tape recorders, earphones, cameras.
- Plant seeds; study, draw, measure, and record growth.

- Draw animals; record measurements of their growth; study their structure.
- Study building and constructing; learn why and how they function. Combine them in new ways, invent new machines based on learned concepts.

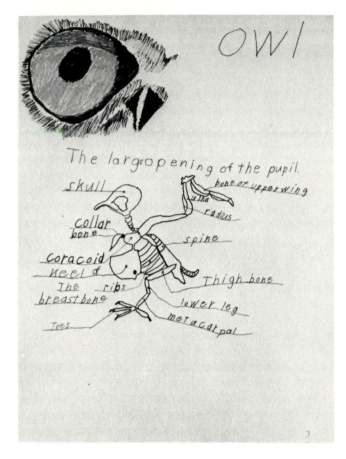

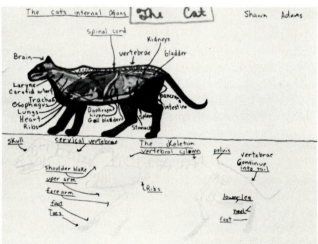

Science study examples.

- Study growing food and its production. Discover aesthetic ways to prepare food for eating. Use ovens, measure amounts, combine flavors, and produce satisfying combinations. Study nutrition and basic food elements to be used in combinations.
- Draw studies of animals and their training. Study how they are produced for commercial use, how the pet plays a part in the community. Study zoos and natural wildlife.
- Study ecology and the balance of the natural environment; study landscapes.
- Try photography, sunprints, and photograms.
- Sculpt, using balance, gravity, kinesthetics.
- Show capillary action in absorbing color on wet paper.
- Look through a microscope, telescope, kaleidoscopes.
- Study salt crystals, hairs, dried paint.
- Produce your own filmstrips with 35–mm film leader; draw on it with permanent felt pens.
- Illustrate ecology words, such as noise, waste, litter, pollution, recycle, energy, foods, and smoke; draw posters about combating such.
- Tape record sounds in the environment.
- Construct rhythm instruments from found materials, such as cans filled with beans and foil pie plates; use with the rhythm of poems, names, songs, and sentences.
- How do colors make you feel? Study color in your daily life. Study primary, secondary, complimentary prismatic colors, and the color wheel. Experiment with color blending.
- Design "touch pictures" and feeling boxes.
- Investigate similarities and differences in foods and tastes. Collect menus and design them. Design a small box.
- Study shadows, reflections, and memory drawing.
- Draw microscopic growth; study ways of communication such as radio and television.
- Draw the changes that take place in growing and cooking foods; design and build bird feeders, bridges, clothes, and art tools; study and draw concepts of solar energy and how wind, electricity, and water generate power; classify tastes, plants, and animals.
- Cameras, magnifying glasses, prisms, microscopes, cassette recorders, different lenses, films, loops, equipment for laboratory experiments—all are essential items to be included for art expression as well as for scientific study.

TEACHING EXAMPLE

For two days we read about prehistoric animals, dinosaurs in particular, and looked at pictures of them. We discussed size, eating habits, and various physical features. We watched filmstrips, a cartoon view-master story, a stand-up diorama. We drew or painted pictures and wrote stories about them. Then we modeled dinosaurs out of clay.

Lorrie Miller, first grade

MATHEMATICS AND ART

- Solve abstract concepts through drawings and renderings. Illustrate mathematical problems in weight, balance, measurement, geometry, and their solutions.
- Learn to use mechanical drawing tools. Draw objects in detail.
- Divide spaces and areas to create optical designs, such as artists use in "optical art."
- Introduce many games that offer visual planning such as chess and checkers.
- Using the blackboard, conduct group problem solving.
- Student has a budget—like $40. Have him select and order from a catalog. (Design and illustrate catalogs.)
- Macrame, weaving, line designs, architectural models, and model construction require measurement and planning.

TEACHING EXAMPLE

In kindergarten, our curriculum includes learning to identify geometric shapes. My goals were to heighten awareness in the use of geometric shapes in the environment and to recognize differences and similarities in texture, size, pattern of fabrics. We looked at books such as *Round and Round and Square* by Fredun Shapur, *Shapes* by Jan Pienkowski and *Shapes* by Mirian Schoien. We looked at shapes around us—in doors, tables, books, windows. The students cut shapes out of paper and fabric and adhered them to paper to make objects or pictures. Then they drew with felt pens to add details. Each child then dictated a story to the aide about his picture.

Lois Allen, kindergarten

HISTORY AND ART

- History becomes alive through art. Visually interpret (draw) past events.
- Draw and paint murals or illustrations concerned with the environment.
- Study other countries—their customs, artifacts; study history through paintings.
- Draw the artifacts of various cultures.
- Study past art works, including the development of architecture.
- Study town forums, places and platforms for community action.
- Draw maps of the city through the eyes of an architect, ecologist, sociologist, parent, student, city planner.

TEACHING EXAMPLES

1. For a transportation unit we discussed ways we travel and the types of travel. We made comparisons between the speeds of different types of travel such as walking, riding animals, wagons, bicycles, motorcycles, cars,

trucks, trains, planes, rockets, boats, and ships. We discussed the uses of the types and how they depended on each other and in what way they served us. We took a bus trip to the airport and later made pictures about what we liked best about our trip. We wrote a letter to the guides we had and sent our pictures to them. We painted and cut out busses, cars, people, planes, trains, airplanes, and put them on a table with houses to make a town. In the background, we painted a mural showing the various types of travel in our town.

Earlene Glaser, second grade

2. As part of our study on the State of Arizona, we studied the different Indian tribes with emphasis on the Hopi Indians and their Kachina dolls. We learned the legend of the Kachina dolls and how they are thought of today. We read about the Indians, viewed films, filmstrips, slides, and photographs from magazines. With various mat media the students created their own Kachina doll. The students had no model to look at, only what they remembered.

The students also discussed what vocation they would like to pursue in later life and why. They came to the conclusion that many vocations overlap with what is considered recreational activities. We made two lists on the chalkboard titled "Americans at Work" and "Americans at Play." Our art project was to use magazine pictures in a collage exemplifying the many activities we had discussed. We discussed the art elements and art principles involved. The groups were given an outlined map of the United States. The collages were great! They enforced the learning of shapes, organization, depth perception, and being creative.

Pat Pollard, fifth grade

3. Over a two-week period we discussed cowboys and rodeos, looked at photographs, read "Cowboy Sam," saw films, and the students played with a cardboard cut-out, stand-up rodeo during their free time. A rodeo clown came to school to do rope tricks. The children drew the rodeo and the clown.

Lorrie Miller, first grade

4. We began by studying our community and its helpers. This led us into many interesting discussions about our environment and what WE can do to present and conserve energy and ecology. The resources we used were films, filmstrips, books, pictures, and charts. We wrote creative stories about pollution and studied limericks. We wrote stories about our environment. In conjunction, we did watercolor paintings, drawings, and collage.

Mary Anne Pape, second grade

5. Our goal was to increase the students' awareness to the environment and community. We discussed Arizona's birthday and the symbols related to Arizona including the flag. Some students were unaware that each state has a flag as well as a country. We discussed the history and the symbolism in the color and design in the United States flag and the Arizona flag. We looked at other flag pictures, historical flags, and flags from other countries. Then the students were told to create their own flag and to consider something special about themselves or their family they would want to put on a flag. Or redesign the Arizona flag or design a flag for the state in which they were born.

Kathryne Diamond, third grade

6. We researched the cultural aspects, the climatical conditions, and plant and animal life, and we discussed the results together. The lesson was planned so the students would realize that the state they live in is quite exceptional and to aid them in broadening their view of Arizona. We compiled a list of our researched facts and information. Each child received a copy of the list as a guide for later classes. We went to the library to find books pertaining to Arizona and derived further information to contribute to the list. We gathered photographs and displayed them. We discussed *Arizona Highways* magazine and what they found of interest. We watched films, filmstrips, and slides. We took field trips to the zoo, pioneer village, botanical gardens, Pueblo Grande Museum to see Indian ruins, and the Heard Museum to see early artifacts. The students' special project was the final unit and was to model from clay, as our Arizona heritage is involved with Indians and pioneers using the clay from the earth. We first sketched our ideas; the majority of students chose to make Indian vessels, stagecoaches, and cactus plants.

Lois Fjeld, third grade

7. To enrich our social studies curriculum I let the students select what related art project they would like to do. They decided to make shadow boxes to typify a scene in a country in the eastern hemisphere. They made clothespin dolls depicting the native dress of that country. Along with the shadow box, they painted a mural as a group. We discussed backgrounds and environments such as a German farm, African huts in rural Uganda, Laps in Siberia, a sidewalk cafe in Paris, a marketplace in Mexico (a child just moved from Mexico), a Polish farmstead, windmills of Holland, an African rainforest, scenic Japan, and farmers along the Ganges. For English, they researched their topic in order to write a paragraph concerning the material to include in the shadow box. We used available materials in creative ways such as toothpicks for fences, soda straws for candles, fruits and vegetables for clay and ceramic tile. Then we made clothespin dolls native costumes. We displayed the boxes, and students from other sixth grades want to make them too.

Virginia Breed, sixth grade

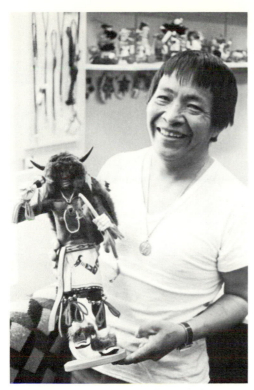

The study of cultures includes artistic expression. This Kachina sculpture represents a spiritual being to the Hopi Indians.

THE GIFTED PROGRAM

Many school districts today have a gifted program. In such a program, selection is from all grade levels and accomplished with achievement tests as well as recommendations from the art teacher. Some programs offer one day out of the five to bus the students to a special school. There the students spend the day in smaller groups, perhaps with the ratio of one teacher to ten students. With smaller numbers of students, the teacher is able to offer more individualized instruction with greater potential for the student.

The many art experiences, concepts, and instructional procedures offered in this book are excellent tools for the teacher to use with the gifted child. The instructor is able to select art ideas for individual student research and enrichment activities from the broad spectrum of art ideas. The study of artists, guest speakers, and art appreciation methods, as well as trips to museums and art galleries are also encouraged.

With the elementary art teacher reaching approximately 1,000 students each week, the advantages of a gifted program are understandable.

ART THERAPY

There are many art therapy specialists working in children's centers, health clinics, hospitals, counseling centers, prisons, ghettos, and in schools. The goal of art

therapy is to focus the individual's energies to create art works that help his degree of self-actualization. Learning to empathize with the person's conflicts and interpersonal relationships through art, the teacher can apply his human understanding and psychological knowledge and establish conditions that foster acceptance and encouragement of self-expression.

Such self-actualization of the indivdiual through art includes art as a nonverbal means of communication through various art media. Along with verbal associations, such art often has a strong relationship to understanding and working through emotional conflicts and problems. The teacher uses the art process with various media to establish self-expression and it therefore becomes a therapy.

In the field of mental health, art therapy is used for emotionally disturbed, brain-damaged children and for special education students in public schools. Its value as a means of identifying behavior problems and inner conflicts had been documented by psychiatrists, psychologists, and art therapists. The emphasis here is not on skills for their own sake or for any purpose other than as expression. When art is used closely with verbal psychotherapy, it may interfere with the directness of nonverbal communication.

"Handicapped individuals have a normal probability of being creative and talented. The Bureau of Education for the Handicapped, through partial support of the Theatre of the Deaf, Gallaudet College Drama and Dance groups, and the National Technical Institute for the Deaf creative groups have demonstrated that deaf individuals have the ability to compete in the world of performing arts. Examples of creative careers by blind performers such as Ray Charles, Little Stevie Wonder, Ann Adams, Eric Klaus, and others have demonstrated success in the musical world. Physically handicapped people have often developed unusual and creative talents in graphic arts.

The use of the arts as a teaching tool for the handicapped has long been recognized as a viable, effective way not only of teaching special skills, but also of teaching youngsters who had otherwise been unteachable. The Committee envisions that programs under this bill could well include an arts component and, indeed, urges that local educational agencies include the arts in programs for the handicapped funded under this Act. Such a program could cover both appreciation of the arts by the handicapped youngsters, and the utilization of the arts as a teaching tool per se."[3]

The VERY SPECIAL ARTS FESTIVAL is a noncompetitive forum for the handicapped to share their accomplishments through the visual and performing arts.

3. An excerpt from Senate Report No. 94–168 on the arts for the handicapped.

Bob, a fifteen-year-old handicapped student, expresses his feelings in paint. The design reminds him of letters.

The program integrates the arts into the general education of disabled indivdiuals throughout the United States. The festival's goals are to provide opportunities to discover new skills and increase future potential for employment for the participants, to help recognize the importance of the arts in the lives of the handicapped, and to provide social and personal satisfying activity. It also provides recognition for efforts, develops communication skills, and aids in motor skills, social skills, and fine arts skills (such as imagination, flexibility, adaptability, appreciation, and environmental sensitivity). Such skills can heighten confidence levels, develop self-reliance in thinking and self-esteem, and encourage an active interest in all areas of learning as well as decrease segregation of the handicapped person from society and its cultural activities.

TEACHING EXAMPLE

I. Goals

The goal of this lesson is to have the exceptional student learn different geometric shapes and to comprehend how they can be used in the aspect of drawing. They will begin by learning the names of the various shapes, how they are made, and how they can be incorporated with different other shapes to produce different objects.

II. Objectives

The students will first be shown a three-dimensional model of each specific shape, told its name, and will have the opportunity to touch and examine it.

The students will be shown drawings of the different shapes to determine if they can relate the drawing of the shape with the corresponding three-dimensional object.

The students will be shown simple drawings incorporating the different shapes to see if they are able to pick out the different shapes, and also to name them.

The students will begin by using only one shape at a time to see if they are able to make a picture using only that shape.

The students will continue using only one shape at a time to make different pictures, until they become familiar with all the different shapes and comprehend the different ways they can be used.

After working with all the different shapes extensively, the students will combine the shapes to make a complete picture.

After completion of the above steps, the students should know the names of each of the different shapes and also how they can be used in drawing.

III. Evaluation

I found this to be a very exciting lesson for my students, and also a very informative one for myself. I discovered that many of my students had a great deal of trouble using only one shape and being able to make a picture with that one shape, and they did much better when they were able to use many of the shapes. I used this discovery to explain to my students the importance different shapes play in our world, and all the different ways they can be used. I found when it came to making a picture with many different shapes, that they did much better and were also much more satisfied with their own work.

Many other areas also showed an improvement when the students learned the different shapes. My students are presently learning about traffic safety and street signs, and this was an excellent way to incorporate the idea of the shapes and to relate the shape with different signs.

This particular lesson in learning the different shapes has been worked on for almost a month, with many of my students still having a great deal of trouble. Due to the fact that I teach *exceptional* children, this particular lesson will continue to be taught for many more weeks to come.

In conclusion, I would like to say that I am very pleased with the results and will continue to build on this idea and incorporate different ideas towards teaching it in the years to come.

Andrea Fenton

Edward Hopper, *Night Shadows*. 6 3/4″ × 8″. Reproduced by courtesy of Gallerie Ann, Houston. The artist emphasizes the emotional quality of mystery by employing scratchy black lines, strong black-and-white contrasts, diagonal lines, a single, lone figure in the night, a long shadow, and a deep bird's-eye-view perspective.

Analyze both of these paintings for composition, line, direction, pattern, texture, and values.

Ben Shahn, *Television Antennae*. Tempera paint. 10 1/4″ × 15 1/2″. Reproduced by courtesy of Galerie Ann, Houston. The quality of the paint suggests thin wash techniques as well as heavy overpainted areas. This street scene could be anywhere.

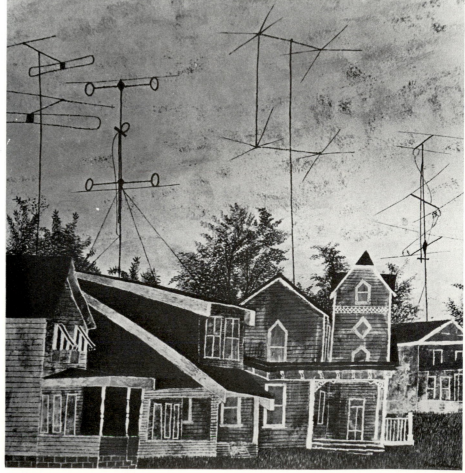

The Artist and Me:
Art Appreciation

Appreciation of art works should relate to an experience the children have had. If the children used paint to express their ideas of horses, then an appropriate selection of art works should consider one or two paintings of horses done by the artists. Again, you should not merely exhibit the works of art as an isolated experience. You should encourage the children to discuss their feelings concerning the paintings. Ask questions that will lead the children to respond actively as they relate their own experiences to those of the artists.— Earl W. Linderman, "Appreciation Deserves An Early Start," *Art and Activities Magazine* 52, no. 2 (October 1962):23-24.

YESTERDAY'S ARTISTS

We have records of the art, but we know little of the artist and the conditions in which the artist worked. Societies have regarded their artists differently. Usually throughout history the artist has worked for a wage or for a commission. Only in the last century has the artist worked independently without an agreement or renumeration.

The earliest cave paintings were simply drawings of animals incised into the rocks, marked in soft clay or drawn with the fingers on decomposing areas of cave walls. During the Paleolithic age, stones provided tools for shaping rock, burins were used for incising outlines, the earth provided colors, and animal marrow was used for binding pigments. Animal bristles were used for brushes to spread the colors. Did you know that the artist's stone lamp was made with animal fat and a moss wick? From the beginning, man has used his own hand as a decorative pattern by imprinting his hand to the cave walls. In some instances, the hand was placed against the wall and color was sprayed round it through a hollow bone or a reed or directly from the mouth. When the hand was removed, a silhouette outline remained.

In ancient Egypt, traditional designs were kept alive. Artists worked in hereditary employment, decorating tombs and working an eight-hour day. Their pay was food and clothing; some even had their own servants. Artists were thought of as artisans, with studios attached to temples. They worked alongside goldsmiths, potters, and woodworkers. Some were asked to take part in the religious ceremonies at the temples, and some reached high positions in administrative or priestly rank. Sculptors were more respected than painters, as they had more responsibilities, including the painter's techniques. They carved mainly from granite or basalt, both hard stones. Workshops regulated the styles and prescribed recipes for exact colors. The art was devoted mainly to funerary purposes and life in the hereafter. Six basic colors were used: black, white, red, blue, yellow, and green, which were mixed to make other shades and tints. Small pots were used to hold fluid paint and animal skin bags to hold powdered pigment. Palettes were of slate for mixing colors as well as for painting cosmetics for elaborate facial adornment. Hollow reeds held mixed colors, which were like our tubes today, and brushes were made from reeds pounded flat on the end till they were fibers.

Phidias was the well-known sculptor of the golden age of Greek art during the fifth century B.C. He was the superintendent of artistic work for the Parthenon. He created the "Zeus" at Olympia and the "Athena," which stood before the Parthenon on the Acropolis. These were 35 feet and 40 feet high respectively, made from wood, and covered with ivory, gold, and bronze. Most Greek statues were painted. Encaustic wax painting (with hot beeswax) was used to preserve the colors when they were outside in weather conditions. Painters added finishing touches to sculptures.

The first independent paintings were on wooden panels. The Greeks held competitions in paintings as they did in sports. The painters used primarily four colors: white, yellows, reds, and black. Vessels were used by every household. Scenes and designs on the pottery revealed the Greek way of life. Production of large numbers of pots were made by assembly-line techniques. Those who made them were considered secondary artists.

In Rome, fresco mural painting on walls of public buildings and private villas were part of everyday life. Statues were everywhere. One theater had some 3,000 statues. The Trojan column in the Roman Forum was decorated with 2,500 low-relief figure sculptures. Roman sculptors added tree trunks and pedestals in copying Greek sculptures. Architecture was considered the only valid art form. Under the Emperor Valentinian I, the artist was granted exemption from some taxes and the free use of state-owned workshops. During the fourth to twelfth centuries, monasteries were the art centers in Western Europe. The function of the library workshops was to copy the Bible and other religious works. Each book was printed by hand, one at a time, with monks as scribes and illuminators. These craftsmen worked endlessly, laboring over the illumination of these beautiful books inscribed with intricate designs and scrollwork on the vellum pages (made from calfskin). Gold leaf was used in the ornate initial lettering and painting. Black, brown, or red ink with a pen was used for outlining. Hatchwork and details were then added with pen. Brushwork was used for filling in the drawing with flat colors, then shadows and modeling in darker shades were filled in.

The medieval studio also produced mosaics and fresco wall murals; these artists worked on the site, such as a church. Mosaics were made by covering a wall with a layer of fresh cement, then embedding small pieces of colored marble or enamel into the cement. Mosaics were often used by the Mesopotamians, Greeks, and Romans with centers at Byzantium and Ravenna. Buon fresco painting meant applying water-based pigments on newly-laid wet lime plaster, which formed a durable binding film of crystalline carbonite. These had to be done correctly the first time as retouching was not possible. Fresco seccos meant tempera wall painting where an adhesive-like egg white or gum was mixed with pigments and then applied to a dry plaster surface.

Associations of tradesmen, called guilds, were formed during the Middle Ages to protect the individual and maintain standards of performance and quality. There were three classes in the guild: (1) the master, who bought the materials and sold the finished work, (2) the journeymen, skilled craftsmen who worked by the day and were paid by the master, and (3) the beginners or apprentices, who did the menial tasks while learning their skills and received room and board in exchange.

An apprentice was trained according to a written contract under a master, as art schools did not exist. He learned skills for his lifetime and adhered to standards set by the guild. During the Italian Renaissance, "students" were often the sons of noble and wealthy families. Michaelangelo, for example, selected students from influential families.

During the Middle Ages, the artist had business problems, such as a small industry, with the master as the director and representative and the assistants as foremen over the apprentice. Fees were based on the manhours needed to complete a work. Fine art was highly commercial to the artists, such as El Greco, who painted the same pictures several times. The artist worked to the dictates of a patron who commissioned him. A contract between patron and artist was signed agreeing on the theme and price. Complete drawings were done on toned paper with ink, chalk, watercolor, or tempera. The finished drawing was then "squared" up so that the assistant could repeat the contents of each square on a large panel or canvas.

Many studios made copies of paintings in engravings or woodcuts (with an expert engraver) in order to advertise or circulate the skills of the artist. Workshops had stamped signs or monograms as trademarks, which were approved by the master.

The church was an important patron of the arts in the late Middle Ages, and church leaders were often rivals between cities. The wealth was in the church and the nobility, and the best of art was found in the churches. In the seventeenth century, royalty became the grand patron of the arts. Rulers would appoint artists to paint extravagant projects to enhance their reputations.

The old masters derived their pigments from earth, minerals, and semiprecious stones (such as carbon, coal, tar, oxides, and sulphides). Lapis lazuli was found in the mountains of Afghanistan and was needed for painting blue robes and cloth. Painting mediums were added to the pigments, such as water, honey, egg, or oil. Ruben's palette included earth colors and madder, malachite, orpiment, untramarine blue, vermilion, and vert azure.

In the late eighteenth century, art schools were founded in various art centers. These schools taught conventional drawing, anatomy, perspective, and copying the work of masters. The Royal Academy of Art was founded in 1768 by George III. The Pennsylvania Academy of Fine Arts was founded in 1805 in America. The late eighteenth and nineteenth centuries found art schools becoming allied with the many new industries, due to the financial support by these industries. This program changed the plans of art schools so that art was not only a means of self-expression but also a consumer product. Art was an integral part of everyday life in the industrial age. The Bauhaus was founded in Weimar in 1919 with Walter Gropius as director. Their philosophy emphasized the unification of art and industry. The teachers at the school included such artists as Paul Klee, Kaethe Kollwitz, and Wassily Kandinsky. Art schools today offer curriculums in both fine art and commercial art.

ART MOVEMENTS

"The image grows in the sense that man sees what he wants to see. As each tool has its own unique way of living on the picture surface, so each individual has his own way of binding optical signs into shapes and images that he would like to see"—Gyorgy Kepes, LANGUAGE OF VISION (Chicago: Paul Theobald and Co., 1951), p. 194.

A great amount of information has been written on the art movements and the ideas of the artist. These ideas are the expression of the artist and his interpretation of his experiences as they deal with life people, places, events, objects, and ideas. This imagery takes form and reality through an art product, the artist's handling of the subject and the art elements and principles.

The following art movements represent the contemporary movements of the nineteenth and twentieth centuries. Beginning with impressionism, the emphasis shifted toward a more contemporary view in art as the art work not only represented the subject matter but went beyond to consider the appearance of light on a surface and atmosphere. Impressionism is a transition from the traditional to a new technical approach to painting. The following movements are simplified and can act as catalysts for further study in the classroom.

IMPRESSIONISM

Can you paint a picture in an impressionistic style?

Nineteenth-century painters wanted to paint sunshine and light in their work. They simplified forms, and they became concerned with the way light was reflected off surfaces, sometimes losing the outside edges and silhouettes. Light and atmosphere were their chief concern. They painted mostly out-of-doors. Colors were used purely and brightly. If you were to look closely, you would see the color is broken, one stroke being placed next to another with a slight space in between. The eye mixes the color into combinations. When viewed closely, the form is almost lost. When viewed from a distance, the form is obvious. They used intense contrast between light and dark, bold shadows, and their paintings are alive with movement.

Artists: Edgar Degas, Pierre A. Renoir, Claude Monet, Camille Pissarro, Paul Cézanne, and Pierre Bonnard.

NEO-IMPRESSIONISM, OR POINTILLISM

The artist was concerned with the complementary relationship of color. The eye would be forced to bring colors together into a more pure or less pure light, e.g., red and green would be placed next to each other, orange against blue, yellow against purple, and the eye would see them at a distance and fuse them.

Artists: George Seurat and Paul Signac.

EXPRESSIONISM

Emphasis is on what the artist feels, rather than on what he views.

Expressionism reflects powerful, emotional feelings concerned with the emotional essence. There is a subject, but often it is distorted in form, color, or space. There are powerful contrasts of light and color, and there is dynamic movement. Expressionism is a highly personal interpretation of life. The distortion of the subject helps capture and clarify the meaning or idea.

Artists: Georges Rouault, Vincent Van Gogh, Paul Gauguin, Ernst Ludwig Kirchner, Emil Nolde, Wassily Kandinsky, Paul Klee, George Grosz, Max Beckmann, Chaim Soutine, and Edvard Munch.

CUBISM

Artists use angular forms, sometimes architectural, sometimes geometric (without modeled shadings). Forms become transparent and merge with the background. They may combine many views of the same object in the same picture. They may tilt tops of objects to make them more interesting and angles more lively.

There is no depth of space; a flat two-dimensional surface is used. There is no background or foreground as such, but there are combinations and interrelating of parts. Interpenetration of forms is used for the best composition.

To indicate motion and vibration, the same object is repeated many times, overlapping and interpenetrating one another.

Artists: Pablo Picasso, Paul Cezanne, Georges Braque, Fernand Léger.

SURREALISM

Artists used unnatural combinations, psychological effects, strange combinations, new associations to invent a new reality through new relationship by ordinarily unrelated themes. The subconscious mind dominates the actions.

There is unusual use of time, space, and symbols. The subject could be of any time, any place.

There are shocking mental effects, shocking combinations to make us wonder, perhaps dreamlike and unconscious experiences. The artist used realistic objects, but they were set in an unrealistic way. Symbols were used to suggest many things. Deep perspective indicated the movement of time.

Artists: Salvador Dali, Yves Tanguy, Giorgio de Chirico, and René Magritte.

ABSTRACT ART

A term used to describe nonrepresentational or non-naturalistic forms of expression. An object may be more or less abstract, varying from the slightly less naturalistic to the unrecognizable.

Artists: Pablo Picasso, Piet Mondvian, Georges Braque, Henri Matisse, Mark Rothko, Stuart Davis, and John Marin.

NONOBJECTIVE

There is no object or subject, nothing that can be recognized. The paintings are abstract; natural forms are abstracted. Compositional relationships, such as color, shape, and textures, are most important. Kandinsky was the founder of nonobjective art. He used simple shapes and believed painting was composed of three elements: line, color, and shape. Lines assume attitudes and are rhythmical; colors have emotions of their own. Low-key colors are somber, quiet, and moody; bright colors are happy. Nonobjective paintings might select one form such as the circle and vary the design.

Artists: Wassily Kandinsky, Joan Miro, and Piet Mondrian.

POP ART

These artists are concerned with commenting on the contemporary, natural environment and on commercial aspects of our culture. They use themes such as cakes, pies, and soup cans. Many times these objects form patterns and are repeated.

Artists: Wayne Thiebaud and Andy Warhol.

OP ART

The artist is concerned with the optical illusions he can achieve with small patterned areas of shapes and moving visual effects. The "pattern painting" movement is related to optical art.

Artists: Bridget Riley and Richard Anuszkiewicz.

MINIMAL ART

This is a term coined by the critic Barbara Rose in an article titled "A B C Art" in *Art in America,* October/ November, 1965. A term she describes as a shift towards a new sensibility occurring in the 1950's and of an art "whose blank, neutral, mechanical impersonality contrasts so violently with the romantic, biographical Abstract-Expressionist style which preceded it that spectators are chilled by its apparent lack of feeling or content". This new kind of art intentionally left out the traditional requirements of uniqueness, complexity or expressive content. The art maintains a maximum degree of visual simplicity, simplification to an extreme.

Artists: Josef Albers, Robert Rauschenberg (exhibition in 1952 of all white followed by all black canvases), Morris Louis, Al Held, Tony Smith, Robert Morris, Donald Judd.

COMPUTER GRAPHICS

This is a product of computer-produced art; the process dates from the mid-1950s. Interest has occurred over the world but has centered in large research sections of industrial companies or universities. Aesthetic use of the computer is a result of investigation into its practical uses

for industrial designers, engineers, mathematicians, and scientists and for complicated techniques of computer programming. The most outstanding role of the computer in the 1970s was in the field of computer graphics, produced by a graphic plotter. The plotter is controlled by a magnetic tape, a cathode ray or TV tube, or by a printing machine which is programmed to produce patterns with the typographical symbols at its disposal.

CONCEPTUAL ART

An art style which began in the 1960s. It is said that the real work of art is not the physical object (as a painting) produced by the artist, but is the *concept* or *idea* behind it. Its purpose is to call attention of the spectator to the *process* by which the art work comes into being and to involve the spectator by actual participation. Often ideas are documented with photographs as they change.

Artists: Ann Mendieta, Alice Aycock, and Mary Miss.

Other art movements include action painters, color field painters, multimedia artists, super realism, art as environment (*Artists:* Charles Simonds, Christo, and Robert Smithson).

THE ARTIST MODEL

ANDREW WYETH

His subjects are familiar favorites: farmhouses, reflections in a pond, in the kitchen, empty rooms, shiny buckets coated with the grease of cream. Everything is well scrubbed and clean.

His studio is a one-room school house that came from across the bay, a very typical early school—austere, and drab. Christina, a subject, went to school in it and it epitomizes the simplicity of Maine and New England. He likes to go in the room by himself and sit and watch the sun creep along the floor boards and move up the wall. He did a portrait of the house absolutely as he knew it. Every detail from the color of the curtains and the rag stuck in the upper right-hand window are as they were. He wanted to get everything of the building in his mind.

Drawing, to Wyeth, is like fencing. With a pencil, you dart in and put down a sharp notation and jab at it. Then you move back, recover, and then jab again. To catch that movement clearly and with excitement is what he tries to do. It is the very excitement in his hand, even the shaking, that is impossible to copy and this becomes the life to the line. That's what drawing is to Wyeth.

WAYNE THIEBAUD

Wayne Thiebaud discussed his art in a videotaped interview at the Phoenix Art Museum during a recent retrospective exhibit. His work attempts to have the painting create its own light. Light can't be emulated, but the artist can render things and in the process of careful analysis and perceptual awareness, make a record of it. The problem of light energy and color as energy has always fascinated him. Also, the drama of the image is heightened by isolation, insulation, and emphasizing certain dramatic elements in all sorts of situations. Objects are the means, the vehicles by which the drama of the language of vision might occur. The subject matter, such as a pie, cake, figure, or landscape, does have iconographic force and interest, but these are less important than the structure of learning to paint as a problem; extending the paintings limits; and playing around with a notion such as isolation.

In figure painting, the isolation becomes a formal problem changing the volume from spatial attitudes that are very round to very flat, of infinite space and what happens when you insulate a figure in such a way. White is extremely dramatic space. The figure is posed, not saying or doing anything, not fighting or loving. A certain minor drama occurs, raising the question of what the figure might be doing. If one watches figures in airline terminals or driving a car—people one doesn't know—the faces are placid. Most of us go through life with some kind of mask; it might be a smile, a frown, or an attitude. When people are just sitting with nothing to do, they might have this kind of mask on or an introvertive stare. It seems to be alienated or isolating, but then again it could only be resting. The facial muscles relax and the face seems to be expressionless. The expressions on the faces come from the fact that the sitters have been sitting for what seems long to them.

Four Ice Cream Cones, by Wayne Thiebaud. Courtesy of Phoenix Art Museum.

Andrew Wyeth. *The Tolling Bell.* Watercolor. 29″ h. × 21″ w. Arizona State University Art Collections. Note the wet wash sky. The darker values were brushed in next, and the fine lines of tree and steeple were painted last.

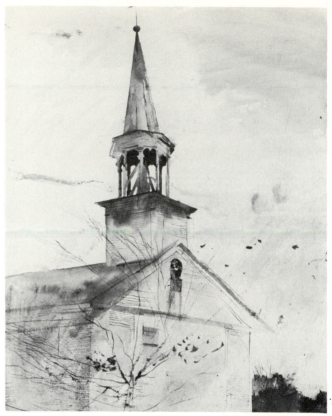

University Art Collections

Photograph courtesy of Scott L. Harris

EARL LINDERMAN

For me, the imaginative world of my art is a slam-bang, dynamite adventure that derives from selective and aesthetic exprreriences. Just as Matisse did not wish to become a "prisoner of reality" in his art, I too have taken the raw stuff of life and invented a panorama of electric personalities that exist in media. I choose to create a new reality in my work, rather than to replicate a given subject or form.

I am very much a traditionalist in the sense of pictorial composition. That is, the space must work for me. In this reference, I seek to thrust forms back and forth in order to achieve an infinity of depth on a flat surface. At times, the forms can ride on top of the plane, or they can drop back. Each part must relate to the whole. The classical ideas of balance, rhythm, harmony, are all present, yet interpreted in a contemporary context.

Color is used to heighten and express form in both an emotional and intellectual sense. For me, it has to be gutsy and speak for itself. I constantly try to find new modes for the manner in which a color, a line, a shadow, etc., can imply or suggest the form or the idea; the manner in which two colors meet, or edges merge, or the slash of a line, or the implication of events beyond what is not apparent—all have pertinence for the way in which I search for expressive form. And it is this search that captures me completely—the artistic and ideational merging of what the skilled hand and the skilled mind can create.

For me, the art falls together as a visual novel or illustrated fiction with no words necessary. There is no time setting for the art, yet one might think of the thirties and forties for they are the years of my experiences. Yet the works are timeless, for I am very much interested in universal themes—the big ideas that deal with life-death-love-hate-mystery-humorous aspects of such heavy subjects. Who has not laughed when they might have cried.

"Doktor Thrill and His Phantom III on a Bleak Winter Night." 38″ h. × 44″ w. By Earl Linderman. Courtesy of Marilyn Butler, Fine Art, Scottsdale, Arizona.

"Pablo Casals" by Marlene Linderman. Lithograph 24″ h. × 18″ w.

MARLENE LINDERMAN

The electronic media has opened a myriad of opportunities for the artist. Thirteen years ago, CBS-TV, Phoenix, invited me to be their courtroom artist. Since that time, the courtroom has been an endless panorama for the production of my art. As a visual reporter for the local and national CBS network, I have drawn numerous county and federal court cases which have included everything from rape, murder, land fraud, bank fraud, illegal aliens, and arson. Several well-known personalities have been part of this drama: attorney F. Lee Bailey, Navajo Tribal Chief Peter MacDonald, physician Edward Diethrich, and attorneys Paul Smith, John J. Flynn (Miranda case), and Percy Foreman. The most recent trial has been those connected with newsman Don Bolles and Richard Kleindienst.

Drawing for television is challenging and exciting. For me, each drawing is a finished art work in itself. And the action that happens in front of my moving hand never stops. This means that I must rely on a quick but artistic eye and memory to capture likenesses, action, gestures, and movements which occur in a very short span of time, (no one stops to pose for the artist who replaces the camera). During each trial, there are moments of humor to break the tenseness of the ordeal. Each trial has its corresponding mood and atmosphere—and the artist sits quietly as the skilled hand and mind records each dramatic moment. It's the job of the artist to capture each person's characteristics and personality.

My subjects are the immediate reality of my work. I interpret each drawing in traditional pictorial terms. Color, line, shape, balance, contrast, placement, etc., are all used to heighten the visual impact and bring home the essence of the story unfolding. The space is defined, and the figures of the courtroom move in and out on the picture surface. The drawings are intended to read as narrative in visual form. Although silent, they speak of the human tragedies involved—the detached spectators, the performers, one force contrasted with another. Often there is mystery, intrigue, and prolonged suspense. As the artist, I try to capture these moments in visual form. The home viewer, who sees the final story, will add the bottom line according to his or her own interpretation. And my art, which is the result of many years of drawing and painting the figure, is crystallized electronically and exhibited over the network.

Bruce Babbitt, Governor of Arizona. Watercolor by Marlene Linderman. Courtesy of Bruce Babbitt.

GEORGIA O'KEEFE

Her career began as an art instructor teaching at several universities. In her thirties she gave up teaching after several art exhibits of her paintings in New York. She is considered an artist ahead of her time and one of the important American pioneers of modernism. She is widely known for her paintings of enlargements of flowers and plant forms, her New Mexico landscapes, and her works of clouds and skies.

GEORGE BRAQUE

When Braque was in his twenties, he met Pablo Picasso; the two of them painted together and originated the cubist style. He thought of cubism as the materialization of a new space and that fragmentation of objects was to establish space and movement in space. In his paintings, he flattened the planes and continued the decorative patterning. Around 1912, he was the first to introduce the concept of the collage, combining fragments of the real with the illusory image. He introduced commercial lettering into his paintings. His subjects were still lifes (fruit, guitars), Greek themes, and a series of birds and moons.

WILLEM DE KOONING

Dutch born, he came to the United States in 1926. His portraits and figure studies of the 1930s are considered a more traditional style of his work. At this time he also did murals including one for the New York World's Fair in 1939. After his first exhibit in 1948, he became an unofficial leader of the artists' group called the abstract expressionists who emphasized the spontaneity of action painting. He is well-known for his figurative theme of the abstract female figure. Concern with abstract spatial problems, the creation of ambiguous and chaotic space, and merging the figure into the environment. The figures were distorted and fragmented, often exaggerated, and always painted with an expressive energy of brushstrokes.

Because of his originality, de Kooning is thought to be one of the most influential painters in the abstract expressionist movement.

EDWARD HOPPER

Starting in 1981, the Whitney Museum of American Art has transported an extensive exhibit of Edward Hopper to major museums across the country. This would have pleased Mr. Hopper, as he was intrigued with the light, the solitude, the feeling of space that he found within the American landscape: the city, the town, the routine, and remoteness. Whether it was a lighthouse on a hillside, a Pennsylvania coal town, a room in Brooklyn, a stairway, a bridge, a street in Paris, or Jo (his wife) in Wyoming, he focused on capturing the presence of light, the solitude of the individual within an environment, and the space involved; that is, looking into a deep space. Sometimes the space was an interior (see NIGHTHAWKS, p. 175) or a street (see NIGHT SHADOWS, p. 84); he was concerned with the powerful handling of the contrast of light and shadows and tried to capture your imagination as you might feel if you were there—the silence, starkness, loneliness, and mystery.

He started drawing when he was very young and "by the time he was ten, he was signing and dating his small sketches. As he grew up and continued drawing, he continued to use himself as a model."

BEN SHAHN

Ben Shahn was born in Lithuania, and when he was five years old, his father was sentenced to Siberia for revolutionary activities. It was during this time that he would spend all day lettering words from the Bible, memorizing Psalms, and studying the stories. This study would reveal itself in the artist's mature work when he would create rich biblical imagery. His father escaped and brought his family to America when Ben was eight years old. When he was just thirteen, he was apprenticed to a lithographer in New York City.

During his career as an artist, he worked for government agencies and did murals for various federal buildings. He enjoyed a variety of media, such as drawing, painting, mosaics, lithographs, prints, and serigraphy (which he often hand colored), frescoes, murals, and graphics. His ideas grew from literature, religion, politics, and everyday life. His style was his own: linear, flat areas of color, distorted proportions—patterns, textures, and shallow space. He continued his concerns with politics, tragedies, religion, and emotional involvement, depicting the people and life around him. (see p. 84, "Television Antennae," and "All That Is Beautiful," p. 189).

LOUISE NEVELSON

Born in Kiev, Russia, she came to the U.S.A. in 1905. She is famous for her sculptured walls which are wall-like reliefs made of boxes and abstract shapes placed together with objects like chair legs and other found objects. The constructions are painted a uniform color—usually black. Her sculptures that began as assemblages turned to more permanent materials like lucite, aluminum, glass, or steel.

JOHN MARIN

His paintings might be considered fragmentary; they are spacious and airy. He was interested in capturing atmospheric effects. Tension and balance created a restless expression in his work. He is known to have said, "You cannot create a great work unless the things you behold respond to something within you . . . the whole city is alive; buildings, people all are alive and the more they move me, the more I feel them to be alive. It is this 'moving of me' that I try to express." (see p. 226)

KATHE KOLLWITZ

A German artist and sculptor, she lived in Berlin. He work expressed her feelings of sympathy for the poor and oppressed and of strong social convictions. The great tragic themes of life were her inspiration, such as mother and child, death, and social protest. She is thought of as belonging to the German expressionist movement. (p. 207)

HELEN FRANKENTHALER

An American painter, she is thought of as an abstract expressionist. She is known for her unique staining of unsized canvas by pouring pigment on the canvas rather than brushing it on. She is thought to be an innovator in colour field painting (where large areas of flat color are applied). Her paints are primarily acrylics and her colors strong, retaining the staining technique.

OTHER ARTISTS TO STUDY

Portraits and Figures

Henri de Toulouse-Lautrec, Paul Cezanne, Auguste Renoir, Paul Gauguin, John Singer Sargent, Edvard Munch, Odilon Redon, Auguste Rodin, Henri Matisse, Vincent van Gogh, Georges Rouault, Jacob Epstein, Constantin Brancusi, Edouard Vuillard, Andre Derain, Pablo Picasso, Kaethe Kollwitz, Edgar Degas, Gustave Gourbet, Rembrandt, Oskar Kokoschka, William Merritt Chase, Ernst Ludwig Kirchner, Alexei Jawlensky, Gustav Klimt, Emil Nolde; Pierre Bonnard, John Sloan, George Grosz, Marcel Duchamp, Egon Schiele, Diego Rivera, Amedeo Modigliani, Joan Miro, Thomas Hart Benton, Marc Chagall, Alexei Jawlensky, Max Weber, Wilhelm Lehmbruck, Rene Magritte, Maxfield Parrish, Salvador Dali, Max Beckmann, Ashile Gorky, Artitide Maillol, Henry Moore, Ivan Albright, Grant Wood, Peter Blume, William Gropper, Ben Shahn, Milton Avery, Marsden Hartley, Andrew Wyeth, Edward Hopper, Leonard Baskin, Richard Lindner, Richard Diebenkorn, Larry Rivers, Saul Steinberg, Robert Rauschenberg, Andy Warhol, Mel Ramos, Wayne Thiebaud, George Segal, Red Grooms, Philip Pearlstein, L Alfred Leslie, Chuck Close, Jack Beal, Philip Guston, Sylvia Sleigh, Alice Neal, Nancy Grossman, Alice Neel, Audrey Flack.

Still Life

Paul Cezanne, Albert Pinkham Ryder, William Merritt Chase, Edouard Vuillard, Henri Matisse, George Braque, Pablo Picasso, Pierre Bonnard, Fernand Leger, Oskar Schlemmer, Joam Miro, René Magritte, Giorgio Morandi, Salvador Dali, Emil Nolde, Charles Demuth, Paul Klee, Alberto Giacometti, Andy Warhol, James Rosenquist, Claes Oldenburg, Mil Ramos, Wayne Thiebaud, David Hockney, Edward Kienholz, Allen Adams, Alan Kessler, Victor Spinski, Wendell Castle, Audrey Flack, Joseph Raffael, Stephen Posen.

Landscape

Paul Cezanne, Andre Derain, Vincent van Gogh, Maurice Pendergast, Claude Monet, Winslow Homer, Maurice de Vlaminck, George Braque, Vasily Kandinsky, Piet Mondrian, Giorgio de Chirico, Fernand Leger, Childe Hassam, Lyonel Fenninger, Marc Chagall, John Sloan, John Marin, Joseph Stella, Marsden Hartley, Paul Klee, Arthur G. Dove, Georgia O'Keefe, Salvador Dali, Yves Tanguy, Maxfield Parrish, Chaim Soutine, Joan Miro, Charles Demuth, Lyonel Feininger, Rene Magritte, Oskar Kokoaxhka, Stuart Davis, Grant Wood, Charles Burchfield, Pierre Bonnard, Edward Hopper, Reginald Marsh, Philip Evergood, Mark Tobey, Max Ernst, Andrew Wyeth, Richard Diebenkorn, Jean Dubuffet, Larry Rivers, James Rosenquist, Robert Indiana, Richard Estes, Wayne Thiebaud, Robert Bechtle, Ann and Patrick Poirer, Red Grooms, Charles Simonds, Robert Smithson, Christo, Walter de Maria, Robert Morris, Carl Andre, Michael Heizer, Deborah Butterfield, Alice Aycock.

Abstract Art

Constantin Brancusi, Jacob Epstein, Max Ernst, Pablo Picasso, Jean Arp, Vasily Kandinsky, Paul Klee, George Braque, Kasimir Malevich, Kurt Schwitters, Robert Delaney, Sonia Delaunay, Marsden Hartley, Arthur G. Dove, Piet Mondrian, John Marin, Georgia O'Keefe, Charles Demuth, Lyonel Feininger, Yves Tanguy, Stuart Davis, Josef Albers, Joan Miro, Charles Sheeler, Joseph Stella, Laszlo Moholy-Nagy, Alexander Calder, Jacque Lipchitz, Alberto Giacometti, Gaston Lachaise, Henry Moore, David Smith, Joseph Cornell, Barbara Hepworth, Oskar Kokoschka, Fernand Leger, Milton Avery, Mark Tobey, Adolph Gottlieb, Wilhelm de Kooning, Ashile Gorky, Jackson Pollack, Barnett Newman, Jean Dubuffet, Ad Reinhardt, Hans Hofmann, Clyfford Still, Marino Marini, Leonard Baskin, Robert Rauschenberg, Peter Voulkos, Louise Nevelson, Lee Bontecou, Mark di Suvero, Karel Appel, Richard Lindner, Richard Diebenkorn, Mark Rothko, Franz Kline, Robert Motherwell, Frank Stella, Sam Francis, Ellsworth Kelly, Kenneth Noland, Jasper Johns, Philip Guston, Morris Louis, Helen Frankenthaler, Saul Steinberg, Bridget Riley, Victor Vasarely, Robert Indiana, Claes Oldenburg, Robert Morris, Sol LeWitt, Donald Judd, Robert Arneson, William Wiley, Larry Bell, Nancy Graves, Suzanne Lacy, Al Held, Jim Dine, Frank Stella, Roy Licktenstein, Tom Wesselman, Francis Bacon, W Ellsworth Kelly, Jose Orozco, Edward Keinholz, Millerd Sheets, Mel Ramos, Ralph Goings, Greg Kondos, and the many artists illustrated in this book.

CHERYL, KELLY, DAVID, AND JAMES

Cheryl, at age 8, writes in her book, *What Is Art?* "I suppose you're wondering what art is? Right? Well, art is anything that you make up or is anything made up of

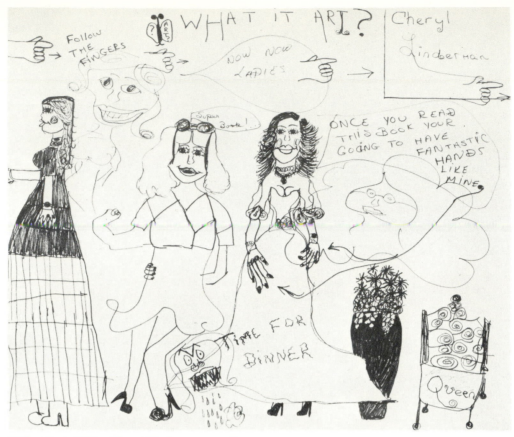

"What Is Art?" by Cheryl Linderman, age 9.

the human mind. Do you think art is hard? Well, art isn't anything at all, it is as easy as learning to tie your shoe. But, even easier! I should know because I am an artist!!! Can you draw as good as me? I bet you can if you try. Art is anything at all. If you take art lessons, you should know because I have and I learned a lot of things."

Kelly, age 12, writes, "I want to be an artist because I like art and I like making art!"

David Mears, age 13 says, "I feel lucky that I can do artwork. It makes me feel good about my ability and at the same time it's fun. I get my ideas from my favorite people, my favorite animals and nature. I like creating things that are realistic and imaginable. I like sculpturing the best because it looks life like and it's dimensional. I wanted to make the eagle because it's my favorite bird. . . . It is important for artists to try different methods."[1]

James Baxter, sixth grade: "I make monster heads. Seems weird? Well, they look weird, too. I start with a hunk of hay dried clay usually made up of scraps of clay that have settled together at the bottom of the clay barrel. Then I begin to carve a monster head from the hunk. Because the clay is scrap clay, it always comes in very odd

shapes. From these shapes I figure out what the monster will look like. For example, I may imagine a huge hump as a bulging eye or a large nose, or if there is a hole at one end it may be the start of jagged teeth. The oddly shaped scrap clay pieces are just perfect for the beginning of a monster head. . . . I thought, since I draw monsters, why not try carving them from hard clay? I tried it and it worked!"[2]

How clearly stated. From these students' points of view, art is a necessary part of one's thinking and life attitudes. Art is for all people. Art is an adventure for one's self and for expressing to others. It is a means of revealing one's ideas; it is an interaction and feedback within one's self, which often is a source for self-motivation. It is a personal vision of your world, made up of the human mind. What we say in our art is a record and enables us to reflect back on it as well as to provide new avenues for learning. Art tells us where we are in our perception, what skills we know, and what skills we want to pursue. Art expresses our feelings to ourselves and to others and helps others to perceive our ideas, feelings, and experiences. It communicates to others our beliefs and values.

1. "The Young Artist," *Arts and Activities Magazine* 81, no. 4 (November 1976):39.

2. "The Young Artist," *Arts and Activities Magazine* 80, no. 2 (October 1976):39.

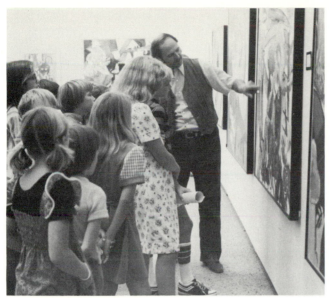

above: Artist Earl Linderman talks about his art to sixth graders at the Scottsdale Center for the Arts.

below: Signing lithographs.

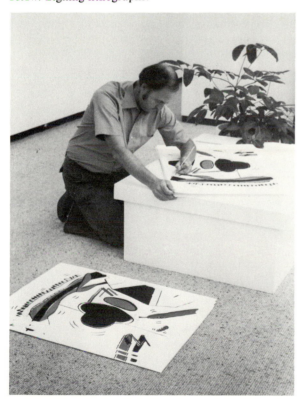

THE IMPORTANCE OF THE MUSEUM

In any one year more people in the U.S. go to art museums than attend all major and minor sports events. The Metropolitan Museum of Art, with 5½ million visitors per year helped add to the 280 million people that attended museums in 1974. Gertrude Stein once said she took a friend through a museum (his first time) and told him that if he didn't do something about the museum, it would do something about him.

Going to San Francisco is an experience in itself. The city is a continuous stimulation of the senses. For an artist, the meaning of visiting a city such as San Francisco involves a myriad of feelings—the visual excitement, the varied landscape, combinations of buildings and people; nature's different offerings of water, hills, giant redwood trees, flowers, coupled with bridges, bakeries, museums, dwellings, and the delicious, cool ocean breezes. Each picture of the city is a painting in itself.

For someone studying the arts, there is no greater motivator than visiting the galleries and museums available in such a large city.

It seems unreal to live on the desert and be able to get on a plane and be in this city in little over an hour. Step off the plane into a different world! For a culturally sensitive person, the museums and galleries are a *must!* There must be exposure to and study of art works.

Our last visit was during a retrospective Henri Matisse drawing exhibit at the Palace of the Legion of Honor. Anyone who has visited this museum knows the facility itself is an aesthetic experience. Surrounded by green, lush foliage, it is situated next to the bay, high on a hillside overlooking the Golden Gate bridge.

Coming upon the exhibit is like suddenly coming upon a grove of beautiful flowers in a walk through a forest.

The drawings covered a span of some forty years. Here in three rooms was the work of one man's life. He did many more drawings and paintings, but these were selective drawings dealing mostly with the figure and its placement in the environment, one of Matisse's dominant recurring themes. There were representative drawings done in different media—but mostly charcoal. His insight into the form, performed so simply in a drawing, is truly magnificent. Next time you see a Matisse, notice how he often used incomplete lines to suggest outside forms, yet the open lines allow your eye to move in and out of the

form so easily. Notice how he worked into the surface of the paper, sometimes rubbing out, to enhance the surface surrounding the form; notice his simple spaces, his asymmetric lines indicating a portrait, his great perception and representation of *eyes* within a portrait—so much expression and emotion in these eyes, yet two eyes are never the same on the same face. See how his lines are sometimes employed to define a form; at other times, a soft repeated line conveys the idea of a form.

The secret of experiencing an exhibition of art is knowing *how to see art*. Joseph Albers has said of his teaching at Yale University, "I don't teach people how to paint, I teach them how to see." And seeing is the secret to learning about art. If you have ever visited an art museum, you may have noticed that some people seem to race through and see an art exhibit in fifteen minutes. Other people seem to take hours, lingering as they walk, looking at each piece of art for several minutes. You may think to yourself, "What is it they look for? What is it they see? Do I see the same things they see? How can I learn to see more? What do I look for?"

The challenge of an exhibition program is not unlike that of an artist standing, with brush in hand, before an empty canvas. The spirit of adventure is felt from within as the new material to be exhibited is brought from the crates.

The often vague information concerning the exhibition limits preconceived ideas of the ultimate installation. As elements of the exhibit unfold, the collection begins to pull together. Developing a concept for an exhibition is very much like developing a painting or sculpture.

There is some special "flicker of light" that some people, artists, have that others do not. The creative process and development of it can best be approached from a high quality art education program. The results of the art experiences will influence our decisions for years to come.

An exhibition hopes to bring to the public a diversity of ideas, new approaches, and solutions along with the artist's statement. At some times the statement is aesthetic; at other times it is social. An exciting exhibition program ignores no direction of art but attempts to merge all in meaningful ways that benefit all concerned. The underlying determinant is validity based on honesty, originality, integrity, and craftsmanship.

John Armstrong, Visual Arts Manager for the Scottsdale Center for the Arts, says the Center tries to break down the elitist concept of what art is; to eliminate the preciousness of what art is. The Center is a multifunctional space which invites total participation in all of the arts—from theater to paintings to music to dance. The Center brings the sincerity of the arts of the public.

THE JUNIOR MUSEUM AT THE PHOENIX ART MUSEUM

Put on your white lab coat, attach your headphones, step inside and be turned on! It's as popular an exhibit with adults as it is with students. Muriel Magenta, Arizona State University professor, commissioned by the museum, along with graduate students combined energies in a team effort to produce a collective concept for this exhibit.

The objective was to place something into the space that would make people wonder about how it ever got there, like placing a ship in a glass bottle. It was planned to be monumental and out of scale to ponder about the sheer fact it was there at all.

What was conceived was 36 Arizona ponderosa pine trees, 10 feet tall and 16 inches in diameter. Each tree weighs 1000 pounds. A floor lift was rented to bring the trees from the forest, a dolly made, and each tree individually lifted, one by one, and brought separately to the museum.

The artists wanted the viewer to walk into the environment and be totally surrounded, be enclosed by a space and invited to participate in the work and become part of it.

The trees stand six feet apart in a false floor. Each tree has a channel carved in it into which is placed audio recording wire and covered with bark; there are three tracks.

Soundingboards: An Environmental Work by Dr. Muriel Magenta, Phoenix Art Museum, 1975–1977.

The trees talk. Songs with color references, sound tracks that include colors, nonverbal tracks that include water running and birds chirping. The relationship of the technological and plastic synthetic media and the natural media play against each other. The sounds are a study in contrast. The trees appear to have human characteristics even though they are inanimate objects. The listeners have a surprise attitude of inquisitiveness as they hear the unusual associations. After all, it isn't often that one runs into a talking tree.

The trees are in an abstract situation; the sounds are a contrast of verbal words and nonverbal sounds. The room has an eerie surrealistic dreamlike quality as one enters, almost like stepping into a painting. One listens for the leaves to rustle. All trees are beautifully textured and invite one to feel the surface.

The students hesitate for one moment, and then begin looking for the place to "plug in." Because of the three tracks, most people hear something different. Students speak out louder than normal, "Must be raining," "I hear birds," "Drum beats," "White," "Blue." We moved freely with lots of laughing, giggling, surprise, and amazement, then moved to another tree. It was fun to touch! Afterwards, the students shared what they had heard, still with a look of unbelief on their faces.

THE SCOTTSDALE SCHOOLS "GREAT MASTERPIECES" PROGRAM

With all the concern about rising costs of education, the Scottsdale Fine Arts Commission, a group of concerned parents ably directed by Pam Krewson, has coordinated a program of art appreciation for the Scottsdale elementary schools at no cost to the school district.

"The Great Masterpieces" program is totally the result of the involvement of volunteers, generous city businesses, and participating school PTAs. Each elementary school that expresses an interest in the program is encouraged to find a parent to be that school's coordinator. The coordinator, in turn, signs up parents of the school children to be "art guides."

An "art guide" visits the classroom twice a month, with a reproduction of a known art masterpiece and spends 10–30 minutes talking about that reproduction. The time she spends in the classroom depends on the wishes of the teacher, the interest of the students, and the knowledge of the art guide.

Before going into the classroom, the art guides are provided with a training program by the "Great Masterpieces" program. The training includes five one-hour slide talks on various periods of art history, presentations about media and perception, techniques for working with children, and a trip to the Phoenix Art Museum. The slide talks and many of the other presentations are provided by docents from the "Speaker's Bureau" at the Phoenix Art Museum. Last year the Art Guides also toured the art museum at Arizona State University, which has an especially fine collection of American art.

The lectures include "The Use of Media," "Taking a Picture Apart," "Nineteenth-Century Art" (neo-classical, realist, romantic, barbizon, preimpressionist, and impressionist), "The Post-Impressionists," "Fauve," "German Impressionists," "Modern and Contemporary Periods of Art," "American Art," "The Use of Books in the Program," and "Classroom Techniques for Working with Children." Participating volunteers receive pass-out sheets with a synopsis of the talks.

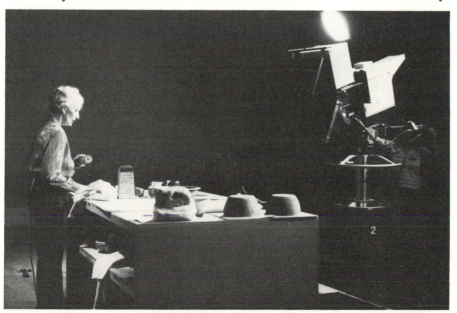

A television crafts series, developed for the Rio Salada School District in Phoenix by Marlene Linderman, reaches vast public audiences.

Each school had Shorewood reproductions, according to the number of classrooms, and a corresponding file that contains written information about the artist, the painting, and the artist's time and art movement. The files are resource material for use by the volunteer parents.

The program for the school children begins in November and continues through April. The reproductions are left in the classroom for about 10 days, so each participating elementary school student should become well acquainted with 11 or 12 "Masterpieces" each school year.

The money that is given by the participating schools' PTA and has been given by local business is used for buying reproductions. The program started with 60 reproductions andn now has over 200. The money has also been used for buying laminating and finishing materials. All the laminating is done by the parents in the school.

The enthusiastic response of the involved students has proved the program worthwhile and a beneficial addition to the art curriculum of the Scottsdale elementary schools.

LOOKING AT ART

Each student's response to an artwork will be unique, unusual, revealing, and a personal interpretation of ideas and concepts based on his past artistic encounters. Past encounters are influenced by the home environment, cultural and social heritage, level of perceptual awareness, inherent art abilities, expressiveness and imagination, and the student's previous art skills. The teacher leads the initial classroom discussion. Through classroom analysis of the major period of art in history, the children can discover that art has many visually fascinating and always changing forms and a variety of purposes. Through discussion, analysis, and viewing, personal attitudes and concepts toward art are developed.

The following resources will aid the classroom teacher in discussing aesthetic experiences with the students:

> Art teachers and consultants
> Artists in residence programs
> Visits to artists' studios
> Visits by artists to the classroom
> Original works of art
> Reproductions, small study prints (postcards)
> Slides, films, and filmstrips
> Collecting of beautiful natural forms
> Multimedia presentations
> Visits to museums and art galleries
> Books, magazines, and television programs concerned with art
> Artifacts and folk art, art trunk exhibits
> Artmobiles, traveling kits, and exchange art exhibits
> Centers for displaying art and art-related forms
> Museum Speakers Bureau

USE YOUR IMAGINATION

Form picture frames with your fingers; select and focus on various interesting parts. Discuss why they are interesting to you.

Study the artwork. Then close your eyes and describe the artwork. Try describing the artwork without using words, just gestures and sounds.

Pretend you can walk into the painting. How would you feel? What would you see?

Take poses of figures in the painting or sculpture. Invent body movements as you feel the figures might move.

Invent new titles for the artworks. Invent stories that relate to the works.

Pick out something special about an artwork, such as a color or shape. Take an adventure with a color and describe what you might see on your pretend trip through the painting.

Study expressions and gestures of figures in an artwork. In an abstraction, examine the movement or line direction. Imitate these gestures and expressions with your body.

If you could express a painting in one movement, taste, smell, or touch, what would it be?

Write a fun poem to the artwork. Invent musical sounds, rhythms, or movements.

From the art piece, describe what you think the artist must have been like.

Improvise a play or skit about the art piece. Invent a mystery story; look for the clues to solve the mystery.

Describe what the artwork would be like if it were supersize, or if it were a miniature? Or perhaps done in a different medium?

How could you fantasize about this art piece?

If you had a dream about this art piece, what would it be like?

If you could, how would you change this artwork?

Look for relationships and transitions between succeeding paintings.

Explore art through games, such as "I Spy" and "Treasure Hunt."

If you could touch this painting, what would it feel like? If the painting could make music, what would it sound like?

Who and what type of people are in the painting? If they could come alive, what would they be like or be doing? Look for the details of the hands, faces, clothing, and other things.

How would it feel to be inside this art piece? What would the outside look like looking from the inside?

Head(s) Improvization. Oil pastel drawing by Karen Appel. 28 1/4″ × 34 1/4″.

ART ANALYSIS AND DISCUSSION

Take a careful look at the art elements and art principles. Direct attention to the articulation of lines, colors, shapes, textures, and patterns, and how they relate to balance, rhythm, harmony, unity, proportion, repetition, contrasts, similarities, and their significance. Discuss how these ingredients are structured into the final composition. The teacher could list these terms and consider them in relation to the following:

Materials used: What medium has the artist used (paint, stone, wood, pencil, silver)? How has the medium played a part in helping to convey the ideas and feelings that the artist intended? Would the artist's idea be different if expressed in a different material?

What is being painted? The times, places, feelings, ideas, beliefs, social and cultural differences, expression of ethnic groups, story line, abstract qualities.

Composition and organization: Discuss how the art elements function together. Does the design emphasize the message? Which shape is closest to you, farthest away? What is the interval between colors and shapes? Do colors move fast to your eye? How has the artist used colors and values to evoke feelings?

What do you see first in the artwork? Where does your eye move next? Why? Does color or line carry your eye? How does the artist achieve space? Is it with color? Do shapes come forward or recede due to their color?

What type of people are they? If they were alive what would they say or do? How do they make you feel? Do the details of the clothes give you some clues?

Students find delight in and respond enthusiastically to discussions of work of art. The instructor can provide meaningful background information regarding the artwork that is being studied. Such information may include art processes or materials, subject-matter insights, background of the artist, time and place of production, and other pertinent data relating to the artist or the work. Keep lists of new art terms and art vocabulary. Keep the discussion periods open-ended, and always encourage critical statements that delay premature judgments concerning the artworks.

What is the art medium? Is this work of art a drawing, painting, sculpture, print, tapestry, or an architectural form?

Tell us about what you see. This may be the subject matter, an emotional reaction or feeling toward the content of the art piece, or a description of the formal art elements (color, textures, shapes).

What is the artist saying (the message)? Is the artwork telling us about something that had meaning for him? Something about the times in which he lived, his beliefs, the scenes or customs of the day? Something about his culture and traditions? Is the artist's world different from or similar to yours?

Does the artist express himself in his own unique way? Discuss how this art piece is different from any other art piece. How does the artist transmit his ideas and feelings?

Does the artist show me new ways to see that I have never seen before? New ways to see life? New ways to understand other people? Or new places and times?

"Indian with Star Shield" monoprint by Fritz Scholder. 31″ × 23″. Courtesy of Marilyn Butler, Fine Art, Scottsdale, Arizona.

What is the artist trying to communicate through his work of art? What is the most important statement in this artwork? Is he trying to communicate a feeling? Does the artwork make you feel a certain way? When you see the artwork, do you feel excited, joyful, angry, unhappy? Why do you feel this way? Certain colors, the angular forms, or rough textures?

Does the size of the art piece make a difference? Is the work of art intended for a home, museum, gallery, public building, school? Or, is it to be used as a decorative element such as jewelry or a woven garment.

Name the style: What style has the artist used? What period is it from? Is it abstract, realistic, nonobjective, surrealistic, pop art, and so on.

Describe the technique: This is the individual manner in which the artist has used the tools and materials to create the art work. For instance, are the tones softly blended, such as the pencil drawings of Ingres? Or does the work indicate the linear quality of one of Rembrandt's prints? Can you see large brushstrokes?

Compare the art piece to others by the same artist: Is this piece part of a larger series? Is it unique in its concept, or might it be a change in direction for the artist?

Compare this art piece to works produced by other artists of the same period: Is this a unique and personal statement, or is it imitative of another artist's work? What makes a work great? What makes an artist great?

How does this art piece make me feel and why? How do I feel about it? Do I know the artist a little better because of this art piece?

Does this art piece have a place in history? What does it reveal to us about the times in which the artist lived?

How did the culture influence the artist and the work? Was the artist supported by a patron of the church or by royalty? Was he from Africa, Egypt, Alaska? How did the depression of the 1930s influence the arts, such as the WPA public murals and the emerging film world?

How does the art piece function in history? What does it reveal to us about the times in which the artist lived? What is the intended use, such as an African carving, a Russian Icon, or an Egyptian fresco? Was the artist a professional painter or a folk painter? Did the style change after events in the artist's life? Did the artist follow a movement or was he/she an innovator?

What meaning does this art piece have for the school and community?

Study the artist as a professional person.

If you were buying an art piece, discuss how to select it and other decision-making factors.

Discuss how to build a community-arts collection: Take sides and argue the pro and con of an art piece.

Discuss the relation of other art avenues such as filmmaking and the movies. The importance of movies and television in our contemporary society.

Making a judgment: Encourage students to delay making a judgment about an artwork until the above issues have been discussed. Final questions might be "What do you think of this artwork?" "Do you like this artwork? Why?"

EXAMPLES: TEACHING ABOUT ARTISTS

HOW WE INTERPRETED THE STUDY OF JOAN MIRO IN THE FOURTH GRADE

Project: Learn about Joan Miró and surrealism. Create drawings in the manner of Miró.

Lesson I: Acquaint the students with Miró and his style of painting and surrealism.

References used:

Gasser, Manuel, *Joan Miro.* New York: Barnes and Noble, Inc., 1965.
Matthews, J. H. *Introduction to Surrealism.* University Park: Pennsylvania State University Press, 1965.
Walton, Paul H. *Dali/Miro: Masters of Surrealism.* New York: Tudor Publishing Co., 1967.

We began by discussing music and its many variations—rock, country, folk, classical—and the various composers with their individual styles. We carried this idea into discussion of art and the many types of art that students have observed on visits to galleries and museums: landscape, still life, psychedelic, light paintings, etc. Mention was made of various artists with unique styles.

The teacher presented a simplified explanation of surrealism and mentioned that a variety of artists have practiced this type of art. One such artist is Joan Miró. Photographs of Miró were shown on the opaque projector, and a brief resume of his life was given. A few of his earlier works were shown to illustrate how he changed his style. Then, additional plates of his works were shown. The students reacted with interesting comments. Special emphasis was given to his 1940–1955 period.

Lesson II: Some of the students' favorites of Miró's works were reshown, and there followed a more detailed discussion of the style, ideas portrayed, and the repeated symbols he used—colors, shapes, lines. The students were asked to close their eyes and do two things: (1) invent a symbol of their own to be their trademark and (2) think of some feeling, place or idea they would like to represent in a drawing. They were asked to fold a large piece of newsprint and jot the idea and the secret symbol inside. Then they were to try two illustrations a la Miró, using one of his characteristic symbols and their own symbol in each illustration.

Imaginative paintings by fourth-graders after they had studied Joan Miro. Emphasis was on the use of unique "secret" symbols. Below is a painting after a suggested title, "Minibike Trail at Four Peaks."

Lesson III: The students were then asked to do a larger illustration, using the same theme, or another of their own choice, and their own symbol and perhaps one Miró symbol. They were to create and title the drawing, selecting materials from felt pens, crayons, or pencil.

Lesson IV: This time paintings were to be done on an assigned theme, version of an Arizona desert happening. Suggested titles were "Siesta in the Sun," "Lost in the Superstitions," "Horseback at Dawn," "Stranded on Camelback Mountain," and others. Or, they could create an Arizona feeling with lines, colors, forms, etc. They were encouraged to use paint or to combine paint with other materials such as construction paper.

Following the lesson, students individually showed their creations while classmates tried to identify their secrete symbols. The students thoroughly enjoyed this project.

Miriam Chynoweth, teacher

PAUL KLEE AS INSPIRATION FOR SECOND-GRADE DRAWING AND PAINTING

Motivation: The children in my room were grouped around me in a semicircle while I showed them pictures of paintings by Paul Klee. Two books were checked out from the library. As the teacher, I made no comments. The children exclaimed as I turned each page and showed different paintings. In the discussion that followed, the children commented on how well they like the paintings, the various shapes, the brilliant colors, the nonrealistic style of the paintings, and the surrealistic quality—meaning the unreal people and places. We left the books on the table, available for the children to look at. Some looked at them alone, but most liked having his "best" friend with him to talk to about the pictures. A high level of interest was sustained; they didn't seem to tire looking at them.

Working time: Every child thought it would be a great experience to paint a picture, looking-through-the-eyes-of-Paul Klee style. Not one child said he couldn't do it; they liked the idea tremendously. Each child did his "own style" of Paul Klee painting.

The students had their choice of paper—colored, white, or manila drawing paper. They could select from crayons, watercolors, or combinations of materials. One child pointed out that he would be unable to get the color effects with crayons that Paul Klee did with oil paints. I thought that was a good observation. There was no time limit; some continued working on their paintings for two or three days' free time.

This project was a delightful experience for the children. One of the most interesting reactions and discovery was that one could draw any way one wanted to, and it was just great! Their artwork did not have to be "real" looking. They were very enthusiastic and pleased with their drawings and paintings.

Hazel Scott, teacher

WE STUDIED MARC CHAGALL IN THIRD GRADE

Motivation: We wrote Marc Chagall on the chalkboard. We looked him up in the encyclopedia and discovered he was an artist. We looked at his paintings and tried to think as he did. We looked on the map of France and Russia to find the areas he lived in. We gathered a special table of books, clippings, and photographs to be studied by students. Note: one of my slow readers became so interested that over the weekend he went to the library and checked out two more books on Chagall. He proudly brought them in on Monday to add to our art table. On the opaque projector we studied his paintings, and I presented a thumbnail sketch of the artist's life. The children made some interesting comments: "The paintings are prettier than the windows"; "Look how one thing is painted on top or inside another"; "Colors are so deep"; "Notice the animals, churches, couples." The class preferred the paintings of *The Juggler, The Poet, I and the Village,* and *The Birthday.*

We wrote the following words on the board and discussed them in relation to Chagall and his paintings: *contemporary, colorful, fantasy, fanciful, dreamlike, happy, poetic, life, marriage, love, death, musical.*

The class did a preliminary sketch. Then they invented ideas from their imagination in a Chagall interpretation. They used larger paper and choice of materials. I covered the drawings with a clear plastic spray. Each child presented his idea before the class. They all enjoyed doing this project.

Mary A. Baltz, teacher

Marc Chagall. *White Crucifixion.* Oil on canvas. 61″ × 55″. Gift of Alfred S. Alschuler. Courtesy of The Art Institute of Chicago.

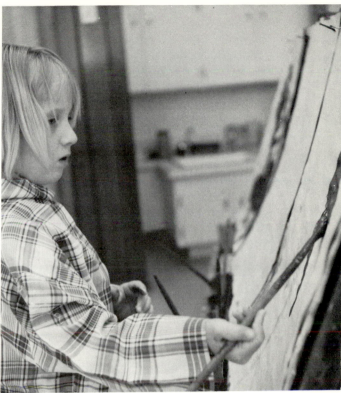

You're great Sarah Jo! Age five.

Part 2

Art: The Visual Structure

The creative artist learns what he needs to know to fulfill his vision and discards the rest; in short, he absorbs only that which is personally meaningful. . . . To speak about texture, or line, for example, divorced from all other considerations within a work of art, can be misleading, for texture, line, value, and the rest are tools in the service of a vision and not an end in themselves.—Bernard Chaet, *The Art of Drawing,* New York: Holt, Rinehart & Winston, Inc., 1970.

The upcoming chapters present the art concepts, or ingredients, for use in practicing the visual structure. Artists and art appreciators understand that the art concepts are not separated within a work of art and that all art elements and design principles build upon each other to form the total content of the work. Each art concept interrelates with the other and influences the total vision.

Artworks contain subject matter (realistic or abstract), medium and art concepts. The art concepts are the design principles (balance, rhythm, dominance, contrast) and the art elements (line, shape, value, space, color, pattern, texture). We think of these components when we discuss a painting, sculpture, crafts, architecture, clothing, cars, utensils, and product design, as well as music, poetry, literature, theater, and dance.

There cannot be "one set" of procedures or sequences for you to follow. You, the teacher, are the motivator, the supplier of the art challenges. The sequences you choose to select can be as varied as the needs and goals of your students and classroom. The included studies are only the initial stepping stones into the unfolding of the secret of art.

The studies offered will deepen your insight and knowledge about the process of art as well as open new possibilities to select, imagine, and develop artistic skills. The goal today is to explore oneself and find one's great potential in and through art. Included are art concepts, skills to achieve, student examples, motivations, grade level practice, and artists to study.

What and *how much* you include determines your composition.

6

Design Principles

The young child is a natural, intuitive designer. The graphic marks on a surface are spontaneous, instinctive rhythms of expression. His unconscious art usually germinates with a high sense of organic unity, and the resulting designs are often dynamic forces in themselves.

A drawing is a reflection of your special self. During the act of creating art, your thinking is focused on the magical process of visual perception. Through our eyes, our optical receivers, the brain transforms energy to our computerlike nerves and sends skill forces to our hands. The drawings that result are direct images of your unique self; you then communicate in a nonverbal manner—the same way the artist does. You and the artist create a "pictorial language."

Your art also tells others how you see and feel about the world; in turn it also tells *you* about *you*. You are expressing a unique world, something that before has been inexpressible. Your art brings into reality a fragment of life. In turn, the drawing image takes on a reality of its own.

A visual structure is a composition, arrangement, or an ordering, beginning with the first pencil mark or brush stroke on a surface and continuing until the final detail is completed. Design as integrated parts takes place in all forms. The fundamental concept of design is to organize the design elements into a dynamic, integral, unified whole. Design exists everywhere from all of nature, to all handcrafted forms, all art, all architecture, all music, all of written form, all dance, all theater, and in all of life's activities from preparing foods to house arrangement. The artist uses the visual structure or design as a tool to analyze and compose the art product.

This area discusses the visual structuring of art forms, or the parts that we can analyze that make up the design. We focus on visual structure by perceiving and creating objects in our life and as a part of our environment. John Dewey states that design is an essential seeking for order, for reason, and for structure out of chaos.[1] The act of organizing artistic form is a universal desire to compose.

Visual structuring can range from simple to complex. It can be intuitively achieved, as it often is with young students, or be complex conscious relationships, as is often the intent of the artist. We, as teachers, can help develop such design awareness in students. There

1. John Dewey, *Art as Experience* (New York: Putnam, 1958).

are no formulas for producing "good designs," but the search for organizing the artistic qualities is the *creative process* in a work of art. The traditional components of composition (or the artistic qualities) are lines, shapes, forms, colors, space, patterns, and textures. These are the fingers, the spine of vision. Without these qualities, all the pieces fall apart. As art producers, the artist, young or old, places these qualities into visual relationships. These relationships are both conscious and deliberate and unconscious or spontaneous. We can direct attention to these artistic qualities so that the students of design incorporate both thinking systems.

Every individual brings to these visual qualities the art elements and visual relationships (the arrangement of the elements).

All designs carry the individual mark of the creator, reflecting our personalities, feelings and emotions, statement of message we express, our perceptions, our experiences, and our way of ordering the visual elements.

We respond in unique ways in creating design. In understanding design, we will need to investigate the design processes, or the ways of going about expressing with order and with variety. This kind of study in education will help students clarify their thinking about ways to read art objects, to respond to their environment, to establish their own visual value systems, and to assess and form judgments in art preferences.

We begin by analyzing, by sorting out what we *see*. We *see* chaos. We take this visual information and begin to organize it in our minds; we create order from what we see. All of what and how we see is influenced by our emotions. We see likenesses and differences; we see order and variety, between lines, shapes, colors, patterns, space, and textures.

We rarely see forms in isolation; we see them in relation to each other. The impact of a color depends on the impact of other colors in relation to it and surrounding it and on how the colors are used together. The relationships change depending on size, the existence in space, the tension (balance) between spaces, the dominance of a form (center of interest), and the movement and direction of forms (rhythm). According to L. Moholy-Nagy, "Design has many connotations. It is the organization of materials and processes in the most productive, economic way, in a harmonious balance of all elements necessary for a certain function. . . . He must know that design is indivisible, that the internal and external characteristics of a dish, a chair, a table, a machine, painting, sculpture are not to be separated. There is a design in organization of emotional experiences, in family life, in city planning, in working together as civilized human beings . . . there is no hierarchy of the arts, painting, photography, music,

poetry, sculpture, architecture . . . they are equally valid departures toward the fusion of function and content in 'design.' "[2]

From L. Moholy-Nagy we understand that content, materials used, processes, and function are part of the whole design.

In all painting, drawing, and the arts, we first consider the idea. What is the idea you want to express? Do the elements and their arrangement focus on your idea? Do the materials and tools selected expand the idea? Do the rhythms of the colors, lines, and masses suggest a beat or visual music? Do the textures, patterns, spaces, and dimensions add to the orchestration of the art piece? Let's discuss how we organize art into exciting art products. This process is initially one of intuition and feeling.

BALANCE

Balance is the act of visual equilibrium determined by weight, directional forces, and opposing tensions in a work of art. You and I are aware of equilibrium within our bodies. When we are balanced within a space, we feel comfortable. When we fall, or are off balance, we feel uncomfortable. So it is within a picture surface. When the design within a picture is in balance, affected by everything happening within the picture space, we feel it is in balance. If the structure is unpleasant to our sensibilities, it is visually pulling or attracting an upset somehow. We feel psychologically unequal. Balance is an illusion of forces. The artist, or creator, determines what looks right. As in our physical bodies, balance is achieved by a center of gravitational pull that is gained by forces of opposing strengths pulling from opposite directions. In other words, one factor influences the other factor within the total picture structure. Our eye gains perceptual balance when the different weights feel right.

Asymmetrical balance: unequal distribution of forces on (either side of a central axis) either side of the picture.

Symmetrical balance: equal distribution of forces on both sides of the picture. For example, in an asymmetrical drawing, a large object on one side of the drawing creates an overpowering feeling—a heavy WEIGHT.

Radial balance: all the art composition radiates from a central point.

Weight: The weight often depends on the location in a drawing. For example, if you balance a large, heavy weight on one side by three smaller weights on the opposite side, a balance occurs, just as you would think of balancing a scale equally. A weight, or large form, in the center of a composition, does not disturb balance. A large

2. L. Moholy-Nagy and Sibyl Moholy-Nagy, *Vision in Motion* (Chicago: Paul Theobald, 1947).

object in the upper part of a design is heavier than one located on the lower. A large object on the right feels heavier than one placed on the left. Weight is also affected by size. A large form will be heavier than a smaller one. An object placed alone will appear heavier than an object surrounded by other forms. A geometric shape appears heavier than an irregular shape. An object placed at the bottom of the picture appears more stable and appears to have weight because of gravitational pull.

In order to balance a drawing, you will have to organize the lines, shapes, values, spaces, colors, patterns, and textures until they feel right to you. There are several hundred possible solutions. To balance comfortably, you will have to use your own judgment.

Concepts Chart: Balance

Discuss "feeling" balanced.
Discuss balance in nature.
Discuss balance in architecture and spaces.
Discuss balance as found in artist's works.
Discuss how balance can influence mood.
Study symmetrical design.
Study asymmetrical design.
Study radial design.
Discuss how "weight" affects balance with location, size, colors, singly or in combination, geometric/irregular.
Discuss balance as it relates to other design principles: Rhythm, Contrast, Dominance.
Discuss balance as it relates to the art elements: Line, Shape, Value, Space, Color, Pattern, Texture.
Discuss balance in decorative art works.
Discuss balance in abstract art works.
Discuss balance in realistic art works.
Discuss ways balance can create a mood or feeling.

DOMINANCE/EMPHASIS

Dominance is a focal point of greatest emphasis or stress. Emphasis, center of interest, or dominance can be created by:

- Placement in the center
- Brightest color surrounded by more muted colors
- Size—a large object balanced by smaller objects or vice versa
- Value—the darkest form in center of lighter forms or vice versa
- Contrast—differences in forms, colors, textures, shapes
- All-over similar designs (Some works do not have focal points.)
- Changing the sequence to create a focal point

Concept Chart: Dominance/Emphasis

Discuss how to create a center of interest with: size, placement, color, value, contrast, balance, rhythm.
Discuss how to create dominance in line, shape, value, space, color, pattern and texture.
Discuss dominance in decorative designs.
Discuss dominance in abstract art works.
Discuss dominance in art works with subject matter.
How can dominance/emphasis create moods and feelings in art works.
Discuss how artists use dominance/emphasis in various ways.
Discuss how artists create centers of interest or focal points.
Discuss how dominance or centers of interest are established in architecture.
Discuss dominance in a psychological use.
Discuss how we have focal points in our lives.
Discuss how society has certain dominant characteristics.
Practice achieving dominance-emphasis; centers of interest; focal points with various media.

RHYTHM/MOVEMENT

The artist may create rhythm or movement with a regulated flow of art elements or combinations of elements. The repetition or beat can be pleasing or not pleasing, just as in music.

Continuity, flow, or repetition of a line, shape, value, or color suggest a rhythm or movement. If nothing interrupts the movement, it suggests a moving force and direction.

A curved line suggests a different movement than a straight line. A sequence of images can suggest motion and rhythm. Multiple, overlapping imagery suggests movement through time (such as Marcel Duchamp's painting, "Nude Descending a Staircase").

Repetition of an object with some changes, such as diminishing size or value, can indicate movement. If spaces between art forms are equal, there is feeling for order and unity. If spaces between art forms are different, there is great amount of variety and little order.

Movement can move across the picture. It can be implied by the path of a line traveling from deep space toward the picture plane. It also can be from foreground or middle ground to background.

Concept Chart: Rhythm/Movement

Discuss meaning of rhythm such as flow, repetition.
Draw a design with sequential images.
Draw a design by varying the sequence of images.
Discuss repetition of lines, values, shapes, colors, etc.
Discuss repetition of design with changes of lines, shapes, etc.
Draw or discuss spaces between art forms if they are equal (order and unity), or unequal (variety).

Discuss movement across a picture.
Discuss movement by a path from deep space forward.
Discuss movement with forms in foreground, middleground and background.
Discuss rhythm in pattern.
Discuss rhythm in decorative designs.
Discuss rhythm in abstract designs.
Discuss rhythm in drawings that use subject matter.
Discuss the relationship between rhythm and pattern.
Look at art works for rhythm using similarity, repetition, movement, unity, variation.
Identify rhythm in nature, in architecture, in designed products.
Discuss rhythm and pattern in relation to cultural objects (such as Navajo Indian rugs, see p. 178).
Choose three art reproductions in the book and discuss how artists use rhythm, movement and pattern as important design elements.

CONTRAST

Similar art concepts (the art elements and principles) create harmony and unity. When they are opposites, or contradictions, there is contrast, such as contrasts between light and dark, thin and thick lines, hard and soft edges, smooth and rough textures. Differences add visual interest and focal points.

Objects that are similar in line, size, shape, color, texture, pattern, or space provide the feeling for order; objects that are different in line, size, shape, etc., create variety and greater contrast.

Concept Chart: Contrast

Identify contrast in all the art elements.
Discuss and draw contrasting lines (thin, thick; rough-smooth; etc.).
Discuss and draw contrasting, shapes, values, shadows.
Discuss and draw contrasting spaces (in art, architecture, etc.).
Discuss and draw contrasting colors, patterns, textures.
Discuss contrast in nature.
Discuss contrast in the environment, in our living patterns.
View art works and identify ways the artist used contrast.
Identify contrast in decorative design.
Identify contrast in abstract art.
Identify contrast in art works that use subject matter.

SUMMARY

Composition is an orderly arrangement, placing the parts together into a whole—whether composing a musical piece, a dance, a painting, an essay, or a poem.

How do you know when you arrange something to its "best advantage"? Much of the decision is based on knowledge, amount of previous experience, exposure to the problem involved, study of other artists' solutions, and, very often, on pure intuition. It stands to reason that a person who is just beginning will have a different solution than someone who may have been involved in designing all of his life. Why one person "likes" one house and another "prefers" another designed house involves personality traits, environmental conditionings, and "vogue" pressures.

We may not be able to explain intuition or feelings, but we are able to examine certain design principles. Those design principles, or concepts, are *balance* (a felt visual weight), *dominance* (areas of emphasis, centers of interest, focal points), *rhythm* (a repetition of a line, shape, color, etc., to provide a continuity or flow; this can be regular or irregular), and *contrast* (the interaction of opposites).

Only you can decide what you will include in your artwork. Suppose you are working with a still life and have many objects to select from; you may not wish to include them all. Eliminate some of them; or change the position of some. In a portrait, you may wish to eliminate an eye to heighten the emotional attitude of the subject.

Decide how you will handle the space—what is your point of view, realistic or imaginative, flat or in-depth. Will the forms have volume? Shading from a light source? Will the shapes be flat and two-dimensional? Will the colors be emotionally interpreted? Will the forms be exaggerated or distorted? Overlap and interpenetrate? Will there be light against dark, dark against light, positive and negative spaces? Consider the outside shape of the paper, whether it is rectangular, square, round, or irregular; when many beginning students draw, they place the main object in the center of the space and scribble fill-in meaningless lines that do not relate to the design. All of these concepts will determine the outcome of your design. (See concept charts for line, shape, space, etc., for performance levels.)

Remember, you the artist have the privilege to change the design as you will. When someone looks at your drawing a year from now, he will be considering the design, theme, composition, not how the subject actually looked when you drew it. A design is successful when it is complete in itself and one can respond enthusiastically to it with excitement and interest. *Art itself is a continually challenging adventure.*

Art, a challenging adventure.

Students interpret birds with lines. Examples are from kindergarten through grade six. Drawings were done from photographs as well as pets brought from home and trips to the zoo. Note how first-grade drawing (top left) is relatively flat; sixth-gade drawing (bottom right) shows dark edges, overlapping, joints, and twisting forms. All birds have textural qualities.

Upper-intermediate examples.

The Art Elements: Line

The design concepts just discussed indicate to us how to compose or place together the art structure, whether realistic or abstract. Next we can consider the art elements, the specific art workings of the art structure, and the tools we use to construct our art.

Lines are everywhere in our vision, are edges of forms, are drawn in a variety of directions and with many kinds of tools. They are often the beginnings of paintings, sculpture, and crafts. They are a compositional element, can indicate spatial illusions, and can express the feelings of the artist.

Shapes are varied in proportion and size; contain forms that can often be identified; can indicate symbolic meaning; can be two- or three-dimensional; can create tension by their proximity; can be overlapped or exposed; and can be realistic, imaginative, abstracted, or stylized.

Space is determined by placement on the picture plane (near or far), is created by color, value, and shape; can be positive or negative; can be opened or closed; can express emotion with strong contrast (floating-fore-shortening); and is emphasized or minimized (bird's-eye view or flat space).

Color can be derived from pigment or light, has value and intensity, is transparent or opaque, can have symbolic meaning, often expresses moods, and is related to colors around it.

Pattern is lines, shapes, colors, or textures that are repeated at intervals. Nature is repetitious with pattern; patterns are found on man-made objects, such as in textiles and on pottery in eating utensils. Patterns are found in music, dance, poetry. They have order and unity or contrast and variety.

Texture is tactile (can be touched) and is visual (an illusion). It can be natural or man-made; it can be simulated with line, paint, or color.

LINE AS EXPRESSION

The very young child expresses himself when he does scribble line drawings. The pure joy of defining a line seems to hold kinetic fascination for him.

In the history of man, the earliest expressions were cave drawings found in Spain and France. They were highly personal, symbolic, individual in concept, and interpretive.

The Egyptians invented symbolic forms with lines to express their religious and social attitudes. Their drawings were designs conceived in flat forms as though the person or object were flattened on the wall surface. Did you ever notice that the figures seem to move along on a straight line, with no depth indicated? Children do this in the early stage of drawing when they put people, houses, everything along a base line at the bottom of the paper.

The early Christian artist represented the human form much as the child draws during the schematic age—simplified, repeated shapes and forms drawn with simple flat lines and shapes. The forms represented symbolically what the artist felt rather than how he actually saw the form.

Medieval artists concerned themselves with illustrating scriptures and building architectural structures to glorify Christianity.

It wasn't until the Renaissance that man began to draw what we might call the visually representative image. He drew the form with modeled interpretations, discovering how the light on the object created depth and shadows, modeled relationships, and forms graduating from dark to light or light to dark, with smooth tones and scenes represented in perspective. The flat picture plane was established, and everything visually represented was thought of as if there were a piece of window glass in front of the viewer, and objects were drawn on the glass as they might appear, indicating vanishing points, perspective. The student becomes aware of diminishing space but doesn't begin to indicate this awareness or interest until the fifth or sixth grade.

LINE AS A TOOL

As your finger moves, you create a line. It is a record of action. You are moving in a direction; you are creating a defined motion and are flowing in space. Your path of vision is a line! *Now!* Let your finger become a pencil, pen, crayon, felt-tip pen, charcoal, chalk, brush, or colored pencil. Let your hand and eye become one unit of thought so that they become a visual adventure in space together. When a line moves up, down, in, out, in front of, or behind a form, you are able to *feel* the direction as well as see it. When you draw a line, you can feel it through your fingers, hand, arm, your whole body, because you are training your eye, mind, and hand to explore together. Stop right now and spend some time discovering different kinds of lines and edges and how they move! How they feel! Think of your own body movements in terms of directions and lines.

Have you ever looked at your neighbor and thought of him as a bunch of edges? When you have finished *looking,* pick up your tool and experiment. Try to remember the various kinds of lines (edges) that you saw. Make a drawing using lines that you have discovered. Even your paper has an outside edge or line, and the drawing you create is defined by this outside edge. Lines define form. Try drawing with only straight lines or curved, spatial, zigzag, or pointed lines.

If you have been using a pencil, try another tool such as a ball-point pen or a piece of charcoal. What happens when you push down hard with the tool? Hold it very lightly? Twist it as you draw? Rub it in your palm? Can you discover a new way to hold the tool? On the side? On the point? Try drawing with your other hand, with both hands together. Experiment! Explore!

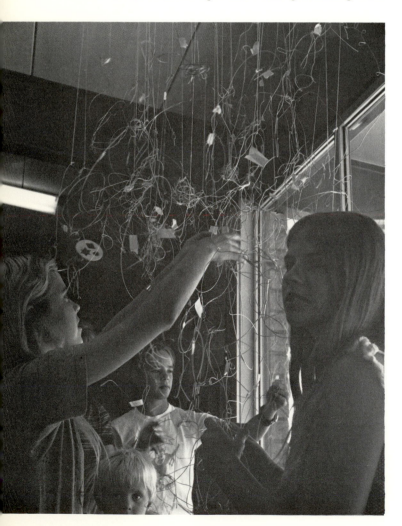

Lines and edges
are everywhere!

What have you discovered? Did you find that your tool influenced the outcome of your drawing? Did you try combining two or more tools together, for instance, felt-tip pens and pencils, crayons with water-color? What happens when you draw with chalk into starch on paper? Can you achieve the same feeling by drawing with a pencil as you can with a crayon? Do you find you cannot get the same detail with a crayon as you can with a pencil or pen? But you also get different textures, color, or impasto with crayons than you do with a pencil or pen.

CONTOUR DRAWING

PERCEIVING THE DETAILS—CONTOUR

Contour drawing is done by looking and thinking of the object as if you are touching it with the tool. Your eye becomes the pencil, and both should move at the same time, very slowly and sensitively. Sit close to the object. Look only at the point your eye and pencil are on. Don't let your eye get ahead of your hand. Pretend a fly is on the model, and your eye follows the movement of the fly as it moves along. Remember to think you are touching the model. Do not look at the paper as you draw.

If you have been drawing while looking at the model (not the paper), the proportions and relationships will not be realistic. They will be exaggerated and perhaps unrelated. However, the lines should be sensitively drawn with feeling. You should have many lines going up and down as well as in and out. Look at your drawing when you stop. When you begin to draw again, start at the same point and look back to the model.

When studying the model for contour drawing, study the line that exists between the line changes (from corner to corner or curve to curve).

Practice closing your eyes and remembering the contour after studying the contours for several seconds. Do this before you begin to draw.

Very often an edge does not end on the outline but continues moving inside and then outside. Sometimes lines meet other lines (or edges), or they may end suddenly. Contour drawing also gives a feeling of the depth of the figure or object. It indicates three dimensions and thickness (often called cross contour).

In this type of drawing, as in any other, the more you or the students practice, the better drawer you become. You will see how the relating parts or proportions will seem to improve and go together. Your lines will become more sensitive. You may want to spend hours on one contour drawing. You will begin to improve your vision— you will see more!

Look at the drawings of Matisse. Look at the drawings of Paul Klee and Ben Shahn. Touch the surfaces of the objects before you contour-draw them.

CONTOUR LINES PRACTICE Do contour drawings of figures, portraits, still lifes, and natural forms such as weeds, trees, flowers, insects, hands, feet, and eyes.

Use acetate overlays to place one form over another.

Use string or yarn to establish contour lines.

Draw irregular forms such as a hat, a shoe, antiques, a vegetable like squash, still life of dolls, hands. Draw cross contours. Draw one continuous line where the line never stops until the drawing is finished.

Draw contour lines of a group of objects, such as still lifes of odd combinations. Do contour drawings of a group of heads, a grouping of hands. Emphasize and distort certain parts. For instance, drawing one eye on a head while omitting the other might add mystery to your drawing. Old dolls piled on a table are fascinating objects to draw.

Interesting patterned objects are fun to draw, such as large plants (philodendron). Include lines that add to the overall composition; eliminate lines that don't add interest to the whole.

Musical instruments make a more complex drawing; machines do too.

While drawing the line, consider the line quality itself. By applying various pressures to the tool, pencil, crayon, etc., the line itself will get heavy; at other times it will be light as a feather. Important edges and surfaces might be darker; less important surfaces might be lighter. Shadows might be indicated by darker contour lines. Different tools create different line qualities.

Draw from a costumed figure. Borrow some costumes from the drama department for the model to wear— large floppy hats, long patterned gloves, old-fashioned shoes and boots, and long lacy dresses. Perceive more closely to capture the pattern and form of the clothes.

Change your view of the model and repeat the contour drawing on the same page, this time from a different viewpoint.

Try drawing various views of the same subject, but vary the sizes, letting them overlap and become transparent. One contour might be a study of a certain area, for instance, the corner of a room or an enlargement of a detailed eye. Another study might include varying parts of the figure all on the same page. Try contour-drawing with your left hand. Try drawing on black paper with a white pencil. Draw on unusual-size papers. Explode a drawing.

QUICK CONTOUR

You will be working faster with *quick contour* than with the regular contour. You must determine, therefore, which are the lines most essential to indicating the total form. The student draws without looking at his drawing; instead he concentrates on the form. There will be some distortion and exaggeration, but that seems to add to the "abstract quality" or uniqueness of the drawing. Try to

"Hands." Courtesy of Edna Gilbert, Mesa Public Schools, Arizona.

Continuous line contour.

Contour drawing.

take advantage of this approach and use this fantasy quality overall in the finished drawing. Always remember, draw as though the pencil were actually touching the contour surface you are drawing.

QUICK CONTOUR PRACTICE Select three objects to draw. Do not arrange them into a still life, but place them randomly on a surface. Draw each object separately, but permit the lines from each object to intersect and overlap. Try to think of the placement as to composition and how it will relate to the other forms.

Instead of always beginning at the same point on the paper, start your drawing at the top of the paper, or at the sides, or at the edges, and work toward the center; or start at the center and work toward the outside edges of the paper.

Ask a model to change poses every thirty seconds. Do a quick contour drawing of each pose, but place all drawings on one page.

Contour draw at parks, baseball games, restaurants, zoos, or schools.

Try quick contours on a huge scale—on large mural paper, working on a wall or on the floor.

You will think of many other instances to try quick contours. Be inventive.

Try a combination of drawing—first gesture, then contour over that; or first contour, and gesture over the contour.

GESTURE DRAWING

SEEING THE ACTION—MOVEMENT!

Feel the life force of the action.

Feel the inner thrust of the figure.

Feel the weight of the figure. Where is the figure resting—on a leg? on an arm?

Always remember that all movement of the figure (gesture) interacts with the whole figure. Each part of the body depends on all other parts of the body. The arm is not separate from the torso; all forms influence and force other bodily parts to respond, depending on the balance, the movement.

Contour drawing extends beyond the edges of the paper to create an exciting spatial composition. Different value lines are made by different-colored felt pens.

Gesture drawing stresses movement of the figure.

Gesture drawing is the capturing of a movement and feeling—what the object or person is *doing!*

Gesture drawing is done quickly—sometimes in ten seconds.

Gesture drawing is discovering and feeling the dynamic sensation of the form.

Gesture drawing is done as an exercise and is never meant to be a finished drawing, so plan to throw many away; draw as a learning exercise.

Sometimes the drawing will look like scribbles, but they will be descriptive of the action as you, the drawer, sees it.

Think of the object or figure as a whole unit; use linse to express the interaction of the whole.

Respond to the figure or object to show the way you might feel about it—joy, fear, sadness.

GESTURE PRACTICE Make many moving figures (this means only ten seconds to see the gesture or action) in crowds at the supermarket, in the lunch line, at the football game. Where the contour is an outside line, the gesture is the internal bulk. Try to place yourself within that other form and move with the form. Feel the action and the change of direction.

Complete the whole drawing at once. The drawing may not appear more than a scribble, but the student drawing will show whether or not he was able to capture the essence of the gesture. There will be *no* details, such as fingernails, in gesture.

Practice and be aware. Try gesture drawing from television.

Try to draw moving animals.

Make a gesture drawing of just a head. Feel the changes and movement of the surfaces and forms.

Try some of inanimate objects such as glasses, shirts, or drapery. Think of them as having action and movement.

Try gesture with pencil as well as lithograph crayons, or charcoal, using the sides of the tool.

Experiment with other tools such as brush and ink, or paint.

Combine gesture drawing with other methods of drawing (contour, memory).

Begin with gesture drawing of a figure, a landscape, a still life—continue with more detailed drawings.

OTHER LINES

THE CALLIGRAPHIC LINE

This line is more of a quick stroke that varies from thin to thick in one stroke. By varying the pressure of the hand, a brush describes a calligraphic line. Sometimes the

The calligraphic line.

brush stroke is very light, causing a faint, thin line, while at other times it is dark and heavy. The Oriental masters are well known for this linear drawing technique. Here, again, an object of clothing or a figure in action is a good subject for calligraphic drawing. Many people enjoy writing their names using the calligraphic technique.

THE OUTLINE

This is simply a line which describes the edges of the form. It may be a continuous line that is rather hard and unvarying, or it may be a soft line that describes a rough or smooth texture. Sometimes it is difficult to separate the two types of lines—the contour from the outline. The contour line should be more sensitive and include more details.

MEMORY DRAWING

This type of drawing requires practice in remembering, and it trains and disciplines the student in visual recall. One finds himself developing a keener awareness

Lines can indicate form and roundness. Drawing by Marlene Linderman.

of existing relationships and perception by practicing his memory. Think of all the details you saw on the way to school. Can you name the color of the walls in the room you were just in?

- Observe a model for thirty seconds. While the model rests, draw what is remembered about the pose.
- Draw animals, people on TV, people in crowds.
- Draw still-life objects, such as a favorite toy, old dolls.
- Draw from projected slides or photographs. Observe carefully for one minute; look away and draw.
- Draw what you did last Saturday. Include your feelings.
- Capture the likeness of a friend without the model. Remember this is practice and fun, not an exact likeness.
- Select a "happy time" you remember, such as a party, circus, or basketball game. Draw everything you can remember about it. Do the same thing with an "unhappy time."

CARTOONING

One of the most neglected areas of the art-drawing curriculum is the area of cartooning. The student is aware of the cartoon from the initial experience of watching television. From that time on, much of communication and even education is processed through cartoon ideas. Who can say they have never watched TV cartoons or read a comic book? Who has never heard of Walt Disney, an American artist of our culture, or his inventive creations, Mickey Mouse and family? He was one of the first to take a new concept—animation—and develop it creatively into animated cartoons—all of which are drawings. Who has not read the newspaper comics? Today action comics, Superman, and others are valuable collectors items, as they are original Americana. Comics and cartoon drawing are reflections of the American culture. Charles Schulz and his creations, Peanuts and Snoopy, have commented on many a social theme.

The five key words for cartooning are *imagination, humor, exaggeration, action,* and *expression.*

HOW STUDENTS UNDERSTAND LINE

PRIMARY

Lines are edges and outlines. The approach is more impulsive and spontaneous.

Lines can be thought of and named—

straight	diagonal
curved	wavy
long and short	sharp
thick and thin	soft
vertical	hard
horizontal	gentle

Lines are ways of communicating ideas. These lines combine to produce forms and shapes.

Experiment with spacing of lines.

Make lines with various tools—pencils, brushes, crayons, felt pens, etc., and torn paper.

Find lines in the environment: bricks, piano keyboard, necklace, lines of print, tunnels, strings of car lights, street lights, pipelines, sewers, rainbows, sunbeams, rubber hoses, chains, irrigation ditches, patterns of animals, telephone wires, curbing, barbed wire, cracks, horizon line, feathers, zipper, hair, stitching, chain link fences, trellis, jet stream, age wrinkles, thread, ribbon.

A line starts at a point.

Lines often change direction.

Lines often change from wide to thin and thin to wide.

Lines can be light or dark.

Line has infinite variety according to the medium and how it is used by the artist.

Lines are located between points.

Stress thinking of whole paper space. Fill space with lines.

Study and draw individual objects rather than groups of objects.

INTERMEDIATE

The approach is thought out and planned with more reason.

The student is attempting to make order and classify the objects he draws and paints.

Geometric lines form basic environmental shapes, such as figures, houses, flowers.

Student will include important lines and shapes and omit unimportant lines.

Student does not look at object he is drawing; therefore object is simplified.

Student will use more detail in drawings if given meaningful experiences.

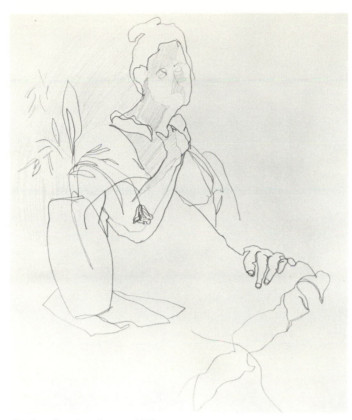

Outline drawing (see p. 123).

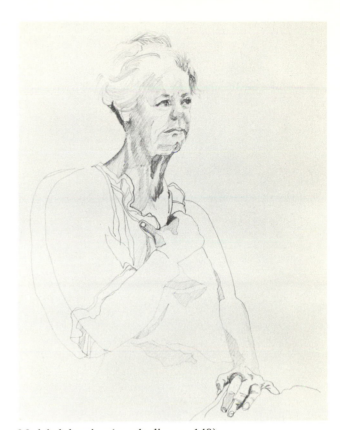

Modeled drawing (see shading, p. 148).

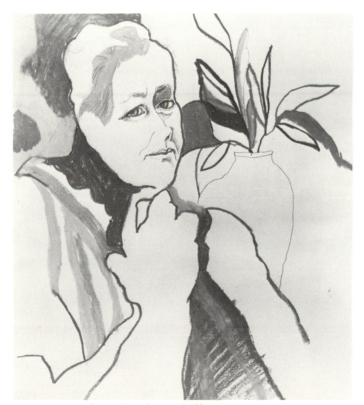

Drawing with flat values (see p. 142).

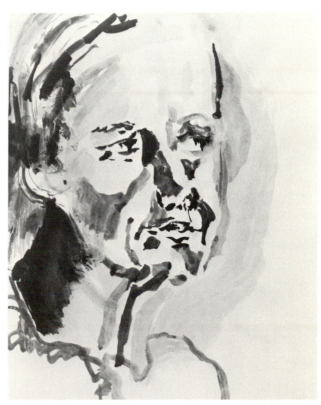

Calligraphic line. Wash drawing with brush and ink (see p. 123).

Line examples:
All drawings, by the author, are of the same model in the same pose. The varied drawings illustrate the many approaches that are possible for the artist.

Modeled drawing with oil pastels. Turpentine brushed over pastel to create soft, blended tones. Added pencil line.

Building of tones and values with lines, few edges. Broken, unfinished lines permit the eye to move back and forth into space.

Combination pastel and ink line.

Imagination drawing. Strong blacks do not follow figure shape but create a mood and excitement.

Minnie and Mickey Mouse creations of Walt Disney artist/cartoonist.

Without important experiences, he will draw what he remembers seeing, not what he is capable of seeing.

Encourage students to see many details. Observe carefully, feel objects, name and describe details in objects.

Student drawings become a means of forming concepts, symbols, schemata. Sometimes he will be more imitative than imaginative.

Student is concerned with what is "real," what is "right now."

Lines often appear in some order.

He does not see lines in correct proportions or sizes, shapes or perspective.

Talk about contour lines being outer edges—limits of objects. Emphasize contour lines of concrete objects. Continue searching the environment.

Continue to draw individual objects rather than groups, stressing contours of objects.

Continue study of linear drawings of artists. Discuss making judgments and choosing favorites—likes and dislikes, and why.

Continue study of media and move into more complex media such as conté crayon, charcoal.

UPPER INTERMEDIATE

Study various types of lines.

Student begins to perceive distance in space. He represents perspective with a single viewpoint. Lines can represent depth and space.

Lines become more complex. He begins to represent people and objects with greater three-dimensional accuracy.

Some students begin to analyze their environment more accurately and exhibit this efficiency in both two- and three-dimensional work.

Student has a better understanding of relationships between objects.

He is able to describe similarities and differences in lines and other elements.

Students are able to interpret art objects for their own meaning.

Study of line as it represents roundness and depth; also changing surfaces.

Use of line as a means of expression of mood, emotion, and feeling.

More complex understanding of perspective, two- and three-dimensional space.

Line as a means of describing surfaces, textures, and patterns.

More complex grouping, such as still life or groups of people.

Student should be helped to improve individual drawing techniques.

LINE MOTIVATIONS

BIRDS

Observe in detail feathers and change in movement in the way they grow. Analyze the underlying bone structure.

Look for basic geometric shapes and how they grow together—the shape of the head and body, and the way they are attached. Contour silhouette lines of the entire body forms.

Notice the texture of the legs and feet, the proportion of the feet in relation to the body and head. See where the legs extend from the body.

Carefully examine the details of the wing. Observe the basic shape when it is extended, the basic shape when it is next to the body, the varying lengths and sizes of the feathers as they grow from the body, how the beak attaches to the body, the position of the eye.

What colors and changes of colors are there on the wings? Body? Feet? Eyes? Head?

How do you combine lines to indicate textures? Does texture change colors?

below: Bones are good subjects to draw.

Student line examples:
Intermediate and upper-intermediate.

above: Hands become more three-dimensional.

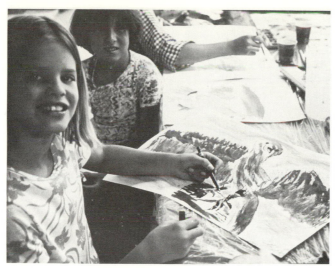

Looking at the bird, Carol draws with felt pens and watercolor.

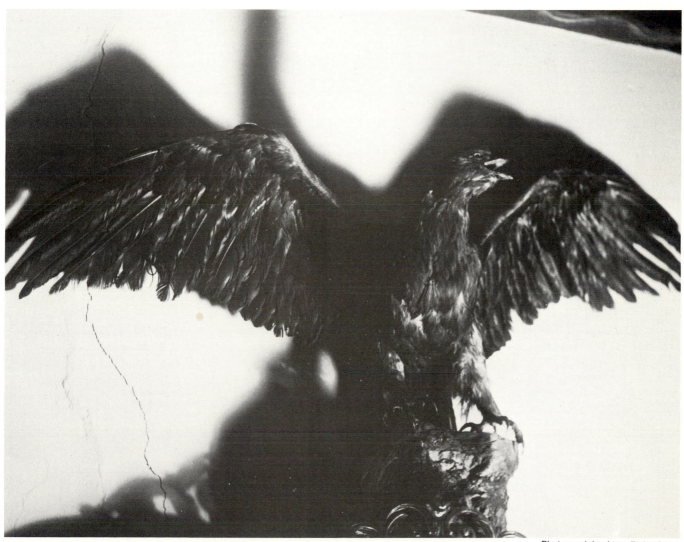

Dramatic photographs can be exciting idea-sparkers!

Photograph by Janet Eickenbury

This bird was drawn by a fourth-grade student. It is especially sensitive due to the lines of different weight and the interesting forms.

Drawings below indicate motion. The various sizes suggest families of birds—one family is crying.
Bottom left: The drawing is done with a stencil, suggesting motion by overlapping.

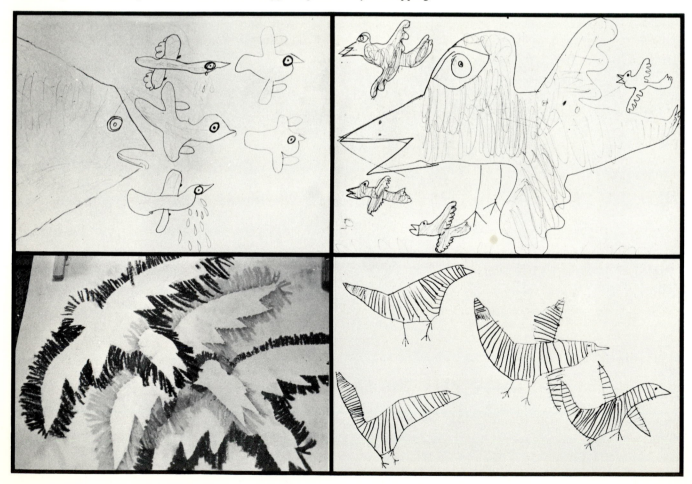

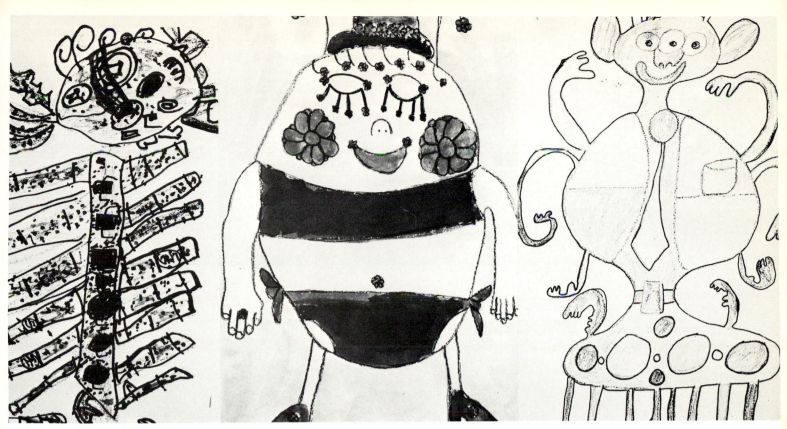

The insect examples that appear here are from grades one through six. They are interpreted realistically as well as imaginatively and are drawn with a variety of tools, from felt pens, crayon, watercolor, collage, crayon resist, to pencils. Motivations were from studying insect parts, observing under microscopes, and imaginary ideas. Personalities reveal themselves in all drawings.

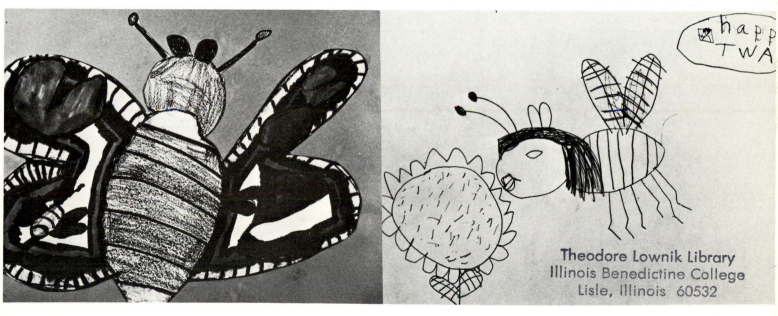

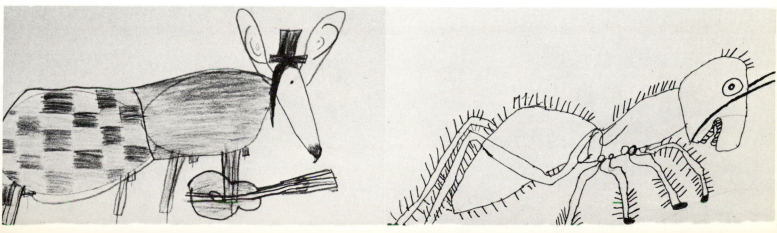

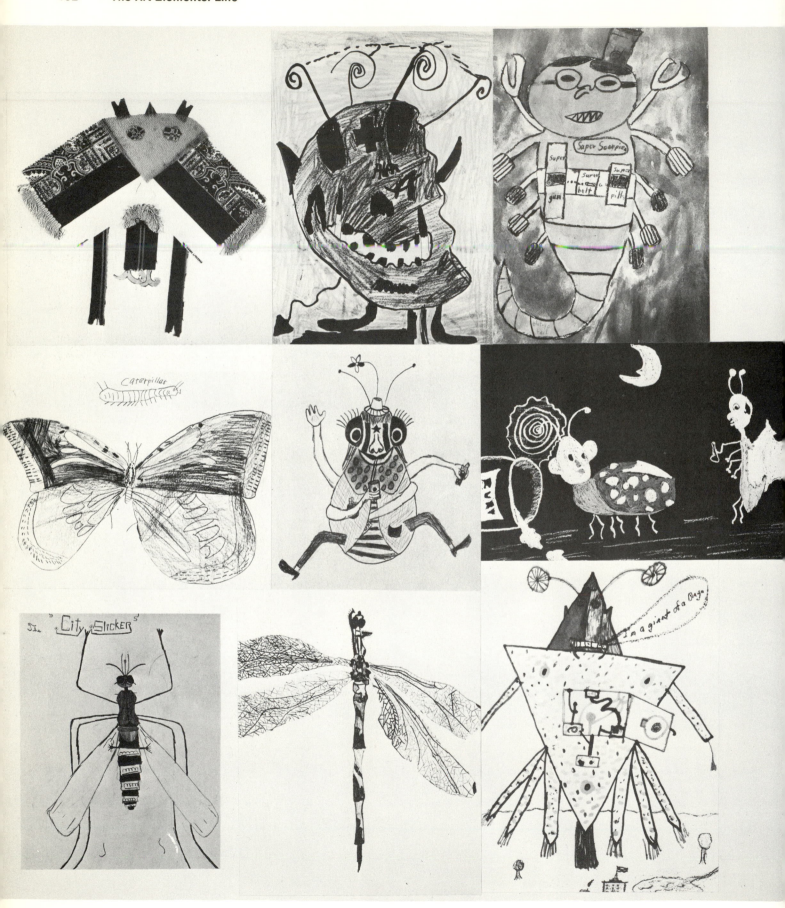

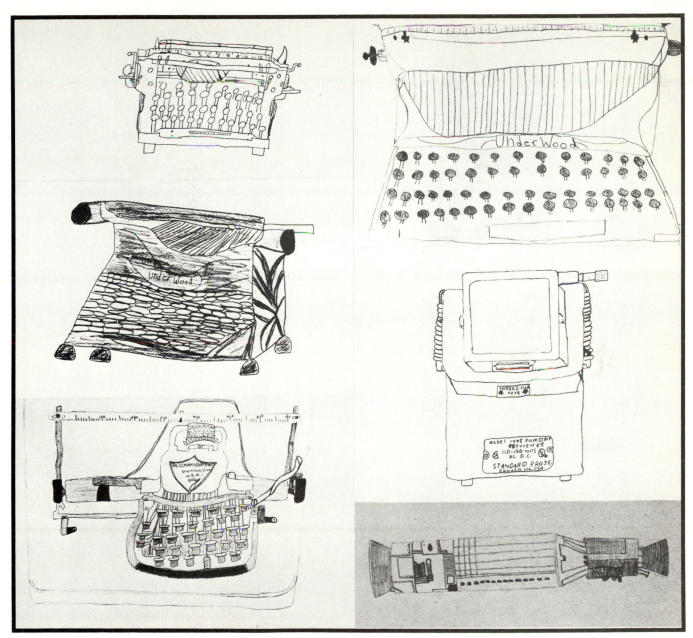

These examples are from intermediate and upper-intermediate grades (3, 4, 5, and 6). Note drawing three which shows front and side elevation. Drawing four shows top view. Drawings five and six show greater detail, rounded forms, and an indication of lights and darks.

What happens to the body, head, and wings as the bird flies? As it lands? When it's at rest? When the wings are in motion? When the bird eats? Sleeps?

What happens when there are two chickens pecking at each other.

Touch a bird. Smell it.

Why and how does a bird fly?

Identify body parts such as head, wings, etc.

PRECISION INSTRUMENTS

Study the object very carefully, looking for intricate details. Old clocks, inside radios, TVs, musical instruments, guitars, microscopes, earphones, pianos, typewriters, electrical apparatus, motors, machines (insides), car parts. Use tools that allow lines and details, such as pencils, felt-tip pens, and ball-point pens.

David's grin reflects the unusual subject matter for his drawing—a large drilling bee drawn with black felt pen.

INSECTS

Carefully observe insects' body parts. How many legs to they have and where do they extend from the body?

Look for basic shapes of the body and how large the shapes are in contrast to legs and antennas.

Watch how insects move.

View films. How do spiders weave their webs?

How do they eat? Rest? Interact with environment?

Look through microscopes and magnifying glasses for closer details.

Have children collect and bring in collections (butterflies, beetles, spiders).

Study the design and organization of insects and how their parts are put together (body parts, head, throat, etc.).

Can you invent your own insect?

How are insects alike? Different?

Where do you find insects—such as the scorpion, tarantula?

SKELETAL PARTS

Observe skulls, skeletons (human), fish bones, fossils for drawing studies.

Notice how the skeletal forms are the underlying structure of the object.

Look closely at size relationships and how they get larger or smaller.

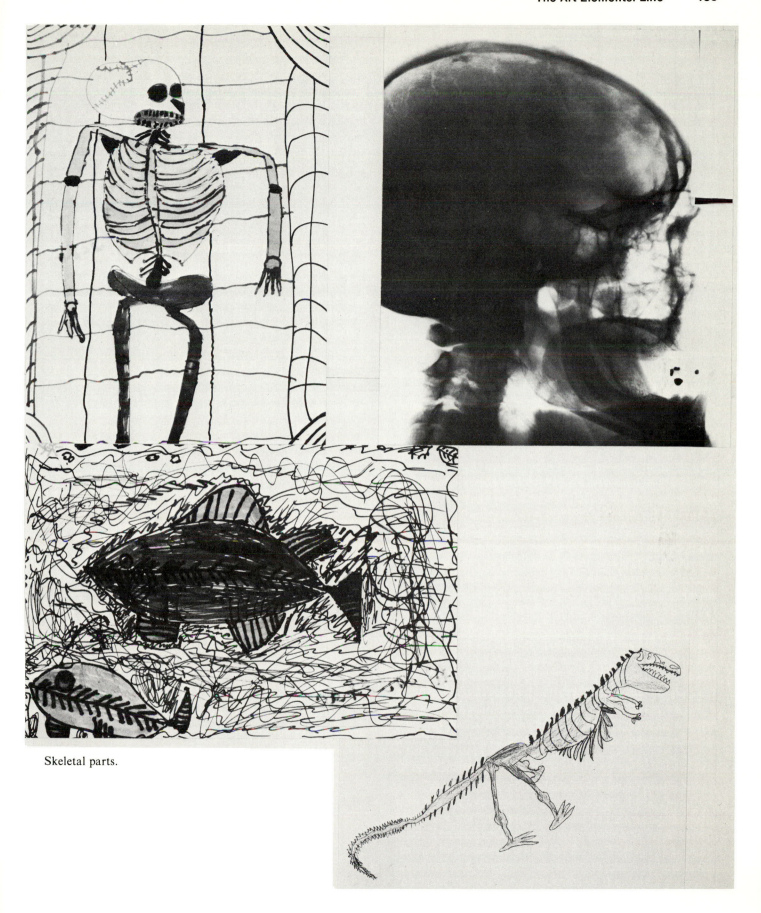

Skeletal parts.

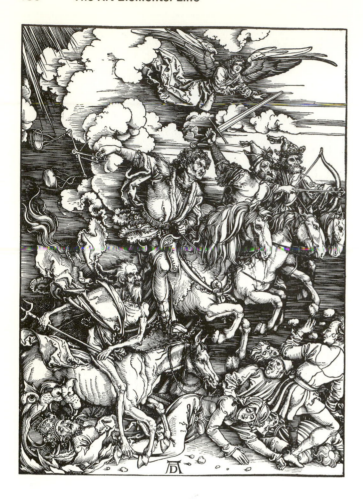

left: Albrecht Dürer. *The Four Horsemen of the Apocalypse.* Engraving. Courtesy of The Art Institute of Chicago.

above: Earl Linderman. *The Plot Thickens.* Pen and ink.

right: Marlene Linderman. *The Raven.* Pen and ink.

Look for textures. Touch them.

Even beef bones from the market are interesting to feel and draw.

Can you create an interesting drawing with bones and structural objects?

Watch how construction sites change as a structure grows.

Construct a visually pleasing structure, using only paper forms that will support three books.

GROWING THINGS AND FLOWERS

Examine closely how the plant grows. Make discoveries, keep data.

Observe changes and relationships, similarities and differences.

Look and feel textural surfaces. Make "rubbings."

Determine the underlying structure of the flower and its many parts.

Do the leaves grow opposite each other, or do they alternate up the stalk toward the flower? What happens to the veins in the leaf? Hold the leaf up to a light. What do you see? Do the petals on a flower remain the same size, texture, color, form, or do they change from the center out?

Feel, smell, taste, take apart the flower to intensely "see" it.

IMAGINATIVE IDEAS

• With felt pens, crayons, or chalks draw to music. First close your eyes and listen for the changes in the patterns and movement, much like a music conductor. Let your arms move as though you are conducting. Then let your hands dance across the paper as you "feel" the music, responding to the music action with dynamic strokes, bends, ripples, and gliding. Listen for the pauses in the music and the change of rhythm. Hear the varying instruments and capture each one with a color. In the next drawing, listen to different music and draw to that, developing compositions.

• Create a "doodle" drawing, letting the lines and patterns grow into a design. Practice how many varieties of line you can create, such as scratchy, bumpy, flowing, or bold.

• On the next pages of photographs, do a line analysis to establish the main lines of the composition.

• Practice the variety of drawing techniques illustrated, such as contour, gesture, modeled, memory, calligraphic outline, and cartoon.

• Practice drawing with a variety of tools, such as felt pens, pencils, crayons, and paint and discuss their differences and similarities.

• The reader should practice drawing in a sketchbook and try out all the suggested motivations to experience the various modes of drawing.

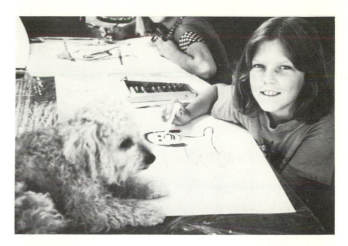

James and Helen draw their favorite models—their pets. Cats, dogs, birds, snakes, and other animals have always been subject matter for artists to interpret personally.

Stuart Davis. *Composition with Boats*. Oil on canvas. 20″ × 22″. Courtesy of The Fine Arts Gallery of San Diego.

ARTISTS TO STUDY

AUBREY VINCENT BEARDSLEY (1872–1898)

The artist lived and produced his art during the late 1800s—from 1872 to 1898. Although he died at an early age, his talent created many highly decorative pen-and-ink book illustrations. Some historians feel he was strongly influenced by the sharp contrasts of black and white used by Oriental artists and very popular at that time. He delighted in using dotted lines, lacy scroll lines, intricate patterns, delicate lines against strong blacks. One shape might be a dark form against a light background, contrasted with a light form against a dark background. He was aware of how surface lines could create forms, and used these lines to indicate rounded forms. His individual use of sensitive, delicate lines and simple areas against busy area add intrigue and expression to his drawings. This period of art is often referred to as *Art Nouveau*.

HENRY MOORE (1898–)

During the Second World War, Mr. Moore was in England in the bomb shelters, and at this time he did some interesting drawings in preparation for his sculptures. The black paper apparently lent itself well in the darkened shelters. He used white lines to indicate the moving forms as they turned from one shape to another. It's interesting to see how these linear drawings take form in sculpture where they become very solid, rounded forms.

STUART DAVIS (1894–1965)

Using popular themes, like "Lucky Strike" in 1921, he used lines to show patterns, and linear letters often became important in the design. He used other elements such as color and patterns, but line was important in his concept. He painted themes of America—jazz, cars, gas stations, airplanes, signs. He was one of the first artists to add lettering as part of the composition—a contemporary, happy, active statement.

ALBRECHT DURER (1471–1528)

This sixteenth-century German artist mastered many printing techniques, such as woodcuts and etchings, and used a linear method which appears as pen-and-ink drawings.

JOAN MIRO (1893–1984)

This artist must be a very happy and humorous man, because his abstract paintings include shapes and lines that are gay, moving, and colorful. His paintings look almost childlike in concept, but are done with sophisticated understanding of design and combinations of themes. He makes us very aware of his inventive imagination (see pp. 196).

PAUL KLEE (1879–1940)

This is another artist who creates a happy feeling in his work, humorous and delightful to all. It is as though the artist is communicating with children and making them laugh. His lines are varied and different in quality, depending on the themes he uses.

Summary Concept Chart: Line

Discuss what a line is.
Discuss how lines can express feelings, emotions.
Produce various kinds of lines (straight, curved, etc.)
Produce various qualities of line (thin, thick, blurred, cross-hatched).
Use contour lines in drawings.
Use gesture lines in drawings.
Practice the calligraphic line.
Practice the outline line.
Practice the cartoon line.
Practice memory drawing.
Discuss and draw lines as they define shapes.
Practice line as movement in space.
Use line to indicate volume, round forms.
Discuss and draw various line directions.
Use lines to produce contrast, dominance, balance and rhythm.
Identify line in nature; line in man-made objects.
Identify line in architecture, communications, products, etc.
Discuss ways artists use line in art works.
Discuss line in decorative art, abstract art, etc.
Discuss line as found in various cultural designs.
Identify line as a symbol in alphabets, signs, newspapers, religion, artifacts.
Discuss careers that employ skill in line such as cartoonist, illustrator, architect, draftsperson.
Practice line and details in Line Motivations; Birds, Precision Instruments, Insects, Skeletal Parts, Growing Things and Flowers.

Paul Klee. Comedy of Birds. Lithograph.
20″ × 14 1/6″. Courtesy of The Art Institute of Chicago.

Pablo Picasso. *Au Cirque*. Wash drawing. 9 1/2″ × 12 1/2″.
Courtesy of Lee Ault and Co.

Photographer Jack Stuler interprets body reflections in metal to create unique images.

The Art Elements: Shape, Value, and Shadow

SHAPE

When a line moves through space until it meets itself and forms an enclosure, it becomes a shape, form, or mass. An outline, silhouette, or contour defines the form and describes the shape, or object. Curvilinear lines are sometimes circles, or they may be amoebic, free-form shapes.

Now that you know what a shape is, look around and you will see that everything is a shape! Everything with dimension, that is! Often the object is composed of more than one shape. Study a plank of wood. The bottom is the large rectangle. The top, if you are able to see it at the same time (which you may not unless the object is glass or plastic), is identical in shape. The long edge is another rectangle, and the short edge is, again, a different rectangular shape. Young children will often draw the top and bottom of an object in the same picture. As adults we want to draw it as we see it, but children draw it as they know it. Georges Braque, a cubist painter, would indicate both sides of an object as he knew it to be. Table tops are tilted up to see more of the top. Children will also include front views and side views of houses and buildings shown together, as they know the structure to be. They know the object has three dimensions, but they represent the object with many sides showing as flat surfaces.

We know that lines or edges, when they meet and come together, become various shapes and forms. Where you are viewing it, how you see it, makes a difference as to the shape it becomes. The top of a book we know to be a rectangle. But when we view it from an angle, it becomes a trapezoid. So, shapes are not only what we know them to be, but also depend on how we *view* them—where we are in relation to the object.

POSITIVE SHAPES—NEGATIVE SHAPES

When we compose a picture, we start with a determined size of paper. The paper becomes the *format,* the outside edges of the surface. The format of the surface becomes a part of the design, because the various shapes that appear are influenced by this limiting space. In drawing, we arrange the design within the format. The design consists of the arrangement of the positive and negative shapes inside the boundaries of the paper. The very young child seems unaware of this boundary and instinctively produces well-balanced compositions.

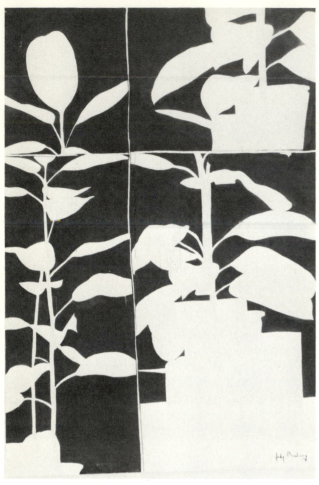

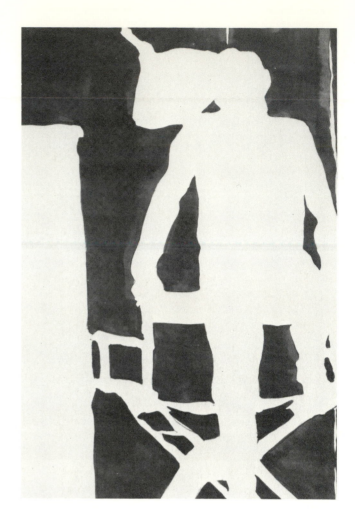

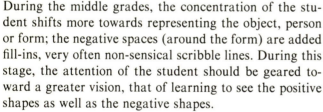

Seeing negative shapes (dark areas), and positive shapes (white areas).

During the middle grades, the concentration of the student shifts more towards representing the object, person or form; the negative spaces (around the form) are added fill-ins, very often non-sensical scribble lines. During this stage, the attention of the student should be geared toward a greater vision, that of learning to see the positive shapes as well as the negative shapes.

The physical object or person represented is the *positive shape*. The empty space around the form is considered the *negative shape*. Both positive shapes and negative shapes are arranged within the paper format. In other words, many of you have probably never thought about the spaces around the form. The practicing artist is constantly aware of both shapes and uses this concept as a strong device for organizing artworks. You will have to practice seeing in this way, and a good starting point is to use an empty slide holder as a viewfinder. Hold the viewfinder next to one eye and look through the opening. The finder acts as a border. Select an object, such as a plant, and direct your gaze at the positive shape (the plant); then concentrate on finding the negative shape or the space surrounding the plant. Wait until your vision accepts the negative shape and think of it as a separate form. Now imagine that the plant vanishes, and what do you have left? The negative spaces become shapes in themselves. Try drawing just the negative shapes. You will find that as you focus on individual shapes, they become forms in themselves, but as they build together, they begin to reveal the form of the lamp (or the positive form).

This is a very valuable way to see shape and form. And it is just as valuable for you as it is for the artist in learning to perceive detail and form. Practice this seeing with all kinds of forms, shapes, and objects.

DRAWING WITH FLAT VALUES

This type of drawing is made with a range of tonal values, but rather than using modeled volume to indicate rounded forms, the artist uses a range of flat values to represent a surface. Just as we did drawings using the light/dark shadow drawings with black ink, use the same concept of flat areas, but increase the range of grayed tones

A value scale is a series of gray tones that increase from white to black. The human eye can distinguish many, this scale changes about twelve times. A student can be aware of varying gray values and include three or four when producing a drawing.

Painter Carol Bidstrup stands beside *Illusion No. 6*. The forms are simple, flat shapes. Their positioning creates the illusion of depth.

rather than just using black. Using the grayed flat tones (eliminating a gradation of the rounded form) achieves more of an abstract quality or decorative effect. Commercial artists often use this approach for designs in posters, fabrics, and silk screen printing. In other words, each form is one flat tonal value. Experiment with this concept in drawing faces, landscapes, and still lifes using this approach. To do this, select the subject, divide the drawing into sections like a map, and fill each section with a grayed tone. Begin with three grays, black, and white.

SHADOWS

When light exists, it reveals the object, the tonal values, and the object's shadow. The tonal values and shadows indicate to us that the form has three dimensions.

Shadows are created from (1) the number of light sources there are and (2) the distance from the light source the object is.

Shadows are important because they not only reveal the form of an object but they are shapes. For some reason, we tend to ignore shadows as shapes, but in thinking about the shapes of a shadow we focus on the form. When we draw shadows, we are drawing a shape with value. Therefore, as we thought of negative shapes, we can think of shadows as shapes. If we were to draw just shadows (without the object), the shadows themselves would reveal the object. Artists practice this kind of light/dark relationship by using just black ink for the shadows. By

Patterns become designs for more complete paintings.

Photographs by Janet Eickenbury
Light from above-below
 right-left

Shadows are determined by the light source. Note the changes of the shadow against the wall. In photo 2 the outside silhouette is lost. The light from below casts an eerie glow of mystery to the face. It appears as a circular form against a dark background. In photo 3 the outside silhouette is dark against light, with only half the face in light.
Study the shadow forms. Begin with these photos and isolate the shadows from the light forms. Draw all the shadows as dark as you can (use a soft pencil). Draw from magazine photographs, still lifes, or people and continue to practice strong contrasts of darks and lights.

above: Natural light from several sources. Heather Linderman. Tie-dye dress by Patsy Lowry.

Shadows are forms, also. Photograph by Gwen Linderman

Cut white paper forms are mounted on white paper to study shadow shapes.

Photograph courtesy of Eric Kronengold

Photographer Eric Kronengold captures a moment when shadows can express significant ideas.

looking carefully, a decision is made about where to separate the light side of the object from a shadow. The shadow is drawn as an independent shape. Then another independent shape is drawn in with the black ink. Soon these separate shadow shapes begin to relate to each other, and the total form takes place, almost like placing parts of a puzzle together. You will be surprised how your vision is sharpened in discovering the shapes of shadows. After practicing seeing shadows as shapes, begin to develop an eye for seeing tonal differences within a shadow.

The artist can decide how many shadows there are and how many to include in his drawing. This is very important, and the artist can be arbitrary in his choice, depending on the design and concept of the whole composition. The artist can include the shadows to improve the working drawing, or he can omit those which interfere with the whole composition. While one shadow may be important in the actual object, if you were to move your position to the other side of the object, or if you were to turn or alter the object or move it closer or farther away from the light, you would alter the shadow. You may wish to sharpen a shadow or quiet it—perhaps even exaggerate or change the shape. The artist always has the matter of choice and discretion. Remember, the viewer will not ever know what the real object looks like, or the still life, only the way you, the artist, represent the object, still life, or whatever the subject is in your drawing. Only you are the designer, organizer, planner.

Shadows are sometimes made from reflected light as well. It is better to use reflected shadows only when they help describe the form. They can become very complicated, especially for the beginner. For instance, in a bottle or glass object, the reflections can become very complex. Opaque objects close to each other cast soft reflected glows and changes, too.

1. Shadows on the objects help explain the structure (volume) of the rounded forms.

2. Distance of object from the light determines shape and strength of the shadow. As the light becomes stronger, the object gets brighter, the shadows darker. The shadow will change shape as well, as the light comes closer or moves farther away.

3. Shadows are made *from* the object (just like your own cast shadow). Shadows help relate one form to another. Be sure to observe the forms carefully. You can have lots of fun exaggerating, simplifying, or imagining and making up shadows. In a realistic representational drawing, you will be more concerned with the actual shadows. Sometimes it is better not to try to include all the shadows that you actually see. Keep the shadows more subdued— not as important as the object itself. Sometimes, placing

a dark shadow next to a light object can place more importance on the object. Remember, shadows are shapes, too.

4. When the light is dull, there is little contrast in value between object and shadow.

5. Shadows are caused from reflected light—glass, mirrors, shiny metal, etc. Close objects cast shadows and reflections very subtly on each other.

LIGHT AND VISION

Transparent. Transparent objects are materials that permit light to pass through them unchanged, such as glass, plastic, air, water. These materials do not cast shadows.

Opaque. Materials that stop light waves are called opaque, such as people and buildings which do cast shadows.

Translucent. A third type of material which we cannot see through, but does permit light waves to pass through it.

Reflection. On rough surfaces, light is diffused, meaning the light is bounced in different directions from an uneven surface. The light is bounced in many directions by small surfaces reflecting at various angles. By bending light with a mirror or other smooth or shiny surface, the light is changed from its normal straight line and bounced off at an angle. Try this with a flashlight.

In reflective mirrors, real objects are reversed images.

Refracted light. Light goes through different materials at different speeds.

Light bends or slows down when passing through water. When light passes from one material to another, bending or refraction can take place, such as when light passes from air into water, air into glass, glass into water.

In the setting sun and in rainbows, refraction occurs when light waves pass through moist air near the surface of the earth. Each droplet acts like a prism, breaking down the sunlight into a spectrum. Pools of water are sometimes seen as mirages during driving trips, as the moist, hot air above the road acts like a reflecting pond, reflecting the sky above.

A large rising moon is the result of light waves bending as they pass through moist air close to the earth.

Lenses.

1. Prism. A triangular-shaped glass which bends the light toward the base.
2. Convex lens. Thickest at the center. Light rays are bent toward the center.
3. Concave. Thinner at the center. Light rays are spread away from the center.

Illumination. The amount of light reflected by an object. This depends on the brightness of the light source and on the space between the light and receiving object.

Shadows. Determined by size of the light source, size of the opaque object, and size or length of angle at which the light hits the object.

Light waves. Wave frequency is the number of waves measured for a specific length of time. The wave frequency is the distance from crest to crest of each wave. Scientists have special instruments to measure the frequency of differently colored light waves in the spectrum. Red wavelengths are much longer than violet wavelengths. The other color wavelengths vary between these two—longer when closer to red than when close to orange, yellow, green, blue, indigo; and shortest when closer to violet.

SHADING

We find that objects are made up of the following:

• Flat planes or surfaces
• Rounded forms—volumes

An object consisting of flat surfaces will have fairly flat tones or shadows and flat, simple values. Suppose you are viewing a box. The brightest surface will be the plane facing or nearest the light; the sides will be grayer or lower in value; and the darkest plane or surface will be the surface farthest from the light.

In rendering rounded forms or volume, the same is true, except that the edges of the surface are softer and the shadows blend from one form to the next. The forms closest to the light will be the lightest and brightest, and as they recede, the values softly become darker until the forms farthest from the light source are the darkest.

MODELED DRAWING

Most commonly used of all the drawing methods, modeled (tone) drawing is the representation of form through the use of a variety of values and a range of tones from light to dark. The contrast is determined by the amount and source of light and the shadows created on the form. This method represents nature as ordinarily seen. It is up to the student and artist to include personal feelings in the drawing by changes in and additions to the drawing (see modeled drawing p. 125).

Begin with simple forms, such as cylinders, blocks, rounded forms, oval forms such as an egg. Decide on a range of tones from one to four. Using these four tones (lights and darks) render the form, studying the lights and the shadows on the form and surrounding the form.

Pencils of different weights will permit different tones.

Various tools will create other tones—such as crayons.

Use reflective paper and see what happens. Try absorbent paper to see the difference. Try toned papers; use white chalk for the lightest tone.

Draw the difference between a feather and a door.

Draw opaque objects when beginning. More advanced students may want to try transparent surfaces such as glasses or bottles.

Draw a piece of fruit. Study one shape at a time, and draw each one in detail. Study carefully the changes and directions of the form. An apple will have a different form from a grape. An apple and grape are both reflective surfaces.

Select a piece of cloth (any material will do, e.g., a coat). Drape the cloth over a chair; or tack it onto a wall and drape the cloth. Using a range of four or five tones, draw the changes in drapery very carefully, concentrating on the lights and darks. Where the cloth goes under or behind is very often where the greatest darks are. The forms that come forward are very often the lightest forms. In between are the other changes in tones. Think of the form as being modeled in clay, pushing in and pulling out (see drawing drapery p. 222).

Think of the background as being part of the total composition so that you will create tones behind the object also.

Experiment by thinking in reverse. Try white chalk or crayons on a dark paper.

A pen and ink can create tones either by building up lines or laying in washes.

Dry-brush technique can indicate tones from light to dark. Try dots, crosshatching to build tones.

Draw your left or right hand, starting with a contour drawing; look for the surface qualities. Build up the tones and forms of the fingers with modeling.

After several practice modeled drawings, try doing portraits in modeled drawing. Keep in mind the changes of the forms as they move in and out, behind and under (as the drapery), as though you were a sculptor creating in clay.

Experiment in reverse. Draw the forms lightest where they appear darkest visually. Also, draw the forms darkest where they visually appear lighter.

Try drawing with your left hand.

Now you are ready to combine forms together to compose the drawing. Individual forms and their placement will determine your composition.

When a combination of forms occurs, the student indicates space. There is a foreground and background and often a middle ground.

HOW STUDENTS UNDERSTAND SHAPES, VALUE, AND SHADING

PRIMARY

Following are simple and short lessons:

- Student should be able to name and identify basic geometric shapes: circle, square, rectangle, triangle, oval, and diamond.
- He should be able to describe similarities and differences of the shapes.
- He should be able to produce likenesses of these basic shapes.
- He should see differences in shapes:
 > large and small
 > light and dark
 > in and out
 > smooth and rough
- He should be able to identify shapes in his environment.
- He should look for and identify contour—or silhouette—forms of objects perceived.
- He represents the human figure as basic geometric shapes, such as circles for head and body, lines added for arms and legs.
- His paintings are often outlines which he fills in with color.
- The objects he is drawing are not necessarily related, but appear all over the page in a random manner.
- His concentration will be on one subject at a time; then he will go on to another object and seem to forget the previous one.
- His space concept consists of all forms on a base line.
- His proportions, size, and representation of shapes are not realistic.
- He has fun inventing and changing forms like imaginative insects.
- The student's imagination should be encouraged to invent new forms.
- Opportunities should be provided for exciting, perceptual *looking* and *feeling* experiences with shape and forms.
- Develop games of "feeling" and identifying shapes.

INTERMEDIATE

- Student begins to classify objects through series of perceptual experiences. He is concerned with placing in order these concrete and real things. Learn about basic shapes of various kinds of objects.
- See them, feel them, discover and classify forms. Practice observing objects, noticing the similarities and differences within the shape.
- Each shape and form may be studied individually and drawn individually rather than as part of a group. Objects begin to have dimension.

- Encourage student to describe and name objects and the parts that he is drawing.
- Student is able to see the proximity of objects—how close they are to each other.
- He sees that an object can be surrounded by something else.
- He sees that objects may appear in an order.
- He does not see three perspective points.
- He has difficulty with correct proportions.
- He does not always draw the object from the angle he is looking. For instance, he draws the sides and top of the typewriter; he shows several sides of an object; he looks through the walls of a house.
- Find shapes in nature and in the environment.
- Begin to study shadows and talk about volumes and mass.

UPPER INTERMEDIATE

- Review basic shapes.
- Discover new shapes, irregular ones such as the human body.
- Discover harmonious shapes, disharmonious shapes. Look for relationships.
- Shapes become two- and three-dimensional. Student draws them quite accurately.
- Learn techniques of how to make shapes appear round and three-dimensional.
- Shapes are influenced by textures, colors, and patterns.
- Student is more interested in the "real" world than in the imaginative world of shapes.
- He is able to draw more complex geometric shapes such as cylinders, cubes, pyramids, and pentagons.
- He has ability to draw grouping of objects and shapes in space.
- He has great interest in attempting to improve his skills and techniques.

MOTIVATIONS: SHAPES, VALUES, SHADOWS, AND SHADING

Review the level performance (primary, intermediate, and upper intermediate) lists on the previous page and the concept chart, then adapt the following motivations for your grade level.

- Can you make a drawing using only cast shadows?
- Can you make the forms of a drawing without using any outside edges or lines, only with values?
- Can you use only values to describe the form and volume of an object?
- Draw a still life with five values and no edges or lines.
- Can you find one basic shape that is repeated over and over in a painting?
- Can you find basic geometric shapes in the structures of animals? People? Environment?

Design with cut paper shapes by first-grader. Note the texture rubbings. Rubbings can be made with pencils, charcoal, or crayons.

First-grader begins with basic geometric shapes—
Heather Linderman, age five.

A third-grade student begins to indicate depth with shading.

A teacher, along with her shadow, greets her class. Drawing by a second-grade student.

Forms and shadows in nature.

Reflections become shapes.

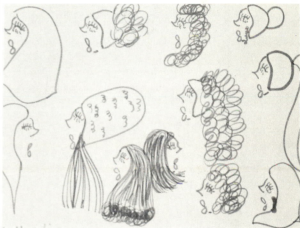

left:
Sixth-grader draws a motor indicating three-dimensional form.
below left:
Shapes are added to extend the design of the photo.
below:
Hair shapes interest sixth-grade girl.

left:
Shapes invented by fourth-grader create "Mools in the Midnight."

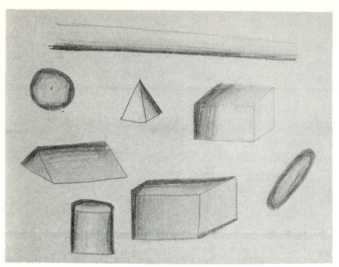

Forms appear to be round, and they recede with darks on one edge, gradating toward lighter tones. Drawing by Heather at age eleven.

Dick, grade five, created tones with just dots.

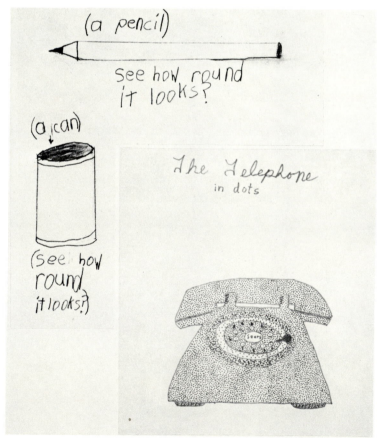

A student begins to show the depth concept in his art.

MOTIVATIONS—*con't from p. 149*

- Can you find some basic shapes used in architecture?
- Try an experiment making gray tones with your pencil (sides and point), with charcoal.
- Can you create shadows by using just lines? Cross-hatching?
- Draw a picture using some important lines and important shadows. Remember that interest in a drawing is created by variety—variety in dark and light, in strength or delicacy, variety of lines, soft and hard edges, large and small shapes, busy and quiet areas.
- Did you notice that shadows change colors of an object? An orange or grapefruit may be basically yellow or orange, but the shadows cast on the object from other objects will alter the color where the shadow is.
- Do you think that drawing with different tools can create different feelings or shadows? Charcoal from ink? Watercolor from chalk? Oil paints? Pencil? Try describing rounded forms using washes with line drawings over the washes as Rodin does in his wash and pen drawings.
- Try building shapes in sand. In clay. With sticks. With blocks of wood.
- Some artists use only lines; others only shapes; some use combinations of both. Look at some Braque paintings and see how he used forms.
- Look at a Rembrandt painting. Decide which is most important: outside edges, shadows that describe forms, or the cast shadows.
- Repeat some unknown flat shapes. Invent some unknown rounded forms.
- Experiment with stencil printing.
- Provide carving experiences to discover forms in wood.
- Provide modeling in clay experiences to "feel" mass and form.
- Cut out silhouettes.
- Experiment in creating grays from white to black, blending a range of tones on a piece of small paper.
- Divide a five-inch square into ten boxes. In each box create a gray tone, starting with white and ranging into black.
- Try tones with other tools: crayons, charcoal, pencil, ink, chalks, paints.
- Try getting tones with colored chalks. Use one color and see how many tones you can achieve.
- Build a value range with just lines rather than blending. This time you will have to place one layer of lines on top of another.
- Look at simple objects, like an apple or an orange, and draw the object, searching for the various tonal ranges.
- Crumple up a paper bag and draw all the tones you can see.
- Use a drawing that you have completed (a contour drawing or an outline drawing). Draw in the shadows where you remember them to be; or using your imagination, draw in a separation of areas. Instead of visual tones (where the light might cause shadows), draw in random tones, making the drawing unrealistic and more abstract.
- Try this again—random separation of shadows. This time use only stark whites and blacks, eliminating the middle tones.
- Now look at your subject and do not draw any outlines; just put in the very darks.
- Use a gray-tone paper—even brown wrapping paper is interesting. Using white chalks or pencils and black or gray tones, describe what you see.
- Start with a gray-tone wash over the whole paper. When dry, draw in the tones and the whites and darks.
- Look at some mineral specimens—an amethyst crystal is beautiful and exciting visually. See if you can draw the various darks and lights.
- Try drawing a bottle—here the student becomes involved with reflections. This needs a new tonal range because of absorbed as well as reflected light.
- Subjects can suggest value tones to be used. A light, happy, bright subject suggests a light tonal range, clarity, brightness, happiness. A middle-gray-tone picture (one in close value relationships) suggests a rainy, gray, foggy day, somewhat unreal attitudes. A very dark range of tones—values—might produce ominous, nighttime, evil, fearful, mysterious feelings. Tonal ranges and values can suggest ideas in themselves. A strong contrast of darks and lights might suggest a bright day at the beach or skiing down a slope.
- An interesting texture is created when a middle-gray tone is created with pencil or charcoal; then an eraser is used to take away areas to create light tones.
- Draw in whites with rubber cement or a white candle. The white will not show, so you will have to generalize and remember where you have put it. After the cement is dry, put in wash tones, working darks in as well. The tones can be wet as you work, or let one gray dry before adding the next gray tone. This is crayon-resist technique; the wax appears white.
- Draw rounded forms using simple forms such as fruit (apples, oranges, lemons).
- Place rounded forms (fruit) on draped cloth as in still life.
- Draw hands; draw portraits. The film *Face of Lincoln* is good for seeing and feeling masses and forms of the face.
- Draw a draped white cloth (rags, sheets, coats, etc.).

Let the cloth drop arbitrarily on the table, or drape it on the wall. Place the cloth so that the shadows formed are interesting as a design. Remember that you are going to draw on a whole surface where all the forms rendered develop into a unified composition. The whole paper design is to be considered, not only one object put on the paper!

1. Look for the contour edges of the cloth and indicate these first in your drawing.

2. Next, indicate the soft fold edges with the side of your pencil.

3. Then with your eye as the control, decide on three values of gray (or whatever color you are using)—a light gray (tone), a middle gray (tone), and darkest gray (tone). So, in reality, you have four tones, including white.

4. Start building up these tones, letting one gray surface blend with the next edge. Where the contour edges are sharp, you will naturally have a sharp contrast in value—perhaps a light tone next to a dark one.

5. Always remember that you are building a design on the entire surface, so consider the art elements and also rhythm, balance, size, contrast, center of interest, selection, and omission.

6. What tool you use will influence the drawing. Using a softer material such as a soft pencil, charcoal, or pastel, you will be able to blend with more ease. It is advisable to use pencil, charcoal, or some gray-tone tool for the beginning student; color at this time could become too involved.

VARIATIONS

Follow the same procedure as above, but use a sheet of paper or paper bag wrinkled up, then opened flat. There will be angular and rounded surfaces formed. The edges may be more abrupt and sharper.

• Continuing the pursuit of line and form; think in terms of cubism. The problem is to take one or more geometric shapes, repeat them, letting the lines intercept and overlap. Where the lines overlap or intercept, fill in the spaces, alternating the color or value. Limit design to one or two colors plus white and black. The filled-in spaces become forms, and the resulting design is an optical illusion. Show geometric designs printed on acetate papers. When one is held on top of the other, and the two sheets are rotated and moved about, the illusion is very "optical"—a more deliberate, planned approach. Good for fourth-graders and up.

A CLOSE-UP LOOK AT INSECT AND SPIDER FORMS

• Imaginary insects: consider again the problem of line and form and design an interesting imaginary insect, keeping in mind the elements of line and flat as well as rounded forms. These can be humorous, mysterious, etc. For students of all ages.

• Study skeletal structures of fish, people, and vertebrates to motivate students' thinking in terms of using these ideas as potential design sources. Repetition, symmetry, scale, and linear construction are some of the necessary considerations for this idea growth. Complex or simplified fossils, bones of animals or fish, are possibilities to stimulate imagery.

Because you are all different and are individuals, your drawings will be different. You have different personalities, feelings, and past experiences. Even though your eyes may see the same view or same objects, your mind will see and feel the view differently. *You are the artist! Each drawing you make is always your own "creation"!*

ARTISTS TO STUDY

MILTON AVERY (1893–1965)

One of the most memorable exhibits we have visited was an exhibit of paintings by Milton Avery in Washington, D.C., in 1969. Until that time, we had occasionally seen only one or two of his paintings. The drawings and paintings were displayed in a retrospective of his work.

His paintings can best be described as lyrical poems. Each painting contains within itself a fluid statement of simplicity, creating a mood and feeling with primarily clear, simple shapes and related colors filled with light patterns. In his work we are made very aware of the importance of the shapes and forms used flatly and related to the design of the format. Familiar forms at once recall a landscape, a bird, a figure, with control and expression that could come from just one man, Milton Avery.

Seeing so many of his paintings at one time gave us a truly comprehensive direction of this man's work (a better understanding of his emotional expression). We went away feeling as though we knew the man, for here he had left his whole life's work, thoughts, and ideological reflections of the environment surrounding him.

Again, in 1982, Milton Avery was honored with a major retrospective exhibit at the Whitney Museum in New York City.

HENRI MATISSE (1869–1954)

This artist also used flat tones of color, but in each painting he used many more decorative elements. Both artists were interested in objects within the environment. Henri Matisse concentrated on the forms surrounding the figure, to a great extent, rather than on the forms within the figure. His paints are rich and heavy with decoration; his colors and shapes are clear. (see p. 230)

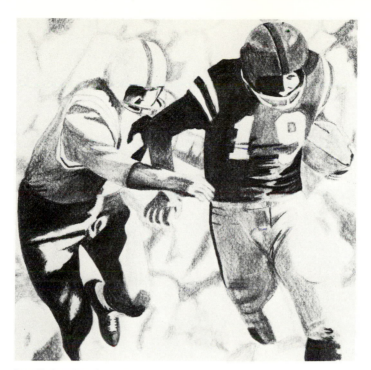

Pencil drawing from photograph.

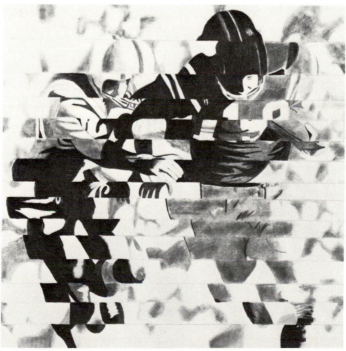

A second drawing made by imagining it is sliced, and shapes are alternated left to right.

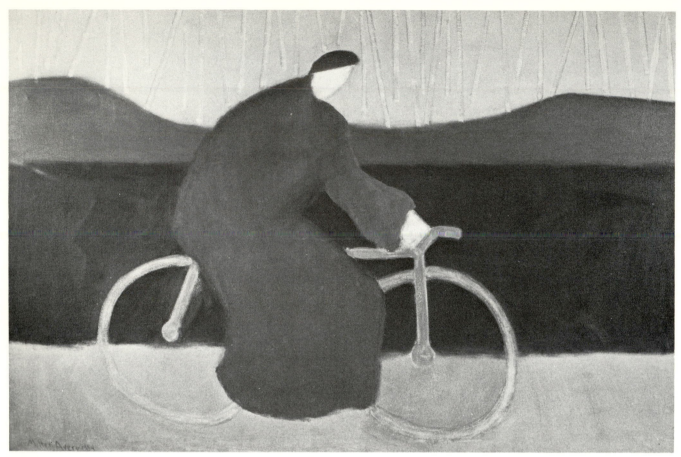

Milton Avery. *Bicycle Rider*. Oil on canvas. 38″ × 55″. Courtesy of Mrs. Milton Avery, New York.

Henry Moore. *Reclining Figure*. Sculpture—bronze.
53½″ h. × 90½″ w. Gift of Mr. and Mrs. Arnold H.
Maremont. Courtesy of The Art Institute of Chicago.

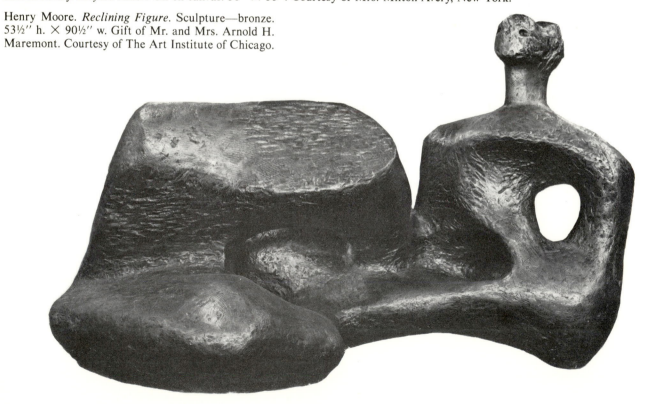

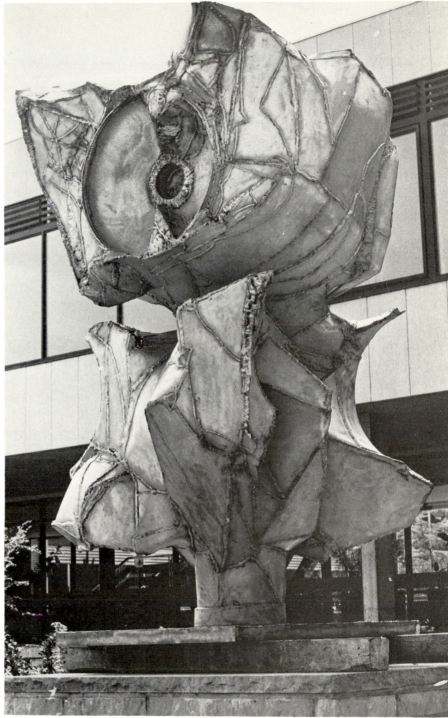

Courtesy of Arno Beckmann, Hamburg, Germany

From a linear drawing grows this monumental sculpture by Arno Beckmann, Hamburg, Germany.

Summary Concept Chart: Shape, Value, Shadow

Upper Grades:

Identify the difference between two-dimensional and three-dimensional shapes.

Identify organic shapes; identify geometric shapes (nature).

Practice shape in decorative design, abstract art.

Draw imaginative shapes and construct a decorative design.

Practice positive-negative shape drawings.

Practice drawing shapes and changing the value.

Practice developing five values in a drawing.

Discuss kinds of light and how it affects vision.

Draw a value scale of contrasting values.

Draw using close (similar) values; draw using contrasting values.

Practice using massed lines to create value.

Identify light, medium, dark values in nature—in man-made environment.

Use black and white photographs and differentiate values.

Practice creating values with various media.

Demonstrate how light can change shapes and forms.

Identify ways of producing shadows (how their shapes change in natural or man-made light)

Practice shading forms.

Practice using various media to shade forms; pencils, pen and ink, charcoal, crayon.

Consider shapes in balance, rhythm, dominance, contrast.

Practice changing shapes with color, texture, patterns.

Discuss how one's viewpoint changes a visual shape and shading.

Discuss how shapes can create movement in space.

Draw shapes as they change in perspective.

Discuss how placement of shapes creates visual tension, near-far, etc.

Discuss how artists use shape in design, value in design, shading in design.

Discuss how shapes are used in signs, logos, flags, books, furniture, architecture.

Select five artist reproductions and identify various shapes, values, shading techniques.

Discuss various careers and what value, shape and shading mean in architecture, commercial art, television artists, advertising, interior designers, photography, etc.

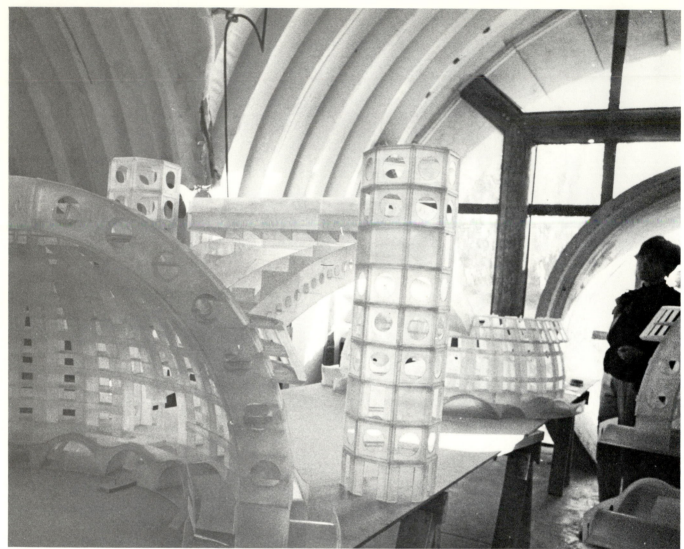

Mrs. Paolo Soleri stands next to Arcosanti model.

Paolo Soleri, architect, has been designing compact, complex cities which he calls "arcologies," architectural ecologies. These can be envisioned as superstructures rising as many as 300 stories high and extending five blocks in each direction. They are organized into apses, cones, and towers. The design captures the air, sunlight, winds, and tides, and uses them to power the cities. The arcologies are rough models to illustrate the concept. They are "core ideas" for architects, engineers, and other specialists to design the details. An arcosanti is currently under construction in Cordes Junction, Arizona.

9

The Art Elements: Space

The dimensions of space determine the world in which we move and live; and space, in turn, is established by the objects or forms that occupy it.—Graham Collier, *Form, Space, Vision*, Englewood Cliffs, N.J.: Prentice-Hall, 1967.

VISUAL ILLUSIONS

We create visual illusions within art works related to space. We also actively deal with space in our environment. We move through space, both in interiors and exteriors. Existing enclosed spaces are in our homes, schools, communities, neighborhoods, cities, countries, and the world. We can consider three-dimensional environmental space design from arranging objects on a surface to designing a building to planning a school zone to planning a community. We can think of the space concept as it exists for an ant to space as it exists in the universe. When we draw and paint, we create the illusion of space; when we build, construct, or move three dimensionally, we design spaces within an environment.

Have you heard the story about the third-grade teacher who was teaching the sky concept to her school children? She explained that when you look out to the distance, you see how the sky comes down to the ground. And little Scott remarked, "Yes, Mrs. Johnson, but I've been over there, and the sky does not touch the ground."

The young child draws *what he or she knows about the object.* He does not draw it as it appears spatially or with volume. For instance, a drawing of a face is a circle with eyes, nose, mouth—generalized information. The drawing is whatever he says it is and it often describes a person, object, or what is happening. Drawings are used as visual symbols for telling stories. When the child enters school, the drawings are more complex storytelling devices, such as "going to the store with my dog Jasper." They describe events and often reveal aspects of the child's emotions. For instance, a family portrait might describe to you the feelings of concern the child has shown by the sizes of the figures, exaggerations of people or parts of figures, and many other details that give form to hidden inner emotions. The drawings can reveal how he feels about himself and the world in which he lives. The drawings represent symbols of people and objects, not realistic visual representations. The symbols are primarily flat without roundness or depth.

Space is an illusion; an interval of distance.

Around six, he realizes he is within the world and places himself in relationship to others and other places in his art. Houses, trees, parks, school, the sun, flowers, and dogs find their way into his art. He searches for the sense of space; things are near and far. Somehow he relates himself within his environment. He is still the center of his world and emotionally expresses this spatial relationship. Proportions may be exaggerated as to how important the subject is. Sizes and placement are expressed according to how developed his concepts are and how he feels about them, emotionally ignoring any realistic placement. An object is shown as to the type of experience the child has had with it. At this time enriching information related to the object will deepen his understanding and show in his drawings with increased detail.

Space is infinite. About the age of nine, the student is concerned with the concept of space as it relates to his drawing imagery. He begins to conceive of ways to present the illusion of three-dimensional "real" space on a two-dimensional surface. He is ready to learn ways of creating "real" space as well as indicating objects in space or the illusion of "round" forms (see Shading, p. 148).

We know that the sky does not actually touch the ground; we know that a person at the end of the room is the same size as one close to us; we know that the room is the same width at the other side; we know that the space does not alter, yet what we *see* disagrees with what we *know* about space.

Space is an illusion. Space is the interval of distance between you and the objects in your environment. Where we exist in space determines our point of view. We must be in space in order to interact and create that space. The time element influences your existence within a given space and what you see in that space.

All of what we see is an illusion. Shapes, colors, size, patterns, and line direction all change as we move within a space. We know what the sizes are, what the colors are, and what line direction takes place, but when we change our position at our viewpoint, we change the illusion of an object. Movement changes what we see.

Nothing is stationary. Everything is in a constant state of flux and change; just moving our head from side to side or taking a step to the left changes our existing space relationship and therefore changes what we see. How we *know* it, how we *see* it, and how we *feel* about space is always changing. We *know* sizes and colors do not change as they get farther away or closer, we *see* objects change, and we *feel* about objects in terms of our reactions in space. Visual imagery and concrete reality are not the same. What we create in our art is an illusion determined by what we know about it, what we see about, and what we feel about it.

We can develop greater perception of an object by searching for the details. We can select out of our world of clutter and concentrate on the specific. Detail drawing aids in our concept of objects. How many of us can tell right now, without looking, what is on the wall in back of us? We can practice searching for details, and drawing an object helps us to know more about, see more about it, and respond emotionally to it. In teaching detail drawing to students, it is helpful to call attention to differences and similarities, sizes (what is large, what is small), what is most interesting and why, how parts join or work, what the structure is. For instance, ask "Where is it located?" "How many parts?" "How much space does it occupy?" "What is it made of?" "Describe in words the similarities and differences?" Other questions that apply include the following. "How did you create such an illusion?" "What drawing technique did you use?" "What surface quality is there?" "What light source is there?" "How do you indicate the value (the light, middle, and dark tone)?" "How did the time of day change it?" "What shapes, textures, patterns, and colors changed as you got farther away?" "Closer?" "What view do you see—top, bottom, side, or three-quarter?"

Such questioning serves as motivation for greater observation of detail.

IMAGINATIVE SPACE

We now have a space shuttle that will carry us into outer space much as riding on an airplane. People are placing their names on lists for such a ride in years to come. The idea of riding in space fires the imagination of everyone. What a thrill to be able to travel out beyond our space boundaries! One can only "dream" about such possibilities, which will some day become realities. That is true with all our imaginary visions. We "dream" up unreal situations and then they become realities. Artists do this in their art products. Our art is a personal illusion of space. Artists project their illusions into their art. In other words, we (the viewers) never see the concrete object they have drawn. We see the art product, the artist's illusion of the idea. Many times these illusions are fantasies and dreams dealing with space. In Joan Miro's *Personage with a Star* (Fig. 196), we see invented shapes that appear to be flat. There are no shadows, ground lines, horizontal lines, or perspective hints to help us know where these forms are in space. Therefore there is a feeling of unknown space, a dream, a fantasy. In Rufino Tamayo's *Woman with a Bird Cage* (p. 208), we clearly see flat shapes (no modeling) that appear in a *foreground, middleground,* and *background,* clearly telling us about the existing space. On page 232, Roland Peterson's *Picnic of Changes* lets us feel a realistic space illusion through vanishing lines diminishing in the distance. We know we are up high, as our horizon line (or eye level) is indicated about 1/6 from the top of the painting. All images are seen from the top view below the horizon line. Artists that illustrate imaginary space are Salvador Dali, *Spectre du Soir,* page 175; photograph by Jack Stuler, page 140; Paul Klee's *Comedy of Birds;* Stuart Davis' *Composition with Boats,* page 137; Marc Chagall's *White Crucifixion,* page 106; and Ben Shahn's *Television Antennae,* page 84. Imaginative images invent personal concepts of space.

In these imaginary spaces, paintings appear to float, sometimes in the sky, or objects are turned upside down. In *White Crucifixion,* the bodies float, the boat and houses appear together, the candles are as large as some figures, there is no horizon line, the body parts have unreal proportions, and the light is invented light that does not cast realistic shadows. In *Personage with a Star,* the emphasis is on the invented shapes, which sometimes overlap and appear transparent so that they create new forms. There are no shadows, and the outside contours are primarily curvilinear. Multiple, overlapping, penetrating forms create imaginative space illusion.

In Milton Avery's *Bicycle Rider,* Tom Wesselmann's *Seascape #21* (p. 158), Ben Shahn's *Television Antennae* (p. 84), Tamayo's *Woman with a Bird Cage* (p. 208), and George Braque's *Fruits and Guitar* (p. 231), we see that the shapes are flat (without modeling); the lines do not appear to recede into space, but do create an illusion of space by placing an object in front; and objects appear in middleground and in the background. In imaginary space, anything goes!

Imaginary space concepts that exist on a two-dimensional surface of the picture plane are related more to design concepts and more in keeping with contemporary art movements. As art practicers, we create the illusion of space in a variety of ways.

The positive-negative space illusion relates to the positive space that the object occupies. The negative space is the space surrounding the object. In Larry Poon's *Fliegende* painting, on page 190, the positive oblong forms appear to float, but the negative space surrounding the forms also becomes a shape in space. On page 150, the design cut paper shapes by a first grader are the positive shapes; the space surrounding the shapes becomes the so-called negative spaces. In many contemporary or modern art movements, the space illusion is flat and related more to design principles such as balance, unity, contrast, dominance, rhythm, and movement across the surface, and what you select as form, line, color, shape, value, texture, and pattern. The placement and distance between forms plays a major importance in such space designs, sometimes called tension.

On page 186, are design experiments in space. Repeated patterns appear to move across the surface of the paper in a flat space. The radiating lines on the lower right create a spiraling of space; the circles appear to float and

Positive/negative space design.

forms that possess length and breadth only and lack thickness, depth, or volume;

interpenetration of forms—forms may appear transparent allowing shapes to overlap and shapes behind to show through front shapes;

forms that appear flat—no volume—picture plane is parallel to surface paper;

disregard of reflected light, values, and color becomes choice of artist;

imaginative forms—invented unknown shapes related to each other in unconnected floating space;

positive space; forms, masses, shapes, or areas which the artist creates and manipulates;

negative space; unoccupied space existing around the shape or mass left void; both realistic and imaginative space contain positive and negative spaces; and

exaggeration or distortion of forms or space.

Photo describes reverse positive and negative space.

Imaginative flat forms appear to float in space.

move one on top of another as they overlap without any shadows or horizon line; the design in the lower right moves dramatically into space from bottom to top through a progression of lines and the pointed arrow. We create illusions of space in all art forms, including sculpture, weaving, clay, textiles, jewelry, and photography. Space is a common denominator in all the arts: in dance we move through space in patterns and rhythms; in music there are space intervals—high is opposite low; in film and photography we clearly observe size, shape, and distance to create space illusion. In imaginative space the artist may be concerned with one element or a combination of elements:

multiple views of a particular object;
disregard of perspective;
flat forms;

REALISTIC SPACE

Space is an illusion. We feel comfortable in realistic space; it is what our eyes tell us. To exist within a "landscape" of objects is as close to reality as possible. The camera duplicates this reality as our eyes do. Today, many artists use the camera to capture subject matter as an aid in recording images for art. The camera image helps select out as well as establish gray values. With the camera image we can readily see line angles and directions that create the illusion of space (see p. 164).

The upper grade student begins to deal with space as he sees it. He wants to know how to represent three-dimensional volume on a two-dimensional surface (a drawing). We can aid in his space knowledge by offering avenues of perceiving light, depth, and volume.

All through history, artists have devised various systems of representing space. During the Renaissance, great emphasis was placed on a system called *perspective*. In the etching by Durer, (see below) we see how the artist draws the object on a clear "window" surface, or "picture plane." This window was used the same way that we use a photograph or a viewfinder to select and "see" how to conceive realistic perspective.

Perspective comes from a Latin word meaning "to look into, view, perceive—also, the art of representing solid objects on a flat surface so as to give them the same appearance as in nature when viewed from a given point." Therefore, the object exists in deep space, it displaces air, it contains volume and mass, it reflects light and casts a shadow. The following terms are listed for your further understanding.

The concepts of *overlapping, placement, spatial levels, shading* and *shadows,* and *color* and *size variation* can aid students to better understand ways to create the illusion of space in art. Other important concepts follow. *Eye or station point.* Where we are determines our viewpoint.

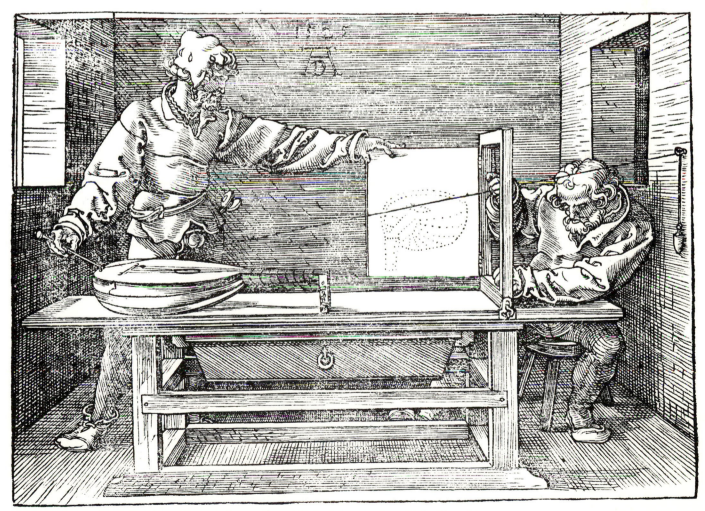

Albrecht Dürer. Page 508 from *Book of Proportions*. Clarence Buckingham Collection. Courtesy of The Art Institute of Chicago. Explaining perspective according to Albrecht, *A.D.* 1525.

Converging lines. Look down a long table, up a sky-scraper, down the side of a fence, along cross-ties of railroad tracks, or telephone poles, the receding lines appear to converge at distant points.

Horizon line/eye level. The horizon line will always be at the observer's eye level. It is an imaginary line ahead of the viewer which is level with his horizontal line of sight. The vanishing point is located on this line. All edges and lines of the object pictured converge to the vanishing point. The forms above the eye level will recede down to the eye level line; the forms below the eye level will converge up to the eye level line.

Picture plane. The flat drawing surface on which we create three-dimensional space.

Vanishing points. These imaginary lines meet at a point on the eye-level line where receding parallel lines appear to converge.

Overlapping. Forms that overlap create distance; the whole form is in front of the overlapped form.

Detail. Detail will vary in showing distance, the clearest detail being in the foreground, the less distinct detail occurring with distance.

Color variation. Bright colors come forward, colors become more neutral as they become distant.

Size variation. Large forms come forward, small forms recede. The houses on a street illustrate how the largest house is the nearest.

Placement. Placing forms lower on the paper so they appear to come forward, placing forms higher up on the paper causes them to appear to recede.

Spatial levels. Establishing levels creates distance such as foreground, middle ground, and background.

Shading and shadows. We see three-dimensional objects in light; the light creates the shading and shadows. The object appears dimensional when we include shading and shadows.

Foreshortening. A visual technique that has a sharp size change in space, which results in visual impact. The forms are exaggerated in foreshortening.

The terms above attempt to clarify some aspects of looking at space. A simpler way of finding illusions of depth is to use a viewfinder. Hold the viewfinder in front of one eye, with the other closed, and the outside edges of the finder create a window. Select a view within the window, and with the outside edges as the boundaries, compare the angles and line directions that appear in the window. The edges of the finder can compare to the edges of the paper, being vertical and horizontal. The angles and line directions that you see can be drawn on the paper in the same relationship as you see within the window.

Receding lines converge at vanishing points. These points are on horizon lines which are actually eye-level lines. Our positions in space and movement cause our perspective views to change constantly. Many artists today disregard perspective space and interpret depth in more personal ways.

Use a pencil or your hands as a guide to establish the vertical and horizontal lines (or edges). Within the picture, find all the *vertical* lines, find all the *horizontal* lines, and all the *directional* lines. Now, "eyeball" the *angles* where the se lines meet. Next, where these lines intersect, they form shapes. Practice drawing a negative shape next to a negative shape until you build the entire drawing. This kind of perception increases your ability to visualize line directions and angles as well as seeing a shape as a form.

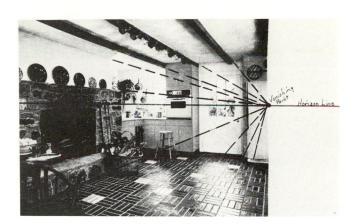

A slide mount makes an excellent viewfinder. Viewfinders aid in sorting out information as well as establishing horizontal and vertical guidelines.

Courtrooms are like stages with many lines and angles within a space.

Draw the line directions and angles in the photographs.

Another technique artists have used for a long time is to use a pencil as a measuring and angle finder device. The pencil is held either vertically or horizontally in front of the eye about arm's length away. Visually estimate the angle of an object and compare it to the vertical or horizontal pencil. Move the pencil to the angle and then back again. Now, you can estimate and draw the angle in your drawing in relation to the edges of the paper. The same process is used in comparing size (length) measurements. Hold the pencil about arm's length from your one eye, and measure visually the lines that appear. For instance, the eraser of the pencil can be at one point; place your thumb at the end of the object. Now change the pencil to another edge and compare the length with the previous length. Be sure to keep your arm fairly stiff so the measurement is consistent. Place your observed findings on your drawing in the same relationship as you viewed them. Keep in mind the visual relationships, whether they are angles of lines or size proportions, are out in front of you. What you are doing is seeing clearly what is before your eyes. You are drawing what you find in ratio to an outside imaginary border (determined by vertical and horizontal edges). The proportions and comparisons you find exist in relation to how you see them. Photographs can aid in understanding distance. On page 110 we see how the camera captured the same image in three consecutive sequences: far away, middle, and close-up views. The forms change as they come closer. Viewing black and white photographs can point out the line angles and directions and the changes in gray values; it can also emphasize the modeling of rounded forms.

HOW STUDENTS UNDERSTAND SPACE

Students at different grade levels handle space in different ways: How they relate themselves to their environment, what they know about space, how they see space, how they feel about space.

PRIMARY

At age five there is still no indication of shading or form. Around seven to nine years of age, a wondrous phenomenon occurs. There appears in the drawings an understanding of an order in space relationships. Now the student realizes, "I am on the ground" (and so are Tom, Lisa, sister). "Flowers, trees, houses grow from the ground." Everything in the picture runs along this line, sometimes called the "base-line" concept. The base line can be other spaces such as a room, a dentist's office, playground, or wherever the child is within that space. The sky is usually indicated by a line running along the top of the page. The open space in between is "air." Objects are colored in with flat bright, primary colors. Space is flat, two-dimensional, without rounded forms. As he learns more about the world in which he lives and his interests and knowledge increase, he becomes more concerned with the details in his life.

Beginning about nine, he looks for how things work, how they are made, what they are made of and what happens when we. . . . He wants to know more about patterns in cloth, textures of trees, styles of hairdos, the mechanics of a motor, the proportions of a face and body, and so on. At this time he can conceive of the proportions of the head, the parts of the body. The more he finds out, the more he wants to know; he is intrigued with how things can be drawn more realistically, like the "real" world. Now we are able to introduce varied aspects of representing space. He realizes that he is a part of this growing world; he is a social being. He likes to work with others and is increasingly aware of how things really look in the world in which he exists and this is reflected in his drawings.

No orderly space relationship except emotionally.

They experience themselves as the center of space (egocentric attitude).

Student draws space as he feels about it and knows about it, rather than how it looks.

A space can be filled with lines, dots, and shapes without appearing to represent any particular thing. These elements can be arranged in space to form designs or can be repeated with sequences of space to form patterns.

He can perceive length and realizes something about distance, but he cannot represent these spatially.

He manages to draw one object at a time but cannot perceive overlapping of objects. He does not represent depth or three dimensions.

Student represents space in the following ways:

a. Base line—a ground line indicating a base and terrain. Sky is at the top; a line is at the bottom. Everything walks along this line.

b. Folding over—the base line is in the middle of the paper, and both sides face or fold over to the center.

c. Mixes forms of plane and elevation. Top views, side views, front views—all mixed together.

d. X-ray pictures—inside as well as outside is shown.

e. Space-time representation—journeys and traveling stories are used. Different time sequences are represented in a single space—taking a walk through the desert, walking from my house to school.

No correct proportions or size relationship; no "real" proportions.

He sees objects as being separate and distinct.

He sees objects as being enclosed in something else, such as a toy in a box, features in a face.

Flat forms, geometric forms, base-line space—Mark Linderman, grade one.

X-ray drawing of interior space.

He sees things in order; objects appear in succession, such as beads on a string, a familiar person's face, the opening of a door.

He sees the object as an uninterrupted surface or a continuous flow of a line.

Objects are drawn without any attention to the angle from which they are viewed, such as sides and tops and fronts of houses together.

INTERMEDIATE

As a result of egocentric attitudes, student still has difficulties in seeing spatial depth. Projects dealing with cooperative group work where the child cannot achieve the results alone and encouraging spatial concepts in creative work will improve the child's social behavior.

Base-line concept is removed. Several planes are represented.

Sky comes down to the horizon.

He can overlap sky and objects, indicating depth.

He has discovered the plane.

Fills in spaces between the base lines.

Student understands how close objects are to each other—intervals of space.

He knows that objects can appear in an order of succession.

He knows that an object can be enclosed or surrounded by something else.

Objects, such as a line, can be seen as an ongoing entity.

Still has difficulty with perspective.

Still has difficulty with correct proportions and size (objects getting smaller as they recede).

Disregards the angle from which he views the object.

Student remembers what he is drawing, rather than what he is capable of drawing; therefore drawings are rather simplified.

Experiences with close observations of detail are important for greater awareness.

More interested in classifying and grouping things, so many objects or people will appear.

Very interested in real concrete things as well as imaginative things.

Has ability to draw more complex geometric shapes such as cylinders, indicating movement around the form.

Visual symbols become more realistic—space relationships more accurate.

Student is more aware of his own point of view, and this permits him to draw what he sees and to establish a more or less single perspective—frontal views.

Develops foreground, middle ground, background.

Courtesy of Jane Kolber

Scratchboard by a Navajo Indian student shows foreground, middle ground, background. Ganado Elementary School, Ganado, Arizona.

UPPER INTERMEDIATE

Produces artworks emphasizing combination of objects into groups.

Interest in objects overlapping in shape and color.

Interest in color changes with distance.

Great interest in building spatial concepts. First-grade student sees object from a single point of view; in fifth and sixth grades he begins to see changes in depth and dimension.

Has ability to discriminate between differences and similarities.

Much practice needed in looking, talking about, and producing artworks in space.

Very interested in art "techniques"—how to make things look round, blending and shading to suggest form and space.

Use of spatial depth and realistic space concept for visually minded.

Retrogression to base-line concept or inclusion of environment only when they are emotionally significant by the nonvisually-minded child. Understanding of space and depth is related to the emotions, not to nature.

Problems relating to foreground, middle ground, background.

Interested in the use of space in the environment, ways of improvement and function. Interior spaces (classroom) are initial space consciousness arenas.

SPACE MOTIVATIONS

Study the section on "How Student's Understand Space", and gear many of the ideas for motivations at your particular grade level.

Ideas that involve group participation deal with subjects like, "Getting Together a Halloween Party", "My Swim Team Made First Place", "Organizing a Car Show", "Exploring a Super Market Together", "Building Our Spook House".

Use an empty slide mount as your viewfinder, and practice selecting views for line angles, line directions, overlapping, and spatial levels.

Study the photographs and artists' reproductions to analyze the ways to represent space both realistically and imaginatively.

Discuss how environmental spaces have changed throughout history, including the spaces we live and move in. Materials and technology have changed space as we know it.

PRIMARY AND INTERMEDIATE

Following is a list of suggested art ideas that deal with space:

Rockets to the moon

Imaginary spacemen

Walking in outer space

Walking from school to my house

Traveling the Colorado River Rapids

Walking down main street

Drawing the typewriter from many views

My house—inside and outside

If I were the Mickey Mouse balloon in the Thanksgiving Day parade

Visiting a department store—what I saw

If I were an ant—ant's-eye view

If I were a bird—bird's-eye view

My trip to the zoo—seeing all the animals

If I were a piece of candy just swallowed

If I could climb into a TV—what I would see

UPPER INTERMEDIATE

A realistic approach may be used in the following: landscape scenes, environmental design.

Draw a still life with volume and mass.

Draw a view looking down the street.

Draw a chair, car, airplane.

Draw cubes and boxes.

Draw cakes, pies, etc., in pop-art style.

Paint a scene in an impressionistic interpretation; a surrealistic interpretation.

Draw books on a shelf.

Look up at a tall building.

Draw a drinking glass from many view points.

Use an imaginative approach in the following:

Take a walk on the desert.

Draw a still life in a cubistic interpretation with flat forms.

Draw a still life in an expressionistic way.

Invent forms that float and relate to each other as if they are floating in space. Tension—without base lines.

Optical art.

Take one object and draw it many times from different views, allowing the forms to interpenetrate.

Look down a staircase from the top of the stairs.

Draw a self-portrait by feeling the forms rather than how they look.

Unusual combinations of objects in a composition.

Create a space design as if an ant crawled across your paper.

Illustrate stories and poems.

Draw a map of your town from a bird's-eye view.

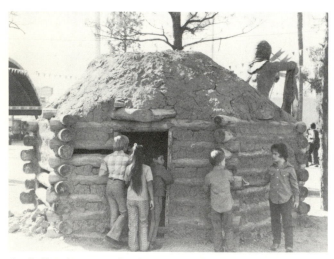

An Indian hogan made of mud and logs. Many Indians live in this type of structure today.

The interior of the hogan—looking up through the center opening.

Redesign your house, school, or community.

Build three-dimensional dioramas related to the environment.

Design an arts center.

Design a model of a new city.

Summary Concept Chart: Space

Space is around student with objects placed at random.

Places objects along a line (base-line) sky at top, objects in sequential ordering.

Foldover, X-ray, and Space-time representation.

Sky meets horizon.

Overlapping of objects.

Objects appear in order of succession.

Disregards viewing angle.

Draws more complex geometric shapes-rounded forms.

Foreground, middle ground and background.

Interest in detail, classifying and grouping.

Visual symbols more realistic.

Understands close-far; intervals of space.

Difficulty with correct size and proportion.

Understands big and small concept.

Understands space nearest bottom of page, closest to viewer.

Understands concept of positive-negative space.

Enjoys using imaginative space such as multiple views, interpenetration of forms, flatforms.

UPPER GRADES:

Deals with realistic space: perspective concepts.

How value changes achieves depth.

How color changes achieves depth.

Size changes in space.

Foreshortening, exaggeration in space.

Shadows and shading create three-dimensional illusion, depth.

Spatial levels; foreground, middleground and background.

Learn art techniques to create depth.

Study how artists create various kinds of space.

Identify space in our environment.

Discuss careers such as architecture, engineering, landscaping, sculptors, craftspeople concerned with space.

ARTISTS TO STUDY

Artists illustrating realistic space include Edward Hopper, *Nightstand,* p. 230, and *Nighthawks,* page 175, Hans Breder, *#/32, Cubes,* page 230, Carol Bidstrup, *Illusion No. 6,* page 143; Pierre Auguste Renoir, *On the Terrace;* Rembrandt van Rijn, *Young Girl at an Open Half-door,* page 209; Paul Cezanne, *The Basket of Apples,* page 230, Albrecht Durer, *Book of the Proportions,* page 167; Mary Cassatt, *The Bath,* page 208; Salvador Dali, "Spectre du Soir" page 175; Edgar Degas, *Woman in a Rose Hat,* page 211; Andrew Wyeth, *The Tolling Bell,* page 90; and others. Can you describe the kinds of space used?

above: Edward Hopper. *Nighthawks.* Oil on canvas. Courtesy of The Art Institute of Chicago.

below: Salvador Dali. *Spectre du Soir.* Oil on canvas. 18″ × 21½″. Courtesy of The Fine Arts Gallery of San Diego.

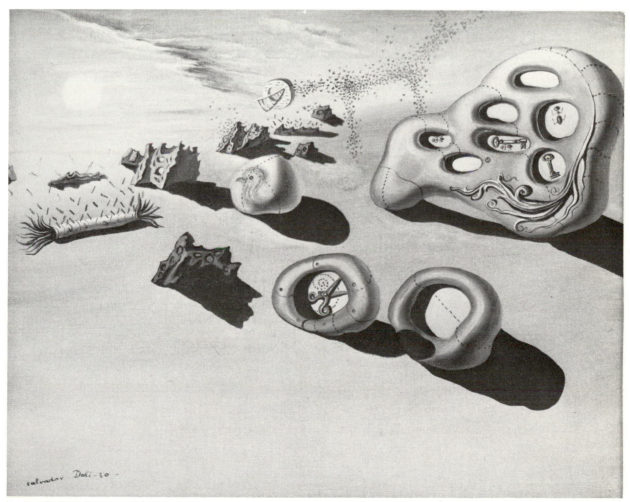

Both paintings have qualities of mystery, unusual space, interesting shadows, and strong lights and darks. In Dali's painting the forms appear to float and be timeless, since we do not see any surface on which they are resting.

right:
Patterns projected on a screen are dynamic.
below:
Drawing by Robbie, grade five.

10

The Art Elements
Color, Pattern, Texture

Color is like music—a melody. Separate musical notes are beautiful in themselves but do not have as much meaning when alone. When they are placed in special relationships to each other, a beautiful melody results.

The same musical notes or colors placed in different positions can produce a whole new melody; the change in the shape and the amount and placement of color can create a complete new feeling.

Color is the perception of a light stimulus by the mind and the eye; each color has its unique effect upon us.

Sir Isaac Newton performed a famous experiment in 1665; he found that he could pass a narrow beam of sunlight ("white light") through a triangular prism, and the white light changed into a multicolored beam of light. The colors are known as the spectrum: red, orange, yellow, green, blue, indigo, and violet. He also found that by passing this beam (the spectrum) back through another triangular prism, he could again produce the white light. White light is a combination of all colors.

Color depends on—

- whether the object is transparent or opaque;
- the light in which we see the object; and
- the reflected color.

The color in which we view the object will affect the color of the object. In sunlight a daffodil looks yellow because it reflects the yellow light waves and absorbs all other colors. If we looked at it in a blue light, the flower would look black, as there are no yellow light waves to be reflected. Colors are reflected light; a blue surface means that blue is the color reflected, and all other colors are absorbed in a white light. White is the presence of all colors. Black is the absence of all colors.

For the artist, color is more complex and interdependent with the other visual elements in the art product. Color can be a very personal form of expression. Children often select color preferences due to the appeal to the child's personality, although very little research has been done for color preferences and personality. Most students like to use color, and its sensual appeal is captivating for all of us. As we discuss the properties of color, keep in mind that like a melody of notes, we see color in relation to the colors that exist around it.

Colors, textures, and patterns are all around us.

Photograph courtesy of Scott Harris

Hubbell's trading post, Ganado, Arizona. Navajo Indian rugs are famous for their individual pattern designs.

Photograph courtesy of Scott Harris

Banners and flags are colorful contemporary forms of artistic expression.

COLOR VOCABULARY

Hue. The classification or name of a color; the artist often uses the word hue to indicate color. The hue of an object is the wavelength of light reflected from it. The reflected wavelengths of light do change, causing changes in color.

Value. Value refers to the lightness or darkness of a color; sometimes called a tone. The lighter a color, such as yellow, the lighter the value; the darker a color, such as black, the darker the value. If we add white to a color, we lighten the value. If we add black to a color, we darken the value.

Intensity. The brightness or dullness of a color is sometimes called the saturation chroma, or purity of a color. A hue that is not mixed with any other color is at its maximum intensity. Mixing a color with another color lowers the hue's intensity. It is the pure, unadulterated color. Bright red has greater intensity than brown or dark blue.

Warm colors. Red, orange, yellow—and derivatives.

Cool colors. Green, blue, violet, and related colors.

Monochromatic. All shades, tints, values, and intensities of one color hue.

Analogous. Colors side by side.

Opaque. Thick, nontransparent color; tempera, oil paint.

Wash. Color thinned to appear transparent. Glazes, watercolors.

Related colors. Colors that "go well" together. Personal selection.

Achromatic. White, gray, black.

Chroma. The brilliance or intensity of a color.

Spectrum. Red, orange, yellow, green, blue, indigo, violet (light breakdown).

Primary colors. Primary hues (for the artist working with pigment) are red, yellow, and blue. These hues cannot be made by mixing other hues.

Secondary colors. The secondary hues are created by combining the primaries. For instance, yellow and blue produce green, blue and red produce violet, and red and yellow produce orange.

Tertiary colors. Are a result of mixing primary and secondary colors together, producing a green with more yellow than blue, say, or red and violet for a red-violet, and so on. These mixtures become very subtle and can be experimented with and used freely and creatively.

Complementary colors. On a color wheel, this term refers to colors opposite to one another. Red is opposite green blue to orange, and yellow to violet. Mixing opposites will often neutralize them, or produce a "graying" of the colors. Artists often "gray" colors this way, rather than adding black or white to a hue. A hue and its complement contain

the three primary colors, so that complementing a color is the same as mixing the two remaining primaries. In theory, black results from combining the primaries, but in practice, more potentially interesting "grays" result from mixing complementary colors. When complements are used side by side, such as red next to green, a visual illusion of maximum contrast is produced with great intensity.

Analogous. Colors side by side that have something in common. Such a color scheme would be yellow, yellow-green, and blue-green, yellow being the color in common.

Tint. A tint is a hue lightened by adding white. Pink is the tint to red. Adding white to a color reduces its intensity and makes it a tint.

Shade. Darkening a hue by adding black to it. Maroon is a shade of red.

Tone. A hue to which black and white have been added.

Pigment. The coloring matter, usually found as insoluble powder, which is mixed with oil, water, wax, etc., to make paints, crayons, chalks, etc.

Purity. The purity of a color is the amount of the hue; the degree of maximum strength (or saturation) of any given color.

Color relativity. How the color is in relationship to other colors.

Color balance. The color arrangement in a design indicating an equilibrium or harmony or disharmony.

Color blend. Placing two colors of similar characteristics side by side.

Color contrast. When two colors distinctly different are placed side by side.

Color effect. When the artist conveys a color impression on the viewer through the use of color.

Color advance and recede. The sensation of color coming forward or color being back of another color.

Color emphasis. A term that implies that one color stands out from other colors through the use of contrast.

Paint has always been a medium that allows colors to mix either on the palette or on the paper after the paint is applied. Artists often use the technique of glazing with oils or watercolors, which is the method of painting on one color and allowing it to dry and then painting over the color with another thinned transparent color. In this way, the color from underneath blends through.

You can encourage children to try new colors by presenting names of colors. After they have freely explored the many possibilities of mixing at random, ask them to try to mix a very definite color. Hold up a swatch and see if they can match it. If they can, try to remember exactly how they mixed the color. Write it down and have a color chart. When teaching color, you will find that *discovery of the color by himself will always be more meaningful to the child, rather than having you tell him how*

to mix it. Spend several hours just mixing colors. Different media will determine different colors. For instance, chalk gives a very different green when blue is mixed with yellow than paint does. The color blue and the color yellow will vary the green also. Learn the names of different blues, yellows, and greens; this can be exciting and quite a game!

Children always like to try new and different materials. New and varied color crayons can be challenging (they always have the name printed on them) and exciting. We always start children in the first grade with a *large box* of sixty-four colors. So much fun to try! Why limit the children to eight *primary colors?* They can still blend and mix the sixty-four to get different colors. If your district cannot afford them, ask the parents to supply the large boxes of crayons. Remember, *always plan on time for "playing arond" or experimenting with new materials.* Other color games could involve using layers of tissue paper, experimenting with lights and acetates, drawing on film, gelatins, oils, slides, overhead projectors.

COLOR PSYCHOLOGY

The psychology and the perception of color have always been intriguing. Very little has been researched or concluded on the phenomenon of color and how we perceive color visually and emotionally.

Color and reproduction of color have mystified man since the beginning of time. Among the first impressions that children recognize are colors. When Bill, our first son, was just weeks old, he became very fond of a papier-mâché mask we had hanging on the wall. Turning his wobbly head, he would search the room until he found this favorite form, and he would smile and smile at it. We couldn't imagine what it was that he was smiling at until we realized he liked and enjoyed the bright colors. Color appears to be a dominant influence in recognizing forms.

We are all aware of how colors can influence us emotionally. Many studies have been done to support mood with association of colors. Some researchers suggest evidence that most color preference is a result of learning. Other researchers conclude that color is purely an emotional response determined innately. Color has a variety of meanings for each individual: our learned past experiences, our total emotional perception, and the symbolic meaning it may have for us.

In 1943 Rose Alschuler and LaBerta Hartwick conducted a study with one hundred and fifty preschool children in eight separate nursery groups. Each child's artwork was recorded for one year, along with the child's social and developmental date. Case studies and statistical analysis did indicate that color gave insight into the child's emotional life. Their findings indicate that red is the most

emotionally toned of the colors studied. During the preschool years when color is somewhat of an impulsive choice, red is the preferred color. As the child gains more emotional control and develops into the age of reasoning, the interest in red decreases, and the interest in cooler colors increases. Red is associated with feelings of affection and love, as well as feelings of aggression and hate.

Blue is more often associated with drives toward control; green is associated with those functioning with more control and showing little emotional reactions. Orange tends to be used with tempered emotions such as friendliness and sympathy and by students who turn more to fantasy and imaginative realism. Black is associated with intense anxieties and fears. Other findings indicate that color placement also gives clues to personality; color overlay reflects repression.[1]

Dr. Anne R. Lenzner has been pursuing a study on the relationships of color and how it affects children and their learning environment.[2] She feels that a more intelligent utilization of color can be used as an instrument in modifying the environment.

In a study to determine how children in different socioeconomic groups think and feel about color, she surveyed different socioeconomic groups of ten-year-old school children in the fifth grade. Three schools with a population of twenty-eight children of mixed sexes were used in the study. One school was in a high-income level, the second in a middle-income level, and the third in a low-income level. Following are some of the questions she used:

Is a socioeconomic factor relevant in color preference in one's feelings about color?

Are children being subconsciously indoctrinated in predetermined color concepts through contact with unaware teachers?

Do children change their own color concepts in the school environment? If so, is there a grade level at which this occurs?

Does color influence our emotional reaction? In what part does color determine taste, instinct, or intuition? Scientists today are just beginning to research the effects of color in behavior and aesthetic choices. There are approximately two and a half million hues in the visible color spectrum.

Behaviors appear to be influenced by color in the environment. Pink has been used to retard aggression among prisoners (although leaving anyone in a room of the pink color longer than 30 minutes has undetermined effects) and at a South Bronx, New York, school for severely hyperactive children, a youth facility in San Bernadino, Ca., and a psychiatric ward at the VA hospital in Los Angeles.[3] Bright reds and oranges supposedly stimulate appetites. And there are color preferences between sexes, age groups, socioeconomic levels (with bright strong colors preferred by lower income groups, regardless of race).[3]

Following are two of the questions Dr. Lenzner asked the students and their answers.

What is your favorite color?

"I like blue and red colors because they are bright to me and they kind of flash to your eyes."

"Blue is my favorite color. It is my favorite color because my dad was in the Navy and I love the sea and the water."

"Silver, and I don't know why I like it." "Psychedelic green."

"Green, blue. They're bright, the color of my room."

"Blue, because it makes me happy, nice. Red, because it makes me alert, awake, alive."

"Purple and blue because they're pretty and alive."

"Green because it makes me feel like baseball and I like baseball."

"Pink, it makes me feel nice. Purple, because it makes me feel sleepy."

"Olive green and pink. They look good on me."

"Black and green. Black gives me a happy feeling. Green to me is lucky."

"Gray, because I had a gray cat in El Paso, Texas, and when we were over visiting my grandmother, she got lost and got hit by a big moving truck and I loved her very, very much."

"Hot pink. It is my favoriate color because it is bright and happy. To me it looks like an optical illusion."

"Green, it makes me think of candy." "Bright orange—I do not know why."

"Blue, I like it when it is over a light." "Red, it is a fast color."

"Blue, because my eyes are." "Red, because it's in the flag."

"Green, because that is the color of the Sunnyslope Vikings football team."

"Green, it is so different from the rest."

"Blue is my favorite color because it is so much alive like myself. I like it because it can be sad, glad, alive, and dead, and because it has so many shades. Actually, blue-green is my favorite color, but I call it blue."

What is your definition of color?

"Color is something happy and very pretty and most of them are soft."

"Alive."

"It makes everything funny."

"Makes life bright and fun."

"Color is a thing that has shape and gives moods that are odd and it makes you feel different and it makes your pictures alive."

"Color could be sad, happy, angry, dead, and other feeling."

"Color is shape and gives mood."

"My definition of color is that it has feeling and some kind of mood in it."

"It makes me feel sort of secure. It has a lot of feeling to me."

"It is a mood and temperature, and motion."

1. K. Warner Schaie and Robert Heiss, *Color and Personality* (Berne, Switzerland: Hans Huber Publishers, 1964).

2. Dr. Anne R. Lenzner, "A Critical Investigation of Selected Data Pertaining to Various Aspects of Color" (master's thesis, Arizona State University, June 1972).

3. Alexander Schauss, unpublished research (American Institute for Biosocial Research).

Dr. Lenzner's study presented a group of color cards to the students. They had to rate the colors as to

1. moods: happy, sad, alive, dead, alert, sleepy, angry, nice;
2. temperature: hot, cold, medium; and
3. motion: slow, fast, in between.

Generally, the students indicated these responses to the following colors:

Red: happy, alive, alert, hot, fast
Yellow: alert, alive, hot and fast, sad
Blue: sleepy, nice, cold, medium, slow, happy
Orange: happy, medium, in-between, fast, nice
Green: alert, cold, slow, in-between
Purple: happy, cold, hot, fast
Brown: dead, sad, cold, slow, hot
White: alert, alive, cold, slow, dead
Gray: sad, sleepy, cold, slow, dead
Black: dead, sad, cold, hot, slow.

Dr. Lenzner states that there is a need for continued research and accumulation of scientifically documented data on color and color psychology. Color is potentially inexhaustible in the dimensions of creative and behavioral learning development as it relates to and affects children.

Of particular interest are (1) relationship of color to behavioral responses in children; (2) effects of color upon the learning potential of children; (3) sex biases in color preferences; (4) indoctrination of color conception through when, where, and how; and (5) how children in different socioeconomic groups think and feel about color.

By continuing to advance knowledge and in seeking to establish a sounder foundation for learning and appropriate behavior, the implications of color research are very challenging and positively enlightening.

COLOR MOVEMENT

THE CAMERA AS AN ARTISTIC TOOL

The great strength of the film, the thing that appeals to the filmmaker, is that you put on the screen what you have seen, what you have thought of, and there it is, fixed forever; it cannot be changed. Consequently it is closer to graphic arts, to painting, than to theater cause there it is, even though it's moving, it can never be altered.[4]

One tool that has unlimited possibilities for expression is the camera! Just by putting your eye to the viewfinder, you find you are isolating a particular view from the rest of the world—for an instant and moment in space and time! When you photograph something, you are isolating an object and preserving it for further study. You

are composing and saying, "This is what I feel is important enough to separate and study and perceive again and again." You are composing your view, contrasting certain lights and darks, indicating and combining certain colors, forms, and action.

It would be helpful to make a cutout rectangle from a firm piece of paper (oak tag) and carry it to look through in order to find exciting contrasts and interesting ways of seeing something—such as unusual angles. When you draw or paint on a surface, you are doing the same thing; you are isolating some forms and saying you feel these are the most interesting and most expressive of the way you feel about something. There are *infinite* ways of saying the very same thing—whether with words, paint, movement, music—or unlimited combinations of forms. You will say it the way you feel is the most expressive for you. All paintings are different even when they are of the same still life. Each painter sees it through his own eyes and mind.

The camera is another tool to use for expression. In black and white the selection will be subjective contrasts of lights and darks, most interesting way to express the subject, perspective (e.g., unusual angles), shadows and feelings, depth, forms, textures, lines, discriminating attitudes, size relationship, a segment of reality, focusing attention, patterns. And with color film, another element is added.

In the moving picture, the excitement is heightened by the addition of action; the scene is constantly changing. By adding the challenge of the moving camera, some things will be intentional; other occurrences will be "happy accidents" that can add or detract from the final image—for instance, out-of-focus, incorrect light exposure, increased feelings of zoom depth, ultra close-ups. The images created in filmmaking can accentuate and recreate definite feelings and emotions. The mind alone isn't fast enough to capture all the details in the instant the camera is able to. Anyone who has experienced filming knows the excitement of the action and the expectation of waiting to view the images captured and recorded.

For studying nature and the environment, the camera, still or moving, is one of the greatest tools we have available. Every classroom should have at least one camera available for use.

MAKING A MOVIE

THE ANIMATED FILM

Equipment needed: A Super-8 camera with a single frame exposure, tripod, photolights

Some students and I decided we would have a "fun" experiment with film, and that's exactly what it turned out to be.

4. James Salter, "Artists in America," television series (Public Broadcasting Service, Oct. 1971).

The artist students—those who felt they would like to draw—created their own animated figures and ideas. They realized that several body parts would be needed for the figure to move and that they would have to disjoint the figures to allow for movement.

Other students preferred not to draw, but to use magazine photos as cutouts and then use these collages of forms to change and move to express ideas.

Two paintings of movie heroes were brought in, and students made up different features for the portraits—new eyes, mouths, noses, beards, mustaches, teeth, glasses, etc.

Several students did animation with wet clay. The idea moved quickly with the addition and subtraction of wet clay. As a result, the film was a collage of "fun" images, short sequences of ideas and a beginning in making animated films.

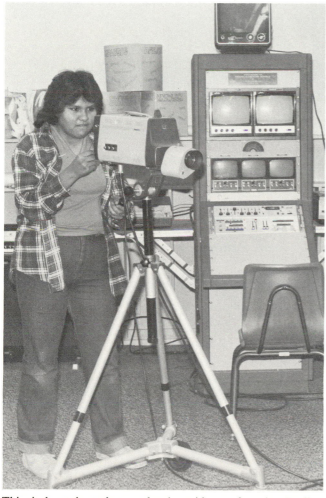

This sixth-grade student, under the guidance of teacher Pauline Branstetter, is participating in a gifted program where the students produce their own video productions (control center is against wall). Another sixth-grade student, Jessica Wood, took this photo and made the enlargement for this publication. (Pauline Branstetter is author of "Picture Perfect," A.M. Publications, Phoenix, 1981.)

THE EXPERIMENTAL FILM

Equipment needed: A 16-mm projector

Almost everyone has seen *Fiddle-Dee-Dee* at some time, the 1948 Norman McLaren film that was one of the first films using images painted directly on the film. We decided to try this.

The students stripped some old 16-mm film. Using liquid bleach directly on the film dissolves the emulsion. Other stripping agents can be used, such as lacquer thinner or rubber-cement thinner. Students discovered that leaving some images on the film added interest, variety, and some sound.

Then the students drew images on the film with colored inks and pens, felt pens, ball-point pens, brushes and ink, pens with fluorescent ink. I discovered another technique that added much visual interest. By applying Cryst-L-Craze paint which is available in art colors (I used the clear) over the drawn areas, the images appear on the screen looking like snowflake crystals, and, of course, they change in motion also. The paint is transparent as it goes on, but crystallizes on drying.

Sixteen-millimeter leader can also be used. The emulsion is scratched away or punched, leaving designs; then color is added to the lines and textures.

Each student was able to participate and either drew on individual sections of film, or long strips were laid out on tables, and students drew on sections which were later spliced together.

THE LIGHT SHOW AS MOTIVATION

Materials needed:

Colored inks	Colored alcohol
Acetate paper	Mineral oil
Slides (2″ x 2″ mounts)	2 crystal dishes, 10″ and
Colored acetate sheets	12″
Overhead projectors	Automotive oil
Slide projectors	Another glass dish
16-mm. film projector	Vegetable oil
Super-8 projector	Plastic wrap
Black lights	Eye- or nose-dropper
Strobe light	Liquid soap
Spotlights	Fizzies
Rotating mirror ball	Rubber cement
Music—bands or records	Screen
Tapes	Optical illusion acetates
Small floating objects such as Styrofoam forms, stars, etc.	Moiré kit from Edmund Scientific Co.
Decorations with fluorescent paper, painted designs, and posters—all for phychedelic atmosphere	

(For making slides, refer to p. 247, "Making and Painting from Slides.")

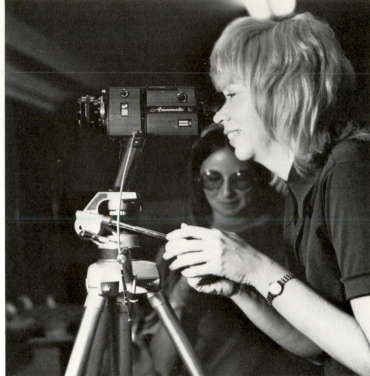

Teachers enjoy making films. During a work-shop class, groups of six teachers plan, draw, and make a two-minute animated film, selecting a theme that relates to their teaching.

Procedure:

Create your own slides.

On one overhead projector is a roll of acetate painted with brightly colored inks in abstract designs and patterns. On this roll, place a variety of other acetates, either cutout patterns, filigree designs, pinhole designs, or grids, and additional colored acetates. These are manipulated manually to the tempo of the music.

On the second overhead projector, place two graduated crystal dishes, one approximately 10" and the other 12", stacked inside one another. Move them gently. A mixture of colored alcohol and mineral oil in each of the dishes will project changing amoebalike images on the screen. Colored acetate sheets held in front of the overhead scope change the color effects.

A glass dish of automotive oil will black out on another overhead. By wiping through the oil with a finger or other device, images of light travel across the screen.

Liquids used with the overhead present designs of color which flow into each other, and bubbles appear as huge white circles swirling around the screen. To achieve this effect, try filling plastic bags with colored water; add vegetable oil to the water, then add coloring to the oil. Add a fizzy to the color to see it bubble and fizz.

Add plastic wrap over color and watch the water, oil, and color move. Add rubber cement. Add liquid soap and see the bubbles. Use eyedroppers to add colors. Blow with straws. Make your own slides by using vegetable coloring, oil, rubber cement, pens.

Mirrors provide a startling effect when used with overheads. Broken pieces glued to a piece of felt suspended by rubber bands in a wooden frame reflect a fractured image.

When pressed or rubbed, the images split in many directions and scatter rhythmically across the projection screen. Three square mirrors taped together into a slide box also provide an unusual reflective surface for the reversed overhead.

Another mirror instrument consists of three mirrors, each 12 inches long, taped into a triangle tube. When placed in front of the overhead scope while the acetate roll is turned, a radial kaleidoscopic pattern appears on the projection screen. The familiar mirror ball is created by gluing mirror pieces on a papier-mâché ball formed over a balloon. Colored minispots are hung near the turning mirror ball in the center of the ceiling. The continually moving lights projected in this manner extend the environmental aspects of the show.

The slide projectors provide the multiple projections which are blended and faded by using hands in front of the lenses. Friction wheels of colored acetate, rotated by motors, allow ease of color changes. Slides of current events, faces, local scenes, students, and designs are manipulated. A film adds a taste of psychedelic art on the 16-mm projector. Also, a student-produced film enhances the audience's identity with the content of the show.

Program the techniques and sounds together, following a crescendo approach. Start with a low-key beginning of subtle changes of color and images; lead to a building of intensity of rhythm, light, and color, and the addition of dancers.

Taped music and live bands add excitement. Students enjoy standing in front of the images, and by moving they add still another dimension. For the finale, all the effects provide a powerful conclusion.

Practice handling the technical equipment and procedures. Be aware of the art principles such as color, line, patterns, textures, etc. Experiment with optical distortions and exaggerations and the illusions possible. Coordinate dancing, music, etc., for maximum participation. Develop the perception of each individual.

HOW STUDENTS EXPRESS COLOR

PRIMARY

Provide simple, short, colorful, bright experiences. Study one object, tool, or medium at a time.

The student can name most colors at this itme. He uses color unrealistically and in a random manner.

Color has an emotional appeal—selection is not in a specific way. For instance, a favorite color may be any color, perhaps yellow one time, blue the next.

He will use several colors, at least four. Provide opportunities to use many colors.

His use of color is spontaneous, not deliberate.

Explore and experiment with the mixing of color—mixing on as well as off the paper.

Investigate relationships of color; for instance, how the color of your hair looks next to the color of your eyes; next to your skin; next to your dress or shirt.

Investigate colors in flowers, the change in a petal from light to dark.

Colors change from light to dark. Identify the qualities of light and dark.

Colors change from bright to dull. Identify colors from bright to dull.

Be aware of and discover colors in the environment.

Student should discuss differences and similarities in colors.

Student should be able to match and sort colors, such as different blues.

Colors should be discussed as to feelings—sad, happy, beautiful, loud, quiet.

INTERMEDIATE

Relating colors to objects

The student begins to think of color in a realistic way: grass is green, sky is blue. He doesn't necessarily see variation in color unless he has a meaningful experience with variations in color.

The student continues to use color in a way that expresses what he knows about it, not as he sees it.

Color is simplified: all sky is blue, not a variety of blue; all daffodils are yellow, not a subtle variety of yellow. He may recognize differences when having meaningful experiences with color, but then he will rely on his memory of a colored object. Study differences within a color.

Begin study of color tints, shades, variation.

Study artists and how they interpreted color.

Color schema is based on visual or emotional experiences. Schemata deviate due to first significant emotional experiences.

UPPER INTERMEDIATE

Color becomes more varied.

Student should show interest in mixing color.

Student may select personal colors to indicate moods and feelings.

Emphasis is placed on emotional selection of color.

Student desires to represent color realistically; therefore, learning shading of color and practice in mixing white and black to achieve values, tints, and shades are important.

Mix complementary colors to explore shades of colors.

Learn to differentiate colors. All reds are not the same red; there are blue-reds, orange-reds, green- or gray-reds.

This leads to the need for learning names of various colors like crimson red, or Chinese red; cadmium red bright; cadmium red medium.

Interest in study of shading color.

Response to color: what is pleasing, what is non-pleasing; making judgments.

Understanding of vocabulary words such as *hue, intensity, value.*

Study of light on surfaces; changing color such as in landscape.

Study of primary and secondary colors.

Study of warm colors, cool colors, and how they are used to indicate depth and modeling.

Study of color part of design and composition.

Study of how color is used to create

balance	space
harmony-disharmony	repetition
movement	rhythm

Importance of color as expression of ideas and feelings.

Discuss importance of color relationships in environment.

Continue to experiment with various tools and media; these will influence color.

Discover colors to express unique feelings.

Develop a color consciousness.

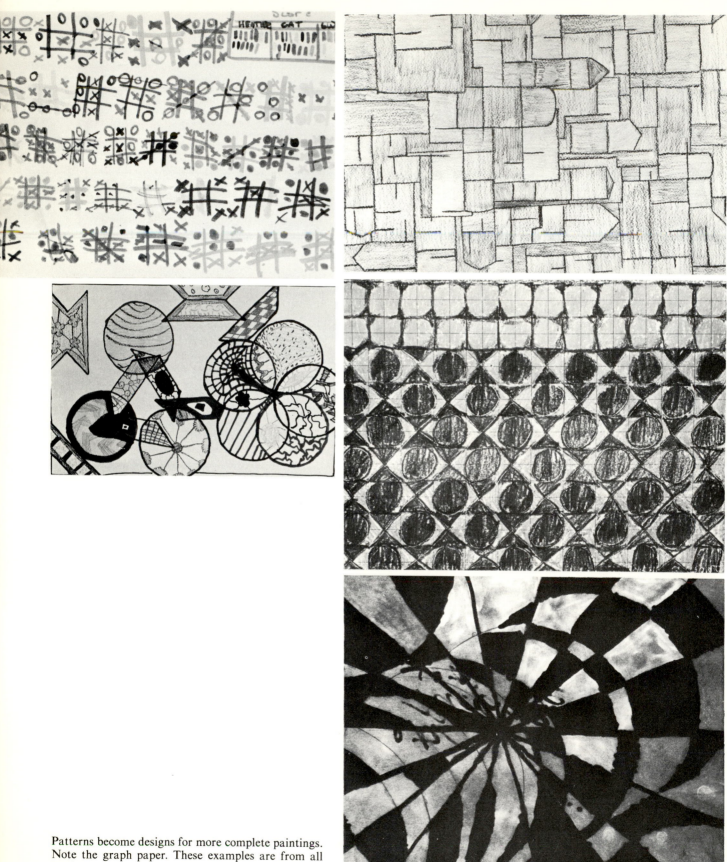

Patterns become designs for more complete paintings. Note the graph paper. These examples are from all grades.

Observe how colors are influenced by colors around them.

Study perspective—space—and how it changes color and light.

Use various textures and observe how the texture influences and changes the color.

Continued study of artists, their use and interpretation of color.

COLOR MOTIVATIONS

Blow bubbles. Look at them through a concave lens.

Look through prisms; through convex lenses.

Look at paintings through sheets of colored acetate or film.

Look at one color outside through different times of day.

Look at colors in an oily puddle; at rainbows.

Look at mist around street lights.

Find colors that express different feelings—happy, sad, love, hate.

Stare at something red for one minute. Look away and close your eyes and see the complementary color.

Look at a painting inside under artificial light and outside in natural light.

Look at leaves on a tree. Are they all the same green during the day? At night?

What colors come forward; which ones recede?

Identify colors that go together, colors that you feel clash.

Can music have color? Listen for moods and effects that relate to a color.

Think of a story. Which color would express the idea in the story?

Look for color combinations in rooms, magazines, clothes, and in nature.

Color never exists by itself, only in relation to the colors around it. Are black and white colors? White reflects all color; black absorbs all color.

Have you ever worn something black on a hot day? White on a hot day? In which color were you more comfortable?

Look for color in movies and in TV (Why does a desert scene look hot? Snow cold?)

Look at the sky and clouds. Is the sky always a clear blue? Is it ever red? Purple? Green?

Look at how other artists have used colors in paintings—shading colors, flat colors.

Do some paintings make you feel calm? Excited? What colors were used?

What colors are used in factories? Department stores? Grocery stores? Restaurants?

Look at objects under a white light bulb. Under a red light bulb. A blue bulb.

Make a spectrum with a prism or glass of water.

Look at light as it is refracted in water.

Look for mirages in roads. The moon as it rises at night. The rainbows in the sky.

Moving the light source closer to the object will create stronger, brighter light color and darker shadows.

The lightness and darkness in a group of colors depend on the color relationship to each other.

The average person can see about nine steps from white to black, but the media used will vary these nine steps. Can you draw or paint nine steps from black to white?

Have fun by mixing just two colors together, varying the amounts of each color added. Do this in steps. Can you mix gray?

Do you know what pointillism is? Try putting dabs of colors together to form shapes. From a distance your eye should fuse the colors.

What happens when you mix blue with all other colors?

What happens when you mix yellow with all other colors?

Can you mix gray? Brown? Other neutral colors?

Can you discover colors to make you feel love? Hate? Joy? Sadness?

Can you find and use in a design four colors that are ugly together?

Can you find and use in a design four colors that are pleasing together?

Can you make a *srong* painting? *Strong* colors? *Weak* colors?

Can you paint a *thin* painting? Opaque painting?

Can you discover *new* colors?

Look at many different colors through many different colored glasses and papers.

Turn off all light and slowly add light with flashlights, with spotlights.

Look at colors and objects from far away, like mountains; then get close to the objects and see the changes.

Write down as many different names as you can think of for colors.

Look at one artist's work, such as Vincent Van Gogh, and discuss how he used color. Look at other artists' works as well and have discussions about color and other art elements.

Close your eyes and remember as many colors as you can.

How does one color affect its neighbor?

Create a painting using just primary colors.

Create a painting using secondary colors, another which is just monochromatic. Another using just complementary colors. A painting using tints, another using shades.

Create a painting using opaque colors, another using wash colors. Combine the two.

Create a painting using related colors, another using unrelated colors.

Create a painting using close value colors, contrasting values. Try a high-intensity painting.

Summary Concept Chart: Color

Identify bright-dull colors. Identify light-dark colors.
Discuss and practice three primary colors.
Discuss and practice the three secondary colors.
Discuss and mix the tertiary colors.
Discuss and mix complimentary colors.
Discuss and practice mixing tints and shades of a color.
Discuss and practice using warm colors, cool colors.
Discuss how light affects color.
Discuss and practice analogous colors.
Discuss and practice mixing tones of a color.
Discuss and practice color relativity; the use of one color next to another.
Discuss how color realitivity is used to produce contrast, balance, rhythm, dominance.
Discuss how color relationships produce space; they advance and recede.
Discuss how color can express a mood or feeling.
Discuss your color preferences and why.
Determine color in nature/ color in man-made items and spaces.
Discuss various artists and art movements and how they used color.
Discuss how color is used in various careers—Film, television, illustration, photography, architecture, interior design, clothing designers, craftspeople.
Use color spontaneously. Use color with deliberate structure.
Mix colors spontaneously; mix colors as to complimentary, shades and tints, warm and cool.

PATTERN—RHYTHM

Listen to your breathing! The train! The rain! Listen to the birds singing! Leaves on a tree! A bird flapping his wings! Listen to your heart beat!

Look at the bricks in a wall! Look at wheels on a bike, on a car! Look at fences! Ripples in water! Shingles on a roof! Holes in a pegboard! Look at the design of windows in a building! Building units in a city! Spaces in your school! Designs in a rug! On a chair! In a painting! Look through a kaleidoscope! Look at jets in the sky! Listen to children singing a song! Saying a rhyme! A jingle!

We repeat many things that we see, hear, feel, and taste. We even repeat the way we live: eating, sleeping, Mondays, Fridays, January. We create patterns for ourselves. We arrange days or items in an orderly and most interesting way.

Patterns have been used since ancient times in the expression of the arts. Musical rhythms and beats are repeated. Dance forms are organized in patterns. Buildings are constructed in space units with contrasting patterns of textures and design of materials.

The Greeks, inspired by the trees, repeated the columns of the Parthenon and used tall openings. The arches of the Gothic cathedrals are said to have been inspired by hands pointed in prayer. The rounded openings of the ancient Colosseum in Rome are repeated to form an interesting structure. Today many of our buildings have the feeling of the cubists, with repeated geometric shapes, cylinders, spheres, cones, and cubes. (Greeks used geometric designs in their patterns of decoration.) We are especially aware of patterns when the surface is flat rather than a round form. When a form is repeated, such as in a design, it often becomes decorative. In this instance, then, a pattern is used to embellish a surface. A repeated pattern is often involved with other qualities, such as color, line, shape, positive and negative spaces, lights against darks.

In nature we see patterns everywhere—a branch, a group of flowers, the cluster of leaves describing a pattern as they alternate in their growth on the branch. A row of trees becomes a pattern. The reflected city lights create a pattern. Melodies of tone often repeat themselves and form a pattern. In poetry the sounds are repeated, and the number of sounds forms a pattern.

All patterns have repetition. Repetition in a pattern gives it order, or unity. The way the pattern is put together will give it contrast and variety.

All patterns have rhythm. The beat of rhythm may be regular or irregular. Pattern is based on repetition of units at regular spaces or intervals.

TEXTURE—A SURFACE

It should not be hard for you to stop sometimes and look into the stains of walls, or ashes of fire, or clouds, or mud, or like places, in which . . . you may find really marvelous ideas.[5]

We see these textures:

Natural or actual—such as tree bark
Man-made—glass, cloth
Simulated—photographic illusion

Texture in drawing—the textural quality of a drawing:

The surface quality of the object being drawn.
The way the student manipulates the tool affects the texture represented.

5. Leonardo Da Vinci, *Notebooks of Leonardo Da Vinci,* ed. Jean P. Richter (New York: Dover Publications, Inc., 1970).

Whenever you draw a tone or value, you also will have to consider the texture of the object you are drawing. If the surface of the object is smooth like skin, then a soft, blended texture is needed. If the surface is rough like sandpaper, then a different tone will be created.

In arranging still lifes, texture should be considered as well as arrangement of color and other art elements. Various textures adjoin each other. Textures create a tone or value. Try to represent the object with the same all-over texture. Contrasts of textured areas against simple areas will emphasize the textured areas.

Go on a rubbing trip. With a crayon or soft pencil, go around the room or school and find different surfaces. Hold the paper over the surface and rub the pencil sideways on the paper. You will discover many new types of textures. Some may even be signs, lace, etc.

Go on a looking trip. Look and discover many types of textures. You not only feel some, but you can see different textures as well, for example, clouds in the sky. How do wood grains look? How do feathers look and feel? How does velvet look and feel? Does the branch on the tree feel the same as it looks? Can you put textures on clay as well as feel them? Do you think paint has a texture? Houses? How many textures in buildings can you find?

Now draw different textures. How many can you make?

Crayon: Thin and thick, scratch into, wax resist, encaustic (melted) crayons.

Paint: Smooth and bumpy. *Dry brush:* Wet wash.

Transparent colors. Opaque colors.

Sticks and ink. Knives. Pencil textures.

Can you paint velvet? Can you paint grass?

Can you paint wood bark? Can you paint lace?

Can you make a collage with photographic textures?

Look at and study different artists and how they made different textures in their paintings.

TEXTURE MOTIVATIONS

Experiment with a crayon to see the texture it makes. Experiment with charcoal, with pencil, with pen and ink, with washes, dry and wet.

Use the surface of an old wall and draw it.

Select a small area of an interesting surface, like the skin of a gourd, and examine it closely. Enlarge it so it fills the paper. See what textures you can create in an interesting abstract design. With extra-strong lighting, strong contrasts of darks and lights, the texture will change.

Go on a walk around the school looking for textured surfaces. Make rubbings from these surfaces.

Use crayon to make drawings on a piece of sandpaper.

Do a texture collage. Collect unusual scraps of papers, woods, and cloth and combine these textures into a design.

Select a theme, such as textures found on the desert, on a walk through a forest, on bark of trees, etc., and create a design emphasizing the feelings of the theme.

Using a variety of media—chalks, charcoal, pencils, pens—draw a still life emphasizing the textural differences of objects. Fruits and vegetables have a variety of textures and shapes, yet are closely related in subject.

Draw an egg showing the textured form. An egg is a difficult challenge because of its simplicity in form and texture.

Draw a still life or subject using one all-over texture; only change the tonal range to describe the form.

Cut open an orange and draw the texture.

Summary Concept Chart: Pattern and Texture

Feel surfaces.

Produce texture rubbings from actual surfaces.

Produce textures and patterns in a drawing by looking at and simulating them.

Draw natural textures and patterns.

Draw man-made textures and patterns.

Produce textures with a variety of media.

Discuss and draw various textures (soft, hard, rough, smooth, etc.).

Discuss relationship of texture to line, shape, value, space, color, pattern.

Discuss texture and pattern in relation to contrast, dominance, balance, rhythm.

Determine various ways artists have used texture and/or in art works.

Identify textures and patterns in plants, trees, homes, clothing, weaving, ceramics, jewelry, sculpture.

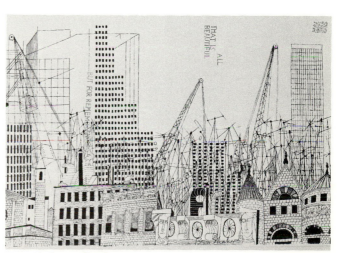

Ben Shahn, *All That Is Beautiful.* Serigraph. Courtesy of Galerie Ann, Houston.

Larry Poons, *Fliegende*. Acrylic on canvas. 102″ × 153″. Collection: Stedelijk Museum, Eind-haven. Artist Larry Poons selects simple shapes as a pattern for the subject of his paintings. Shapes do not have shadows behind them; they appear to float.

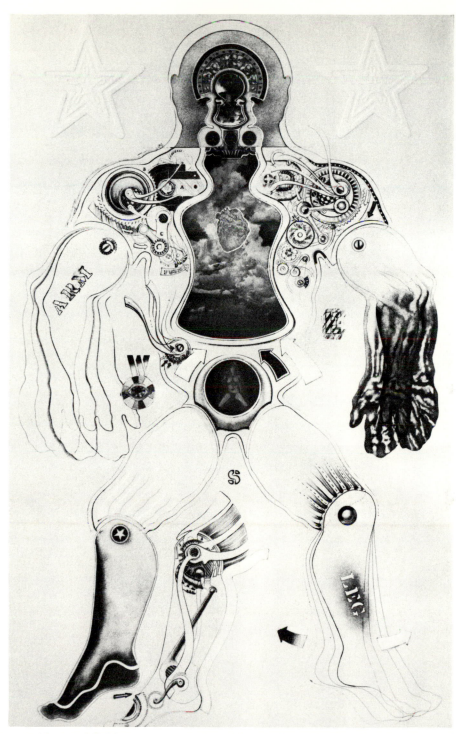

I have been interested in establishing a process of working that would allow for a free interchange of my thought patterns, and greatly expand the possibilities of seeing precisely the same image in new and ever-changing relationships.

It has always been fascinating to me how incidental events in one's life can become major concerns. Perhaps as much as a year before beginning the suite (of etchings), I received in the mails a brochure from Time-Life Corporation, advertising a book and illustrated with a series of anatomical drawings from an eleventh-century manuscript. I liked it and pinned it on my studio wall. About the same time I purchased a sabre saw. Both things had little to do with my immediate interests at the time; but over the course of the year a distillation of the figure from the manuscript reproduction became the model for the suite, involving the anatomy of the contemporary human condition, and the sabre saw became the primary means of realizing the idea.

The central innovation was cutting the plate apart—once I had decided to do that, anything became possible. When all the plates were complete, or nearing completion, I assembled them on the press bed. At this point, the whole image was brought together for the first time. Kenneth Kerslake, Artist, University of Florida. From the series: "The Anatomies of the Star-Spangled Man."

Part 3
Art Practice

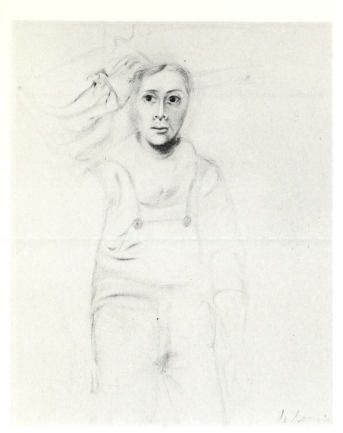

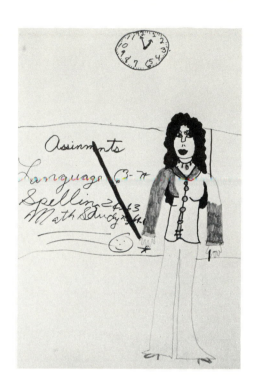

William de Koonig. *Working Man.* Pencil on paper.
Courtesy of Allan Stone Galleries, Inc., New York.

Drawing Is Seeing

Expression, to my way of thinking, does not consist of the passion mirrored upon a human face or betrayed by a violent gesture. The whole arrangement of my picture is expressive. The place occupied by the figure or objects, the empty spaces around them, the proportions, everything plays a part.—Henri Mattisse, *The Joy of Life,* Montgomery, Penn.: Barnes Foundation, 1967.

Drawing is fun. When you draw, you see things you may never have seen before. By drawing, you can rediscover the world.

Just like practicing the piano or playing a sport, getting started places you into the search of discovery, study, experience, and practice of a skill. The more you do it, the more you learn and the better you become. We can all improve whatever level of ability we are at. Artists throw themselves into their work, just like working at a job, and they spend their whole lives in that quest. Just like the pianist starting with the basic scales, you can start with the basic understanding of the tools of design. In other words, don't expect to create a masterpiece the first time you draw. A teacher of mine once said, "You must throw away the first hundred drawings—then see what happens." Rarely is there anyone who seems to be born with the gift, or seems to have "it" right from the start. More often, "it" is acquired with practice and study—like anything else. What fun it is finding the magical secret. We all have inherited abilities; your desire is the only limit.

HOW DO ARTISTS GET STARTED?

The secret of learning to draw is to first learn to see. See and draw everything and anything. How do artists get started? Some artists I asked said, "While everyone else was out playing baseball, I was drawing comic strips for hours and hours." "When I was in the third grade, we didn't have art teachers, but I was the student who got chosen for drawing the class murals or posters that were needed." "In the sixth grade, I was given an art scholarship to the local art museum, and I had to trudge in the snow and on busses to take advantage of that opportunity." "When I was twelve, I was ill and in bed for months at a time. My father bought me an oil painting set—an expensive gift." "Visiting art museums got me in contact with students of all ages and looking at acclaimed artworks was an education in itself."

In a dinner conversation once, Adolph Gottlieb said that he never attended an art school, but his education was going to the best art museums and studying the paintings. Well, which comes first? The desire? The talent? The practice? The environment? The encouragement?

Do we learn to see at home? At school? At museums? From friends? Probably all these places help to build toward the conditioning of becoming an "artist" or of liking art. Does the artist see differently? Can this vision be learned? Many artists say that drawing places them in a special awareness state, in a relaxed, freeing mood that helps transport their minds to another plateau—something like listening to music. "Letting your mind go," calling on the imaginative and inventive forces stored in your mind, and opening your visual potential can work together to form higher visual functions. What we are doing is opening our minds to permit this visual processing to take place. Then it is up to our eye-hand-brain coordination to improve our drawing skill. In art, we communicate the processed information in a nonverbal way.

Do you know the work of the artist Joan Miro? He was born in 1893 and was a friend of Pablo Picasso. He spent his whole life cultivating the freedom of a child in his art expression; the first time you see his work you might feel it is very childlike. He does not mirror nature in a traditional way. He does not consider proper proportions or perspective depth. He mixes realism and fantasy. He sees with his eyes the very same things we all see, but then he takes from what he sees and knows and "plays" with it, improvises with it, in a unique way, until all the forms resolve themselves in a personal statement. His paintings are not photographic and are far from realistic in appearance. They are gay, often humorous, full of vitality and symbols, and very much alive. His paintings are the reflection of his temperament, inspiration, and his unrestricted imaginations; they are a reflection of his skills, of all his years of study and involvement with art, of his personal individual statement of ideas, thoughts, and feelings.

Children and adults see differently, and they also draw differently. A second-grader can instinctively draw charming, delightful pictures that we all consider excellent. They may be good results for a second-grader, but you and I would not be satisfied with similar results. There exist certain standards that we expect at certain levels of understanding. There is no one way to say which is the "best" way for you, however, since each person will explore what he feels most interesting and exciting. The paintings of Pablo Picasso are far different from those of Rembrandt, or Dali, or Rouault.

Imaginative approach: Joan Miro. *Personage with Star.* Oil on canvas. 78¼″ × 97½″. Gift of Mr. and Mrs. Maurice E. Culberg. Courtesy of The Art Institute of Chicago.

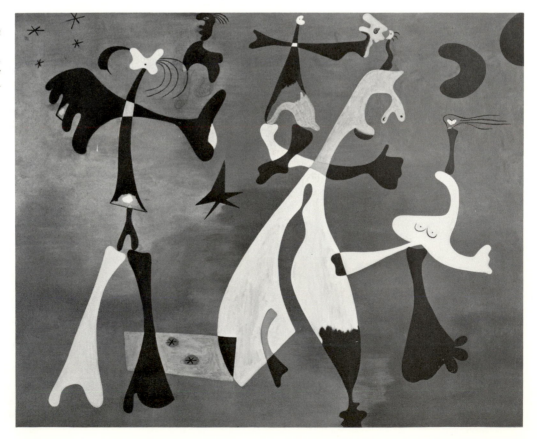

Drawing approaches.
1. Imaginative approach. Second-grade student extends a photograph to create a whimsical statement of an image. Note the important, exaggerated long arm and the other, very short arm.
2. Visual approach. Watercolor, washes, and ink lines indicate shadings and tones. Marlene Linderman. *Girl in Sunday Hat*. 18″ × 24″.
3. Emotional approach. Very often we express our innermost feelings through art.

Rembrandt, a Dutch painter of the seventeenth century, was concerned with the way light reflected on objects, the atmosphere created by different lights, the shadows cast by light, and the composition. Picasso, a contemporary artist, was more concerned with abstracting the art elements and with lines, variations, textural qualities, forms, imaginative shapes, and composition in terms of unusual relationships. No one has dared to say who was the "better" artist, but it is helpful to realize that there are many approaches to art. Different artists are motivated in different ways. The same is true of children. Not only are there different areas of interest, but there are also different abilities and expressions in developing art.

DRAWING APPROACHES

Some approaches to starting a drawing or painting include the following.

1. *The imaginative approach.* Using forms and ideas that are invented, having ideas materialize and develop from the imagination. Sometimes real objects, models, or photos stimulate ideas. Often the forms are not taken from real-life objects, but are fantasies, "make-ups."

2. *The visual approach.* Portraying and representing the object as accurately as possible by using a technique with a direct light source and shading to represent the object realistically in space.

3. *The emotional approach.* A subject is thought of but is interpreted by using exaggeration and distortion to emphasize an idea or express a feeling.

PORTRAITS

Can you remember when you first scribbled? Most of us cannot. But it is remarkable to realize that the marks on a paper can be controlled and represent a symbol for something or someone. In most children's development, the circular movements of a pencil on paper symbolize the head of a person, usually "Mommy" or "Daddy." The very first representations are heads. As we grow, we still hold the fascination of drawing the head. Artists have always been intrigued with drawing portraits.

In the young child's development, the arms then grow out directly from the head, and then the next forms to appear are the legs growing from the head. So it appears that the head is the central focus from the very beginning. The young child draws the way he feels about himself, how he sees other people, and what he knows about them. His drawings are filled with emotion and reveal much about how he sees life. Not until the fourth,

fifth, and sixth grades do students become aware of differences in features and changes due to light, atmosphere, and the more emotional expressions of love, fear, and sorrow.

One approach for the beginning student is to feel the three-dimensional forms of his own face. The student has been looking at himself for years, so he has some idea of the basic structure of the bones and shape of his features. He has a good passive knowledge about himself; we want to bring this knowledge to active consciousness. When he has thought about, felt, and explored his own features, he is ready to try drawing a face.

Another way to begin is to sculpt a face in clay. In this way, the student builds with the clay, is able to construct the three-dimensional forms, and thus feels the changes in the curves and angles, the movements in and out, and the shape variations for the nose, mouth and eyes.

A third alternative is to draw on mirrors with felt pens. Standing at arm's length from a mirror, the student can start with the oval shape and measure to find the distances between features and the forms and details of his own face.

When the artist paints a portrait, he attempts to capture the spirit and character of the person as well as the likeness. And when we draw a face, we step into the artist's shoes because we reveal not only the person we are drawing, but we reveal our own spirits as well, the artistic vision of each of us, our own special hand.

Drawing a portrait is a growing process. You learn from the experience, and it is highly rewarding. The young student emphasizes the inner emotional attitudes of a person rather than the exterior visual qualities. For the older student, the following guidelines will aid growth and understanding of the head form.

PORTRAIT PROPORTIONS

Although we are all different and head forms vary, the basic head proportions are general guides for learning.

Study a skeleton of a head, the basic structure from the front and from the side.

Start the drawing with a basic oval-egg shape.

(This oval shape will have slight variations toward a heart-shape, square, round or long head as every individual will vary slightly.)

Draw a vertical line down the center of the oval. The eyes are halfway between the top of the head and the chin line. (The tendency for beginning students is to place the eyes closer to the top of the head.)

The nose is halfway between the eye and chin line. The center line for the mouth is a little less than halfway between the nose and the chin.

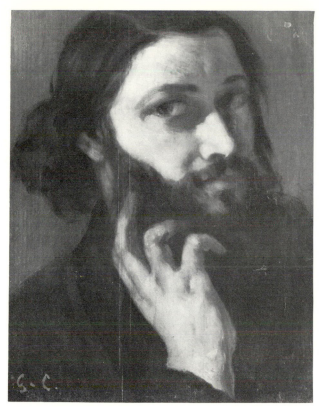

Gustave Gourbet. *Self-Portrait*. Oil on board. 17" × 13⅞". Published by permission of M. H. de Young Memorial Museum San Francisco.

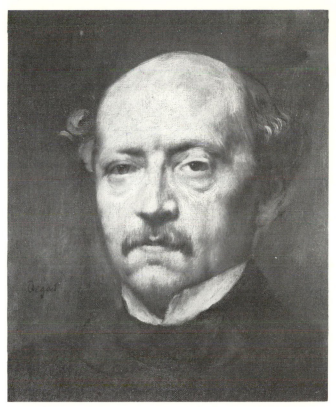

Edgar Degas. *Portrait of a Man*. Oil on canvas. 16" × 13". Published by permission of M. D. de Young Memorial Museum, San Francisco.

These self-portraits are more than paintings. They reflect the image as well as different personalities. Note in both of the above paintings that the light source appears to be coming from the left side. In one instance, the front of the face is illuminated; in the other, the side of the face is in the light. Therefore, the shadows created are different. The backgrounds are also different values. One face appears to be a light shape against a dark background; the other face is a darker form against a lighter background. Look for various strokes and textures made by each artist's brush.

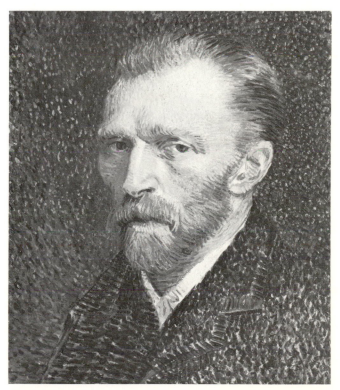

Vincent Van Gogh. *Self Portrait*. Oil on canvas. Courtesy of The Art Institute of Chicago.

Skeleton of head.

The space between the eyes is about the same as the width of another eye.

The width of the mouth is about the distance from pupil to pupil when the eyes are looking straight ahead.

The eyebrows are about one-third the distance from the top of the head to the chin line.

The space between the eyebrows is basically triangular.

The forehead is a rectangle.

The ears are approximately from the eyebrows to the bottom of the nose.

The eyes fit into holes in the skull, the eye sockets. They are round like balls and are controlled by four muscles—top, bottom, and two side muscles.

The eyelids surround and rest on the eye. The upper lid moves when blinking. The upper lid is longer and follows somewhat the shape of the forehead and the cheekbone. The eyelids are important because they determine what the shape of the eye will be. Some are heavy (in older people); others are hardly seen at all. The eyelid shape will vary greatly and will need great observation.

The bottom eyelid appears to have a shelf form close to the eye.

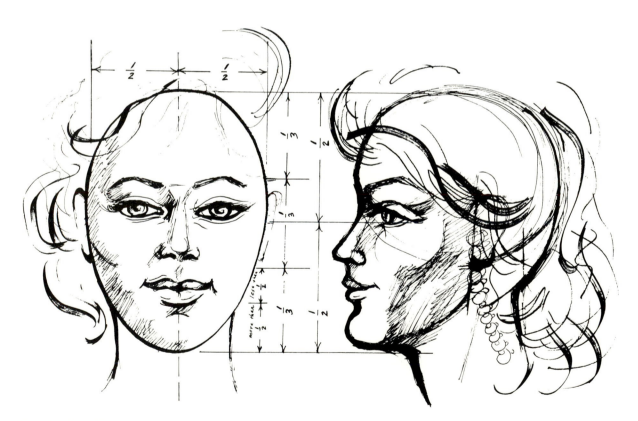

The drawings illustrate portrait proportions.

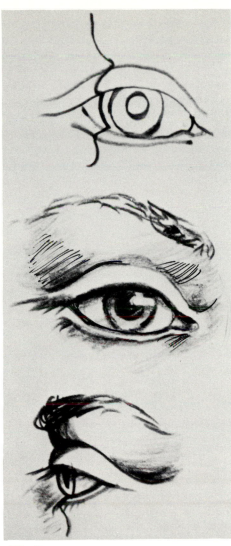

"Eye"

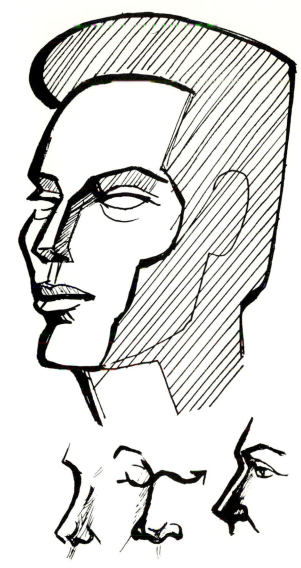

"Nose"

The eyes are placed deeper in than the eyebrows or cheekbones.

There are definite planes (surfaces) of the forehead, nose, cheeks, and chin that move in and out, back and forth.

When the head is viewed from various angles, the planes change.

The nose is primarily a triangle that juts out from the face.

There is a plane under the nose. The nostrils have definite shapes.

The lips can be thought of as two different shapes. Basically, the total head is a cube shape, having six sides—four sides with top and bottom.

The head sits on the spine, which intercepts approximately at the ear. This is the axis and the head pivots on the axis. (Students tend to make the neck too narrow.)

The cheekbones are round on the sides, following the skull.

The hair grows away from the skull.

The hair also has a basic shape and adds to the person's individual character. When drawing the hair, see the form from the general shape to the detail. Each hair should not be drawn, but the form can be indicated with lights and darks.

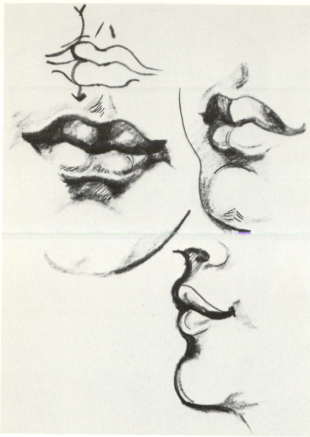

"Mouths"

When drawing a profile, follow the same basic proportions. Study the negative shape (the shape surrounding the profile) before beginning. Consider the size of the head to the neck. Observe the size of the head compared to the hand. Study differences in nose contours.

Practicing the above proportion relationships is an aid in drawing the head. It's a good place to start. After awhile, the information becomes second nature and the student doesn't have to use the guidelines as a beginning. I have found, in working with classroom teachers, that starting with the basic proportions as an initial experience is very positive. We begin with a blank oval and mark the various lines lightly on the paper. Then we stop and I demonstrate how to draw the basic individual features as separate elements. We talk about, feel, and look at each other's eyes, noses, and the various contour edges and shapes. We feel how the eye is placed in the skull, the shape of the nose and cheekbones. The nose is the most perplexing form to draw because there are no defined edges; the nose is indicated primarily with shading, but feel the

form, see how the nose begins at the eyebrow, has individual bumps and turns. Feeling the cheekbones and how they move from the front plane around to the side does give a better concept of the rounded form. We discuss how everyone's nose, eyes, cheekbones, mouths, chins all have individual forms. No two are alike and it is in looking at the differences in each face that we find the characteristics that create the "look" of the individual.

I have found that students who have never drawn a face before are excited and delighted to have learned these basic foundations. So many times they will say, "I have never been able to draw a face, but this is the first time I feel I've learned something and I'm happy with the drawing." They'll then go home and practice drawing people in their families or working from family photographs. For fun, when they have finished their drawings, we place them on tables, walk around the room, and try to pick out who is in the class. Try this with your students and be as surprised as I was with the high degree of success.

PORTRAIT MOTIVATIONS

Practice looking through a viewfinder. This will give you a limited space (window) and will establish a negative space around the figure.

Look at the skull or skeleton.

Feel the forms in your own face and neck and shoulder.

Using a pencil, compare the measurements and proportions of the various features.

Ask three students to stand next to each other.

Observe the shapes of their eyes; compare their noses, hair styles, mouths, and head shapes.

Build clay models.

Draw on mirrors (self portraits) with magic markers, comparing proportions.

Do contour drawings of faces and features.

Do cross contour drawings of the same.

Do gesture drawings of the same.

Do positive/negative drawings of faces.

Pretend there is a fly crawling across the face, draw what the insect sees and finds.

Place a spotlight on the face first from the side, second from the front, third from the back, fourth from above, fifth from below. Study the light effects and how they change the way the forms appear (see page 199).

Draw a face with just shadows (no lines).

Try different tools and media to draw faces (e.g., pencils, pens, charcoal, brushes and ink).

Study how other artists have drawn faces (see pages 199).

Draw individual features and fragments of faces.

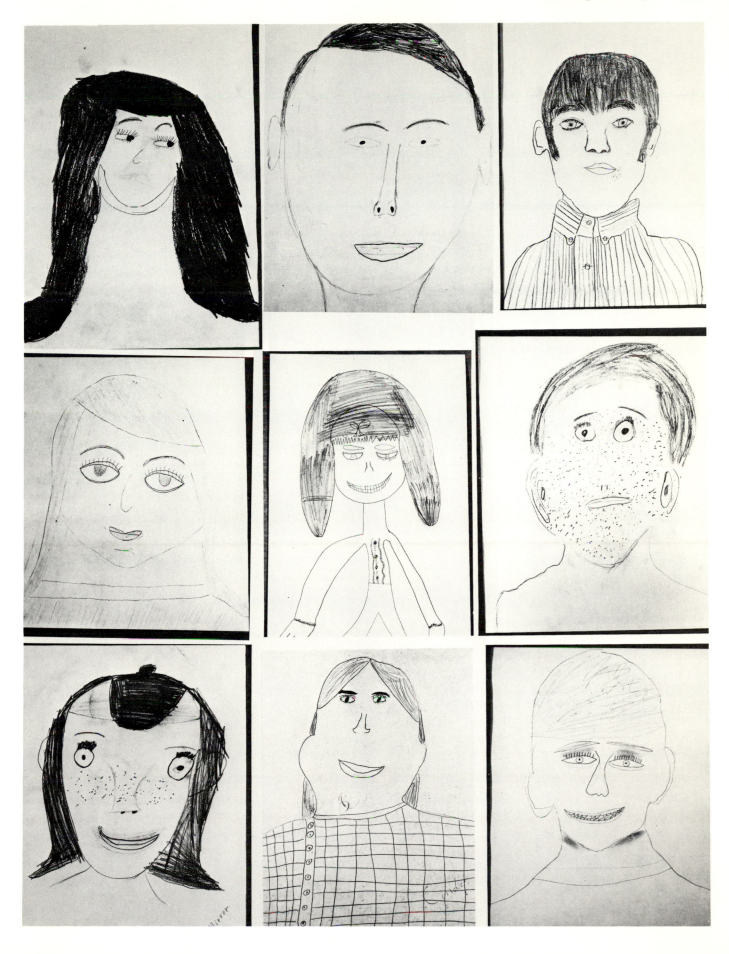

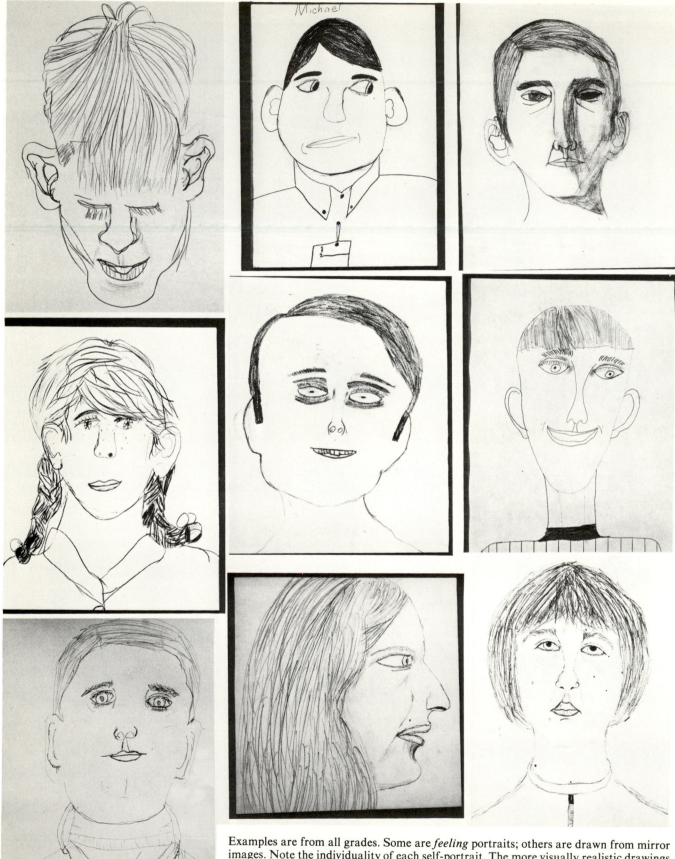

Examples are from all grades. Some are *feeling* portraits; others are drawn from mirror images. Note the individuality of each self-portrait. The more visually realistic drawings are from upper-grade students. First the students were asked to draw themselves just by feeling their facial forms; then they were asked to look into a mirror and draw themselves.

Raovl Castro, former Arizona Governor. Marlene Linderman, watercolor.

Photograph courtesy of Steve Woodward.

Charcoal portrait.

Combine features in new ways.

Make a face out of a collage with the printed page.

Make "feeling" portraits—how you feel when you're angry, happy, sad, etc.

Pretend you are a character in history, such as George Washington. What do you look like?

If Pablo Picasso were doing a portrait of you, what would you look like?

If you were a centipede or a scorpion, what would you look like? A bird? An elephant?

If you were from the planet Saturn, what would you look like?

If you were under a red light, how would your portrait look? Under a blue light? How would you feel?

Subjects that deal with "brushing my hair," "cleaning my teeth," "eating my favorite candy," "turning my head inside out," "what my brain looks like," "wearing my favorite hat and jewelry," "my secret me."

Four personal interpretations of self-portraits by Geneva Farthing, art teacher.

"Feeling the form."

"Mannequin Heads," ink and wash drawing, Marlene Linderman.

Woman with Folded Hands, etching by Kaethe Kollwitz (German, 1867–1945). Collection of the author.

Rufino Tamayo. *Woman with Bird Cage*. Oil on canvas. 43¼″ × 33¼″. Joseph Winterbotham Collection. Courtesy of The Art Institute of Chicago.

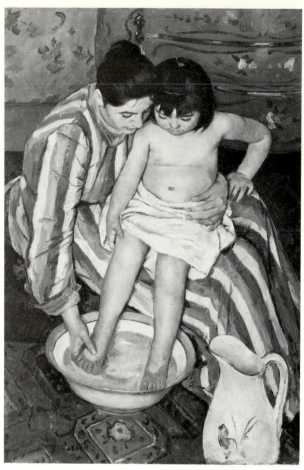

Mary Cassatt. *The Bath*. Oil on canvas. 39″ × 26″. Robert A. Waller Fund. Courtesy of The Art Institute of Chicago.

Artists paint people in many ways and with many tools. Can you name the media and the technique?

FIGURE DRAWING

The search for the exact perfect proportions of the human figure has intrigued many artists. Vitruvius, during the first century B.C., established a measurement for the body; if a man lay on the floor with arms and legs spread out, they would be perfectly held within a square. He also proportioned the head as one-eighth the overall length of the body; the face being divided into three equal parts, the forehead, nose, and the space between the nose and chin. Most artists today do not copy nature exactly, but a knowledge of the structure helps us to draw with greater freedom. Artists today enjoy distorting and invention, exaggerating and creating figures with personal imagery.

Drawing the head and figure encourages positive self-awareness and provides for individual self-expression. Most students like to draw the figure once they have

learned simple proportions. If students shy away from drawing "people," it is due to their lack of drawing experience and knowledge. Our teaching indicates that when students are offered many opportunities to learn to draw the head, the figure, and the figure in action, their achievement and feelings of confidence are motivation enough for creating figurative art. Emphasis on practice, questioning, learning, and "let's try it" attitudes contribute to the satisfying enjoyment of drawing portraits and figures.

Bodily awareness is the action of perceiving the human body as a complete organization of rhythmic parts into a whole and how this designed force exists and moves within a given space.

The human body is always in movement, even when at rest. To the eye, the body may appear unchanged. We know that the cell structure is constantly regenerating and

Rembrandt's *Young Girl at an Open Half-Door,* in contrast, seems to be suspenseful—waiting in anticipation. The strong contrasts of light and dark, along with the firm edges of forms, the simple background with the faint light opening from the left—all add to the mysterious expression on her half-lit face.

Rembrandt. Young Girl at an Open Half-Door. Oil on canvas. 40⅛″ × 33⅛″. Ryerson Collection. Courtesy of The Art Institute of Chicago.

Renoir's *On the Terrace* is a beautiful melody of color. The theme is delicate, light, and airy. Even the edges of the forms are soft. He was concerned with the airy quality, and the soft brushstrokes reflect this feeling.

Pierre Auguste Renoir. *On the Terrace.* Oil on canvas. 39½″ × 31⅞″. Mr. and Mrs. Lewis L. Coburn Memorial Collection. Courtesy of The Art Institute of Chicago.

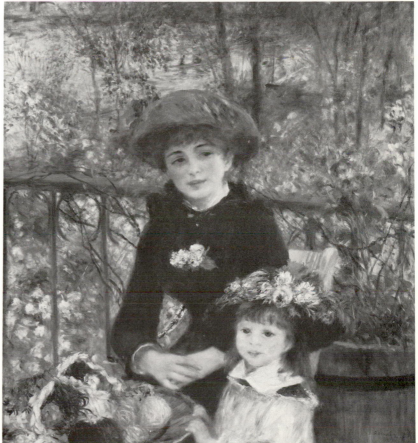

Drawing by Norman Rockwell. Courtesy of Mrs. Bruce Hamilton.

Edouard Manet. *The Milliner.* Oil on canvas. 29″ × 33½″. Collection: Mildred Anna Williams. Courtesy of California Palace of The Legion of Honor, San Francisco.

growing. When we draw a figure in repose as a still model, we are drawing an unreal situation, but we try to capture the momentary feeling the figure expresses to us.

It is important to have a basic understanding of the structure of the form in order to be able to express the feeling of the existing form and the way it relates to its environment. Just as one color never exists by itself, only in relationship to the colors surrounding it, so the figure never exists by itself, only in relationship to the forces generating *within* and *about* the figure.

Children somehow capture this mystique, or unknown quality, in their drawings when they draw a human figure. The *mood,* the emotional tone, the movement, the contrasts of feelings—humor, sadness—always seem to be present along with the details and proportions that comprise the complete statement of the form.

Learning how the human figure is constructed will aid anyone interested in drawing the figure. Think of the figure as three large simple masses of the body: the head,

the chest, and the pelvis. Attached to the masses are the arms, legs, neck, spine, and abdominal muscles. All of these forms move, twist, bend, and turn. A general rule is that the top of the leg where it meets the hip is the halfway mark in the figure. A center line, using the *spine as the center,* establishes the action of the figure and holds all the masses of the figure together.

If the figure is in motion, such as running or jumping, there is no center of gravity. When the figure is still, such as standing, sitting, or resting, a center of gravity can be established. The center of gravity (the distribution of body weight) is an imaginary vertical line through the figure, which acts as a balancing scale, creating counteracting forces on both sides. This center line runs through the pit of the neck down to the supporting weights (feet).

The best way to begin a figure drawing is to study the pose carefully for a minute or two. Look for the "action" line, the weight of the body, and the bends, twists,

Edgar Degas. *Woman in a Rose Hat*. Pastel 33¾'' × 29⅝''. Joseph Winterbotham Collection. Courtesy of The Art Institute of Chicago.

and masses of the figure. Then begin the drawing by placing a short line at the top and one at the bottom of the paper to indicate the top and bottom dimensions of the figure. Once the drawing has started, think of the line as a piece of flexible wire or a clay mass, a form that is dealt with in terms of line and mass.

The three large masses of the body are (1) the head, (2) the chest, and (3) the pelvis.

Attached to these three masses are the arms, legs, neck, spine, and abdominal muscles. These all move by bending, turning, and twisting.

The center of gravity is considered to be where the supporting weight of the figure is. When the figure is in motion, this is difficult to determine. Only when the figure is stationary can you establish the center of gravity.

The human figure appears to follow some general proportions. Each body differs in proportions—tall, short, fat, thin, etc. Rarely is there a perfectly proportioned figure; keep this in mind as you draw. Look for dissimiliarities; they tell us how one person is different from another.

The figure also appears changed, depending on the viewpoint we have, our position in relation to the model. The action and the movement of the figure will alter the proportions (see p. 217).

The torso is divided into two equal parts, shoulders to waist and waist to thigh, and we use a half-section of the torso as the unit of measure. From the shoulders to the waist then we count as *one*. From the waist to the thigh is also *one*. From the collarbone to the top of the head is approximately one or somewhat less. From the highest point of the leg to the middle of the knee is *one and one-half*. From the middle of the knee through the foot, if it is placed flat on the floor, is also *one and one-half*. The highest point of the leg on the outside is less than half of the way up into the lower part of the torso.

The width of the shoulders equals *one*, and the neck occupies a third of the distance across the top of the shoulders. The arms fit into the torso at the shoulders just as sleeves are set into a coat. From the shoulder to the elbow is *one*, and from the elbow to the wrist is *one*. The head is longer in the front than it is at the back so it sits on the neck at an angle, and the neck seems to be set down farther in the front than it is in the back.

The upper part of the torso is supported by the basket of the ribs and the lower section by the pelvic bone, and the spine holds these two sections together in the back. In the front they are held together by the large perpendicular muscle of the abdomen. From the side the two sections of the torso have the same proportions as from the front, but because the spine has a slight curve they appear to be joined together in the back and somewhat separated in the front. When the body bends, either forward or back, the torso seems to fall in or expand, rather like an accordion.

From the back the proportions are naturally the same because the silhouette is exactly the same. (The front view and the back view of any object must be the same in silhouette.) The back of the figure, however, looks different from the front. It is a good deal flatter, and a difference in muscular construction makes the torso seem longer and the legs shorter. In the front the muscles of the chest do not overlap the arms as the muscles of the back do. But the bone construction, front, side, and back, is necessarily one thing, and it is the bone construction which causes the proportions.[1]

UNDERSTANDING THE FIGURE

Very young students can be motivated by experiences that call attention to the parts of the body that need to be developed. From the beginning, basic geometric forms representing the body grow to developed schemata that are rich in detail. A geometric circle is a head (the most important part of the body). From the head grow the arms and legs.

1. Kimon Nicolaides, *The Natural Way to Draw* (Boston: Houghton Mifflin Co., and London: Andre Deutsch Limited, 1941), pp. 106–7.

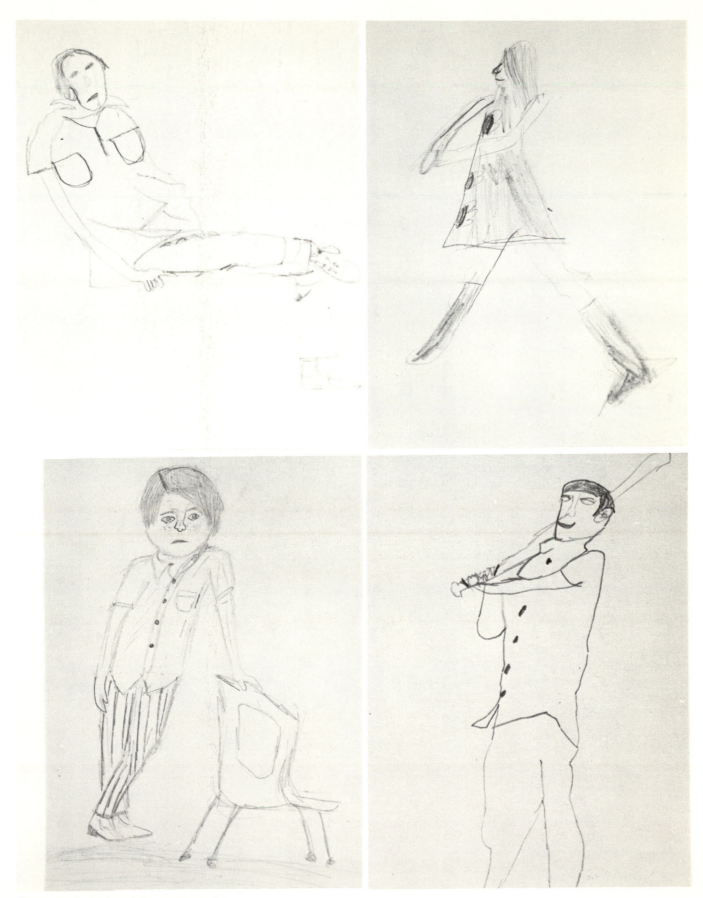

Gesture and posed models—upper grades.

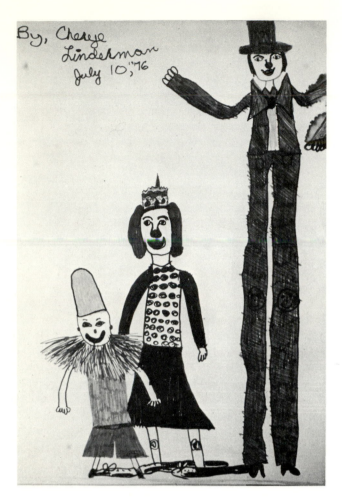

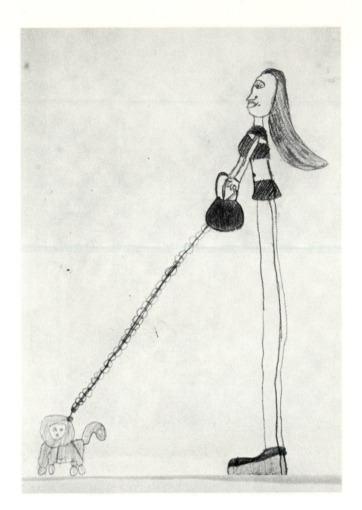

Cheryl's drawings of the circus at age 9. As the child begins to perceive details and differences, the figures become "men" and "women" and are more realistic in imagery. The legs remain stiff, yet the drawings reveal very personal statements.

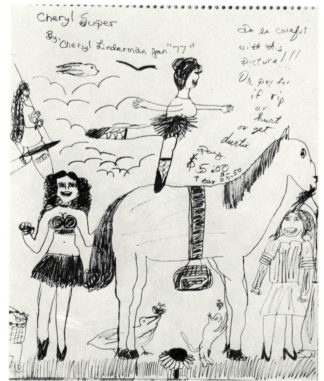

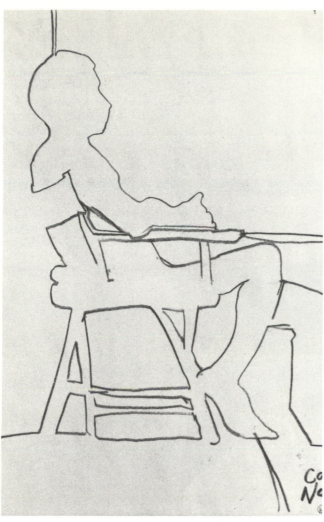

Looking for negative space with line and shapes.

As the student receives strong motivations and develops awareness of his own body, his concept of the figure will become more enriched. The concepts will include much more detail, more understanding of the parts and how they move together and of the forms as they change and move. Then the figure will have more meaning for him.

The young student develops his own schema by repeating symbols that are meaningful for him. Rich experiences—strong, significant experiences concerning the body-self—will encourage greater concepts, and the student's drawings will include greater details of important forms.

In the intermediate grades, the students find that geometric lines are unsuitable for their expression, and they move toward a more realistic approach. They like to characterize girls and dresses, hairdos, boys and suits, costumes and uniforms. They do not see folds and ripples

yet. The representation is more a characterization, not a visual statement. The figure is still stiff due to the egocentric attitude of the student.

Fifth- and sixth-grade students have developed an awareness and interest concerned with real life. This includes social themes and real-life situations. They also like imaginative and inventive areas. They have a new and serious concern with their changing bodies and their forming of self-images. It is important that they accept physical changes confidently. Not only is there physical growth, a change you can see, but their brain maturity is almost at its full growth (at age thirteen).

The teacher's responsibility is to motivate students' awareness in two ways. The visual student is most concerned with more realistic attempts. He is interested in the changing appearances due to changing light, space, and atmosphere. He concentrates more on the whole, on folds and wrinkles, where the joints are, how the clothes

White pastel on black paper.

fold around the joints, how the light and shadows change with movement, on correct proportions, exterior qualities, shading on figures, bending and movement of body parts.

The nonvisually-expressive student will concentrate more on the emotional attitudes of the figure and on the parts of the figure he feels are more important. Some parts will be exaggerated; some will be omitted. He is concerned with how the figure feels inside, the emotions, rather than with the exterior quality. Great concentration is on gesture and expression of the figure. How does the person feel—happy, sad? He emphasizes experiences that refer to the body-self and the motions.

Practice the figure often, as practice is the only method of improvement and development. As you draw, study the relationships and differences. Keep in mind all the different drawing techniques we have discussed previously.

The figure concept for the student develops from geometric shapes symbolically communicated by the preschooler to the sixth grader's use of realistic proportions, awareness of detail, shading, action, and atmosphere. The emotional focal point of the kindergartner is a unique "me" as the center of "my" world, in the "me" (sixth grade) in the environment. The environment evolves from the individual school, community, and culture to the concept of the figure in a world force of communities and cultures. For a greater comprehension of the figure concept at various levels, review the section on Identifying Art Growth in Preschool through Sixth Grade, pages 28–43.

FIGURE MOTIVATIONS

Posing the model is important for informal and exciting compositions. Study and discuss portrait styles, techniques, and poses as painted by Leonardo da Vinci, Rembrandt, Edgar Degas, Henry Matisse, Vincent Van Gogh, Pablo Picasso, Ben Shahn, Maurice Lasansky, Roy Lichtenstein, Mel Ramos.

Study the skeleton of the human body, paying particular attention to the structure of the hand and the foot. This study will aid you in drawing these body parts.

In figure drawing, look for the action lines, the twists, the bends, the supporting weight of the figure, and the large masses, the head, the chest, and the pelvis. The proportions aid in describing the figure, but most figures will vary from them in one way or another.

Draw the—

Mass. Dependent on the underlying structure.

Muscular forms. General, yet individually changing.

External skin. Covering. Texture and color will vary.

Attitude of the figure. Pose, action.

Mood or feeling existing about the figure; generated by the figure.

Forces imposing attitudes onto the figure. Environment.

Enclosure of the figure within a given space.

Emotions or feelings generated by the figure.

The drawing is the interruption of the forward movement of the figure. Change your view-walk around; look from above, from below.

Sometimes include arms and hands in a portrait. They have personality too.

Have the model hold or play an instrument, or hold an object that is his favorite. Adds spirit to drawings.

Have him carry sports equipment or dress up in costumes or hats, creating characters.

Pose the model combing her hair, putting on makeup, looking into a mirror, reading—some interesting action.

Backgrounds and props add to composition, add interest.

Profiles. Unusual views from top or bottom add exaggeration and distortion.

Be aware of placement of head on a paper. Head sometimes appears more balanced when placed near top rather than in middle. Have only half the head on the paper, the other half off the side.

Observe clothing details such as collars and cuffs; clothing curves around the body.

Seams, wrinkles, and folds should be looked at carefully and drawn. Patterns move and change in folds.

Cheryl, age four

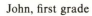

John, first grade

Drawings can express the
way we feel.

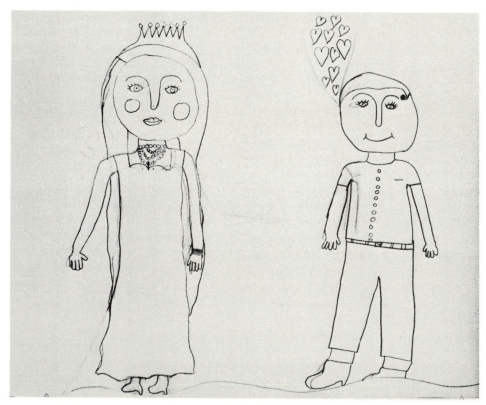

Gwen, age nine

Drawing by Ann, fifth-grade student

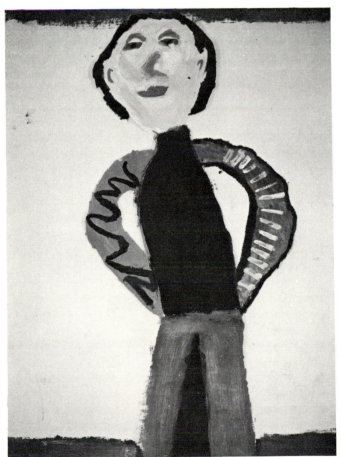

Primary examples

Cheryl—preschool

Gwen, fourth grade

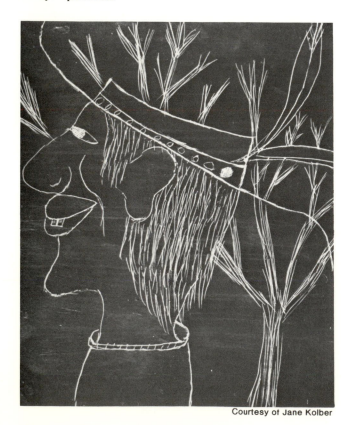

Courtesy of Jane Kolber

Fifth-grade Navajo Indian student, Ganado, Arizona.

Seventh-grade student

On colored kraft paper, life-size silhouettes of students combine to present an action mural. Students stood in front of projected light to make the shadow images.

Courtesy Edna Gilbert, Mesa Public Schools, Arizona

Life-size figures (drawn around students as they lay on the floor) are decorated and painted by third-graders. The figures are then stuffed with newspapers and suspended from the ceiling to add whimsy and fantasy as they move in the air.

Practice many contour drawings of both the head and the figure. Look for significant details and unusual identifying forms. Exaggeration and distortion are part of the excitement of the contour drawing.

Study differences and similarities in friends and family.

Study the frameworks of individuals. We all are different.

Dress figures in many costumes. Draw the identifying costumes of today.

Practice many gesture drawings.

A fast gesture drawing of the figure will add to your understanding of its placement in space. Contour drawings will increase your knowledge of the forms.

Draw figures in environments. When does the figure dominate? When does the environment dominate?

Draw figures in composite groups: grand processions, the characters in a play, people at the market.

Draw how you feel about your own body.

Show emotions through drawing of the figure—happiness, sorrow, fear. Incorporate exaggeration and distortion.

Foreshortening of the figure will add interest to the drawing. Determine where the large masses are and how they are turned.

Draw figures including only important parts, omitting unimportant parts.

Express a theme or idea using certain parts of the body (hands can express love, anger). Draw the parts life-size.

Project lights against a head profile. Have someone else silhouette the profile for the student. The student can then fill in the outside line with intriguing details of his self-portrait.

Have students lie on white butcher paper. Have someone draw silhouettes around their bodies. The students can then draw in the significant forms and details.

Abstract the head and figure, using flat angular shapes.

Using shading to indicate the roundness of the facial forms. Try hands this way.

Draw the face and figure with cross surface lines only.

If you could be anyone in the world, draw the person you would be.

Using just your fingers, practice drawing in the air around people's heads (the negative shape).

Cut out figure and head silhouettes from black paper.

Invent yourself as a fanciful creature.

Draw yourself as a comic-strip character in a comic-strip situation.

If you were a puppet, how would you look and feel?

Experiment with portraiture, using unusual materials such as string, sandpaper, beads, etc.

How small (or big) are you in your family? What size are you compared to your cat? Assume the shape of a ball; how does your body feel? Squeeze your hands and fingers together—do you feel the joints? Reach for a tall branch; how do you feel when you are stretching your spine and on your tiptoes? Can you stand on one leg with the other leg straight out in back and balance? Do a rollover, how does your spine curve?

How do other persons' clothes tell you about the person? Do clothes tell others who you are and what you feel like?

When drawing a person, does the person have happy eyes? Sad eyes? How do we make faces look angry? What expressions do you make with your eyes, nose, mouth, and ears when you eat? Sleep? Laught? Cry? Yawn? Shout? Whistle? Sneeze?

What does it feel like to have a cold? What can you do with just your eyes—stare, blink, squint, wink, frown, or cross? With just your nose? With just your mouth? How do moods change our appearance?

DRAWING DRAPERY

Leave out the unimportant and accidental folds.

Capture the basic design in the folds.

Each fold has a character of its own. Draw the "droop" of a dress.

The type of fabric will influence how the cloth will drape.

Study the underlying structure beneath the material—whether it is a figure, table top, box, animal, doll.

Some folds surround the underlying forms.

Other folds indicate stress and resistance.

When cloth is secured at two points, the folds drop toward each other.

When a fold presses against another fold, the cloth separates into a zigzag form.

A spiral fold is like a spiral form movement around the forms.

Cloth dropped from one point falls in long folds.

Avoid repeating the same folds when they are parallel.

Keep folds various widths.

Imaginary prehistoric landscape.

Remember, the folds are a design and add to the composition of the picture.

Begin by drawing the drapery with three basic planes: the planes facing the light are the lightest; the side planes are a medium tone; and the underneath planes are the darkest. After you understand the basic planes, look for subtle differences and more variety of tones.

LANDSCAPES

What you decide to include in your drawing is the most important consideration.

Your decision will be based upon contrast of color, texture, forms, and spatial interest.

In these forms you will create a *mood* and *visual excitement* by distorting, rearranging, and simplifying.

Review composition—

Surface
Space—viewpoint
Selection
Balance
Center of interest
Dominance
Movement
Similarities-differences

Study the basic forms and underlying structure; for example, how much of the basic structure of a tree do you see? How much influence does the structure have on the final form? When you simplify the outside form, are you still aware of the skeleton? The framework? Discover the basic shapes. Will you reorganize some of the forms to add interest?

Look at your view through a three-inch rectangular matt frame.

Decide on the forms to include and exclude.

Rearrange, simplify, distort.

Consider all compositional structure.

Decide on areas of simplicity and areas of detail.

Consider the outside form of the paper: rectangular, square, round.

Sketch in basic line directions.

Sketch in basic forms (round, rectangular).

Contrast shape against shape.

Consider dark or light values or contrasting values and where they will be.

Consider positive and negative forms.

Consider color relationships. (Try them first on scratch paper.)

Consider variety of forms—simple, detailed, horizontal, vertical, tall, short.

Variety of levels in view. Spatial interest.

a. Foreground
b. Middle ground
c. Background

Are you planning an unusual view such as bird's-eye or ant's-eye?

Will the forms overlap? Or will they interpenetrate like the cubists' paintings?

Consider contours and edges for interest.

Consider the whole arrangement in relation to the outside shape.

Begin with object nearest to bottom of paper and build from there.

Find a shape in the middle. Draw that shape first and build out.

Use fingers or rectangular frame to see relationships.

Consider composition, structure of drawing, detail, and space.

Landscape Motivations

Views of earth from aerial space. Outer-space planets.

Select a topic and draw it in these various ways: explosions, X-ray, superimposing three views, segments, fragments.

Clouds. Irregular free-form shapes. Consider values.

Imaginary forests. Draw trips to an antique shop, to a junk store.

Invent stories, fantasies.

Flowers.

Dreams. Create a composition of an imaginary dream. Combine five unrelated objects or places.

Animals. Visit a taxidermist for sketching.

Poetic themes—poems about "If I could visit anywhere in the world," "If I were a Christmas tree in a forest."

Moods (a foggy morning). A painting of "noise"; of "silence."

Construction views. Make sketching tours of the school, of the community. Working in groups back in the classroom, enlarge sketches into mural size.

Drawing by Mark Linderman, age six. Note the fold-over space concept.

Gwen Linderman, age nine. Note that the overlapping hills indicate depth.

Jeff, age eight.

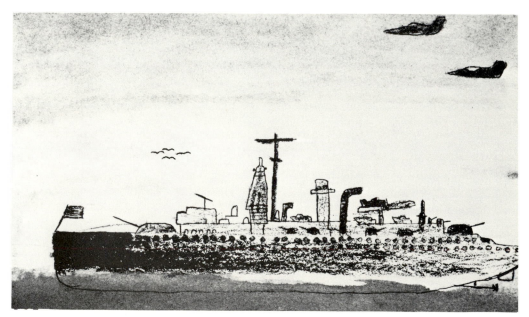

Look down an alley. Exaggerate foreshortenings.

Churches (details). Draw "blow-ups" of architectural details.

Factories, bridges, rivers, harbors, zoos, amusement parks.

Unusual house, construction view, view down street, city buildings.

Study nature forms under a microscope. Enlarge the design to mural size.

Find and compare similar shapes in magnified leaf cells, in textures of a hillside.

Draw and paint flowerscapes, cityscapes, junkscapes, motorscapes, foundscapes, environmentscapes, happenings.

THE STILL LIFE

Select a variety of interesting objects—objects that are commonplace, unusual, man-made, or organic forms from nature.

The objects you select might be antiques, toys and dolls, old bones, skeletons, musical instruments, old sewing machines, interestig plants, lace, old shoes and clothing, old clocks, old machinery, gears, grasses, weed, shells, rocks, seeds, bottles, sticks, lamps, fans, old furniture, stuffed birds and animals, driftwood, flowers, different cloths—patterned, velvet, satin, etc.—screens, insides of radios, TVs, sports things, pocketbooks, lanterns, wristwatches, typewriters, bicycles, and so on.

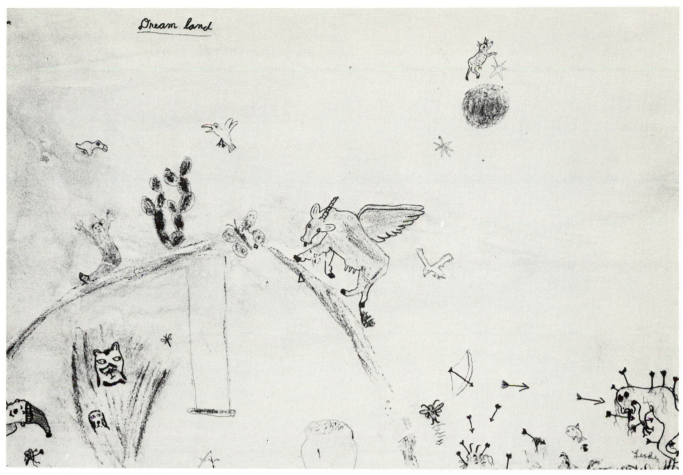

"Dreamland" by Luke, grade four.

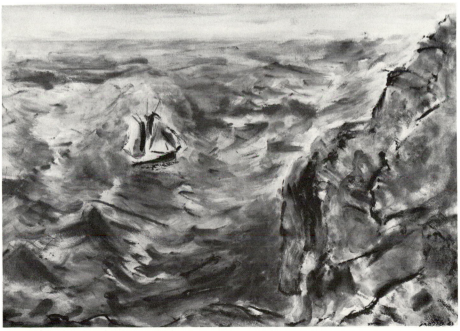

John Marin. *Cape, Split, and Boat*. Watercolor. 15½" h. × 22" w. The Fine Arts Gallery of San Diego.

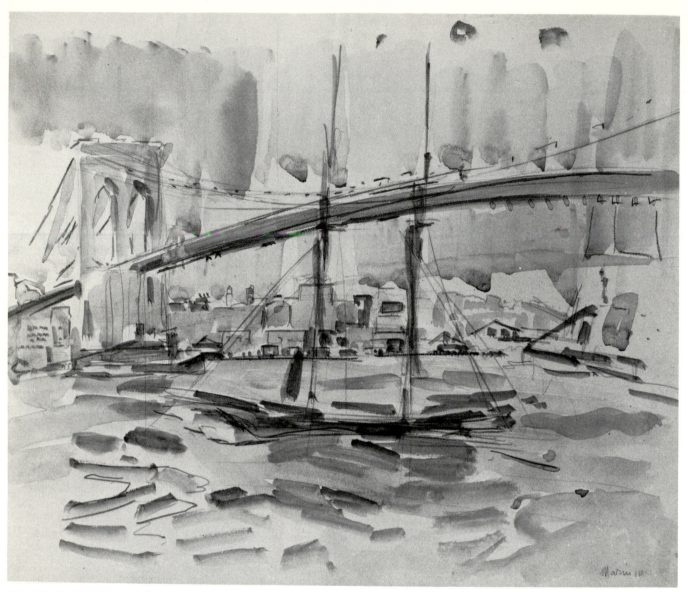

John Marin. *Brooklyn Bridge.* Watercolor on paper. The Fine Arts Gallery of San Diego.

Plan the *arrangement*—the design. Make a sensitive, aesthetic, and interesting selection.

Consider the outside edge of the paper: rectangle, square, circle, triangle.

Combine a single form in one drawing or a variety of forms in one drawing, contrasting shape against shape: simple-detailed, tall-short, round forms-rectangular forms.

Consider *space*—the placement and viewpoint.

From the position of the viewer, how does the painter *see* the arrangement. For instance, is it an unusual view, like looking down on the bird's-eye airplane view, or is it an ant's view—looking up on the object.

Place the objects on the paper in an interesting arrangement.

Are all the objects on the same level like a table, or are there a variety of levels—foreground, middle ground, background?

Do the shapes overlap or connect in some way? Did you consider the edges or contours of the forms and how they relate?

Following are additional qualities to consider.

Are there dark forms as well as lighter-valued forms? How are they placed?

Do the shadows add to the design of the painting? Do they have meaning?

Do you have contrasting lines? Values? Colors? Textures? Patterns? Variety? Interest?

Are you selective in your grouping, or will you include all objects in your painting?

Do you vary your tools as you paint—from brushes to pen line to stick, sponge, wet to dry?

Remember the various painting techniques you have learned and discovered previously.

Can you create a rhythm in the placement?

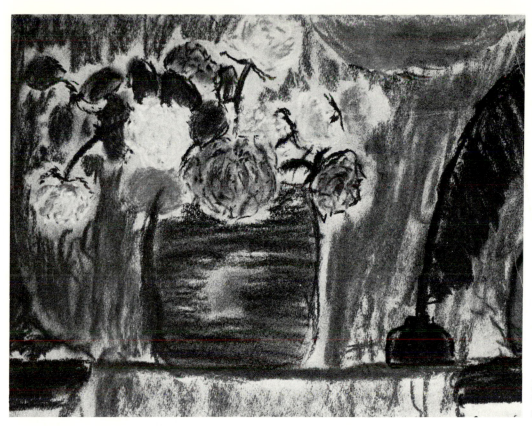

Examples of still life from intermediate level (grades three and four).

Still life motivations

Charcoal drawing by Earl Linderman.

Shading gives form. Drawing by Janet Heflin, from classes of Lyn Matthew.

Pencil drawing by Richard K. Hillis.

Hans Breder. *#132, Cubes*. Chrome, Plexiglas, and mixed media, 15″ × 15″ × 35½″. Collection: Mrs. Burton Peskin, Princeton, N.J. Courtesy of Richard Feigen Gallery, New York and Chicago.

Henri Matisse. *Still Life—Flowers*. Oil on canvas. 55″ h. × 40½″ w. Courtesy of The Fine Arts Gallery, San Diego.

Paul Cezanne. *The Basket of Apples*. Oil on canvas. Courtesy of The Art Institute of Chicago.

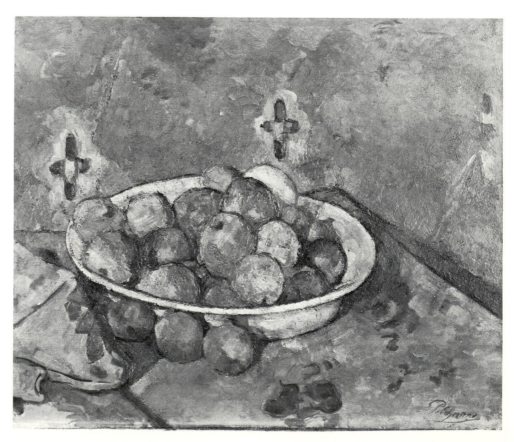

STILL LIFE MOTIVATIONS

Aerial views; ant's-eye view; abstract forms.

Make gesture drawings of "found" objects around the room, such as the "squat" of a chair, the "droop" of a coat. Do several drawings. Select and enlarge one the students feel is most successful.

Create a composition from found-object still lifes. Draw the objects larger than life-size and compose the arrangement as the objects are drawn. Some forms will go off the edge of the paper.

Select five objects in the room. Draw only the basic geometric forms.

Spray-paint several bottles and objects all white. Show slides on the forms, emphasizing textures and patterns. Try various paint colors on objects, including metallic sprays.

Draw close-ups of fragments or sections of objects.

Make many, many contour drawings of still-life subjects, including random placement of such themes as dolls.

Introduce a theme, such as musical instruments, and try drawing compositions in various methods—contour, gesture, and modeled.

Invent drawings over cut-up photographs. Extend the idea.

Select an object and draw it in these ways: an X ray, an explosion of it, a superimposed drawing including five views (top, bottom, sides, foreshortened, exaggerated).

Select three related or unrelated objects and create an emotion such as fear, love, or hate.

Keep sketch books up-to-date.

Use unusual sizes and shapes of paper.

Emphasize line, contrasts, textures, rhythms, shapes, values, movement, space, balance, similarities, differences, memory. Each unit can be a separate drawing.

Study how other artists interpret, invent, and paint still lifes.

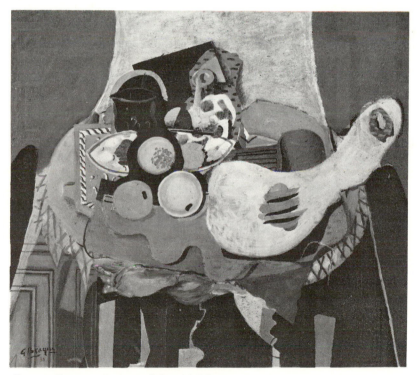

Georges Braque. *Fruits and Guitar.* Oil on canvas. 31⅞″ × 39½″. Gift from Mrs. Albert D. Lasker in memory of Albert D. Lasker. Courtesy of The Art Institute of Chicago.

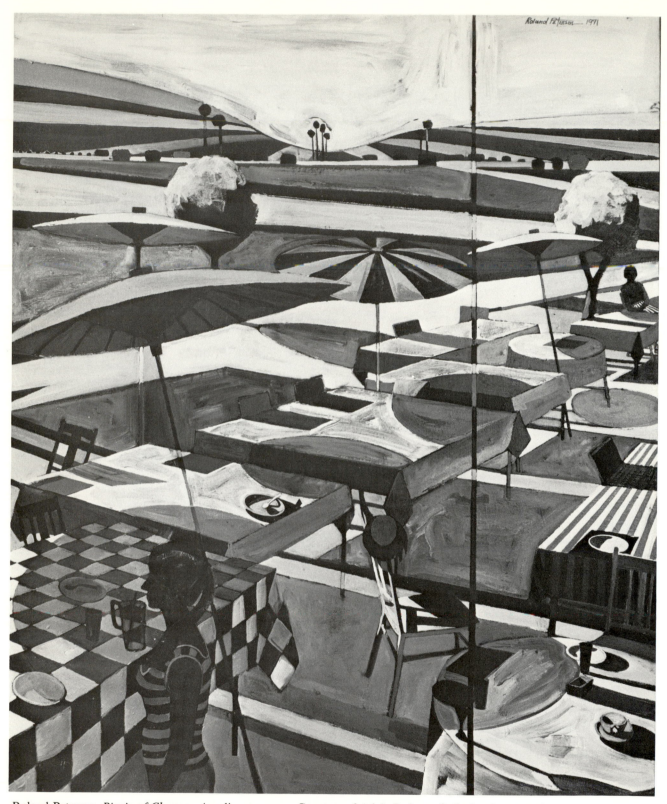

Roland Petersen. *Picnic of Changes*. Acrylic on canvas. Courtesy of Adele Bednarz Galleries, Los Angeles.

In *Picnic of Changes,* I primed my canvas with white acrylic gesso using three coats. The gesso is usually applied in a squeegeed fashion with cardboard. Over this I blocked in my light and dark pattern with a large brush (8″)—usually with thin washes of acrylic (greens and blues) to establish the general idea of the abstract layout. When the desired strength of relationships of the nonobjective balance had been achieved, I over painted with opaque acrylic colors using smaller brushes, usually working from dark hues to light. The objective identity was slowly achieved by gradually using smaller and smaller brushes until the fine detail was worked up. The high keyed color, which is so characteristic of my work, is a desired pitch of intensity which I wish to achieve—fluorescent colors are often used to stretch the brilliancy toward greater color vibrations than can be achieved with normal pigmentation. I often use masking tape for crisp edges and scrape for soft ones.— Roland Petersen, University of California, Davis.

12

Drawing and Painting Materials and Motivations

Before using new materials, encourage the student to "play," to explore and experiment with the media, either singly or in combination with other materials. Thus he can find the media most suitable for his own individual expression and needs. Each material is unique and has its own capabilities.

"How to" formulas should be avoided. Restrictive directions can often inhibit freedom. As the teacher, you can demonstrate the many possibilities of each tool. The tools and drawing materials become an important part of the lesson motivation.

Drawing materials are exciting. Anything that will create a mark on a surface, such as wood, metal, clay, paper, brush, or pencil, becomes a drawing instrument. A finger smeared with clay can express an idea just as a stick dipped in ink can. At one time, artists were separated into groups, such as oil painters or watercolor painters. Today, the emphasis concerns the ideas of the artists; the tools are dictated by the ideas to be expressed. Artists are painters, printmakers, sculptors. The artist selects the most appropriate tool to use to express his idea.

The student's paintings are his own unique expression, his own natural talents; each painting is one interpretation by one individual. His unique contribution is to be valued as a personal statement of what he paints, as he sees it, knows it, and feels it to be, and what meaning it has for him and what meaning it has for others. Painting offers opportunities to explore, enjoy, invent, discover, expand, become deeply involved, and awaken in each student his potential, his abilities, and new possibilities, and to provide creative experiences. Painting is one more way for the student to express his ideas with personal images and meaningful symbols.

The preschooler is an adventurer. A splash of color on a suface, whether it be the wall, paper, or floor, is enormously exciting. He is free and spontaneous; his response is intuitive; there is little reflection on past experiences. We want to encourage this freedom, to offer him new and challenging ideas and a choice of tools and materials that provide him with many art opportunities, such as large crayons, large brushes, large papers, vivid, bright colors, paints that respond opaquely as well as transparently. We want to provide time for just his "awareness."

Repeated painting experiences encourage the student to experiment, build, and boundary-push. Once-in-a-while experiences are not often enough to show development in individual searching. Frequent opportunities inspire discovery, exploration, and eagerness, and reveal new possibilities.

From paint experimenting and mixing develops the consciousness of mixing paint on the paper, a kinetic swirling about. Dots, stripes, circles, and splashes combine to create instinctive organized designs well composed within the paper space.

The student then begins to use personalized symbols to represent forms and objects. He is more sensitive to and aware of existing objects and relationships and his existence within the environment. His symbols are unique, simple, geometric forms, usually flat with outline colors filled in with other colors. He wants to communicate ideas. Encourage him with opportunities for both watercolor and opaque painting. Each tool and material offers its own individual characteristics.

At the upper-intermediate level, the student reflects more within himself and draws the existing world as he sees it in a more realistic representation. He is consciously aware of design and the art elements that structure design—line, mass, pattern, color, texture, forms, space (objects nearer or farther), values (lights and darks). He is consciously aware that light and atmosphere change and influence the appearance of colors. Watercolor can express this quality. He sees the changes that happen within the forms, such as in drapery folds. He establishes a working knowledge of spaces, forms, and color relationships such as tints and shades. This awareness provides working tools to express his strong feelings and new ideas. His interests are wide and include various subject matter, both realistic and imaginative. Remember that painting is really "drawing with paint." Overpainting with color builds changes. Opportunities and experiences will promote greater growth. Everyone likes to paint!

DRAWING MATERIALS

CHARCOAL

Charcoal is available in three degrees: soft, medium, and hard (soft smears the most). It is produced in three forms: (1) natural vine form, (2) compressed chalk form, and (3) wooden pencil.

Charcoal is a black solid residue, made from burning wood in a kiln with very little air. It can also be made from bones and other vegetable residues. Charcoal drawings are usually sprayed with a fixative when finished in order to prevent smudging. Common hair spray or a commercial fixative made from alcohol and shellac or plastic can be used.

For centuries, charcoal has been a favorite tool of the artist. Woods used in the past were willow, linden wood, spindle, and plum.

If you want to make your own charcoal, it is a fairly simple procedure.

Use an airtight chamber such as a casserole dish, or get a threaded piece of pipe about ten inches long. Cover with pipe caps, or secure the lid of a dish with clay or ashes to ensure airtightness.

Cut the wood to the lengths and shapes desired. Bind them together with wire, such as stovepipe wire, and space the loops every few inches to prevent warping under the heat.

Put the sticks of wood into the pipe or dish and close tightly. Place the pipe in an oven or bury it under hot coals of a fire. Leave for several hours. If the wood burns to ashes, the chamber is not airtight.

Charcoal is commonly used when making quick sketches, such as in gesture drawing; when wishing to make quick changes, such as the understructure of a painting, since charcoal erases easily with finger, cloth, or paper stump; when developing tonal studies, where tonal values range from dark to light. Large areas showing lights and darks of a composition can quickly be developed.

Charcoal sticks can be used either on the sides or on the point. Areas of tone can also be built up by using crosshatched lines. A piece of paper toweling under the student's unused hand can prevent smearing accidents. Various types of paper surfaces will produce different textures of the charcoal.

PENCILS

There are 350 different kinds of pencils. Some write on paper, tin, steel, iron, film, wood, plastics, glass, cloth, meat, and even on skin. Some computers need pencils with electronically conductive leads. All kinds of pencils can be used as drawing tools. One of my favorites is a carpenter's pencil. It's flat (square), and when I use it, I hold it as I would a shovel. I enjoy experimenting and discovering ways to create lines and textures.

The writing pencil is made from thin slats of cedar. Eight parallel grooves are machined into a slat that is half a pencil thick. The leads are laid in, and a similarly grooved slat faced with glue is clamped on. The slats are dried under intense heat. The grooved portions are sliced into eight pencils that are then smoothed, sanded, lacquered, imprinted, and fed into a machine which fastens on a ferrule and inserts an eraser plug. A good pencil has up to eight coats of lacquer, and the gold stamping on some pencils is real gold—to hold up under constant handling.[1]

Drawing pencils have a range of eighteen degrees, from 10H (the hardest lead) to HB (the middle) to 7B (the softest lead). Soft leads smear easily, while hard leads give clear, sharp marks that do not rub off easily. Most students prefer softer pencils, such as 6B, 4B, and 2B for drawing. Soft leads are thicker and usually more fragile

1. Courtesy of the Joseph Dixon Crucible Company.

than hard leads. Hard leads are preferred for small, detailed work; soft leads for freer, darker, and more spontaneous drawing. Artists use the range from 6H to 6B. A good range for classroom use would be 6B, 4B, 2B, HB, 2H, and 4H.

Pencils are used to create tonal ranges from light to dark. They are also used where more detail is desired.

Combinations of pencils create interesting textures and varying feelings.

Line qualities can be changed by varying the pressure. A wide dark line is made by pressing hard; a gentle soft pressure makes a delicate line. A varying pressure is often found in one line to indicate movement in and out.

Holding the tool differently will create various lines. Hold three pencils between your fingers, grasping them in your palm like a spoon, and draw all three together. Experiment and discover new ways.

Colors and lines can be built one on another to create interesting forms, textures, and areas.

Students like to use colored pencils. Some are made with oil or wax, and they cannot be erased. Nongreasy colored pencils may be brushed with water for a watercolor texture. Grease pencils (marking pencils) are more like a crayon pencil.

GRAPHITE STICKS

These sticks are available in rectangular shape, approximately $\frac{1}{2}'' \times \frac{1}{4}'' \times 3''$. The softer the graphite, the easier it is to erase. A kneaded eraser is commonly used. These sticks can be used for large shaded areas and to create varied textural effects.

PENS

1. Felt- and nylon-tip pens come in a wide variety of sizes and waterproof or water-soluble inks. They are a favorite for all school classrooms and students.
2. Bamboo pens are inexpensive and make a sensuous line ranging from wide to thin.
3. Artists' fountain pens come in a variety of pen sizes. They are used with different inks and are usually expensive.
4. Ball-point pens are available in various colors and sizes.
5. Pen points are available in a variety of shapes, widths, and flexibilities. The common crow quill pen makes a small, delicate pen line and is a favorite among artists. Before the improved industrial techniques of stamping metal and forming and grinding steel, pens were made from silver, brass, gold, and bronze and were used mostly for writing. They did not hold much ink, and they cut the paper. During the 1830s, James Perry was credited with producing and patenting a steel pen point that could be put in a holder. The steel pens offered a greater variety of points, longevity, flexibility, and a uniform quality.

6. Quill pens. The four kinds most commonly used by artists from the fifteenth to eighteenth centuries were the goose, swan, raven, and crow quills. Quill pens are flexible, and varying pressures create more personal and freer linear qualities.
7. Reed pens, an ancient pen. George Grosz used the reed pen in many of his drawings. The linear quality is blunter, more powerful, and bolder, not as delicate as the quill, and if used together would offer a strong, visually interesting contrast.

INKS

Black carbon ink, also called India ink, or Chinese ink, is a deep black ink and is a favorite of artists today. It was also used by the ancient Chinese and Egyptians. The carbon is made from soot of burning oils, charcoal, wood, bones, or various seeds or stones of plants and fruits. The carbon is ground to a fine powder and mixed with a binding media of water and glue or gum.

Carbon ink also comes in a stick form. When rubbed with a little water in a dish, the stick becomes liquid. The intensity of the color depends on the amount of water mixed with it. Today, India ink and other "waterproof" inks are made water-resistant by the addition of shellac or resin.

CRAYON

School wax crayons are made from a combination of paraffin waxes which are selected for their hardness and proper melting qualities. Paraffin wax is a residue left over from crude oil after gasoline, fuel oils, greases, etc., are removed. These waxes are melted, and a material called tallow and fatty acids are added to give the smooth and soft feel to the mark. Next, the coloring pigment (a powdered dye made insoluble with chemicals) is stirred into the molten wax and mixed thoroughly. The mixture is poured into a mold. The mold is a boxlike machine composed of many tubes opening onto a common flat surface. The molten mixture is poured into the tube openings until all tubes are filled, and an excess layer is left on top to compensate for shrinkage of the wax. Cold water is circulated around the tubes in this machine, freezing the wax hard. The excess wax is removed, and the crayon rods are pushed out of the tubes. They are picked off by hand and taken to the labeler. A machine wraps paper around the crayons, and other machines pack them for sale.[2]

Oil-base crayons are another favorite with students. They offer a greater variety of color and a different texture than the wax crayon. The colors can be built upon each other, creating new colors. They can also be blended

2. Courtesy of The American Crayon Company, Division of Joseph Dixon Crucible Company.

and brushed with turpentine for new textures and colors. Artists enjoy combining the oil crayon with a linear technique—such as pen and ink or pencil.

Conte crayons are wax-base crayons used by artists. They produce a line and tonal quality which is between charcoal and crayon. They are available in hard, medium, soft, and in black, white, and brown tones.

Lithograph crayons are grease-base crayons originally intended for the graphic process, lithographic printing, but are commonly used today for drawing on paper.

Crayon is the most popular classroom art medium. It is used alone as well as with other materials. It is not used for blending, but the oil crayon is good for building color. Crayon has deeper intensity than chalks.

Crayon batik. Painted wax crayon or paraffin on cloth.

Crayon resist. Crayon on paper, then brush paint or ink over crayon.

Crayon etching. Crayon on the paper with hard pressure, building up brightly colored areas placed in a random, spontaneous way. When paper is filled, cover over with a heavy coating of black ink to create thick layers or cover these colors with black crayon or black (or any dark color) paint mixed with a little liquid soap. Etch design into the dark overlay color, exposing the bright colors underneath.

Wax resist technique. Create a wax-design picture with crayons, candles, or by drawing into waxed-paper over the white paper. Leave enough open paper spaces. Brush paint over the crayon design. Darker colors are very effective over brightly colored crayon areas. The crayon picture will come through the paint (a magic painting).

Crayon etching. Cover the whole paper with brightly colored crayon designs. Make sure the crayon colors are put on heavily by pressing down mixed with a little liquid soap. (Try dusting the crayon with talcum powder, then apply tempera paint, the paint will adhere to the crayon.)

Encaustic. Use leftover crayons. Melt these over heat and drop crayon into the design. Be sure to use a heavy cardboard backing surface. Crayons can also be melted in cans (or muffin tins) over heat and painted with old brushes.

Oil-base crayons can be blended with fingers or cloth; can be overlayed to create new colors; or used with turpentine, the oil crayon blends like oil paint. Can be used on paper.

CHALKS AND PASTELS

These media blend easily and are used for tonal effects. Experiment with chalks to find interesting ways to use them. For example, chalk dipped into sugar water, chalk drawn or dipped into starch, or chalk dipped in water before using will produce a solid and darker line. Oil pastels are the same as above oil-base crayons.

ERASERS FOR ART

There are three types of erasers used for art:
1. Gum eraser. Soft and pliable; does not injure the paper.
2. Kneaded eraser. Soft and pliable; excellent for charcoal; does not smudge.
3. Pink eraser. Regularly used for graphite and pencil.

FIXATIVE

A binder is used to prevent smudging after a finished drawing of charcoal, pastels, chalk, or pencil. Common hair spray (lacquer base) or a mixture of alcohol and shellac can be used. In recent years, plastic sprays have been used. Carefully read *all* labels before using.

PAPERS

A variety of paper is available. The texture of the paper will affect the quality of the drawing—rough or smooth, absorbent or nonabsorbent.

Artists select a certain type of paper for the intended technique, effect, or idea.

Newsprint. A very inexpensive drawing paper. (A heavier-quality newsprint is available for easel painting.) A common size is 18″ × 24″. It is also available as roll ends of newspapers. The teacher can cut sizes and shapes.

Manila. Paper for painting and crayoning. A practical size is 18″ 24″. It is available in cream color.

Bond paper. A smooth-surfaced paper good for pencil, pen and ink, brush, and conté crayon drawings. Available in 18″ × 24″ pads.

Eighty- or sixty-pound white drawing paper. Oak tag, corrugated paper, acetate paper, tag board, bristol board, bogus paper, poster board, tissue paper, metallic papers. Japanese rice papers, watercolor papers, etc., are also available at a higher cost. White manila drawing paper can be purchased in rolls.

Charcoal paper. Available in white, black, and colors. (Tints are used by artists working with colored charcoals.) A rough-grained absorbent paper.

Kraft paper. Large rolls of white, colored, and black paper; inexpensive; good drawing and painting surface. Used for murals.

Construction paper. Offers a wide choice of colors, from bright tones to grayed shades. Good for construction purposes as well as for crayon, chalks, and paint. Also available in paper rolls.

White construction paper is suitable for drawing and painting.

Watercolor papers.

DRAWING MOTIVATIONS

Keep notebooks for sketches and ideas.

Keep individual portfolios, marking progress.

Exchange demonstrations, art publications.

Exchange exhibits with other classes and schools.

Consider the outside edges of the paper: square, rectangle, circle, free form, etc. This will influence the design of your drawing.

Study the basic structure of what you are going to draw: leaves, trees, people, still-life objects, muscles, skeletons, flowers, people. What basic geometric shapes can you find within the form?

Think of the contour edges of the shape (as if the object were black and silhouetted against a bright light).

Will you use surface lines that indicate direction? Will you use lines that move over the forms and across the surface to show roundness without shading?

Density—Determine the placement of the various values, the placement distribution, using shapes of different lightness and darkness.

Cross-hatching may be used to indicate form and three dimensions without blending and shading.

Study and observe how to shade, blend, give objects roundness, three-dimensions.

Objects lighter in value appear to be in the distance; objects darker in value appear closer. Similarity in value gives an overall feeling of oneness.

Overlapping: Objects appear in front of objects when they overlap them.

Depth can be created with heavy lines coming forward and lighter lines receding.

Grouped lines and marks indicate textures and patterns.

Variety of tools and materials, crayon, pen, pencil, etc., creates different lines, feelings, and textures.

Create lines with dots for variety.

Soft tones can be created with graphite, charcoal, sides of pencil, lithograph crayon.

Curved lines give a different feeling from straight, horizontal, or diagonal lines.

Black lines on white, white lines on black surfaces.

Think of positive as well as negative shapes (inside objects—outside shapes).

Values can indicate depth.

Scribble, drip inks, scratch away. Make rubbings of surfaces.

Quiet, simple areas in contrast to busy, active areas. Each will give a different feeling.

Spatial distribution of forms over paper or surface.

Colors create depth: Bright, intense colors come forward; dark, muted colors recede.

Harmony: Similar colors, values, shapes, and lines give feelings of peace, harmony, unity.

Discordance: Opposing colors, shapes, lines, values, etc., give feelings of opposition, discordance.

Movement: The spacing or intervals between objects.

Selection: What will you, the artist, select to include? What will you omit?

Exaggerated proportions—Strong distortions like a big hand to a small head indicate space, create strong feelings, transmit emotions.

Objects with greatest *detail* appear closest; they appear less distinct with distance.

When drawing drapery, folds, etc., consider the relationship of the curves and planes (ins and outs). In this case, light values come forward; dark tones recede.

Interest in your drawing can be created by variety and contrast: variety in dark and light, strength or delicacy; variety of lines; soft and hard edges; complex and simple areas; large and small shapes.

Space can be interpreted with flat planes; surfaces; moving from front to back; rounded forms—three-dimensional surfaces; moving lines across the picture plane, like an ant crawling across the ground; movement from one form to another across the surface, like paintings on a wall.

Optical illusions—a white circle appears differently on a white background than on a dark-gray background; values; sharp contrasts.

Make up games of drawings: "What is it?" Guess where the detail or object is from. Game is based on visual description. Invent games that test "visual recall." Match artists to artworks.

Select one particular landscape view during the year. Observe the changing seasons; the weather changes and light changes during a single day.

Discover how other artists have used perspective and space.

Begin drawings in unusual ways: start from the bottom, top, middle, sides.

Draw on unusual sizes of paper: long, skinny, round, triangular, etc.

Explode drawings (so large that it is hard to recognize the object). Draw miniature drawings.

Build environments in one subject area, such as trees. Trees could include stumps, leaves, branches, etc. Study details under microscopes; project large images on screens. Go on walks; invent sounds and music. Create "blow-up" drawings on various trees, murals of a tree study. Suspend tree mobiles. Build papier-mâché tree forms. Carve various types of wood. Invent dance forms to trees. Classify trees into groups; gather collections. Do detail drawing studies of types and different growth of trees. Study different geographies of tree growth. Pretend you are a tree. How do you feel and move? Interpret these feelings into a work of art.

Subject matter is everywhere.

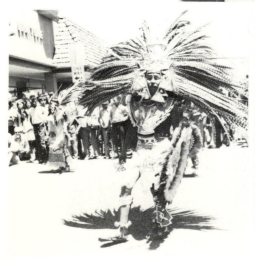

PAINTING MATERIALS

Pigments are manufactured by making a dye insoluble in water through a chemical reaction. Pigment is originally a solid material which is ground to a fine powder. Vehicles referred to can be either oil or water.

TEMPERA PAINT

Powder: Available in many colors. Mixes instantly with water. Commonly ordered in one-pound cans with spouts for easy pouring.

Add liquid or powder detergent with paint for easy removal.

Add liquid starch as an extender for paint. (Also good finger paint.)

Add white glue to tempera when wishing to cover materials, such as wood, plastic, or papier-mâché, to prevent cracking and peeling.

Liquid: Uniformly suspended paint will keep a long time. Covers easily. Brilliant color. Smooth brushing and blending. Available in variety of sizes—jars of eight ounces, pints, quarts, gallons, as well as small individual jars. Somewhat more expensive, but preferred by some teachers because of the convenience and dependable consistency. Also available in unbreakable plastic squeeze bottles which provide easier dispensing and greater convenience. (Start saving household squeeze bottles.)

Available in individual sets of six, eight, or twelve ¾–ounce jars. A new product is a flourescent paint set, six ¾–ounce jars. It is more expensive.

Cake: Comes in 1¼″ square cakes or 2″ × 2″ × ½″ cakes. In plastic trays, each cake is easily replaced individually. The larger cakes can be interlocked without trays and have individual lids. Colors mix with brush and water, never spoil, and are strong opaque colors. Usable on wood, wax, metal, glass, plywood, rubber, plastic, foil, cork.

ACRYLIC POLYMER PAINTS

Acrylic paints are available in tubes as well as in jars for more advance students. They are more expensive and are used mainly by the professional artists. Oil paints and watercolor pigments come in tubes also.

Colors are watercolor formulated with acrylic polymer plastic emulsion. This means that suspended in the formula are fine particles of colorless synthetic resin which forms a clear film when dry. The result is brilliance, toughness, flexibility, and water solubility; water-resistant when dry and can be used transparently as well as opaquely. The color will not change from wet to dry. The paint can be used on paper, canvas, wood, plastic, etc. The finish does not have to be treated with a varnish or covered for permanency, but most artists do cover with a final clear coating of acrylic polymer.

WATERCOLOR PAINT

Transparent watercolor paints are available in plastic and metal boxes (plastic will not rust). There are semimoist half-pans, semimoist whole pans, and semimoist oval pans in eight or sixteen colors. Refills of each size are available.

Opaque watercolors come with eight, ten, or twelve pans of color in boxes. They are not as commonly used as the transparent colors. The paints are more expensive.

Experiment with vegetable juices, vegetable dyes.

Tube or cake paint. A beginning palette could include alizarin crimson, burnt sienna, cadmium yellow, yellow ochre, Prussian blue, ultra-marine blue, green, and add gray. (Payne's gray is good for darks rather than black), magenta, purple, turquoise, raw umber, burnt umber, white, cadmium red light, cadmium red medium, cadmium red dark, and orange. A good flesh color is a blend of yellow ochre, cadmium red light, and a little white.

PAPER

A variety of papers and weights of paper will provide different textures. A smooth surface will react differently from a rough surface. Some papers can be scrubbed; others can be dipped under running water.

PALETTE

A surface to mix colors. These can be bought commercially or improvised. Aluminum pie tins work well, as do plastic egg cartons, ceramic dishes, plastic dishes, or cookie sheets with waxed paper wrapped around it.

BRUSHES

Brushes are round and flat in a variety of sizes. Large flat brushes for large areas; round brushes for detailing and lines that run thin to thick.

Easel brush: A bristle brush, flat, will not fan out and lose its shape. It is intended for large easel painting. Available in sizes of ¼″, ½″, ¾″, and 1″. Another brush is one made of a nylon filament instead of hair or bristle. It is intended for polymer painting. Many teachers like this brush for easel painting. It is more durable and is water-resistant, but is somewhat more expensive. It comes in the same sizes as above. Flat wash brushes are useful for large areas. Common varnish brushes, hardware variety, or enamel brushes are handy (1″ or 2″ size). These can be trimmed short to about 1″ and are good for easel painting.

Watercolor brushes: Watercolor brushes and wash brushes (just a larger size of watercolor brush) are made of squirrel hair (camel or sable.) They are full-bodied (to hold a large amount of paint) and come to a fine point when dipped in water. They snap back and keep their

original shape. Check to make sure they are fastened securely to the ferrule (usually made of aluminum and is rust-proof) so the hairs do not pull out easily. A rounded end on a plastic handle is safer than a pointed end. Numbers 4, 8, 11, and 14 are good selections. Artists use sable-hair brushes for watercolor. They are full and round, but more expensive. They also use camel-hair brushes.

Japanese brushes: These bamboo brushes come in a variety of sizes, are inexpensive, but do not last long. They have an excellent linear quality (a thick to thin point).

All brushes should be washed thoroughly with mild soap and warm water (never hot water, as it will melt the glue in the ferrule). They should be shaped before storing and should be stored either flat or brushend-up in jars or containers.

More Painting Tools and Surfaces

Water container. Jars, plastic containers. (Optional) Boards to tack the paper to. Masonite, wood or fibre boards.

Aprons or smocks, rags, newspapers, sponges.

Wire, sticks, twigs, nails, combs.

Sponge (use as is or cut into 1″ squares for painting).

Rubber cement.

Shoe dyes, cloth dyes, root dyes.

Melted crayon for encaustic.

Batik.

Fingers, soap, feathers, rags, ropes, plastic dispensers.

Carbon paper (various colors).

Candles, cotton swabs, corks, glitter, paper doilies.

Computers, lights, overhead projectors, stencils, masking tape, dabbers.

Charcoal stumps, Q-tips, pipe cleaners, toothbrush, knives.

Cloth, carboard towels, waxed paper, plastic, sidewalks, sand, chalkboards, fences, driveways, glass, stones, wood, cellophane, Saran wrap, corrugated cardboard, film, magazines, telephone books.

Brushes, sponges, spray bottles to add water or spray color, squeeze bottles.

Wadded up paper toweling, cotton.

Put paint on paper then stamp onto painting for unusual texture. Blow paint through a straw.

Dab paint on paper then drag across painting for dry effect and rocky texture.

Make monoprints from interesting surfaces such as wood, plastic, metal tabletops. A *monoprint* is made by applying paint to an interesting surface (smooth is best) usually like glass or plastic—even a cement floor—then putting paper down on it and transferring the paint to the painting paper. A monoprint can be applied to a dry or wet paper.

Salvage old watercolor paintings and keep to tear up and use in collage paintings.

Watercolors, inks, batik dyes, vegetable dyes, cloth dyes, stamp pads and stamps, any carved surface, felt-pen inks, temperas, liquitex paints which can be diluted for thinner washes. Acrylic-base paints give more intense colors and appear to have a glossy finish when used on paper.

Oil paints are very interesting on paper in combination with pencil. Brown wrapping paper.

Rollers for rolling on paint.

Copying machines.

Differently colored carbon papers.

Painting Preparation—Ordering Materials for the Classroom

Discuss with students the best ways to—prepare supplies—mix paints, thin glues, etc.,

pass out supplies;

care for supplies while in use;

return supplies;

clean up room after work;

care for tools;

organize groups of children to take turns in caring for tools, supplies, distribution, pickup and cleanup;

pass out newspapers, paint shirts;

organize storage spaces; and

organize groups for best use of room space, floors, and hallways.

The quantities listed are approximate amounts for a classroom of 35 students.

Crayons: 35 boxes of 64 colors. Also small boxes of 8 primary colors.

Powdered liquid or cake tempera: Red, yellow, blue, white, black, magenta, turquoise, purple, ochre, orange, brown, green, flesh. Amount purchased depends on curriculum projects.

Watercolor paint: 35 plastic or metal box trays with 16 colors.

Brushes: 35 assorted 1″, ¾″, ½″, ¼″ long-handled bristle brushes. Or trim hardware-variety brushes to 1″ length.

35 assorted sizes of round, soft-hair brushes.

15 Japanese bamboo brushes.

Paper: One ream is 500 sheets.

White drawing	1 ream 18″ × 24″, or roll
Manila	2 reams 18″ × 24″
White and assorted kraft (butcher)	1 roll each 36″ wide, 100 ft. long; 5 or 6 colors
Assorted colored construction paper	2 reams, 18″ × 24″
Newsprint	2 reams 18″ × 24″ or roll ends from newspaper
Glossy or glazed (kitchen shelf) paper for finger-painting	1 roll

Charcoal pastels, erasers, variety of drawing pencils: 15 sets (each), 35 assorted pencils.

Felt pens: 35 assorted colored sets, thick and thin tips (splurge on these).

Colored pencils: 10 assorted colored sets (12 pencils in each set).

Glue:

Wheat paste	25 lbs.
White glue	1 gal.
Rubber cement	
Liquid starch (commercial)	1 gal.

Powdered detergent or liquid detergent; scissors.

Water container: Jars (pint size), cut-off milk cartons, plastic cottage containers, coffee cans.

Paint containers: Plastic squeeze jars, TV dinner trays (aluminum), 4″ aluminum pie trays for individual colors, baby food jars, ice cube trays, muffin tins, ketchup or mustard containers (with nail in top for storage), syrup pitchers, large quart jars for storage and mixing.

Rags, newspaper, paper toweling, popsicle sticks, tongue depressors (mixing), assorted papers (like wall-papers), gallon of turpentine. Rollers (brayers), wire, clothespins, line for exhibition areas.

PAINTING TECHNIQUES

Sketch in general idea or design or large areas with pencil or light-colored paint and brush.

Brush in large ares of color. (Use a large flat brush.) Might try wetting these areas first.

Work wet or dry. Wet paper all over and add color areas for blending effect. When dry, add washes for buildup.

Lines. Add lines with smaller round brush.

Pull the painting together by adding colors from background into foreground and vice versa.

Finish with details and textures.

Constantly study other painters, paintings, and techniques.

The more you paint, the more proficient you will become.

When beginning a new material or medium, plan to devote two or three sessions to being *open*—experimenting and investigating the medium to see just what the new possibilities are. Think of as many ways as you can to explore, to be "crazy" with the materials—with paints, brushes, sticks, paper, sponges, etc.

Select one of the following experiments to use as a lesson, or combine several as a challenging motivation.

Soak the paper under cold water. (We do it in the bathtub.)

Wet the table under the paper to keep the paper flat. (Formica table top.)

Use two- or three-inch flat brushes and brush on the paint in large areas. (If areas are still wet, plan on colors running.)

Paint thin washes as well as thick pigment layers. Build up layers of paint, called overpainting.

Try sponging over the painted areas, wet or dry. What happens?

Soak up and wipe away some of the pigment with a sponge. Paint another area with the same sponge.

Drip, blow, or run paint onto the wet paper. Watch how the paint moves.

Pick up the paper and move the paint and washes around, causing them to flow in various directions and create patterns and designs. Use squeeze bottles, knives, sticks, tongue depressors, or 4″ pie tins to add paint to the paper. (Some artists *pour* paint on surfaces.)

Scratch into the painted washes with knives. If you use a serrated knife, several running scratches can be created at once.

Drop some ink into the wet wash and see how the ink reacts differently from the paint when they spread. Drop oil, starch, glue into the wash.

Experiment using rubber cement or dropped waxes (melted crayon—wax resist) on the paper at different intervals before you wet the paper and after the paper has been painted on to resist and retain color (like a batik effect).

Try drawing into the wet paper and washes with pen and ink—black as well as colors. Different sizes of pen points (crow quill pens) create different lines as well. Watch how the ink spreads and creates colors and textures.

Scratch into the pen line with a knife or nail.

Keep some areas wet; let other areas dry. Keep some white spaces open. The whites move throughout the design and keep the painting fresh and clean-looking.

Use enough pigment. As the watercolor dries, you will see that the color loses some of its intensity; therefore, plan to compensate for this by using heavy pigment to get intense color when desired.

Keep the washes fresh and clean. After the paper has dried, go into the painting again with transparent washes. This will build up and create depth and will also change the color.

If you don't like an area, you can wipe out some color with a wet cloth, tissue, or brush.

If you don't like the painting at all, try washing it out under the faucet and start again. You can do this with good watercolor paper but not with thin paper or drawing paper.

Keep in mind that you are constantly involved with depth, value, color, and movement back and forth as well as forward and backward within the picture plane.

Try painting on different types of paper and investigate their resistance to the media (such as common butcher paper in various colors, newsprint, manila, drawing paper).

Paint with unusual printing materials such as combs, sides of carboards, tongue depressors, facial tissues, toweling.

Place ice on the paper. Add paint arount the ice.

Place glue on paper. While wet, add sand or soil, pencil shavings, or coffee grounds.

Drop some paint from ink droppers. Have some fun spattering paint on dry and wet surfaces.

Draw with the stopper tip of the ink bottle or directly with squeeze bottles on wet and dry surfaces.

Draw with a small dowel or a stick; draw with a nail.

Try holding the brush in different ways—like a pencil, a spoon gripped like a shovel. Twirl the brush.

Draw a single rhythmic line. Repeat this line over and over again, but vary the pressure weight of the line.

Combine areas of color with lines of color.

Let water "drip" over the paper in spontaneous flows. Add color at the top of the drip and watch what happens as the color flows and follows the "drips."

Think about positive and negative forms.

Try various brushes and see what textures happen—oil brushes, varnish brushes, scrub brushes, toothbrushes.

Soak the paper. Bruise the paper—crinkle, wad, or crush the paper, creating lines. Let the paper sit about five minutes. Carefully add some color washes. Water will collect at the wrinkles, creating a batik look. Add more colors. Draw with pen lines over all.

Try using wheat paste or flour or glue as a ground (painting all over the surface).

Combine painting techniques with chalk, oil pastels, all kinds of carbon papers, pencils, crayons, stamps, collages, rubbings, transfers, etc.

Select a mood or feeling. Create this mood interpretation with colors that express the feeling.

Start drawing or "doodling" with the brush. See what colors, feelings, and ideas emerge from your inner self.

Paint over pencil drawing, charcoal, grease pencil. Moisten paper with spray atomizer.

The whites of the paper play an important part in the design and should be kept in mind as a painting technique.

It is important to keep water fresh and clean. Change water when it begins to get muddy, or have two jars of water at hand—one for cleaning, one for mixing with color.

Make sure brush is clean when changing colors.

Mixing can be done on the palette first, or blending of colors can happen on the paper.

If you decide the color is too strong or if you wish to wipe away certain shapes, sponges, clean damp brushes, cotton swabs, or cloth can be used to remove paint while it is still damp. These tools can be used to add color, too.

Sandpaper could be used to sand the paper for textural effects.

Steel wool might give your paper an interesting texture. Use the wool when paint is dry.

Paint glue on the surface and, if desired, add sand while wet will give another texture.

Collages of papers can be tried for painting surfaces.

Ordinary household bleach will remove areas of color. This works best with colored inks.

Painting over crayon forms gives a popular painting technique called crayon resist.

Rubber cement used under the paint will resist water when painted over (like crayon resist). When paint is dry, rubber cement can be rubbed off.

Watercolor is a transparent medium. Many artists prefer to work boldly, with confidence, quickly, directly, keeping the painting alive and spontaneous. Artist and student will develop their own handling and application of the paint. These are suggestions that each person can experiment with.

Many other tools can be combined with the watercolor—sticks, pens, inks, starch, glues, opaque paints such as casein and acrylic paints (when thinned with water are the same as watercolors in appearance).

Old brushes or inexpensive brushes have interesting characteristics.

Move whole arm when painting large areas.

Use large flat brush when painting in large areas; tilt board toward you (colors run).

Put background colors in first, like skies.

A broad brush loaded with color (pigment) and a little water dragged over a rough paper will give an effect called dry brush. Use in areas to indicate foliage, stippled effect.

Load paint on a flat brush; then wipe off. Can lay one stroke next to another; will overlap. Good for areas like a board fence.

A broad flat brush can be separated into three parts, and then each area is loaded with paint. This will have an interesting effect as if painting several lines with one stroke.

The edge of the large flat brush can give a fine line. Some artists prefer only large brushes. The large flat brush can also move from wide to fine line when turned with one stroke.

A pointed brush gives a graceful thick to thin line when varying pressure on the point of the brush. Oriental painting is based on this technique.

With a large flat brush, try loading one side with one color and the other side with another color.

Dip the brush in color, remove the excess, then flare the brush (looks like a messed-up hairdo). Will give many fine lines at one stroke.

When painting in areas, use a knife or tool to scrape away areas before the paint dries, leaving the white surface.

To blend, lay in top stroke with dark color, then keep adding water with each stroke as you go down from top to bottom of the paper.

To achieve round form, brush in light tone all over. While wet, put in dark color on the edge. This will bleed toward center.

Holding the brush in different ways will give different line effects—hold straight up and down or like a fork or knife; gripped in the center of the hand. Experiment with various ways to hold the brush and discover different brush effects. Also try holding a pencil in many ways.

Clear unmixed colors will give strongest contrast. More pigment and less water for deepest, most intense color.

When cleaning paints, each cake of paint should be brushed clean. Paints squeezed from tubes will harden and can either be thrown away or saved and mixed with water for use another time.

Dripping of colors, blowing, blotting, painting with string, sticks, bottle tops, etc., can add interesting textures and interest to the painting.

Try "puddling" colors onto an absorbent paper. Rather than have the colors run and blend, add each color as a puddle form. Let each color dry before adding the next puddle color.

Experiment with string painting, collage, spatter painting (toothbrushes, combs, etc.), stencil painting (oak tag or cardboard papers, incorporating both the positive and negative cut stencil into your design), spray painting (old sprays). Invent your own combinations of materials. (Did you ever paint with old coffee grounds? Tea?)

For more intense color, add overlays of paint. Interesting combinations occur when overlaying colors. Be sure each color is dry.

Placing liquid colored pigment in cups might be tried for pouring colors onto paper.

Aluminum foil (dipped in paint), tongue depressors, medicine droppers, or brayer rollers could be used for applying paint.

Strong contrasts of light and dark value give the painting vitality and crispness.

Paintings with similar values create moods and feeling.

Paintings or drawings can be matted, framed, or mounted. Or drawings can be sprayed with acrylic sprays for permanence, and to avoid smudging.

Ask parents for throw-away scraps of wood, cloth, lace, yarn, various papers, buttons, big jars, plastic containers, etc., for collage.

Stamping pad can be made from wet paper toweling (or use sponges) placed in aluminum pie tines. Sprinkle tempera paint on top.

Look for details of flowers and branches of trees, etc.

Indicate space with washes, gradating color from intense to light (remember, strong colors come forward; muted colors recede).

Let textures represent forms. For example, dry sponge or paper-towel painting can indicate leaves on a tree.

Build washes of transparent color to create forms.

Think about outside edges as one form relates to another. Sometimes you will want to outline forms; other times the form is represented with just a simple color wash.

Remember that dry-on-dry brush techniques are especially good for outdoor landscape textures.

Try varying the tools; combine and invent. Try collage. Draw with charcoal pencil into water-color washes. Various tools influence the "happening."

Recall all the various discoveries you have made. Write them down in your sketchbook.

Constantly look for new and personal combinations, such as new color relationships and personal linear qualities.

Keep drawing and painting with sticks, brushes, hands, toweling, cardboard, needles, and anything else you find to express your ideas.

What excites you the most about painting? Emphasize that.

Is there a theme of feeling to your painting?

Paint a picture by selecting a specific mood—storm, the sea, clouds, joy, or anger.

Paint a still life using the color in flat colors.

Paint the subject with a palette knife and tempera paint.

PAINTING MOTIVATIONS

POEM PAINTING

Writing a poem is very much like creating a word painting. Both have texture, rhythm, color, form, idea, free imagination, discoveries; and both are emotionally inspiring. The student's personal statement should be free, inventive, spontaneous (like a painting); the language, feeling, and expression should be childlike. As in art, the important ideas are the sounds, the beautiful thoughts,

"The Cook Out"—Shaona, grade three.

"A Lost Martian Hippy on the Beach at Night"—Jerry, grade four.

"Spaceships in the Galaxy of Terror"—Ron, grade four.

Titles, phrases and poems are exciting idea-sparkers.

impressions, imaginations, happy experiences, or sorrowful remembrances; the ideas are sometimes funny, playful, joyful, always delightful, and are exciting to hear. Emphasize that spelling, neatness, rhymes, and jingles are not the important things to think about; neither are the clichés or the conventional statements. Just as they do when painting, children like to write poetry when it is an innermost expression of themselves. After the first few times, they are usually bursting with ideas for more poems. Combining visual images with thought images is exciting and challenging for all levels of growth development.

The following poems were written by Heather Linderman, grade five:

CHAIRS

Square, round
They mostly stand
They're good when you want to sit down
But when you don't want to, they're just O.K.

CLOTHES

Clothes are bright and dark,
Shiny and broad,
With all kinds of designs on
them.
I think clothes are just wonderful,
Especially for me!

LIGHT

Light
Bright, shiny
It shines on or off,
Light is wonderful,
Shine.

FORESTS

Green, so green,
That smells like pine,
So nice, so beautiful,
I just love to be
in the big pine trees.

SPRING

Bright, beautiful
Blooming flowers everywhere
I like old Spring
Happiness.

RED

Red is nice
Red is like a rash
Red is glistening blood
Red is a sun set
Red is a madman
Red is juicy apple
Red is a ripe plumb
Red can be a tear
Red could be an autumn leaf
Red could be lipstick
Or red can be a ribbon
But mostly Red and
Red for always.

This poem was written by Gwen Linderman, grade four:

GWEN'S GUM

Gwen's gum is
your chum. It's
Chewy, it's bubbly.
You get a freckle in
every chew. It has
that red-headed
flavor. It's tasty,
It's sweet. A real
neat treat that
can't be beat.
Gwen's gum—get some, chum!

More ideas for poems and paintings could have the same thought in each line, such as "Hello to———; goodby to———," "I wish———," "A color is———," "Spring to me is———; Winter means———," "It's fun to———, Work is," "Inside me there is———, Outside me there is———," "My secret feeling is———," "How it feels to be a monster———," "If the ocean could fly, then———," "If the clouds had legs, then———." "If spiders were giants, then———." "When I am the President———," "If I could do anything in the world, I would———," "This magic box has in it———," "When I turn into a———."

Encourage the words and paintings to be inventive—the children's very own. Be sure to have the students read their poems to the other students and display for sharing.

It's interesting and fun to read each other's poems and also to read poems written by other poets. Ask the students to select phrases and jot them down as you read—phrases that suggest images, excite their awareness, express ideas, cause them to react emotionally; that captures their imagination, that they can relate to. These can be inspirations for paintings. See if you can make them part of the painting (write and draw in the key words).

Did this phrase suggest a feeling to you?

Are there certain words that suggest ideas to you?

Did these phrases awaken past feelings and images?

What images developed from your "inner self"?

Can you walk into a poem painting and become part of it?

A stick painting with watercolor—Debbie, age twelve

ANTIQUE PAINTING

Try this for fun and a different technique.

Soak and wet paper thoroughly.

Bruise, crinkle, fold paper.

Brush on a deep color such as raw sienna, brown, sepia, Payne's gray, etc.

Wash off excess under faucet—color remains in cracks of paper; or take off excess with a sponge or toweling.

Stretch over a board (plywood, Masonite, etc.) until paper is flat and tape down with masking tape. Let dry.

Continue painting into "antiqued" paper.

STICK PAINTING

Use a small dowel (approximately ⅛″ in diameter) or a stick from outside and sharpen. Dip into inks and use for drawing (in wet surfaces or dry) for linear quality.

PAINT A STILL LIFE

The following are possible approaches:

Sketch in basic lines, dividing the paper space.

Paint in shadows first.

Work in colors from background to foreground.

Or work from background to foreground with color, then add shadows on *wet* paper.

Put paint on *very wet;* then *mop* away color with either brush, sponge, or toweling for a lighter tone.

Or brush on color very freely. When paper is dry, go back into painting with Japanese fine line (stick, pen point, markers) for linear drawing technique.

FEELING PORTRAITS

How do you feel today?

Select two or three colors that best express the way you think or feel. Use these colors when painting self-portraits.

Paint in some background feeling—perhaps something that happened to you today will be included in the background. Use large brush for washes.

Next, close your eyes and "feel" the way your face moves and changes. For instance, pretend there is an ant or fly on the top of your head and it is going to crawl over your head and face. Think about how the ant moves and crawls in and out over the forms. Use your finger as if it were the ant or fly. Be sure to think about how your finger follows your cheekbones, how your finger moves over your eye, down and under your chin. Go in the opposite direction, from side to side. Explore your head and face as if you were a discoverer roaming over a new land, feeling and exploring a new adventure in space. Begin to paint and draw. Continue to feel your features as you paint. Use your pen and ink for some of the drawing, also for details. Draw into wet paper as well as dry paper. As you discovered, ink will spread in a unique way.

Include as much as you think is expressive. One painter put color washes in the background, leaving the space for the face white. Then she drew only the eyes into the portrait. This emphasized the eyes, creating a distinguished, unique feeling. Another person drew a profile face, putting various brush strokes and forms into the hair and emphasizing the importance of the hair, while only suggesting with broad color the forms for the features. Another person split the paper in half, putting one color on one side, another color on the other. He then drew into the painting with a delicate line for the features. Another person decided to use just blue—monochromatic—for the painting, creating a strong mood. There are as many possibilities as you can think of! Carry forth a "feeling" or "mood"!

COLLAGE

Collage means to combine many papers, sometimes fabrics or cloth, to achieve a design.

Rice paper, brown or colored wrapping paper, paper toweling.

Colored tissue paper (you may want to wash out some of the intense color).

Different types of watercolor paper.

Wallpaper, gift-wrap paper, newspapers.

Magazines, photos, different types of paint, comic books.

Antique photos and magazines, books.

Labels from jars, etc., old credit cards, driver's license, candy wrappers.

Acetate papers, old film, metallic papers.

Interesting textured or patterned cloth (some artists add cut linen forms to linen canvases).

Glitter, Christmas decorations, old valentines.

Old Christmas cards, etc. Antique cards have special charm.

Tintypes, antique stereocards.

Collage forms can be either cut or shapes torn.

When gluing down shapes, be sure to consider the whole composition as you build.

Either while forms are wet or when glued shapes are dry, paint into the collage as you feel areas are needed.

Alternate again, adding collage forms and then painting in.

Opaque paints (such as temperas and acrylics) will cover areas decided against.

Remember, one advantage to watercolor is that you can always wash away what you don't like.

Courtesy of Howard Conant, University of Arizona

Collage portrait

MAKING AND PAINTING FROM SLIDES

The following materials are needed:

Ready mounts	Dust
Clear and colored acetate	Slide projector
Permanent felt pens	Watercolor paints
Colored inks	Oil
Feathers	Vegetable dyes
Lace	Gelatins
Glue	Old discarded negatives
Hairs	Old slides (try burning
Netting	them carefully)
Salt and sugar crystals	Any other small, transpar-
Tissue paper	ent item that you can
Crackle paint	discover
Vaseline	

Cut the pieces of acetate to fit the Ready Mounts (available at photo stores).

Glue into mount and draw directly on it.

Or, use double thickness of acetate and sandwich forms and scraps in between.

Plan your design or experiment with materials, making several slides. Be sure to apply inks and marker designs rather heavily; the heavier the ink, the stronger the color.

Create tissue-paper slides, crackle-paint slides, felt-pen designs, and pen and ink designs. Add feathers, hairs, crystals, dyes, gelatins, old negatives, colored acetate shapes, lace, netting.

Cut designs from second pieces of acetate and glue on first. Cut directly into colored acetate piece, cutting out forms. These forms will appear very white when projected. Spread glue thinly, as the glue will become opaque if applied heavily when gluing forms on. These are ready to sandwich together.

Close mounts. Use less expensive mounts; students can keep slides for further reference.

Project slides one at a time or two at a time, sometimes even overlapping images.

When projected from a distance, the images are, of course, much larger. Figures standing in front of images (light clothing) are exciting when they move. Project slides on objects or mirror balls.

When ready for painting, project image closer to the screen so that the image is smaller for painting on the paper. Colors are also more intense. You might even place the paper in front of the image to see what relationships you wish to include and perhaps exaggerate them in the painting.

Strong color images become very exciting; crackling effects are very unique for detail linear drawings.

Teacher should discuss design and emphasize composition art elements as they appear in the slide image. Students are ready to paint. Suggest indication of moods and emotional statements.

Paintings can be abstract or realistic. Try to capture the free, experimental, loose, abstract forms in the painting as they might appear in the slide. You will be surprised at and impressed with the excitement and interest in painting from these inventive images.

ADDITIONAL PAINTING MOTIVATIONS

Combine geometric shapes and free forms in a single composition.

Use free forms only.

Use geometric forms only.

Create mood paintings. Use only light colors in one; use only dark colors in another. Wet paintings, dry paintings.

Select one geometric or free form and repeat it in several ways in one composition.

Using a free form, create a composition which suggests a view of one of more magnified cells (under an electron microscope magnified 100,000 times), active and moving.

Select an emotion—a feeling—such as love, hate, fear, anxiety, exhilaration, anger, loneliness, hope, joy—and express it in abstract forms. Use color intuitively to create an emotional or mood effect.

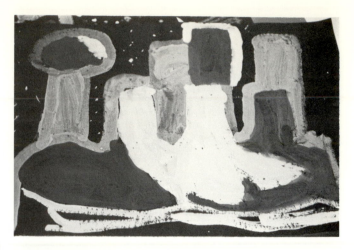

Fourth- and fifth-grade students paint abstract designs after selecting a 2″ × 2″ section of a photograph and enlarging the forms. A rectangular viewer helps in selecting interesting sections.

"Lost in the Superstitions."

Select two emotions—anger and joy—and a psychological relationship as in "anger giving way to joy."

Express this relationship abstractly in a single painting. Use color to express the emotional quality.

Let a movie title, a TV title, or song title suggest the subject matter to you.

Little Big Man	"I Want To Hold Your Hand"
What's Up Doc?	
"Dreamytime Blues"	*Airport*
How Green Was My Valley	*The French Connection*
When the Dinosaurs Ruled the Earth	*Cabaret*
	Skyjacked
Gone with the Wind	*The Frogs*
Chitty, Chitty, Bang Bang	*The Stalking Moon*
Jaws	*Nicholas and Alexandra*
E.T.	*Star Wars*

Think of one variety of tree which you have seen in the past. Compose a landscape. Repeat the same tree in as many different ways as possible.

Select a place, such as the circus, tropical gardens, the state fair, and build a painting composition around it.

Think of an activity that you like to do, such as playing basketball. Put two or more figures in action doing the activity. Use your imagination and create an environment for these figures.

Fill the whole space of the paper with a face. A figure. A finger.

Create a composition using free forms and geometric forms where the shapes go backwards; other shapes come forward. *Use the whole paper.*

Use the free forms and geometric forms. Now superimpose a figure, or a tree, or a house over the other forms.

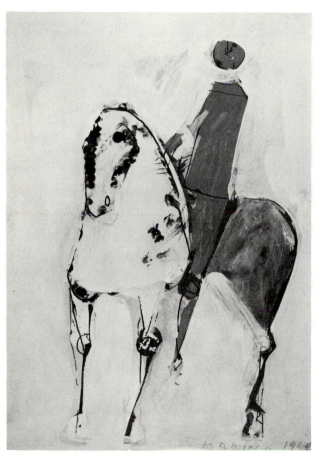

Marina. *Horse and Rider. Gouache.* 15½" × 11". The Fine Arts Gallery of San Diego.

Wild horses by Lon McGargee.

Paper collage drawing of ram by sixth-grade student.

Imaginative paintings by fourth-graders after they had studied Joan Miro. Emphasis was on the use of unique "secret" symbols. Below is a painting after a suggested title, "Minibike Trail at Four Peaks."

Paint *happy* stripes, *sad* stripes.

Combine the geometric shapes and free-form shapes with some still-life objects, like an old doll in the same compostion.

Paint a figure in an environment. Let the figure be the most important part.

Paint a figure where the environment is the most important thing.

Using free forms, geometric and naturalistic forms, *blow up the inside view* of a flower until it fills the whole page. Show all the inside parts such as the pistil and stamen. Explore the flower from inside out. Add some imaginative forms to the basic flower.

Design a new flag for a new nation, a stamp.

Draw three gesture poses of the head from three views. Superimpose and let the forms intersect and overlap. Record the action of the features, as well as the facial characteristics.

Paint a head as if you were modeling it from clay. Think of the head as a series of forms rather than an outline. Use color to help pull out the forms from within the structure. Incorporate the background into the painting.

Make pop-art blowups of a single object—a shoe, an apple, a coffeepot.

Each student writes down a place, a favorite person, and an object. Invent a painting about these three ideas.

Paint a "crazy" painting.

Make a "wish" painting. Tack up a ten-foot mural-size paper. Each child adds himself, "I wish I were ———." (He could be an invented character, like one from "Sesame Street.") Add a balloon which includes his feeling about his wish.

Add-to murals. The large mural-size paper is always tacked up. The students add new ideas to it—how they feel and important happenings—whenever they wish.

Marlene Linderman. *That's All Folks*. Acrylic.

Create paintings about "What it feels like to be a——," "I had a dream about——." Create paintings that aren't true. "If I were—— (sand on the desert, splashy waves, a bird, a rainbow, an ice cube, a President)."

Create "mistake" paintings. See what mistakes you can make on purpose. Let them become "happy accidents." See what you can do with them.

Make a dot painting.

Design a cloth pattern. Create dress designs. Design cars or furniture of the future.

Paint a mural of the community and the significant architectural structures. Paint another mural of how these buildings should look. Paint a mural of the community in the future.

Paint yourself as you would like to come back in another life; in the future; from a past life.

Invent new painting games (find as many reds as you can), exchange and paint on paintings, make up funny rules—inside-out paintings. Make a red painting using every color.

Create painting environments. Cover all spaces with paintings (ceilings, etc.) Create other awareness environments, using plastic panels, large Styrofoam blocks and forms, visual effects like light shows, drape cloth or soft plastic from the ceilings and in front of windows, various size boxes, elastic bandages (to push and pull—stress); other organic, as well as man-made, unusual, exciting forms, and add to these, tapes and other sound systems. Respond, move, improvise, record, communicate impressions; create, perform, and interrelate within these spaces.

Fantasy topics. Looking out my window. The world of the fingerprint. My favorite comic strip. My secret dream. Mystery island. Through the crystal ball.

Inside a dot. The botton of the sea. When I was an elephant in Africa. The Sorceress. The night I caught Harry, the giant. Being a tornado. A raindrop. January 1, 1999. My trip on a flying saucer.

Explore group murals with topics such as Life under the Sea, The Workings of a Factory, The Workings of Motors; story-line themes as *Kidnapped, Through the Looking Glass, Book of Pirates,* The Emerald City of Oz, *Alice in Wonderland,* and many favorites from literature.

Now that you have been introduced to the ideas and suggestions in this book, reflect on them and enjoy the book, and I hope it will serve as the beginning for your lifetime search in aesthetic adventures.

Glossary of Art Terms

Abstract art. Art that has been abstracted from nature. The forms may be simplified, geometric, identifiable, or completely unrecognizable.

Aesthetic. A term in art referring to the perception, appreciation, and beauty in art.

Aim. An attempt to reach or accomplish an object or purpose.

Appreciation. An understanding of things for themselves.

Area. A space referred to.

Arrangement. Placing in an order. Organizing the art elements into a pleasing unity.

Art skill; the ability to perform certain actions *gained* through perceptions, experiences, and study.

Art experience. Perceiving art through an aesthetic activity.

Art expression. The presentation of perception, skills, ideas, and feelings in terms of art.

Asymmetry. An irregularity; an uneven balance.

Atmospheric perspective. The illusion of distance on a flat surface by means of softening or blurring those forms or cooling those colors in a bluish haze that are not in the foreground.

Balance. Equal, stable structure maintained by the distribution of weight.

Baroque. An ornamental, swirling style of painting that was initiated during the late sixteenth century. Characteristic are its sense of motion and grandeur. Often Baroque artists attempted to join architecture, sculpture, and painting into an entity.

Bas-relief. Sculpture in low relief, projecting slightly from the background surface.

Binder. A substance used to hold together pigment particles or to cause pigment to adhere to the surface to which it has been applied.

Carrier. Any untreated surface, such as wood or canvas, upon which a painting is created after the surface is treated.

Cartoon. A preliminary drawing in which organizations problems are solved before putting it on a painting or mural.

Ceramics. The term used for the art of making earthen objects such as pottery, which is fired in a kiln.

Chiaroscuro. A manner of creating light and shade in drawing and painting.

Chroma. The brilliance or intensity of color.

Classic. Emphasis on the formal organization in terms of simplicity and clarity in taste. Often referred to in terms of Grecian concepts.

Color. A visual sensation of light caused by stimulating the cones of the retina.

Commercial art. Art intended for business purposes; advertising.

Complementary colors. Colors which offer the maximum contrast to the eye; colors that are opposite one another on a color chart (red-green). Complementary colors when mixed together in original intensities will be grayed or neutralized.

Composition. The structure, arrangement, and organization of the parts into a relationship through the use of the art elements.

Construct. To build, structure, and create in three-dimensional form.

Content. Often, the subject matter of a work of art; could also refer to the art elements such as the form, color, etc.

Contour. The outside edge, the boundary. Usually a sensitive line indicating the existence of mass in space.

Contrast. Opposites, unlikes, opposing elements in a composition. Example: dark against light, rough against smooth.

Crosshatch. The technique of suggesting modeling or shading by using crossing lines at various angles to indicate depth. Pencil or pen and ink are most often used.

Decoration. A surface embellishment to enhance an object.

Depth. Space which indicates three dimensions. In drawing and painting, depth is the receding space created behind the picture plane.

Design. Composition. The organization of the art elements into a structure. Can also be a plan, a sketch, an outline, a procedure.

Detail. The smaller and more intricate parts of a work of art.

Direction. The movement or path which leads the eye in a work of art. This movement can be created by the use of color or by any of the art elements and the relationships existing between them.

Distortion. A deviation from the actual form. All art forms involve a certain degree of distortion, depending on the artist's concepts and vision.

Domination. Emphasis on one part or area of a composition.

Draftmanship. Drawing skill.

Drawing. The fundamental process of pictorial art, emphasizing line and tone to express the artist's vision of ideas, skill, feelings, situations.

Eclectics. Artists who chose to incorporate elements or philosophical ideas from an era in their paintings.

Egg tempera. Pigment ground in water and mixed with egg yolk.

Elements of art. The fundamental visual tools of the artists—line, shape, value, color, texture, space, and pattern.

Expression. Refers to the artist's personal statements.

Expressionism. Art in which the artist is more concerned with expressing his emotional reaction to an object or situation rather than approaching his subject on a naturalistic basis. Very prevalent in German art in the twentieth century.

Eye-level line. A perspective term referring to an imaginary line ahead of the viewer which is level with his horizontal line—the vanishing point is located on this line. All edges and lines of the object pictured converge to vanishing points.

Fantasy. Highly imaginative and whimsical art forms.

Fauvism. A painting movement characterized by vivid colors and free treatment of form, resulting in a vibrant and decorative effect.

Fine art. Art created by artists and valued for its aesthetic significance.

Fixative. A solution which is sprayed on pencil, chalk, or charcoal drawings to prevent smudging.

Foreshortening. Forms as they appear to the viewer from the angle at which they are viewed. Exaggeration of foreshortened forms adds visual excitement to drawings.

Form. A shape having three dimensions: height, width, and depth.

Form, shape, mass, volume. The representation of a three-dimensional shape; also refers to the totality of an art work.

Formal arrangement. Symmetrical and rigid organization of the art elements.

Format. The outside shape of the surface on which the artists work—round, long, horizontal, vertical, etc.

Free forms. An indefinite shape or invented form.

Fresco. A water-based painting executed either on wet or dry plaster walls.

Functional. The structural elements of art used for a utilitarian purpose.

Genre. A painting of the daily activity of ordinary people.

Gesso. A white substance made of whiting (i.e., refined chalk derived from calcium carbonate), gelatine, and water, applied to a carrier as a warm liquid and used as a painting ground when dry and hard.

Gesture. A drawing approach emphasizing the essential movement. Gesture drawing is usually represented with a scribbly "fast" line or tone.

Glazes. Thin transparent layers of color, applied over layers of solid color, each successive layer darker than the one beneath.

Goal. The end or final purpose; the end to which a design tends, to which a person aims.

Gouache. An opaque watercolor made by mixing white with transparent watercolor.

Gradation. A gradual change from one value or color to another.

Graphic arts. Usually refers to black-and-white drawing or printmaking. The technical process of printing, printmaking, and photography.

Ground. (1) The prepared surface for painting. It is usually white in color. (2) The space or field around the drawing—the negative space.

Harmony. The structural elements formed into a pleasing relationship.

Highlight. The lightest light in a painting, which seems to emanate from a natural (i.e., sunlight), artificial (i.e., electric light bulb), or imaginary light source within the painting.

Hues. Pure color-red, orange, yellow, green, etc.; *the name*. Warm hues (red) and cool hues (blue).

Illusionist. An artist whose purpose is to duplicate the actual appearance of nature.

Illustration. A picture used as a supplement to dramatize, usually related to a story, poem, or written description.

Imaginative art. Art which refers to the highly inventive and creative; not actual visual representations.

Impasto. Heavy "pasty" layers of paint usually applied to the brightest areas of an oil painting.

Imprimatura. A transparent color wash brushed onto the white ground before an under painting is begun.

Intensity. The strength or weakness of a color, brightness or dullness.

Intuitive. A type of response which is spontaneous or instinctive.

Life drawing. Refers to drawing the human figure; using an actual model rather than drawing the figure from memory or imagination.

Light. The illumination which reveals the object.

Line. A basic structural element. It is an abstract invention of man used to describe the contour of a three-dimensional object; it may be a moving direction. To delineate; outline; contour; the course in which anything moves or aims to move; boundary; limit.

Mass. That which adheres together. Applied to any solid body.

Medium. (1) Material used for making a work of art, such as pencils, paints, wood, inks. (2) Paint medium—the substance or liquid into which pigments are ground to make them usable as paint, such as oil, size, egg yolk, or gum arabic.

Mobiles. A construction intended to move about in space, creating variations of shapes, spaces, and shadows.

Modeled drawing. A method of drawing whereby the outside form is drawn freely and through gradations of value or color—a range of tones from light to dark. The form creates mass.

Monochromatic color. One color used in varied values and intensities. Variations are made by adding black or white to a color, thinning with water, or mixing smaller amounts of color.

Mood. An emotional feeling created by the handling of the art elements.

Mosaic. An art form made from adhering small pieces of stone, ceramic tile, glass, etc., to a background. Used in ancient as well as contemporary art.

Motif. The dominant idea in a design.

Movement. The direction or force of relating lines, color, etc., that lead the eye over and through a work of art.

Mural. A painting that is part of the wall structure, either painted directly on the surface or fastened to the wall.

Negative space. The area or space around the shape.

Neoclassicism. The eighteenth-century revival of artistic styles of ancient Greece and Rome.

Neutral color. Colors such as gray which have no positive hue.

Nonobjective art. An artwork which does not have any reference to natural appearances. Not the same as abstract art.

Objective art. Art which is based on the actual physical world. Tends toward naturalism.

Opaque. A quality which cannot be seen through; is not transparent or translucent.

Opposition. A struggle between colors, shapes, lines.

Order. Organization, arrangement.

Organization. Design, structure, arrangement of forms. Results in a unification of ideas or parts.

Outline. The line defining the outer edges or limits of form; it is not a contour line. An outline is flat and two-dimensional—a silhouette.

Overpainting. The final application of glazes, scumbles, and impastos in oil painting. The application of any paint over an underpainting or imprimatura.

Palette. A board or tablet on which the artist has his colors and on which he mixes them. May also refer to the typical color range used by a group of artist such as the impressionists' palette.

Pattern. Forms, lines, or symbols that move *across* the paper surface—not into the surface; arranged in some sequence or movement.

Perspective. An illusion of space or depth and volume in a two-dimensional surface when viewed from one stationary point of view. Developed since the Renaissance. The illusion of objects that appear to get smaller as they recede for the viewer.

Picture plane. The flat, two-dimensional surface of the drawing or painting. Imaginary flat vertical areas which indicate zones of distance within a painting. The three chief planes of a painting are the foreground, the area of the painting represented to be nearest the viewer; the background, the area of the painting represented to be farthest from the viewer; and the middle ground, the area equidistant between the foreground and the background.

Pigment. Coloring matter—paint.

Plane. A flat, curved, moving, two-dimensional surface of any form, such as a side of a cube.

Pointillism. A late-nineteenth century French method of painting, in which small dabs of color are applied to the ground, side by side, so that they appear to blend smoothly at a distance. The intention of the artists was to arrive at more vivid coloring by means of this technique rather than by mixing the colors on the palette.

Polychrome. A painting executed in more than one color.

Potrait. A drawing or painting of a human model in which the artist's aim is to capture the likeness and spirit of an individual.

Positive space. The drawing, the shape, surrounded by negative space.

Poster paint. An opaque water-soluble paint; not the same as tempera paint.

Primary colors. Red, yellow, and blue are the primary colors; all other colors come from combinations and mixing.

Priming. Preparing the carrier with glue size or other materials in order to apply the ground upon which the actual painting is rendered.

Print. An original work of art made from one of the print-making processes—etching, engraving, linoleum block printing, lithography, silk-screen, etc. (not to be confused with a "reproduction print" of a painting or drawing).

Proportion. Relating of elements or comparing of parts as to size, quality, variety, scale, purpose, or meaning. Realistic proportions refer to "accurate" relationships of parts. In expressive works of art, the proportions may be distorted to express the idea or emotion.

Proximity. The closeness of one thing to another; the tension between them.

Realism. Art which represents actual appearances, but little attention to detail.

Receding. Movement into depth.

Rendering. The particular graphic treatment of a subject such as a "line" rendering or a "tone" rendering. Also, the manner of applying pigment to a surface.

Representational art. Art where actual near-likeness to an object drawn is easily recognized.

Rhythm. A tempo; the timing, the movement created by repetition.

Rococo. An eighteenth-century style of very delicately curved ornamental shapes and forms that followed the baroque style but which was lighter in feeling and less grandiose.

Romanticism. A nineteenth-century painting style that concentrated on subjects not directly connected with the obvious, current realities of life. The atmosphere of the painting took on greater significance than the naturalistic objects themselves.

Scale. The proportional relationships of many parts to the whole. The size of a drawing in relation to the object being drawn.

Sculpture. Three-dimensional shapes either modeled, cast, carved, or constructed.

Scumble. Thin opaque or semiopaque layers of color with each successive layer lighter than the one beneath showing some of the color of the previous layers.

Secondary colors. Colors which contain about equal amounts of two primaries. Green, violet, and orange are secondary colors.

Sepia. A color such as sepia ink. A dark-brown pigment made from secretions of cuttlefish.

Sequence. An arrangement in a series to develop a progression.

Shade. A dark value of a hue (made by adding black to the color). Degree of gradation of colored light; as a light shade of green.

Shadow. Shade within defined limits; obscurity or deprivation of light; apparent on a plane and representing the form of the body which intercepts the rays of light.

Shape. The contours of a form of a real or imaginary object. One of the structural elements; a form, mass.

Silhouette. Flat two-dimensional representation of a shape.

Size. A glue substance—usually gelatine and water—used for priming, preparation of gesso, a painting medium, and a variety of other applications.

Sketch. A quick drawing intended as an idea for a more sustained drawing.

Space. (1) An illusion of movement into the picture plane. (2) Spacing which moves across the surface of a two-dimensional picture plane. (3) An interior. (4) An environmental space. (5) The interval between two or more objects.

Spectrum. The range of colors usually considered the color circle.

Static. A fixed, quiet, passive quality in a work of art.

Still life. The subject for a drawing composed of inanimate objects.

Style. Refers to the artist's individual and unique manner of expression. Also, refers more broadly to a characteristic of a school or period, such as the "realistic" school.

Subject matter. The object, experience of, idea, or event used as the motivation for a drawing or work of art.

Symmetry. Formal balance of the elements, the same mirror image or both sides of art work.

Tapestry. A large heavy ornamentally woven fabric used, primarily, as a wall hanging.

Technique. A style or manner in which a medium is used. The artist's individual way of using the art material.

Tempera. A painting medium in which the pigments are mixed with egg yolk or white, whether in a pure state or in emulsion (different from poster paint).

Tension. Stress; opposite of static; quality of pull or strain within a composition.

Texture. The surface quality in a work of art—rough-smooth, shiny-dull. In the fine arts, the surface quality of objects which conveys to the eye the composition of their tissues.

Three-dimensional. Refers to objects that have length, breadth, and depth. Two-dimensional is a form having the characteristic of length and width, not depth.

Tint. A light value; the color plus white.

Tonality. The lightness or darkness of a painting. Also, the coolness or warmness of a painting.

Tone. The lightness or darkness of a color. Also, the coolness or warmness of a color.

Transparency. Permits the passage of light.

Underpainting. A preliminary painting—usually in one color—applied as a beginning step in some painting techniques.

Unity. A harmonious relationship of parts.

Value. A quality of color referring to the amount of light (tint) or dark (shade) contained in the color on a scale ranging form black to white; a basic structural element.

Vanishing. In perspective, the point on the eye-level line where receding parallel lines appear to converge.

Vehicle. The substance or liquid mixed with previously ground pigments to make them more workable.

Volume. A space; a mass; the space occupied by a body; dimensions in length, breadth, and depth.

Wash. A thin, transparent, watered-down use of paint or ink.

Watercolor. A transparent painting medium using pigment with a gum binder.

Bibliography

Foundation books

BEITTEL, K. R. *Mind and Context in the Art of Drawing.* New York: Holt, Rinehart & Winston, 1972.

BLAKEMORE, C. *Mechanics of the Mind.* Cambridge University Press, 1977.

BLAKESLEE, T. R. *The Right Brain.* Garden City, N.Y.: Anchor Press, 1980.

BOFFOLY, R. L. "A factor analysis of visual, kinesthetic and cognitive modes of information handling." *Review of Research in Visual Arts Education* 8 (1978): 17–27.

BOGEN, J. E. "Some educational aspects of hemispheric specialization." *U.C.L.A. Educator* 17 (1975): 24–32.

BRITTAIN, W. LAMBERT, *Creativity, Art, and the Young Child.* N.Y.: Macmillan Publishing Co., Inc., 1979.

BUZAN, T. *Use Both Sides of Your Brain.* New York: E. P. Dutton, 1976.

CAROTHERS, T., and GARDNER, H. "When children's drawings become art: the emergence of aesthetic production and perception." *Developmental Psychology* 15 (1979): 570–580.

CHAPMAN, LAURA H. *Approaches to Art in Education,* 1st ed. N.Y.: Harcourt, Brace, Jovanovich, 1978.

COX, M. V. "Spatial depth relationships in young children's drawings." *Journal of Experimental Child Psychology* 26 (1978): 551–554.

DEPORTER, D. A., and KAVANAUGH, R. D. "Parameters of children's sensitivity to painting styles." *Studies in Art Education* 20 (1978): 43—48.

DISSANAYAKE, E. "Art as a human behavior: toward an ethological view of art." *The Journal of Aesthetics and Art Criticism* 38 (1980).

DOBBS, STEPHEN M. *Art Education and Back to Basics,* 1st ed. National Art Ed., 1979.

DOERR, S. L. "Conjugate lateral eye movement, cerebral dominance, and the figural creativity factors of fluency, flexibility, or originality, and elaboration." *Studies in Art Education* 21 (1980): 5–11.

EISNER, ELLIOT W. *Cognition and Curriculum: A Basis for Deciding What to Teach,* 1st ed. Longman, 1982.

———*Reading, the Arts and the Creation of Meaning,* 1st ed. National Art Ed., 1978.

FORMAN, S. G., AND McKINNEY, J. D. "Creativity and achievement of second graders in open and traditional classrooms." *Journal of Educational Psychology* 70 (1978): 101–107.

FOSTER, S. "Hemisphere dominance and the art process." *Art Education* 30 (1977): 28–29.

GAITSKELL, C. D., and DAY, M. *Children and Their Art: Methods for the Elementary School,* 4th ed. N.Y.: Harcourt, Brace, Jovanovich, 1982.

GAITSKELL, CHARLES D., AND HURWITZ, Al. *Children and Their Art: Methods for the Elementary School,* 4th ed. N.Y.: Harcourt, Brace, Jovanovich, 1982.

GARRETT, S. V. "Putting our whole brain to use: a fresh look at the creative process." *The Journal of Creative Behavior* 10 (1976): 239–249.

GAZZANIGA, M. "The split brain in man." *Perception: Mechanisms and Modes.* Edited by R. Held and W. Richards. San Francisco, CA: W. M. Freeman, 1972.

GERSCHWIND, N. "Specializations of the human brain." *Scientific American* 241 (1979): 180–199.

GOLEMAN, D. "Split-brain psychology: fad of the year." *Psychology Today,* October 1977.

GOLOMB, C. "Representational development of the human figure." *The Journal of Genetic Psychology* 131 (1977): 207–222.

GOMBRICH, ERNST H. *The Sense of Order: A Study in the Psychology of Decorative Art,* 1st ed. Ithaca, N.Y.: Cornell University Press, 1979.

———*The Story of Art.* Oxford, England: Phaidon Press Limited, 1978.

GOODNOW, J. J. "Visible thinking: cognitive aspects of change in drawings." *Child Development* 49 (1978): 637–641.

GROGG, P. "Art and reading: is there a relationship?" *Reading World,* May 1978, pp. 345–351.

HARDIMAN, GEORGE W., AND ZERNICH, THEODORE. *Foundations for Curriculum Development and Evaluation in Art Education,* 1st ed. Stipes, 1981.

———"Influence of style and subject matter on the development of children's art preferences." *Studies in Art Education* (197-): 29–35.

HARRIS, D. B. "The child's representation of space." *The Child's Representation of the World.* Edited by G. Butterworth. N.Y.: Plenum Press, 1977.

HERBERHOLZ, BARBARA. *Early Childhood Art,* 2nd ed. Dubuque, Ia. Wm. C. Brown Company Publishers, 1979.

IVES, W., AND HOUSEWORTH, M. "The role of standard orientations in children's drawing of interpersonal relationships: aspects of graphic feature marking." *Child Development* 51 (1980): 591–593.

LANSING, KENNETH M., AND RICHARDS, ARLENE E. *The Elementary Teacher's Art Handbook.* N.Y.: Holt, Rinehart, & Winston, 1981.

LEE, SHERMAN E. *Reflections of Reality in Japanese Art.* Bloomington, Indiana: Indiana University Press, 1983.

LEWIS, H. P., AND LIVSON, N. "Cognitive development, personality, and drawings: their interrelationships in a longitudinal study." *Studies in Art Education* 22 (1980): 8–11.

LIGHT, P. H., AND MacINTOSH, E. "Depth relationships in young children's drawings." *Journal of Experimental Child Psychology* 30 (1980): 79–87.

LOWENFELD, VICTOR, AND BRITTAIN, W. LAMBERT. *Creative and Mental Growth.* N.Y.: Macmillan Publishing Co., Inc., 1982.

LYNCH, D. J. "An investigation of left and right hemisphere processing specialization and the implications for the Satz maturational lag model of specific reading disability." *Dissertation Abstracts International* 40 (1980).

MADEGA, STANLEY S. *Arts & Aesthetics: An Agenda for the Future,* 1st ed. Transaction Bks., 1978.

———The Arts, Cognition & Basic Skills, 1st ed. Transaction Bks., 1977.

McCALLUM, R. S., and GLYNN, S. M. "The hemispheric specialization construct: developmental and instructional considerations for creative behavior." Paper read at the National Association of School Psychologists, San Diego, 1979.

MITCHELMORE, M. C. "Developmental stages in children's representation of regular solid figures." *Journal of Genetic Psychology* 133 (1978): 229–239.

"National Assessment of Art." *Design and Drawing Skills.* Washington, D.C.: U.S. Government Printing Office, 1977.

NICKI, R. M., AND GALE, A. "EEG, measures of complexity, and preference for nonrepresentational works of art." *Perception* 6 (1977): 281–286.

ORNSTEIN, R. E. *The Psychology of Consciousness,* 2nd ed. N.Y.: Harcourt, Brace, Jovanovich, 1977.

PHILLIPS, W. A., HOBBS, S. B., AND PRATT, F. R. "Intellectual realism in children's drawings of cubes." *Cognition* 6 (1978): 15–33.

TAUTON, M. "The influence of age on preferences for subject matter, realism, and spatial depth in painting reproductions." *Studies in Art Education* 21 (1980): 40–52.

WILLATS, J. "How children learn to draw realistic pictures." *Journal of Experimental Psychology* 29 (1977): 367–382.

WITTROCK, M. C. et al. *The Human Brain.* Englewood Cliffs, New Jersey: Prentice-Hall, Inc., 1977.

YOUNGBLOOD M. S. "The hemispherality wagon leaves laterality station at 12:45 for art superiority land." *Studies in Art Education* 21 (1979): 44–49.

Art Books

BETTI, CLAUDIA W., AND SALE, TEEL. *Drawing: A Contemporary Approach.* N.Y.: Holt, Rinehart and Winston, 1983.

BIRREN, FABER. *History of Color in Painting.* Florence, Kentucky: Van Nostrand Reinhold, 1980.

BRIDGMAN, GEORGE. *Constructive Anatomy.* N.Y." Dover Publications, Inc., 1960.

BRO, LU. *Drawing—A Studio Guide.* N.Y.: W. W. Norton & Co., 1978.

CHAET, BERNARD. *An Artist's Notebook: Techniques and Materials.* N.Y.: Holt, Rinehart and Winston, 1983.

———The Art of Drawing. N.Y.: Holt, Rinehart and Winston, 1983.

COOPER, MARIO. *Painting with Watercolor.* Florence, Kentucky: Van Nostrand Reinhold, 1981.

duMOULIN, YVONNE. *Creative Watercolor Techniques.* Florence, Kentucky: Van Nostrand Reinhold, 1982.

EDWARDS, BETTY. *Drawing on the Right Side of the Brain.* Los Angeles: J. P. Tarcher, Inc., 1979.

ELLINGER, RICHARD G. *Color Structure and Design.* Florence, Kentucky: Van Nostrand Reinhold, 1980.

GELMAN, WOODY. *The Best of Charles Dana Gibson.* N.Y.: Crown Publishers, Inc., 1969.

GOLDSMITH, LAWRENCE C. *Watercolor Bold and Free.* N.Y.: Watson-Guptill Publications, 1980.

GOMBRICH, E. H. *Art and Illustration.* Bollington series. Princeton, N.J.: Princeton Univ. Press, 1960.

HERBERT, ROBERT L. *Modern Artists on Art.* Englewood Cliffs, New Jersey: Prentice-Hall, Inc., 1964.

HOGARTH, BURNE. *Dynamic Figure Drawing.* N.Y.: Watson-Guptill Publications, 1980.

LEE, SHERMAN E. *Reflections of Reality in Japanese Art.* Bloomington, IN: Indiana University Press, 1983.

LUCIE-SMITH, EDWARD. *Art in the Seventies.* Ithaca, N.Y.: Cornell University Press, 1980.

RICHARD DIEBENKORN, ETCHINGS AND DRYPOINTS 1949–1980. Houston, Texas: Houston Fine Arts Press, 1981.

RUBENSTEIN, CHARLOTTE STREIFER. *American Women Artists.* Boston: G.K. Hall & Co., 1982.

SELZ, PETER. *Art in Our Times.* N.Y.: Harry N. Abrams, Inc., Publishers, 1981.

SMEETS, RENE. *Signs, Symbols & Ornaments.* Florence, Kentucky: Van Nostrand Reinhold, 1982.

SZABO, ZOLTAN. *Creative Watercolor Techniques.* N.Y.: Watson-Guptill Publications, 1980.

VANDERPOEL, JOHN H. *The Human Figure.* N.Y.: Dover Publications, Inc., 1958.

Index

Abstract art, 88
 artists to study, 95
Acrylic polymer paints, 239
Appel, Karen, 101
Art
 analysis and discussion, 101, 103
 and perception, 11–13
 and the brain, 10–11
 appreciation, 85–96
 as a universal language, 5–6
 as culture, 6, 8
 assessment, 51–54
 categories of, 5
 curriculum, 23–24
 elements of, 117, 141
 history, 85–87
 in the school, 8–9
 objectives, general, 24, 26
 resources, 100
 therapy, 81–82
 thinking, how to encourage, 60
 what is good art, 64
Art analysis, 101
 discussion questions, 54, 101, 103
Art growth
 fifth and sixth grades, 39–43
 first and second grades, 31–33, 35
 kindergarten, 29–31
 preschool, 28–29
 third and fourth grades, 35–39
Art heritage and judgment
 fifth and sixth grades, 43
 first and second grades, 33
 kindergarten, 31
 third and fourth grades, 38–39
Art instruction
 example of, 50–51
 planning, 48–50
 questions for discussion, 54

Art movements, 87–89
Art sensitizers
 sound and listening, 16
 space and movement, 16, 18
 tactile, 15
 tasting and smell, 18
 visual, 14–15
Artistic and perceptual skills
 fifth and sixth grades, 39, 42
 first and second grades, 31
 kindergarten, 29
 third and fourth grades, 35–36, 38
"Arts involvement" programs, 8–9
 parental involvement in, 9
 school involvement in, 9
 student involvement in, 9
Avery, Milton, 156, 158, 165

Balance
 asymmetrical, 112
 radial, 112
 symmetrical, 112
 weight, 112
Beardsley, Aubrey Vincent, 138
Beckman, Max, 3
Beckmann, Arno, 159
Bidstrup, Carol, 143
Birds, 127, 133
 examples of, 116, 129, 130
 photographs as motivation, 129
Brain, functions of, 10–11
Braque, George, 94, 141, 165, 231
Breder, Hans, 230
Brushes, 239–240

Calligraphy, 123
Camera as a tool, 182
Cartoon drawing, 124
Cassatt, Mary, 208
Cezanne, Paul, 230
Chaet, Bernard, 109
Chagall, Marc, 105, 106, 165
Chalks and pastels, 236
Charcoal, 234
Classroom environment, 57, 59
Collage, 246
Collier, Graham, 163
Color
 definition, 177, 181
 expressions of, 185, 186
 motivations, 187–188
 movement, 182
 preferences, 177, 181
 psychology, 180–182
 relationships, 181–182
 vocabulary, 179–180
Communication
 body language, 60
 verbal, 61
Computer graphics art, 88–89
Conceptual art, 89
Contour drawing, 119–121
Contrast, 114
Craft media
 construction and sculpture, 46

photography-filmmaking, 46
 printmaking, 46
 puppets, 46
 textiles, 46
Crayon, 235
Creativity, 18–21
Cubism, 88

Dali, Salvador, 165, 175
Davis, Stuart, 137, 138, 165
Degas, Edgar, 199, 211
de Kooning, Willem, 94, 194
Design, principles of, 111–112
Dewey, John, 3, 12, 111
Dollmaking, example of, 26
Dominance/emphasis, 113
Drapery, 222
Drawing
 approaches, 198
 drapery, 222
 figures, 208, 209–212
 landscapes, 222–224
 learning to draw, 195–196
 materials, 234–236
 motivations, 237
 portraits, 198, 200–202, 205
 still life, 224, 225, 231
Dürer, Albrecht, 136, 138, 167

Eickenbury, Janet, 145
Environment
 in classroom, 13
 importance of, 57, 59
Erasers for art, 236
Exhibiting artwork, 65
Expressionism, 87–88

Farthing, Geneva, self-portraits, 206
Figures
 artists to study, 95
 drawing, 208, 209–212
 motivations, 216–217, 221–222
 understanding, 212, 213–216
Films
 animated, 182–183
 experimental, 183
Fixative, 236
Flowers, 137
Frankenthaler, Helen, 95

Gesture drawing, 121–123
Glasser, William, 62
Gourbet, Gustave, 199
Graphite sticks, 235
Growing things, 137
Guilford, J. P., 19

Heflin, Janet, 229
Hillis, Richard, 229
Hopper, Edward, 84, 94, 175
Houston, Jean, 72

Illusions, visual, 163–164
Imagination, 18–21, 100
 ideas, 21

IMPACT, 72
Impressionism, 87
Inks, 235
Insects, 134, 156
 examples of, 131–132, 134
Inspiration, 18
Integrated learning
 history and art, 79
 language and art, 74
 mathematics and art, 79
 science and art, 78

Kerslake, Kenneth, 191
Klee, Paul, 3, 105, 138, 139, 165
Kollowitz, Kathe, 95, 207
Kronengold, Eric, 146
Kubie, Lawrence, 19

Landscapes, 222–223
 artists to study, 95
 motivations, 223–224
Lenzner, Anne R., 181
Light and vision, 147–148
Light shows, 183–185
Linderman, Earl, 85, 91, 97, 136, 229
Linderman, Marlene, 92, 93, 136, 197, 205, 207, 251
Line
 as a tool, 118–119
 as expression, 117–118
 examples, 128
 ideas, 137
 motivations, 127
 understanding, 124
 intermediate, 124, 127
 primary, 124
 upper intermediate, 127

MacKinnon, Donald, 19
Magenta, Muriel, 98
Manet, Edouard, 210
Marina, 249
Marin, John, 94, 225, 226
Maslow, Abraham, 19
Materials
 fifth and sixth grades, 43
 first and second grades, 35
 for starting an art program, 66–67
 third and fourth grades, 39
Matisse, Henri, 156, 195, 230
McGargee, Lon, 249
McLuhan, Marshall, 57
Media skills
 fifth and sixth grades, 43
 first and second grades, 31, 33
 kindergarten, 30
 preschool, 28–29
 third and fourth grades, 38
Memory drawing, 123
Minimal art, 88
Miro, Joan, 103–105, 138, 165, 196
Modeled drawing, 148
Moore, Henry, 138, 158
Motion, 130
Motivation
 fifth and sixth grades, 43

 first and second grades, 34
 third and fourth grades, 39
Museums and galleries, 97–98

National Art Education Association, position statement, 23
Neo-Impressionism, or pointillism, 87
Nevelson, Louise, 94
Newton, Isaac, 177
Non-objective art, 88

O'Keefe, Georgia, 94
Op art, 88
Ornstein, Robert, 10
Outline drawing, 123

Painting
 materials, 239–241
 motivations, 243–247, 249, 251–252
 preparation, 240–241
 techniques, 241–243
 tools and surfaces, 240
Palette, 239
Papers
 for drawing, 236
 for painting, 239
Pattern-rhythm, 188
Pencils, 234
Pens, 235
Peterson, Roland, 165, 232
Picasso, Pablo, 139
Poons, Larry, 165, 190
Pop art, 88
Portraits
 artists to study, 95
 motivation, 202, 205, 246
 proportions, 198, 199–202
Precision instruments, 133
 examples of, 133

Read, Herbert, 72
Rembrandt, 209
Renoir, Pierre Auguste, 209
Rhythm/movement, 113
Rockwell, Norman, 210
Rogers, Carl, 19

Scholder, Fritz, 102
Sense awareness, 8, 11–13
Shading, 148
 motivations, 149, 155–156
 understanding, 149
Shadows, 143, 147
 motivations, 149, 155–156
Shahn, Ben, 84, 94, 165, 189
Shape, 141
 motivations, 149, 155–156
 positive and negative, 141–142
 understanding, 149
Skeletal parts, 134, 137, 156
 examples of, 128, 135
Soleri, Paolo, 162
Space
 artists who emphasize, 174
 imaginative, 165–166
 motivations, 173–174

realistic, 167–168, 171
 understanding, 171–173
 visual illusions, 163–164
Still life, 224, 226, 246
 artists to study, 95
 motivations, 231, 246
Stuler, Jack, 140, 165
Surrealism, 88
Swanson, Robin, 68

Talent
 definition of, 63–64
 loss of, 66
Tamayo, Rufino, 165, 208
Taylor, Anne, 56
Taylor, Calvin, 19
Teacher
 body language, 60
 boundary pushing, 60–61
 encouraging art thinking, 60
 enthusiasm, 59
 leadership qualities, 59
 strategies, 59
 verbal communication, 61–62

Tempera paint, 239
Texture, 188–189
 motivations, 189
Thiebaud, Wayne, 89
Tools, 13
 auditory, 16
 smell, 18
 space and movement, 16
 tactile, 15
 taste, 18
 visual, 14
Torrence, Paul, 19

Values, 142
 motivations, 149, 155–156
 understanding, 149
Van Gogh, Vincent, 199
Very Special Arts Festival, 70, 81
Visual structure, 111–112

Watercolor paint, 239
Wyeth, Andrew, 89, 90

X-ray drawing, 172
X-ray pictures, 171